THE GENTLE ART OF FAKING

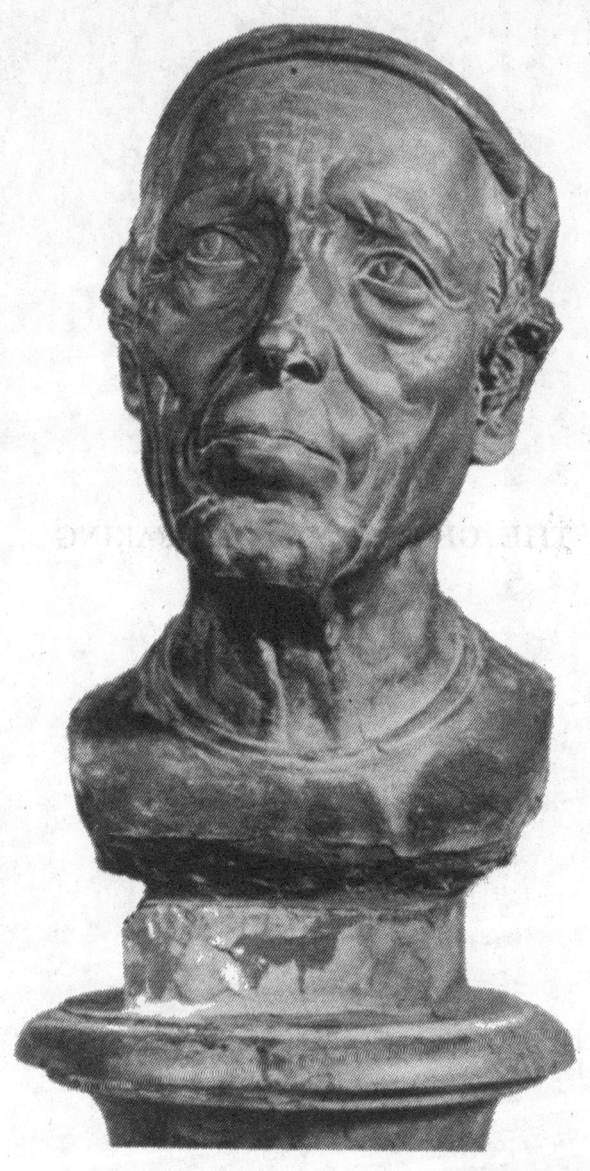

Photo SUPPOSED PORTRAIT OF THE POET BASTIANINI BENIVIENI. Alinari

A direct cast from the original now in Paris and formerly kept in the Louvre Museum.

THE GENTLE ART OF FAKING

A HISTORY OF THE METHODS OF PRODUCING
IMITATIONS & SPURIOUS WORKS OF ART
FROM THE EARLIEST TIMES UP
TO THE PRESENT DAY

BY

RICCARDO NOBILI
AUTHOR OF "A MODERN ANTIQUE"

"Le dernier mot de l'art je le trouve dans la contrefaçon"
SAINTE-BEUVE

WITH 31 ILLUSTRATIONS

Fredonia Books
Amsterdam, The Netherlands

The Gentle Art of Faking:
A History of the Methods of Producing Imitations & Spurious Works of Art From the Earliest Times Up to Present Day

by
Riccardo Nobili

ISBN 1-58963-276-1

Copyright © 2001 by Fredonia Books

Reprinted from the 1922 edition

Fredonia Books
Amsterdam, The Netherlands
http://www.fredoniabooks.com

All rights reserved, including the right to reproduce this book, or portions thereof, in any form.

In order to make original editions of historical works available to scholars at an economical price, this facsimile of the original edition of 1922 is reproduced from the best available copy and has been digitally enhanced to improve legibility, but the text remains unaltered to retain historical authenticity.

TO

MRS. MARY S. SHEPARD

WITH THE DEVOTED AFFECTION OF A SON

THIS BOOK IS DEDICATED

TO
MRS MARY R. SHEPARD
WITH THE DEVOTED AFFECTION OF A SON
THIS BOOK IS DEDICATED

PREFACE

"COLLECTOMANIA" may with some reason be looked upon as a comedy in which the leading parts are taken by the Collector, the Dealer, and the Faker, supported by minor but not less interesting characters, such as imitators, restorers, middlemen, *et hoc genus omne*, each of whom could tell more than one attractive tale.

In analysing the Faker one must dissociate him from the common forger; his semi-artistic vocation places him quite apart from the ordinary counterfeiter; he must be studied amid his proper surroundings, and with the correct local colouring, so to speak, and his critic may perchance find some slight modicum of excuse for him. Beside him stand the Imitator, from whom the faker often originates, the tempter who turns the clever imitator into a faker, and the middleman who lures on the unwary collector with plausible tales.

It is not the object of this volume to study the Faker by himself, but to trace his career through the ages in his appropriate surroundings, and compare the methods adopted by him at various periods of history, so far as they may be obtained.

Ethically, there is a strict line drawn between the imitator and the forger, but in practice this line is by no means rigid. Many imitators place their goods before the public *as* imitations; others tacitly permit their work to be sold as genuinely antique, influenced no doubt by the fact that though possibly

the imitation and the original may possess equal merit, the one is handicapped by modernity, the other is hallowed by age. The inexperienced and unwary collector is in most cases the innocent originator of fraud; if there were no buyer there would be no seller. Too often fashion leads folly, and so fictitious values are created, and as demand increases so, too, do the sources of supply, but unhappily they are frequently not legitimate.

RICCARDO NOBILI.

Ville Marie,
 Via Dante da Castiglione 3,
 Florence.

CONTENTS

PART I

THE BIRTH AND DEVELOPMENT OF FAKING

CHAPTER		PAGE
I.	GREEKS AND ROMANS AS ART COLLECTORS	17
II.	COLLECTOMANIA IN ROME	24
III.	RAPACIOUS ROMAN COLLECTORS	36
IV.	ROME AS AN ART EMPORIUM	44
V.	INCREASE OF FAKING IN ROME	57
VI.	DECADENCE OF ART AND CONSEQUENT CHANGES	63
VII.	THE RENAISSANCE PERIOD	68
VIII.	IMITATION, PLAGIARISM, AND FAKING	83
IX.	COLLECTORS OF THE SIXTEENTH CENTURY	101
X.	COLLECTING IN FRANCE AND ENGLAND	107
XI.	MAZARIN AS A COLLECTOR	114
XII.	SOME NOTABLE FRENCH COLLECTORS	129

PART II

THE COLLECTOR AND THE FAKER

XIII.	COLLECTORS AND COLLECTIONS	135
XIV.	THE COLLECTOR'S FRIENDS AND ENEMIES	150
XV.	IMITATORS AND FAKERS	165
XVI.	THE ARTISTIC QUALITIES OF IMITATORS	181
XVII.	FAKERS, FORGERS AND THE LAW	194
XVIII.	THE FAKED ATMOSPHERE AND PUBLIC SALES	207

Contents

PART III

THE FAKED ARTICLE

CHAPTER		PAGE
XIX.	THE MAKE-UP OF FAKED ANTIQUES	225
XX.	FAKED SCULPTURE, BAS-RELIEFS AND BRONZES	234
XXI.	FAKED POTTERY	246
XXII.	METAL FAKES	263
XXIII.	WOOD WORK AND MUSICAL INSTRUMENTS	279
XXIV.	VELVETS, TAPESTRIES AND BOOKS	287
XXV.	SUMMING UP	301
	INDEX	311

LIST OF ILLUSTRATIONS

Supposed Portrait of the Poet Bastianini Benivieni . . *Frontispiece*

	FACING PAGE
Marcus Aurelius	48
Diomedes with the Palladium	72
Imitations of the Antique	88
Marsyas	96
The Spinario	120
A Child. By Ferrante Lampini	136
San Giovanni	136
Athlete	144
The Battesimo	152
Bacchus	152
The Resurrection	184
Pietà	184
A Portrait	192
A Child. By Donatello	200
An Imitation of Roman Work	240
An Imitation of Sixteenth-century Work	240
A Mantelpiece	266
A Lamp	266
Plaquettes by Various Artists	272
Europa on the Bull	288

THE GENTLE ART OF FAKING

Part I
THE BIRTH AND DEVELOPMENT OF FAKING

Chapter I
GREEKS AND ROMANS AS ART COLLECTORS

Why the Greeks by not being collectors in the modern sense were spared faking in art—How the Romans became interested in art—Genesis of their art collections—The first collectors and their methods—Noted citizen's indictment against art plundering of Roman conquerors—Attitude of noted writers towards art, and art collecting.

THE collector, the chief patron of fakery, being somewhat of a selfish lover of art, it is quite natural that the Greeks, who saw in art a grand means of public education and enjoyment, cannot be called art collectors in the modern sense of the word. Consequently there was hardly room for sham art in a country where art as the direct emanation of public spirit was rigorously maintained for the sake of the people. It was the temples that became art emporiums—museums that everyone was allowed to enjoy—or free institutions, like the pinacotheca of the Acropolis, the collection of carved stone at the Parthenon, the gymnasium of the Areopagus, containing a collection of busts of the most celebrated philosophers. With this public spirit in the enjoyment of art Delphi gathered a famous picture gallery in the oracular temple and, according to Pliny, possessed no fewer than three

thousand statues, one of them being the famous golden Apollo. From this temple Nero carried off five hundred bronze statues, and later on Constantine removed many of the remaining works of art to Constantinople. An identical spirit of public enjoyment of art had turned the temples of Juno in Olympia, of Minerva in Platæa and Syracuse into veritable museums of art and—curiosities also. The temple of Minerva at Lyndon in the island of Rhodes, for instance, contained a cup of *electrum* (amber) offered by Helen of Troy, which was said to have a cavity cut to the exact shape of the bosom of the beautiful wife of Paris (Pliny, XXXIII, 28).

That the Greeks at their highest historical level did not indulge in the private and artistic delights of the collector may also be gathered from the poor construction of their usual dwelling-houses. It is well known that thieves, more especially in Athens, were called "wall breakers," and obtained this odd nickname from their peculiar method of entering houses, namely, by making a hole through the wall rather than troubling to unlock the door. Such flimsy dwellings can hardly have sheltered the treasures of an art collection. Thus simplicity of customs and a clearly defined manner of enjoying art, saved the Greeks to a great extent from a regular trade in antiques with all its strange and deplorable etceteras.

As a matter of fact, we have no information as to anything that might be called a private art collection in Athens, though quite consistently, considering their extreme passion for knowledge, the Greeks had fine private libraries, such as those of Aristotle and Theophrastus. But even these, though containing the rarest and most precious works, were true libraries, not collections of elaborate volumes. The mania for fine bindings of costly materials was later on the caprice of the learned Roman, not of the Greek.

The home of the "collector," and consequently of his faithful companion, the faker, was Rome.

The Roman was not a born lover of art. In fact during

Greeks and Romans as Art Collectors

the early and primitive period of its existence Rome had not only been somewhat negative as regards art, but was even rather averse from its enjoyment. It took centuries for the Roman to overcome the belief that matters of art were trifling amusements that might be left as toys to their conquered people. Thus for a long time Romans saw in the enjoyment of art the chief source of the weakening and degeneration of the enemies they had subjugated. Springing from a progeny of soldiers and agriculturists, born to conquer the world, the Roman citizen assumed as an aphorism the Virgilian saying that his sole duty was to subjugate enemies, by granting them pardon or humiliating their pride.

Thus the early Romans not only show great ignorance as to marvels of art, but even contempt for them. When art treasures were brought to Rome as booty for the first time by Marcellus from conquered Sicily the Senate censured such an innovation. Fabius Maximus, called the "shield of Rome," rose among others in protest, saying that after the siege of Tarentum, he, unlike Marcellus, had brought home only gold and valuable plunder. As for statues, more especially images, he had preferred to leave to the conquered people "their enraged gods." In fact the only statue Fabius took away from Tarentum was the Hercules of Lysippus, a bronze colossus which must have appealed to him either for its heroic size or the large quantity of material.

A type of the early ignorant Roman art collector is given by Lucius Mummius, the general who destroyed Corinth, and of whom Velleius Paterculus tells (I, 13) that in sending to Rome what might be styled the artistic booty of the destroyed city he consigned the statues and paintings to those in charge of the transport with the warning that should the goods be lost they would be held responsible and would have to reproduce them all at their own expense.

Even when with the progress of time art was finally appreciated in Rome, the old contempt for it was transferred in a way from the product to the maker. Thus with the feeling that seems to characterize the parvenu in art, and

with inexplicable inconsistency, the Roman lover of art
persisted in seeing in the artist either a slave or a good-for-
nothing, and never for a moment regarded the artist as worth
the consideration he granted to art. Notwithstanding his
belief of being a lover of art and an intelligent connoisseur,
Cicero calls statues and paintings toys to amuse children
(*oblectamenta puerorum*). In his fourth oration, *In Verrem*,
he candidly confesses that he fails to understand the im-
portance attached by Greeks to those arts which the Romans
most rightly despise.

Valerius Maximus, who lived at the time of Tiberius, that
is to say when Rome had fully completed its education in
art, calls the profession of the painter a vile occupation (*sor-
didum studium*), and wonders how Fabius, a Roman and
patrician, can bring himself to sign his painting with full
name and qualification, " Fabius Pictor " (VIII, 14, 6).

In one of his letters (No. 88) Seneca, the contemporary of
Nero, states that sculpture and painting are unworthy to be
classified as liberal arts. Petronius, the *magister elegantiorum*
of Rome, two hundred years after the destruction of Corinth,
that is to say when Rome had reached its maturity in the
understanding of art, calls Apelles, Phidias and other
famous artists of Greece, crack-brained (*græculi delirantes*).

With such an innately negative sense of art and strong
racial prejudice, it is not surprising that when brought to an
appreciation of art by circumstances, the Romans, though
willing and fully prepared to pay extravagant prices for
works of art, should still retain their old contempt for artists,
those *græculi delirantes* who had come to beautify the Capital
as slaves or tempted by gain.

As a result of this peculiar feeling and in full contrast
with the Greek sentiment which has handed down to pos-
terity a great deal about the artists who lived in Athens
and the honours they received, Rome has preserved for us
hardly a name of painter, sculptor or architect. And they
must have been legion if we consider the magnitude of the
work accomplished. Vitruvius (VII, 15) informs us that

Greeks and Romans as Art Collectors

Damophilus, Gorgas, Agesilas, Pasiteles and other artists were called to Rome by Julius Cæsar, and that so many Greek artists were in Rome that when the temple of Jupiter Olympicus was to be finished in Athens the citizens were obliged to send to Rome, as none of their architects were to be found in Greece.

It is interesting to trace how the Romans gradually became collectors of art, and how there gradually developed in Rome a whole world of lovers of art with all its true and fictitious enthusiasms, furnishing a group of varied types of collectors not altogether dissimilar from those of our modern society of lovers of art.

As we have said, conquest and booty furnished the first articles of virtu. At first statues and objects of art of all kinds were brought to Rome without discrimination, then education gradually progressed, taste developed and plunder became more enlightened. Fulvius Nobilior, to quote one of the many conquerors who brought artistic war booty to Rome, enriched it with 285 bronze statues, 230 marble ones, and 112 pounds of gold ornaments. Following the custom of the Greeks, the Romans at first presented statues and paintings to various temples as ornaments.

Later on, with more discrimination and less greed, Roman officials proceeded to a systematic spoliation of Greece and the Orient of their treasures of art. Statues and paintings followed in the triumphs of Roman generals as did slaves and prisoners of war. Occasionally returning officials brought home with them pillaged artistic mementoes of the place they had been ruling in the name of mighty Rome. Thus Fulvius, consul in Ambracia, brought home the finest statues of that country. One of these mementoes was excavated in the year 1867; it bore the naive and candid confession of the consul:—

<div style="text-align:center">

Marcus Fulvius Marci Filius
Servii Nepos Nobilior
Consul Ambracia
Cepit

</div>

Having carried off the statues of the Nine Muses in his conquest of Ambracia, this same Fulvius Nobilior placed them in the temple of Hercules. At this time Roman conquerors had progressed, and they already travelled with experts and advisers. Fulvius Nobilior was accompanied by the poet Ennius (Strabo, B. X, 5), whose suggestion it may have been to place Hercules in the midst of the Nine Muses playing the lyre like an Apollo, a metamorphosis of the god showing that the Roman had finally harmonized " Strength," his chief and most cherished quality, with the gentler feelings of an understanding of art. This " Hercules Musagetes " seems to symbolize a first conquest of art over the rude, sturdy Roman character.

Departing from the established rule of presenting their artistic plunder to the temples after it had followed in their triumphs to enhance the importance of their conquest, in time the generals began to keep part of the spoil themselves. In this way were the first private collections in Rome formed.

The real artistic education of the Romans dates from this time. The passion and ambition to enrich and embellish private houses helped to teach what was worth consideration. Sulla, who plundered Greece and Asia Minor, is said to have acquired a sure eye for valuable *objets de virtu;* Verres, who with an excellent eye had robbed and collected all that came within his reach, was perhaps Rome's best connoisseur of art. He and Sulla were practically the first to organize that enlightened manner of plundering subjugated countries that finally made Rome the first emporium of art in the world.

Naturally, these early Roman collectors rarely bought their articles of virtu. When they could not obtain by pillage they had ready to hand a speedy and coercive means of gratifying their artistic craving. Sulla placed on the proscription list the names of all possessors of artistic objects who were so unwise as to refuse to give them up to him. Mark Antony did the same to Verres. The latter paid with his life his refusal to offer the despotic Triumvir some famous

Greeks and Romans as Art Collectors 23

vases of Corinthian bronze which he sorely longed to have in his collection.

It was, we repeat, in Sulla's time that the passion for collecting arose among the Romans, not only guided by an artistic sense of discrimination, but with all the peculiar characteristics that seem to attend the development of this passion.

Sulla's collection—to which the spoils of the temple of Apollo in Delphi and of the temples of Jupiter in Elis and Æsculapius in Epidaurus, considered the richest emporium of art in Greece, had contributed—must have been magnificent and without an equal—except, perhaps, that of Verres, Sulla's pupil, who surpassed his master in the art of plundering, and sacked Sicily of all the island possessed of art.

CHAPTER II

COLLECTOMANIA IN ROME

Collectomania develops—Rampant parvenuism in Rome—Extravagant prices paid for art and curio—Faking arrives—Good and foolish collectors as seen by writers and satirists of the time—Art dealing—The *septæ*, shops and auction rooms.

SUCH was the earliest type of the real collector of art in Rome, a first phase in a city where the passion for art was, generally speaking, rarely genuine. This phase led first to the acquisition of what might be styled something between ambition and love of display. Then the trade in objects of art eventually appeared, and as a logical consequence, imitation and fraudulent art finally had their scope. Fictitious masterpieces of painting and sculpture, often signed, as in modern times, with the forged names of noted artists, were already on the market before Cicero's time. " *Odi falsas inscriptiones statuarum alienarum* " (I hate the forged inscriptions on statues not one's own), remarks Cicero, who although somewhat of a collector himself never missed a chance to ridicule the pretentious amateur lost in hysterical ecstasy before imitations supposed to be original works, or of fanning the art lover's pseudo-enthusiasm for the work of Polycletus, which was extremely fashionable at one time among art collectors.

Thus forgery received a great impulse when art reached its climax in Rome and multiplied the number of collectors, dragging after it in its triumphal march wealth and all the fickle forces of wealth. Taste in art, then, became apparently more exclusive, or rather, according to Quintilian, more

Collectomania in Rome

unstable in its standards. "Nowadays," says the Latin rhetorician and critic, "they prefer the childish monochrome works of Polycletus and Aglæphon to the more expressive and more recent artists." Yet, very likely not understanding this not unusual love for the archaic and the odd, so common in collectors of all ages, Quintilian cannot explain the preference for work he considers gross, except by fashion or what we should call to-day a snobbish sentiment. Criticizing the art in vogue, he adds, in fact: "I should call this art childish compared to that of most illustrious artists who came afterwards, but in my judgment it is, of course, only pretension" (XII, 10).

It is evident that with the Romans as with us—the times are not entirely dissimilar; indeed but for art critics, the new modern fad, they might be called identical—prices paid for works of art, or simple curiosities, became freakish and fabulous, going up or down in a single period according to fickle fashion. The momentary passion for *murrhines*, for instance, tempted a collector to pay for one of these cups of fluor-spar a sum approximating to £14,200. Another mania succeeded, that of tables made of *citrus*, a species of rare wood, possibly Thuja, grown on the slopes of Mount Athos. Cathegus invested in one of these fashionable tables a sum equivalent to twelve thousand pounds. Then at another time wrought silver becomes the rage, and prices for this article soon reached absurd figures. When Chrysogon, Sulla's wealthy freedman, was bidding at an auction for a silver *autepsa* (a plate warmer), people standing outside the auction room imagined he was buying a farm from the high sum he offered.

As might be expected, high prices tempted brainless parvenus. There were many in Rome like that Demasippus of whom Horace said, "*Insanit veteres statuas Demasippus emendo*" (*Sat.*, 3), the type of a snobbish visionary and sham art-seeker who bought roughly carved statues, supplying their defects with his fancy, and who, in speaking of his historical pieces, stated that to be admitted into his very

choicest collection a basin must at least have served Sisyphus, son of Æolus, as a foot-bath !

Next to this foolish type of collector of art Rome possessed a great many other characters, who, like those of to-day, might be classified as odd specimens of art-lovers.

"Isn't Euctus a bore with his historical silver?" asks Martial, adding that he would rather eat off the common earthenware of Saguntus than hear all the gabble concerning Euctus' table-silver. Think of it ! His cups belonged to Laomedon, king of Troy. And, mind, to obtain these rarities Apollo played upon his lyre and destroyed the wall of the city by inducing the stones to follow him by his music." But concerning this odd type of collector Martial merits quotation. "Now, what do you think of this vase?" asks Euctus of his table companions. Well, it belonged to old Nestor himself. Do you see that part all worn away, there where the dove is ? It was reduced to that state by the hand of the king of Pylos." Then showing one of those mixing bowls that Latins called *crater*, "This was the cause of the battle between the ferocious Rheucus and the Lapithæ." Naturally every cup has its particular history. "This is the very cup used by the sons of Eacus when offering most generous wine to their friend—That is the cup from which Dido drank to the health of Bythias when she offered him that supper in Phrygia." Finally, when he has bored his guests to death, Euctus offers them, in the cup from which Pyramus used to drink, " wine as young as Astyanax."

Trimalcho is so well known that we are dispensed from a detailed illustration. Petronius must have drawn from life this capital character of his *Satyricon*. Like Euctus, Trimalcho extols the historical merits of his articles of virtu; he has the same mania for inviting people to his table and forcing them to admire his rarities. He talks very much in the same manner as the type quoted by Martial. Thus he informs his guests that his Corinthian vases are the best and most genuine in existence, because they were made at his

Collectomania in Rome

order by a workman named Corinth. As a side explanation of this remark, fearing that the guest might suppose he did not know the historical origin of the metal, he adds: " Yes, yes, I know all about it. Don't take me for an ignoramus. I know the origin of this metal perfectly well. It was at the capture of Troy, when Hannibal, a shrewd brigand by the way, threw on to a burning pyre all the statues of gold and silver and bronze. The mixture of the metals produced the alloy from which goldsmiths have made plates, vases and figures. From this, of course, comes the name of Corinth to designate this mix-up of three metals, which, of course, is no more any of the three!" Trimalcho also possesses a cup with a bas-relief representing Cassandra cutting her children's throats. Not content with this gorgeous historical blunder, and forgetting that he is talking of the bas-relief of a cup, Trimalcho adds as an artistic comment that the bodies of Cassandra's children are so life-like that one might suspect they had been cast from nature.

Continuing our comparison with Euctus we may add that Trimalcho also possesses a rare pitcher with a bas-relief representing Dædalus putting Niobe inside the wooden horse of Troy! When he has finished maiming history, and the guests have patiently listened to his fantastic tales, like a true parvenu, Trimalcho never fails to add, " Mind, it is all massive precious metal, it is all my very own as you see, and not to be sold at any price."

Except for the wording, a trifling difference—the word " expensive " would play a conspicuous part with the Trimalcho of to-day, decorated, be it understood, with " precious," " rare," " unique " and all the rest of the arch-superlatives of modern idioms—such collectors have not been lost to our day.

But there are other types worth quoting. They will certainly help us to understand the part played by art imitations and forgery among the Romans, and how the existence of fraud was in some way justified, that in the end the one chiefly responsible for the existence of faking was

28 Collectomania in Rome

the collector himself. This understanding will be greatly aided by a glimpse at the *septæ*, antiquity or simple bric-a-brac shops, that were grouped together in certain streets of ancient Rome like they are nowadays.

Like to-day, too, sales of art were effected by auctions or by private dealing, the latter in shops or through the usual go-between, the so-called *courtier* of our time.

Public auctions were announced by placards or a simple writing on the walls. An idea of what these announcements were like is given by the following one from Plautus' Menœchme:

"Within seven days, in the morning, sale of Menœchme. There will be sold slaves, furniture, houses, farms. Every article bought must be paid for at the time of buying."

As in our days, an exhibition of the goods preceded the auction. These shows were held in appropriate rooms adorned with porticos, called *atria auctionaria*. In speaking of such exhibitions and commenting upon some special one, Cicero remarks, *Auctionis vero miserabilis adspectus* (Phil., II, 29).

Curiously enough the auction sales of the Urbs were provided with an employé whose function seems to have survived in the public sales of Paris. The Latin *præco* is something like the French *crieur* whose office it is at public auctions to extol and praise the objects offered for sale. It must be said that the *præco*, however, was not only a simple *crieur* but at times a sort of director of the sale, thus combining the functions of *commissaire priseur*, *expert* and *crieur*, but it was certainly in the latter function that his ability best contributed to the success of the sale. Some of these employés must have enriched themselves like regular *commissaires priseurs*. Horace (I. Ep., 7) describes one of these *crieurs* as indulging in luxury, making money easily and scattering it like water, allowing himself every kind of pleasure and yielding tremendously to fashion. A curious description, suggesting that this Vulteius Menas of Horace must have had the lucky career of some of the Parisian auction em-

Collectomania in Rome

ployés and cannot have been indifferent to that form of gay self-indulgence that Parisians call : *Faire la bombe*.

Speaking of auctions and the way Romans disposed of their goods to the highest bidder, it is worth while to refer to what Suetonius tells us happened at the sale held by Caligula, who being short of money thought fit one day to put up to auction everything in the royal palace that was either useless or considered out of fashion, *quidquid instrumenti veteris aulæ erat*. According to Suetonius not only was the Emperor himself present at the auction, but he put prices on the various objects, bidding on them as well. An old prætor, Aponius Saturninus, became sleepy during the sale, and in dozing kept on nodding his head. Caligula noticed it, and told the auctioneer not to lose sight of that buyer and to put up the price each time Saturninus nodded. When the old man finally awoke he realized that without knowing it he had bought at the Imperial auction about £80,000 worth of goods (Cal., 39).

Pliny relates an amusing story, which shows that then, as now, the auctioneer was allowed to group objects.

"At a sale," he says, "Theonius, the *crieur*, made a single lot of a fine bronze candelabra, and a slave named Clesippus, humpbacked and extremely ugly. The courtesan Gegania bought the lot for 50,000 sesterces (about £400). The same night at supper she showed her acquisitions, exhibiting the naked slave to the gibes of the guests. Then yielding to a freakish passion, made of him her lover and heir. Clesippus thus became extremely wealthy and worshipped the candelabra with a devotion as though it were his god" (XXXIV, 6).

As stated above, other sales generally took place in various parts of Rome where antiquaries and bric-a-brac dealers had assembled their shops. A great many of these merchants had gathered in the Via Sacra or the *Septa* of the *Villa Publica*, or *Septa Julia*.

Those parts of Roman streets called *Septæ*, where antiquaries and bric-a-brac dealers had their dens, were the

amateur's fool's paradise and trap, and very likely they were as inviting and picturesque as similar places in modern European towns to-day.

These shops and shows, it is said, offered real rarities at times, such as bronzes of Ægina by Myron, Delos bronzes by Polycletus, genuine rarities in Corinthian bronze, marvels in chiselling signed by Boethus or Mys. The *septæ* not only exhibited artistic pieces but also sham rarities that had won public appreciation in a moment of fashion. Among these was a certain kind of candelabra shaped like a tree with one or more branches. Concerning these candelabras which were almost made to supplant the more artistic ones by a fad, Pliny remarks, "*Arborum mala ferentium modo lucentes*" (like trees bearing shining apples), and states with caustic humour that although their name bore a common etymology with the word *candela* (candle), a cheap means of lighting, they were sold at prices equivalent to the yearly appointment of a military tribune (Plin., XXXIV, 8).

Speaking of candelabras, it may be stated that the finest ever seen in Rome belonged to Verres, being part of the vast plunder of Sicily he accumulated when stationed there by Rome as proconsul. This fact prompted the sarcastic remark in Cicero's indictment of the proconsul, that Verres had in his *triclinium* a candelabra casting light where darkness would have been more appropriate. This rich candelabra must have been of a statuesque style, the kind Lucretius describes:—

Si non aurea sunt juvenum simulacra per ædes
Lampadas igniferas manibus retinentia dextris (II, 24).
(Figures of youths holding lighted lamps in their right hands.)

Naturally it was not only a single speciality, valued through fashion or fad, that was to be found on the market, it was a regular emporium of antiquities in art, and of all kinds of bric-à-brac. Besides murrhines, tables of citrus and other specialities there were paintings of all schools and sizes, down to miniatures, an art not unknown to the Romans. There

were also sculpture, ceramics, fine pieces of Rhegium and Cumæ, Maltese tapestries, Oriental embroideries, etc. In fact, mixed with a good deal that was dubious, these places also offered fine treasures, as Martial says:—

> Hic ubi Roma suas aurea vexit opes.
> (Here where golden Rome brought her treasure.)

It is easy to understand that the people moving in this *milieu* were not dissimilar from those who indulge in articles of virtu in our enlightened times, or who are somewhat of a victim to the collector passion. Such a *milieu*, not to be found in Athens where the passion for art was genuine and essential, was quite consistent in Rome where improvised Crœsuses and rich parvenus abounded; parvenus who, like many of the collectors of our times, took to buying objects of art as a fad or hobby. This type of collector is easily recognized and in its grotesqueness is not essentially different from some of our modern society.

It is true that Rome also produced many genuine lovers of art, many first-rate connoisseurs and collectors such as Agrippa, magnificent collectors of the calibre of Cæsar, keen, intelligent, lovers of art, as greedy as unscrupulous, such as Sulla, Verres and Mark Antony, but as in America to-day, the magnitude of quickly-made fortunes, the impetus of a passion suddenly aroused without any previous preparation, produced only a few types of the true collector. As in America now, for one Quincy Shaw, how many a—Trimalcho and Euctus.

Needless to say, the art market generally follows the inclination of the client, it tries to meet his taste, whims and fads, it may be scrupulous or unscrupulous according to circumstances and, particularly in art and antiques, these circumstances chiefly depend upon the great despotic ruler of all markets, the client.

Thus in the *septæ*, side by side with Firminius, Clodius and Gratianus, dealers enjoying an undisputed reputation in the *sigillaria* (image market) and other quarters where antiquary

shops were gathered, there were to be noted types like the Milonius of whom Martial says:—

"Rare stuffs, chiselled silver, cloaks, togas, precious stones, there is nothing you don't sell, Milo, and your clients invariably carry their acquisitions away with them! After all your wife is the best article in your emporium, always bought and never taken away from your shop" (VII–XII, 102).

The whole gamut of oddities with which the collecting mania abounds were really to be found in the *septæ*.

There was the particular collector who has no eyes but for one certain thing, no enthusiasm but for the objects specializing his particular hobby, as Horace remarks in his "Satires" about people who have either the passion for silver pieces or bronzes:

Hunc capit argenti splendor, stupet Albius ære.
(This one the glitter of silver holds, Albius stands dumb before bronze.)

Seneca informs us that in his time there was an amateur with the hobby of collecting rusty fragments, another who had gone so crazy over small vases of Corinthian bronze that he spent his days handling the pieces of his collection, taking them down from the shelves, putting them back again and continually arranging and rearranging them (De Brev. Vit., XII).

Martial tells us of a man who made a collection of pieces of amber containing fossilized insects, and of another collector who boasted that he had a fragment of the ship *Argo* among the rare pieces of his collection. There was also Clarinus, a debauchee, according to Martial, who vaunted himself upon possessing samples of all the goldsmith's art of his time. "But," remarks Martial, "this man's silver cannot be pure!"

Another type noted by Martial makes one realize that there is a species of collector that will never die. Of "Paullus" Martial observes: ". . . his friends, like his paintings and his antiques: all for show" (XII, 69).

Codrus, quoted by Juvenal, is the needy collector. He

Collectomania in Rome

keeps his books "in an old basket where mice allow themselves the luxury of nibbling the works of divine Greece." He sleeps "on a pallet shorter than his little wife." His collection and furniture are all in his bedroom, the only room he has for living and sleeping in, and conspicuous are six cups, a small *cantarium* on a console with a figure of Chiron the Centaur below it (III).

Eros is another type, that of the mournful collector. This is the way Martial describes this not unusual type:—

"Eros weeps every time he comes across some fine murrhine of jasper or a finely marked table of citrus. He sighs and sighs from the bottom of his heart, for he is not rich enough to buy all the objects of the *septa*." And here Martial comments, "How many are like Eros without showing it, and how many banter him for his tears and sighs and yet in their hearts feel like him!" (X, 80).

Mamurra, another type handed down to us by the inexhaustible Martial, never misses a day without visiting the *septa*. "Spends hours in gadding about, reviews the rows of young slaves which he devours with the eye of a critic, not, if you please, the common ones but the choicest samples, those that are not on show to every one, not to common people like us," adds Martial. "When he has had enough of this show, he goes to examine the furniture; there he discovers some rich tables (*orbes*, round tables) hidden under some covering; then he orders that some pieces of ivory furniture he wishes to examine be taken down from the highest spot; afterwards he passes on to examine a *hexaclinon*, a couch used in the *triclinium*, with six places, veneered with tortoise-shell, and measures it four times. What a pity it is not big enough to match his citrus table! A minute later he goes to smell a bronze: Does it really smell of the Corinthian alloy? Of course he is ready to criticize even your statues, O Polycletus! Then those two rock crystals are not pure, some are a trifle nebulous, others are marred by slight imperfections. Ah! here's a murrhine. He orders about a dozen to be put aside. He goes to handle some old

cups as if he would weigh the merit of each one, more especially that of Mentor. He goes to count the emeralds on a golden vase, and the enormous pearls we see dangling together on the ears of our elegant ladies. Afterwards he goes to look everywhere on every side for real sardonyx; his speciality is to collect large and rare pieces of jasper. Finally, about the eleventh hour of the day, Mamurra is completely exhausted, he must go home. He buys for an *as* (less than three farthings) two bowls and takes them with him " (IX, 59).

Tongilius is the ponderous, important collector. He goes through the places where the antiques are sold in an oversized palanquin and with his cortège and train of followers upsets everybody and everything. Juvenal, by whom his character is handed down to us, remarks rather sarcastically :

> Spondet enim Tyrio stlataria purpura filo,
> Et tamen est illis hoc utile (*Sat.* VII).

Licinius is the type of the lunatic lover of art. He has a fine collection, is wealthy and can buy the most expensive objects of virtu, but he is far from happy. His mania is the fear that his rarities may be stolen or become the prey of fire. He keeps hoards of slaves watching his precious curios, night and day. " At night," says Juvenal, " a cohort of guardians sits up with buckets of water ready to hand in case of emergencies ; the poor man is in continual fear for his statues, his amber figures, his ivory and tortoise-shell veneered furniture."

Naturally, in contrast to the foolish type of collector who seems to have kindled the verve of Roman satirists, the true amateur was to be found, and most select collections of art were known in Rome. Among these also the city afforded all the types of the true collector, the selfish one who never showed his collection to anyone, and the man who gathered objects of art chiefly to share the enjoyment of them with others. Some of these latter wished the public to have the

Collectomania in Rome

benefit of their purchases, and adorned porticoes and public places with their collections.

According to Statius, *Vindex* is the real connoisseur. "Who can compete with him," remarks the poet in his *Silvæ*, lib. IV, "who possesses so sober an eye? He is deeply versed in the technical procedure of all the artists of antiquity, and when a work bears no signature he can decide at sight to which master it belongs. He will point you out a bronze that has cost the learned Myron many a day's and night's work, the marble to which Praxiteles' untiring chisel has given life, the ivory polished by the hand of Phidias, the bronzes of Polycletus which seem to breathe life on coming out of the furnace, he can see the artistic line, the true mark of all authentic Apelles."

CHAPTER III

RAPACIOUS ROMAN COLLECTORS

Some collectors' hobbies—Sulla idolized statuette—Verres the most rapacious of Roman art collectors—Mark Antony and his speedy methods—Cicero as an art lover—Pompey the unselfish art lover—Julius Cæsar.

SHREWD and impassive connoisseurs like Sulla also had their hobbies and fancies. Sulla's particular fancy was a little statue of Apollo he had pillaged from the temple of Delphi. This statue was more to him than all the rest of the precious things forming his unique collection. From this little god, called by Winckelmann "Sulla's private travelling god," he never separated. He used to kiss it devoutly and seems to have consulted it in great emergencies. At times he used to carry it in his breast, says Plutarch. We may note by the way that this Apollo was not considered by connoisseurs the best piece of Sulla's collection, the real gem was his Hercules, a work by Lysippus. The story of this Hercules is told by Martial and Statius, who inform us that it measured a little less than a Roman foot, about nine inches. Notwithstanding its modest dimensions the statuette was modelled with such grandeur and majestic sentiment as to cause Statius to comment, "*parvusque videri, sentirique ingens*" (small in appearance, but immense in effect). It represented Hercules in a smilingly serene attitude, seated on a rock, holding a club in his right hand and in the other a cup. It was in fact one of those statuettes which Romans called by the Greek word *epitrapezios*, and which were placed on dining-tables as the *genius loci* of the repast.

The history of this gem of Sulla's collection is uncommon, and its vicissitudes most remarkable. The statue was

originally a gift made by Lysippus to Alexander the Great. This sovereign and conqueror was so attached to Lysippus' present that he carried the statue with him wherever he went. When dying he indulged in a touching adieu to the cherished statuette.

After Alexander, the little Hercules fell into the hands of another conqueror, Hannibal. It is not known how he came to be the possessor of Lysippus' work, but it may be explained by the fact that Hannibal, being a collector of art and somewhat of a connoisseur and, above all, as Cornelius Nepos states, a great admirer of Greek art, was a keen-eyed hunter after rarities in art. However, be that as it may, Hannibal seems to have been possessed by the same fancy as Alexander, for he carried the little statue with him on all his peregrinations, and even took it to Bithynia, where, as history informs us, he destroyed himself by poison. At his death the Hercules passed, in all probability, into the hands of Prusias at whose court Hannibal died.

A century later the statue reappeared in Sulla's collection. Very likely it came into Sulla's possession as a present from King Nicomedes, who owed gratitude to Sulla for the restitution of the throne of Bithynia.

After Sulla's death it is difficult to locate this precious statue of his famous collection. Presumably it passed from one collector to another, and never left Rome. "Perhaps," says Statius, "it found its place in more than one Imperial collection." The statue reappears officially, however, under Domitian. At this time it is in the possession of the above-quoted Vindex, a Gaul living in Rome, a friend of Martial and Statius and one of the best art connoisseurs of his time.

At Vindex's death the statuette disappears again, and no mention of it has ever been made since by any writer. What may the fate have been of this *chef-d'œuvre* of Lysippus which passed from one collection to another for more than four centuries?

Among greedy lovers of art, with a connoisseur's eye as good as his soul was unscrupulous, Verres takes the prize.

He had learned the rapacious trade of art looting under Sulla. Later on, not being powerful enough nor daring to go to the length of the Dictator by placing reluctant amateurs on the list of proscribed, he studiously sought to gain his end by all forms of violence and vexatious methods. When in Sicily as proconsul, he actually despoiled and denuded every temple in the island.

"I defy you," says Cicero in his indictment of Verres, "to find now in Sicily, this rich province, so old, with opulent families and cities, a single silver vase, a bronze of Corinth or Delos, one single precious stone or pearl, a single work in gold or ivory, a single bronze, marble or ivory statue; I defy you to find a single painting, a tapestry, that Verres has not been after, examined and, if pleasing to him, pillaged."

As for private property, when he heard of a citizen possessing some object that excited his cupidity, to Verres all means of extortion seemed good, including torture and fustigation. His passion was of such an uncontrollable nature that even when invited to dinner by his friends he could not resist scraping with his knife the fine bas-reliefs of the silver plates and hiding them in the folds of his toga. Yet this greedy, unscrupulous amateur, whom Cicero mercilessly indicted in his *In Verrem*, was such a lover of the objects of his collection that he faced death rather than give up some fine vases of Corinthian bronze which Mark Antony had demanded from him as a forced gift.

Mark Antony, who followed Sulla's methods in forming one of the finest of collections, was, like his violent predecessors, a type of collector which finds no counterpart in our times. His fine library had cost many victims, his taste being rather eclectic, there seems to have been no security in Rome for any kind of amateur who happened to possess rare and interesting curios. Nonius was proscribed because he refused to part with a rare opal, a precious stone of the size of a hazelnut. "What an obstinate man, that Nonius," remarks Pliny (XXXVII, 21) most candidly, "to be so attached to an object for which he was proscribed! Animals are certainly

Rapacious Roman Collectors 39

wiser when they abandon to the hunter that part of their body for which they are being chased."

Mark Antony was not so good a connoisseur as Verres, but having no less a passion for collecting art and being no less unscrupulous and more in a position to use violence without the risk of being accused before the Roman citizens, as happened to Verres in the end, there was no limit to his schemes. After the battle of Pharsalia he managed to seize all Pompey's artistic property, as well as his furniture and gardens, and after Cæsar's murder Antony, to whom we owe one of the finest orations ever conceived, the one he delivered before the dead body of his friend, lost no time in plundering Cæsar's property and transporting to his gardens all the objects of art Cæsar had left to the people of Rome. The information comes from Cicero with these words: " The statues and pictures which with his gardens Cæsar bequeathed to the people, he (Antony) carried off partly to his garden at Pompeii, partly to his country-house."

Speaking of this collection, it is believed that the colossal Jupiter now in the Louvre Museum not only belonged to Mark Antony, but was the work of Myron which the Triumvir had stolen from Samos. Should this be so, the pedigree of this statue is one of the few that can be actually traced through the centuries. Brought to Rome by Mark Antony, this Jupiter was later placed in the Capitol by Augustus. The fine statue was then passed from one emperor to another, to sink into the general oblivion of art at the end of the Roman Empire. It reappears in Rome in the sixteenth century. It was then in the possession of Marguerite of Antioch, Duchess of Camerino. The statue was greatly mutilated, having lost both legs and arms. The Duchess presented what remained of this famous Jupiter to Perronet de Granvelle. Subsequently cardinal and minister of Charles V, on his retirement to his native country, Perronet de Granvelle took the Jupiter to Besançon and placed it in the garden of his castle. When Louis XIV took Besançon, the magistrates of the city offered the French monarch what he might otherwise

have taken, the statue of Jupiter. Transferred from Besançon to Versailles, this magnificent statue which by rare chance had escaped serious damage during the barbarian ages finally met two authentic barbarians in the artists charged with its restoration. To clean off the old patina from the statue—think of it—Girardon had a layer of marble taken off with the chisel, and Drouilly, not perceiving that the god had been formerly in a sitting posture, or more probably not choosing to notice the fact as not appealing to his artistic conception, made the Jupiter a standing statue by adjusting and cutting the parts otherwise in the way for this kind of adaptation. The only part of the statue that does not seem to have suffered any damage is the head.

Even Brutus and Cassius appear not to have been indifferent to the collector passion. Brutus, more especially, used to devote to the collecting of art the less agitated moments of his troubled life. The gem of his collection was considered to be a bronze by Strongylion. Pliny tells us that this statue of Brutus was called " the young Philippian," *Strongylion fecit puerum, quem amando Brutus Philippiensis cognomine suo illustravit* (XXXIV, 19).

Cicero may be quoted as a type of the inconsistent art collector. A man of dubious artistic taste and snobbish tendencies but who becomes a true art lover when he specializes in that part of art collecting more closely in keeping with his studies. Thus in his letter to Atticus he reveals his love of books and old Greek works, and how fond he was of good bindings, etc. As a collector of art Cicero leaves one doubtful as to his taste and connoisseurship, qualities to which he seems to lay claim in more than one of his speeches. When he writes to his friend Atticus, his good counsellor, the man charged to buy art for him, he does not express himself either as a real lover of art or a genuine connoisseur. " Buy me anything that is suited for the decoration of my Tusculum," he writes to Atticus. " *Hermathena* might be an excellent ornament for my Academy, *Hermes* are placed now in all Gymnasia. . . . I have built exedras according to the

latest fashion. I should like to put paintings there as an ornament," etc.

In *Paradoxa*, a collection of philosophical thoughts called Socratic in style by Cicero, in which he says he has called a spade a spade, *Socratica longeque verissima*, Cicero has the courage to write the following paragraph in defence of Carneades, who maintained that a head of a Faun had been found in the raw marble of a quarry at Chios:—

"One calls the thing imaginary, a freak of chance, just as if marble could not contain the forms of all kinds of heads, even those of Praxiteles. It is a fact that these heads are made by taking away the superfluous marble, and in modelling them even a Praxiteles does not add anything of his own, because when much marble has been taken away one reaches the real form, and we see the accomplished work which was there before. This is what may have happened in the quarry of Chios."

The gamut of art collectors would not be complete without quoting a few samples of worthy art lovers who either understood art, like the Greeks, as a means of public enjoyment, or in some way showed genuine and most praiseworthy qualities as true collectors of art.

It is doubtful whether the great Pompey really felt any pleasure in collecting art pieces, or whether he simply did it to ingratiate himself with the public. But as a matter of fact his attitude towards the enjoyment of art was certainly of a most unselfish character. Though he very sumptuously embellished his gardens on the Janiculum, this was nothing compared with the public buildings he enriched with rare statues, paintings, etc. His theatre was a magnificent emporium of art of which we possess some samples in the colossal Melpomene of the Louvre Museum and the bronze Hercules excavated under Pius IX, now one of the finest pieces of the Vatican collection. Both these statues were found buried on the spot where once the monumental theatre of Pompey had stood.

But the artistic glories of this theatre were perhaps even

surpassed by the interminable portico Pompey constructed and adorned for the benefit of the public. This spot, which was called the Promenade of Pompeius, became one of the fashionable walks of Rome.

"You disdain," asks Propertius of his lady love, "the shady colonnades of Pompey's portico, its magnificent tapestries and the fine avenue of leafy plane-trees ? " (IV, 8). And in another place Cynthia forbids her paramour this promenade with the words : " I prohibit you ever to strut in your best fineries in that promenade."

Pliny (XXXV, 9), says that Pompey had some famous paintings in his galleries and seems to have been more especially struck by a work by Polygnotus, representing "a man on a ladder," and a landscape by Pausias. Curiously enough the characteristics that seem to have attracted Pliny in the two works do not point to the noted writer as a great art critic. He says that the remarkable side of Polygnotus' painting was that the beholder could not tell whether the man on the ladder was ascending or descending, and that the main characteristic of Pausias' work consisted in two black oxen outlined on a dark landscape.

Cæsar, who showed himself to be a better connoisseur than his rival Pompey, and who, being of a more refined nature, would not, as did Pompey, have indulged in the gratification of parading the chlamys of Alexander the Great in a triumphal car drawn by four elephants, spent considerable sums on the embellishment of Rome with art. He also, like many collectors of art, had his hobbies, carrying with him through his various campaigns an endless number of precious mosaic tables, and always keeping in his tent a fine work of a Greek artist, a statue of Venus, with whom he claimed relationship. Though he showed eclectic taste in his gifts to the town and temples, he was in private, like a true connoisseur and refined lover of art, somewhat of a specialist, being extremely fond of cameos and cut stones. Of these he had six distinct collections that held the admiration of all the connoisseurs of the city.

Rapacious Roman Collectors

He was, however, not only a passionate seeker after antiques, most boldly acquiring precious stones, curiosities, statues, pictures by old masters (*gemmas, tereumata, signa, tabulas operis antiqui animosissime comparasse*), as Suetonius tells us, but also the ever-ready patron of modern art. In this character he paid 80 talents (about £16,000) for a painting by Timonacus. Damophilus and Gorgas, painters, sculptors and decorators, worked for him to embellish the Arena he built in Rome, an edifice capable of holding 2500 spectators. Many artists worked at his Forum, a monument to his name for which he paid a sum equivalent to twenty million liras for the ground alone. Meanwhile he was also busy embellishing other cities of Italy, Gaul, Spain, Greece, and even Asia. Suetonius states that Cæsar sent a company of artists and workers to rebuild destroyed Corinth and to replace its statues on their pedestals.

Being a most unselfish kind of lover of art, Cæsar was one of the few who did not yield to the momentary fashion that led patricians to send their art pieces out of Rome, to embellish and decorate their country houses and magnificent villas.

This peculiar fashion that exiled so many fine statues from Rome, leads us to speak of another noble type of collector, Marcus Agrippa, who, like Cæsar, not only set a good example by keeping all his treasures of art in Rome, mostly for the enjoyment of the public, but protested against the new custom, and held meetings and lectures to dissuade wealthy Romans from sending away from the city their *chef-d'œuvres*.

Such was the spirit characterizing Agrippa as a lover of art.

CHAPTER IV

ROME AS AN ART EMPORIUM

Rome an art emporium—Every rich man is more or less a collector—Chrysogon, Sulla's freedman, competes with patricians—Scaurus' extravagant display—The type of a crack collector as described by Petronius Arbiter—The Roman palaces have special rooms for art gatherings—The Pinacotheca, the Library, the Exhedra, etc., according to the rules of Vitruvius—Fashion creates new distinctions in the appreciation of art and curios—The craze for Corinthian bronze and the classification of bronze "patine"—The hobby of murrhines and citrus tables.

WE do not know how many private collections there were in Rome when the collectomania finally took the city by storm. A list of Roman collectors in the fashion of the modern work (*Ritz-Pacot*) would be most interesting and enlightening. However, judging from the statues and the public buildings we know to have been replete with objects of art, we gather that as an emporium of art Rome must have attained a magnitude unequalled in past or present times. Why this great collection of art did not transform the Romans into the most artistic people the world has ever seen, is a mystery only to be solved by hypothesis. Either the Romans were innately refractory to the refinements of true art, or, like to all *nouveaux riches*, the field of art merely afforded room for faddists, hobbyists and fashion seekers, and, only as sporadic cases, a few real lovers of good art. However this may be, without discussing the causes, the effect was certainly gigantic: art from every land found its way to Rome, which by force of circumstances thus became a monumental synthesis of art. Even at the time of Constantine, Rome counted 10 basilicas, 11 forums, 11 thermes, 18 aqueducts, 8 bridges, 37 city gates, 29 military roads leading to all parts of the

Rome as an Art Emporium

known world, 2 arenas, 3 theatres, 2 circuses, 37 triumphal arches, 5 obelisks, 2 colossal statues, 22 equestrian statues, 423 temples with statues of the gods—eighty of these being in solid gold and seventy-seven in ivory.

It is easy to understand that the above statistics only give a faint idea of the magnificence of Rome, for the 423 streets and 1790 private palaces noted in the same statistics as existing in Rome at the time of Constantine were in a measure respectively open-air museums and repositories of private collections of art, as no patrician mansion, according to Vitruvius, was complete without a place where paintings and objects of art could be exhibited with advantage.

Cicero allows us a peep at the collections and gorgeous palaces owned by notable Romans as well as their style of living. In his oratio (*Pro Roscio Amerino*) he speaks of Chrysogon in these words:

"Look at Chrysogon when he comes down from his fine mansion on the Palatine! He owns a charming villa, where he goes to rest, just at the gates of Rome. He also owns extensive domains, all magnificent and all near the city. His palace overflows with vases of Delos and Corinthian bronze. He keeps there the famous *authepsa* bought by him some time ago at such a price that on hearing the auctioneer's voice repeat the bid, the passers-by imagined a farm was being offered for sale. What shall we say of his chiselled silver? his precious stuffs? his paintings? statues? marbles? How many of such things do you think he owns? Just imagine what has been pillaged from so many opulent families in times of trouble and rapine; and all for the repletion of one single palace."

When one thinks that this Chrysogon, Sulla's freedman, had the chance to amass such an accumulation of art, it is not difficult to imagine the artistic wealth that must have been acquired by Scaurus, the terrible Sulla's unscrupulous son-in-law, the embezzler, the deplored and deplorable Roman Ædile whom Cicero defended before the tribunal with the inconsistency of his easy eloquence.

According to Pliny (XXXVI), Scaurus not only owned one of the most magnificent palaces on the Palatine, but had his mansion crowded with rare things in true Roman fashion. With a Sulla for father-in-law, a Metella, the purchaser of proscribed citizens' goods, for mother, a Scaurus, the *magna pars* of the Senate and Marius' former friend and helper in the spoliation of provinces, for father, he can have had no difficulty, as Pliny informs us, in gathering the unequalled treasures that were stored in his palace. The wonders of the treasures of his art emporium are all the more easily explained, too, when we consider that he not only inherited a large fortune, but more than doubled it by speculations.

To give some idea of his fatuous munificence, we may state that this Roman multi-millionaire built, for one month's performance, a theatre in the city, to hold eighty thousand spectators, and adorned the edifice with three thousand statues and three hundred and sixty columns. Among the precious things of Scaurus' collection were a great number of paintings by Pausias, works intended by the artist for his native town of Sycione, if the Romans had had milder methods of collecting art.

Even those Romans, and they were many, who were not considered collectors in the proper sense, owned fine works of art. The Servilius, who had large gardens on the Palatine near the present Porta San Paolo, had what a modern connoisseur might call a few extra pieces. There was a Triptolemus, a Flora and a Ceres by Praxiteles, a fine Vesta with two Vestals by Scopas and an Apollo by Calamis. It may be mentioned, by the way, that it was to this famous garden Nero retired on the day preceding his death, it was here in the Servilian mansion that he was abandoned by his servants, parasites and courtiers, here that he wandered desolate and despondent before resorting to flight. On the spot formerly occupied by the Servilian gardens a mosaic was discovered, now in San Giovanni in Laterano, representing an unswept floor with the remains of a luxurious dinner. One might fancy this mosaic to have belonged to one of those

Rome as an Art Emporium 47

Roman Triclinia and their noted orgies, or, having the imagination of Ampere, the historian, to the place where Servilia had supped with her lover, Julius Cæsar. History tells us that this matron, the mother of Brutus, was of the pure blood—one might use the modern expression, blue blood—of the *gens* Servilia.

For the sake of the colour, we cannot refrain from giving the description of a true collector of art as related in all its suggestive reality in the *Satyricon,* the only known fiction of Roman times, a work which, though fiction, seems close to nature and a most faithful interpretation of the artistic merits and oddities of Roman life.

"I entered the Pinacotheca, where marvels of all kinds were gathered. There were works by Zeuxis which seemed to have triumphed over all the affronts of age, sketches by Prothogenes that appeared to dispute merits with nature herself, works that I did not dare to touch but with a sort of religious fear. There were some monochromes by Apelles which moved me to holy reverence. What delicacy of touch and what precision of drawing in the figures! Ah! the painter of the very soul of things. Here on the wings of an eagle a god raising himself higher than the air; there innocent Hylas repulsing a lascivious Naiad; further on Apollo cursing his murderous hand. . . ."

At a certain moment the owner of the collection, apparently, arrives. He is of a type not yet extinct: the man who lives for his collection, the man so engrossed in his cherished objects as to forget and neglect other pleasures in life, social obligations, etc.

"A white-haired old man arrived," the author of the *Satyricon* goes on to relate, "his tormented expression seemed to herald grandeur. His garments were of that neglected character which is often distinctive of literary people who have not been spoilt by wealth. . . .

"I thought of questioning him. He was more of a connoisseur than myself in the epochs of the paintings and their subjects; some of the latter incomprehensible to me. 'What

is the reason,' I asked him while we were speaking of painting, 'for the weakening, the great decadence of the fine arts nowadays; more especially of painting which seems to have disappeared and to have left no trace of past glory?' He answered, 'The passion for money, that is the cause of the great change. Years ago when merit, though left to starve, was glorified and appreciated, art flourished. . . . Then, only to mention sculpture, Lysippus was perishing of hunger at the feet of the very statue he was intent upon perfecting; Myron, that marvellous artist who could cast in bronze the life of men and animals, Myron was so poor that at his death no one was to be found to accept his inheritance. We of our time, given over to orgies, wine and women, have no energy left to study the fine art pieces under our very eyes. We prefer to abuse and slander antiquity. Only vice nowadays finds great masters and pupils! . . . Do you believe that in our day any go to the temple to pray for the health of their body? Before all else, even before reaching the threshold of the temple, the one will promise an offering to the gods if his rich relation dies and makes him his heir, the other, if he discovers a treasure, and another if he shall achieve the dispersal of his third million in health and safety. . . . And are you surprised that painting languishes, when in the eyes of every man an ingot of gold is a masterpiece that cannot be equalled by anything that Apelles, Phidias and all the crack-brained Greeks have been able to produce.'"

With the growth of fashion, a collection of art became the necessary complement of a wealthy mansion. The need then arose to give this collection the noblest place in the palace, a room apart to enhance its importance. This new view brought about a new architectural distribution of the Roman patrician mansion, not only on account of the family life and obligations of a wealthy class of citizens, but because the well-to-do Roman had obligations towards art and antiquity. In the Roman mansion we thus find first the *atrium*, a large hall open to friends, clients and visitors at large. The *peristyle* is the second courtyard, and is reserved for the

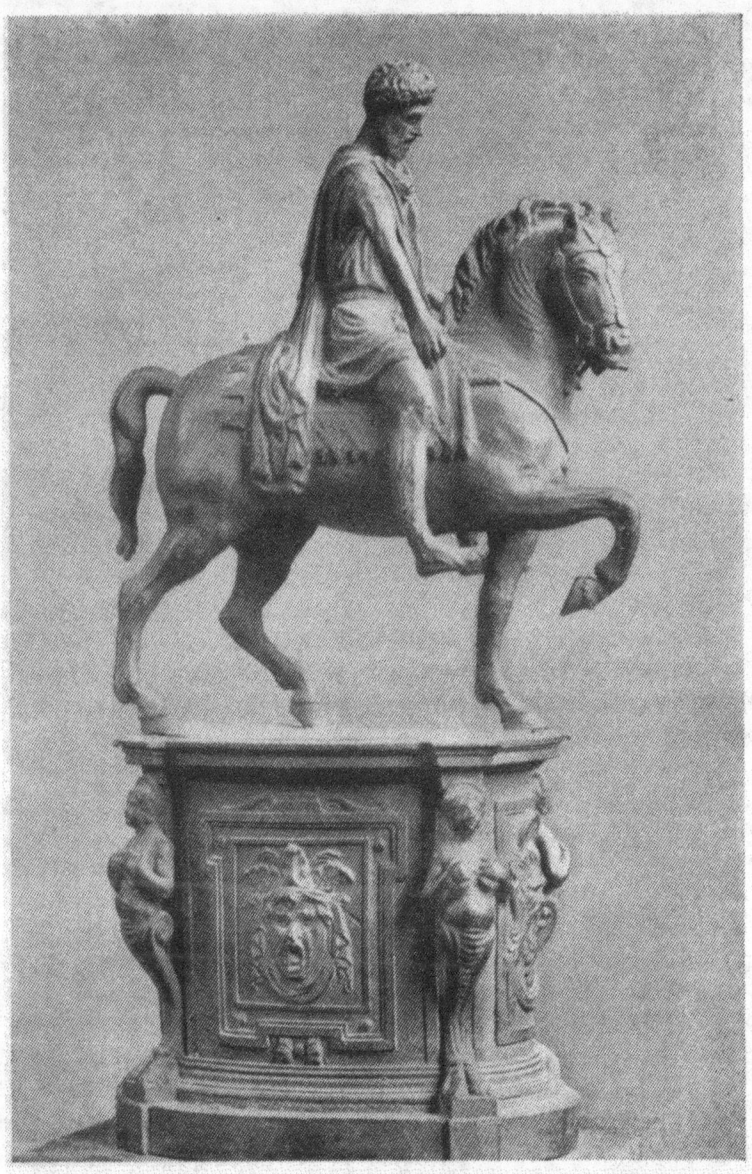

MARCUS AURELIUS.

A XVIth Century copy by L. Del Duca of the equestrian statue in Rome (Campidoglio).

Rome as an Art Emporium

family. In the *atrium* the domestic gods were generally placed and records concerning the family, including genealogical trees (*stemmata*).

With time these *atria* became regular museums, as they were excellent places for decoration and the display of art, being the open central part of the house girded by a colonnade.

An idea of the importance of these *atria* may be gathered from that of Scaurus' palace, which had thirty-eight columns 12½ yards high, made of the same kinds of rare marble that faced the walls—Egyptian green, old yellow or Oriental alabaster, African marble and other rare kinds brought from Syria and Numidia. Scaurus' *atrium* appears to have been hung round with tapestries, embroidered with gold, illustrating mythological scenes. Alternating with these rare tapestries were *panopliæ* and family portraits.

Though perhaps the favourite spot, the *atrium* was not the only place for the artistic display of the Romans. Their palaces also contained *Oeci*, magnificent galleries used for receptions, and the *Exhedræ*, which were rooms for conversation, generally of a more sober decoration. In the *Triclinia* there were kept works in precious metals and the finest pieces of furniture. There was also the *Sacrarium*, a private shrine where precious pieces of art were often hidden. Verres found his famous *canephoros* (basket-bearers) by Polycletus, the Cupid of Praxiteles and the Hercules of Myron in the *sacrarium* of Heius of Messina.

There was also a room in Roman mansions set apart for the library, and some had special nooks for such collections as gems and cameos. The place where the best paintings were shown was called the *Pinacotheca*, and was always built towards the north so that the light from the windows should be without much variation, and above all because a northern exposure left no chance for the sun's rays to enter and spoil the effect of the painting.

The Roman collector of books very often went in for elegant bindings and all the showy and decorative side of a

library. Seneca deplores the fact that while every elegant house in Rome contained a library, many of these collections of books were simply for show. Too many collectors, not dissimilar in this from our bibliomaniacs of to-day, had quantities of works they did not care to read. "What is the use of having so many thousand volumes," cries Seneca, "the lifetime of their owners would hardly suffice to read the titles of the works. . . . There is a man with scarcely the literary knowledge of a serf, and he is buying volumes, not to read them, but as an ornament for his dining-room! There is another who is proud of his library only because it is in cedar and ivory; he has the mania of buying books that no one looks for. He is always gaping among his volumes, which he has bought solely for their titles. Lazy people, who never read, are likely to be found with complete collections of the works of orators or historians, books upon books. One could really forgive this mania if it had originated in a real passion for reading, but all these fine works, the great creations of divine genius, works ornamented with the portraits of their authors, do but serve to decorate the walls" (Tranq., IX).

A large library was the desire of Horace. He wrote to Lellius:

"Do you know my daily prayer?—Great Gods! let me keep the little I own, less if it is your pleasure; let me live according to my choice the days your indulgence has granted me; let me have plenty of books, one year's income in advance that I may not be obliged to live day by day from hand to mouth. . . . As regards the peace of my heart and my happiness, that is my affair" (Sat., II, 6).

Such contrarieties have a genuine echo in our society where the bibliomaniac is rarely a literary man or even slightly interested in literature. Bibliomaniacs collected volumes for the most part either because some of them were considered rare, and therefore advertised the high price paid for them, or because they might serve as a decorative show, but the collecting of general art and curios, with a few exceptions,

Rome as an Art Emporium

appears to have been vacuous and freakish. Even specialization, which is held to be progress in modern times, but as a matter of fact more often merely represents the triumph of erudition over art and taste, exercised in Rome the momentary tyranny of fashion.

An example of this specialization is given us by the craze in Rome for Corinthian bronze. Without entering into a discussion about the legend of its origin, and simply hinting that there are strong proofs that the alloy existed long before the siege of Corinth, we are safe in saying that the craze in Rome for Corinthian bronze was one of those freaks of fashion that has had, perhaps, no echo in all the after-history of "collectomania." Every amateur was at that time bound to have at least one vase of the coveted metal. According to Pliny (XXXIV, 1, 2, 3) in his time this metal was equal to gold in value. In order to obtain two vases of this precious metal Mark Antony ordered the assassination of the owner, and it must be borne in mind that Mark Antony was accused of using golden vessels for the lowest services of his household. Octavianus, supposed to be a collector of mild passions and a man who certainly did give up all such hobbies on becoming emperor, was also very fond of the fashionable metal—*corinthiorum præcupidus*—and did not scruple to adopt the methods of Sulla and Mark Antony to gratify his ultra-fashionable taste.

Times were then ripe for all forms of degeneration. Connoisseurs, like those of to-day, began to discuss *patina*. As it required years for Corinthian bronze to assume the proper patina—*Nobilis ærugo*, Horace calls it—it was natural that this alloy should have the preference over all other kinds of bronze. But there were gradations of colour even in this metal and value was discriminated according to the quality of the *patina*. Of these *patinæ* the Roman collector recognized five different kinds. Apart from these varying degrees of merit, the connoisseur, Pliny tells us, could tell the quality of the alloy from its weight and determine the excellency of the *patina* by its smell.

Rome as an Art Emporium

Another craze in Rome that greatly fostered imitation and forgery was that of murrhines, cups of a mysterious material which was more valued than any other rare stone or rock crystal, though a cup of the latter, according to Pliny (XXXVII), easily fetched 150,000 sesterces, an amount equivalent to £1200. As a rule, always according to Pliny, for one of these cups a bigger price was paid than for a slave.

If the Romans, unlike the Americans, had no detectives at festivals and banquets, they certainly took precautions to guarantee the safety of the treasures displayed and to guard against the possible greed of some guest.

"Whereas Virro drinks from pateras of beryl," remarks Juvenal, speaking to a parasite, "no one would trust you with even a simple golden cup, or, if perchance they do let you use one, be sure a guardian near you has previously counted the precious stones studding it and follows with his eye the movements of your fingers and your sharp nails."

One can really not refrain from giving this gorgeous patch of Roman colour as Juvenal himself puts it :—

> . . . Ipse capaces
> Heliadum crustas et inæquales beryllo
> Virro tenet phialas : tibi non committitur aurum ;
> Vel, si quando datur, custos affixus ibidem,
> Qui numeret gemmas unguesque observet acutos (V. 38).

One may be sure that the man charged with watching was likely to do his duty with the utmost solicitude. Carelessness in handling these precious pieces that were used to decorate Roman tables was not easily overlooked. An anecdote will illustrate this. Vedius Pollio, a Roman nobleman, possessed one of the most esteemed collections of these crystals. One day when Augustus was dining at this favourite's house, a slave broke one of the precious crystal cups. Vedius immediately ordered the slave to be thrown alive into the pond of lampreys. Disgusted at such an order, Augustus not only made a freedman of the slave but ordered that Vedius' whole

Rome as an Art Emporium 53

collection of crystals should be broken before his eyes and thrown into the pond of lampreys.

But as we have said above, the craze for murrhines surpassed the craze for the precious crystal, though comparing the two, we are bound to add, with no artistic justification.

What these murrhines were made of is not exactly known. Some of the scholars of our day believe they were artificial, a mixture of clay with myrrh, hence, perhaps, the name. Winkelmann is inclined to think they were made of a kind of agate, and Mariette and de Caylus respectively believe them to have been mother-of-pearl, or fluor-spar, or porcelain.

In further illustration of the peculiar substance of the murrhines we quote from Pliny:

" The material of the murrhines is in blocks no larger than an ordinary glass, and a stratum no thicker than the marble of a small console. There is no real splendour in this material, but instead of splendour what one might call brilliancy. What gives the murrhines their price is the variety of their tints, the colour of the veining, either purple or pure white, sometimes shading off into nuances, reaching in some species the hue of blazing purple. The white samples shade into roseate or milky tones. Some amateurs are fond of freakish accidentalities or reflex iridescent changes like the rainbow, others prefer opaque effects. Transparency and pale hues are considered defects, as also opaque grains inside even if they do not alter the surface, like tumours, spreading in the human body. The quality of the odour helps to set the price on the stuff " (XXXVII, 8).

It is to be noted that while this rather vague description of Pliny's would seem on the one hand to point to the agate or any fluor-spar, the addition of the odour tends to destroy this hypothesis.

In any case murrhines became the rage of the Roman collector, and the fashion being, as usual, imperative, no one was considered elegant or correct who did not own at least one sample of the precious cups. One of these cups which, according to Pliny's estimate, could not contain more

than a measure of liquid, less than half a gallon, had cost the large sum of 70 talents (£15,400). Adding that the cup had belonged to a consul, and that the edge of it was nibbled, Pliny remarks that " such damage is the reason of the increased price, there is not in all Rome a murrhine which can boast of a more illustrious origin " (XXXVII, 7).

This consul, who loved his cup so much as to nibble it on putting it to his lips, this collector, whose name is unknown to us, used up all his patrimony on his hobby of collecting murrhines. He possessed so many of them, Pliny adds, that " one might have filled with them the private theatre that Nero had constructed in his gardens on the other bank of the Tiber."

Perhaps one of the most esteemed murrhines was that which was considered the gem of Petronius' collection. He had paid 300 talents (£66,000) for it. Knowing how much Nero coveted this precious cup and wishing to baffle his plans, before destroying himself Petronius ordered his slaves to break it to pieces, so that it should not fall into the hands of the man he destested.

A rival craze in Rome to that of murrhines was the passion for tables of *citrus*. Here too there is uncertainty as to the nature of this rare wood called *citrus*. Apparently it grew at the foot of Mount Atlas in Africa, and was in all probability a *thuja*. To obtain the proper grain it was felled at the root and cut into planks of a length to furnish the board of the table.

Pliny seems to think that Cicero—the snob collector—set the example of extravagance in these tables. The one he bought at the fancy price of 4000 English sovereigns was still in existence in Pliny's time and went under the name of the *Ciceroniana*. Cicero's price, however, was surpassed by Asinius Gallus and Cethegus, the former paying 1,100,000 sesterces for his citrus table and the latter 1,400,000 sesterces. Yet according to Cicero, the citrus table that Verres had placed in his triclinium was the finest and most valuable Rome had ever seen.

Rome as an Art Emporium

Needless to add that in this article, too, collectors had their preferences, that there was citrus and citrus, that the precious tables were valued according to the grain of the wood and the *patina*. There were four qualities among the most appreciated. The *tigrines*, the *pantherines* and the *pavonines* were those tables of which the grain and knots of the wood resembled the coats of the two animals in the case of the two first, whereas the wood of the last showed knots like the eyes of a peacock's tail. The fourth quality was called *apiates*, for in these tables the wood looked like a mass of dark seeds, or more accurately a swarm of bees—hence the name.

The collectomania and thirst for display must have not only favoured the trade in spurious pieces of cheap imitation but, have caused in the chaos of tastes at times an equal confusion in general reasoning. Thus wise men and philosophers appear to have indulged in—what shall we say ?—rather amateurish considerations, indicating the reasoning powers of a dilettante. Cicero at one time gibes at collectors and at another boasts of being a collector himself. Seneca, the wise Seneca, the cool-headed philosopher, was no better. Forgetting that his triclinium was adorned with five hundred fine, tripod-like tables with ivory feet, he writes as a comment:

"I like a simple table with nothing remarkable about its grain, one that is not celebrated in the city for having belonged to a succession of lovers of fashion." And then ". . . material considerations to which a pure soul mindful of its origin should give no weight."

At one time fashion demanded that citrus should be used in veneering, an art in which the Romans were extremely skilful, using all kinds of rare woods, ivory and tortoise-shell. Furniture veneered with tortoise-shell, especially, fetched an extremely high price and was in considerable vogue for a time. The fact was sufficient to prompt Seneca to this odd comment: "Is it possible that people are so ready to pay most extravagant prices for the shell of such an unclean and lazy animal!"

56 Rome as an Art Emporium

The prices paid for art were only too often created by fashion, as shown by the artistic *milieu* of Rome we have been trying to outline, and yet the characters we have passed in review in our reconstruction of the past do not seem altogether dissimilar from some of our present-day lovers of art.

CHAPTER V

INCREASE OF FAKING IN ROME

Increase of Faking—Imitation precious stones—Cameos—Restorers and copyists.

IT is evident that in a society like that of Rome and an artistic *milieu* such as we have tried to depict, comprising a few good collectors among a whole hoard of fools setting up as full-fledged connoisseurs, deception and fakery must have been rampant. The large profits promised by a trade in sham art must have helped to perfect those enslaved Greeks in methods of taking an artistic revenge upon their oppressors. Romans, especially in art matters, must have seemed to them mere parvenus. The practised eclectic qualities and adaptability of those *græculi delirantes* (crazy paltry Greeks), so active in Rome, must have helped matters. In time there was nothing they could not produce for the benefit of their patrons, and often to such perfection as to deceive even keen-eyed connoisseurs. As a consequence, already in Rome the imitation of art and curios produced a certain perplexed feeling even among people who claimed to be acquainted with the business of buying art and antiques. Pliny, who was somewhat of a connoisseur, more especially in bronzes, writes to a friend that he has bought a charming statuette of Corinthian bronze, and in confessing that he likes it, "no matter whether modern or antique," seems to reveal the cautious attitude of a man who does not wish to be caught in error, a fear and uncertainty that very able forgers had created in Rome.

Beyond a few hints and gibes about certain collectors and art lovers and a few comments of Pliny and others we have

no detailed account of the part that imitation and faking played in Rome, but it is to be presumed that the latter especially found numerous and ever-ready clients, and that it was able and prosperous beyond the dreams of modern art duping.

According to Pliny the favourite article, the one to which fakers and forgers gave their utmost care and attention, was the article that was in vogue at the moment and therefore promised the biggest return. Thus murrhines did not escape this fate, they were imitated with obsidian. Pliny also adds that all kinds of precious stones were imitated in Rome, not only by coloured glass but also by a selection of stones that, though rare, were of less value comparatively than the types they imitated.

The most esteemed kinds of sardonyx were counterfeited by joining various pieces of the cheaper jaspers or onyx, cleverly alternating red, white and black, and joining the pieces in such a manner that it was most difficult, Pliny tells us, for a connoisseur to detect a fraud. The same writer, who gives valuable hints on the imitation of precious stones, says that in his time there were even books from which one could learn the art of counterfeiting precious stones, that all of them could be imitated, topaz, lapis lazuli, and amethyst; that amber could be coloured, obsidian used to counterfeit hyacinths, sapphires, etc. Speaking of the sardonyx, more especially, Pliny says, " no fraud brings so much money as this."

In this line there were also other kinds of fraud. One of the most profitable was the imitation of precious stones with paste ones. There are some imitation cameos that are a puzzle even to-day. Commenting upon this fraud, Winkelmann benevolently points out that we owe to this unscrupulous commerce of false cameos the preservation of the casts of some precious originals now lost. The marvellous part of these imitation cameos is that the faker was not only able to imitate the plain stone of the original but all its characteristic veining and peculiarities.

Increase of Faking in Rome

With regard to bronzes and other metal works it is to be presumed that not only could the *Nobilis ærugo* of Horace be easily counterfeited, as it is to-day, but the work as well. Pliny the Younger gives us valuable hints about the perplexity that fakery had generated among the connoisseurs of his time.

The Greek artists in particular showed themselves most versatile, they reproduced in Rome the most esteemed originals and could to a certain extent imitate the most appreciated types of art. Zenodorus, for example, copied for Germanicus a cup by Calamis in such perfect imitation of the chiselling that the copy could not be told from the original.

Fraudulent masterpieces of painting and sculpture, often with the forged signature of some great artist, as at present times, were already on the market in Cicero's time. His "*Odi falsas inscriptiones statuarum alienarum*" is eloquent enough.

Phœdrus seems to complete Cicero's information about Roman art faking.

"It is in this way," he says, speaking of faked paintings and sculpture, "that some of our artists can realize better prices for their work: by carving the name of Praxiteles on a modern marble, the name of Scopas on a bronze statue, that of Myron on a silver-piece, and by putting the signature of Zeuxis to a modern painting."

We do not intend to confound fakers with honest restorers of works of art, but in Roman times, as is often the case in our own, faking learned no small lesson from the deft hand of the restorer. The same may be said for imitators and copyists who even in ancient Rome followed their trade openly with no intention of cheating. Copyists in particular were very active and their work was certainly appreciated by a certain class of citizens. The fact is proved by the numerous copies of Greek masterpieces that have been unearthed in Rome and elsewhere. When an original was not to be had, a copy was often ordered. Lucullus sent an artist expressly to Athens to

make a copy for him of a work by Pausias, the portrait of Glycera, the artist's lady love.

Restorers of works of art were, in Rome as elsewhere, the nearest relatives of fakers; their ability to imitate antiquity must have proved a great temptation, and the enormous sums paid for certain objects, and the gross ignorance of some of the buyers, must have paved the way to more than one passage from honesty to dishonesty.

There were many restorers' workshops in Rome, and one has been discovered near the Forum, where apparently new limbs and heads were provided for damaged statues. Many an antique statue has come down to us already repaired. Evander Aulanius, says Pliny (XXXVI, 5), restored the head of Diana, in the temple of Apollo, on the Palatine. Like modern restorers, their forefathers of Rome had not always the delicate hand needed for such operations. When the Prætor Julius ordered the cleaning of the paintings in the temple of Apollo it was done in such a rough manner that all the charm of the works disappeared. A fact that may have induced some good connoisseur to advise leaving untouched the Venus Anadyomene of Apelles, the masterpiece placed by Cæsar in the temple of that goddess, and to let it be damaged by age rather than allow the sacrilegious hand of a restorer to maim the divine painting of the Greek artist.

From what we have been perusing we may conclude that the Roman artistic world was not entirely different from the artistic world of to-day. Certainly the city must have been of a magnificence of which no conception is given by its grandiose ruins. But the artistic life, and the narrow path of the collector, were somewhat similar to those of to-day. Some of the characters we have quoted would seem to be alive to-day, a change of name and a *milieu* of more modern colouring and they would provide ground for an action for libel. We feel quite familiar, in fact, with the characters described by Seneca. Even to-day the world possesses collectors of rusty nails and other worthless objects—mere

Increase of Faking in Rome

cult of fetishism. We feel no less acquainted with some of the other types to whom Martial pays his attention. The man who gathers ants fossilized in amber, the collector of relics who glories in owning a fragment of the Argonauts' ship, might both be alive to-day. So might Lycinius the demented, Codrus the penurious and dissatisfied, Eros the enthusiast and dreamer. They still exist and are well represented in their various shades of foolishness down to that Mamurra who used to upset all the shops of the Roman antiquaries without buying a single thing. Would you resuscitate Tongilius to our modern society just substitute a bright motor-car for his rich and cumbersome *lectica* and, for a certainty, the name of some modern collector of art, some up-to-date Mæcenas, will come to your mind.

Of course, though Mr. Cook had not yet alighted to relieve itinerant humanity from many troubles, tourists existed even at the time when Rome did not possess the modern type of traveller. According to Titus Livius many foreigners used to visit the temples of *Porta Capena*, regular museums of art. The tourists of that time followed a routine, as we can gather from Pliny and other writers. They were taken to the Palatine, to the Via Sacra to admire the temple of Apollo with its peristyle of fifty-two columns, adorned by the simulacra of the Danaides and fifty equestrian statues, one of the finest sights in Rome and which inspired Horace with an ode. This temple of Luni marble with ivory doors, surmounted by a quadriga in gilded bronze carrying the god, was also a museum, containing among other things a fine collection of gems, and a room lined with silver in which the Sibylline Books were kept. The *Domus Aurea*, the paintings of Apelles exhibited in the Forum of Augustus, the temple of Venus, one of the finest emporiums of art, that of Ceres which contained the celebrated "Bacchus" of Aristides of Thebes, the "Marsias" in the temple of Concord, and in the Capitol the "Theseus" of Zeuxis, in Pompey's portico the "Soldier" by Polygnotus, in the temple of Peace the "Hero" by Timante and another famous work by Protogenes.

Increase of Faking in Rome

There were of course foolish tourists who, like to-day, insisted on being fed with more or less authentic anecdotes of relics of an impossible character, who believed the unbelievable. Thus, according to Procopius, who evidently believed the genuineness of the relic, many tourists went to see the boat, still moored in the river, from which Æneas had landed in Italy, etc. This kind of tourist must have inspired Lucian with the comment that Greek guides in Rome might have starved but for the nonsense and legends with which they enriched their descriptions of the city. " But what of that," remarks Lucian, " visitors like to hear such things, and do not seem interested in the truth even if offered to them free of charge."

The revival of the past needed this slight touch to show that the artistic world of two thousand years ago was not, after all, dissimilar to that of our enlightened days.

Need we repeat that the phenomenon of art faking for the benefit of foolish lovers of art generally appears when the passion for collecting takes that Byzantine attitude which makes it ripe for decay and degeneration, when mania, fashion and snobbery chiefly hold the ground instead of taste and genuine love of art, in fact when the parvenus or the lunatic submerge the intelligent collector. It follows consequently that the decline of Collectomania heralds the decline of Forgery. The latter, its errand over with the cessation of the demand for antiques and curios, disappears to await a fresh chance. But the fake-festival and carnival will revive, phœnix-like, with the awakening of a new artistic world—just as though faking at certain moments answered to a sore need of society.

CHAPTER VI

DECADENCE OF ART AND CONSEQUENT CHANGES

Decadence of art and consequent change in the artistic *milieu*—Byzantine art—Its new views do not seem to favour old ways—Art patronage and collectomania tend to disappear—The medieval period—Character of the collections—No imitators but a few forgers.

THE change affecting the world with the decadence of the Roman Empire was logically bound to stamp the successive course of art with the inevitable downfall of past glory. With the Christian era a new society had arisen and also a new art, entirely symbolic, no more satisfied with the early plagarisms, apparently lisping a new tongue but ready to dispel all pagan sentiment in art, to establish the elements of a new expression and purpose more in harmony with the reborn civilization. With an art that Taine considers "after five centuries to be unable to represent man except seated or standing erect," symbolic and calligraphic at the same time, there seemed to be no room for amateurs and collectors of the old type.

There may have been sporadic cases, though Constantine's severe censure of all the cults of the past doubtlessly made it a daring act at that time to profess worship for old traditions in art. Collectomania very likely became a thing of the past. There must have been dealers in art and antiques, as we can gather from the Digest, and transactions between artists and clients, as can be seen from a clause of the Justinian laws, but nothing like there were in the ancient Roman world that had been dispersed by the new civilization.

This clause Justinian was forced to add to a law on artistic property, as judges had so lost all sense of art appreciation that in a dispute between a painter and the man who had furnished the board on which the work was painted, they decided that the painting belonged to the one who owned the board. Justinian was forced to do justice by stating that if a quarrel arose between the artist and the one who furnished the board the owner of the work was the artist, as the value of the board could not be compared with the artistic one. "Think," he concludes, " of comparing the value of the work of Apelles or Parrhasius with the price of a board of very small value."

The time for lovers of art, for private speculations and the all but consequent faking, and all the characteristic figures of an art market had disappeared.

In the early medieval period there seems to have been no scope for faking and forgery. The collector, if the type then existing is entitled to the name, was like nothing that had been seen before or has since appeared. The objects treasured generally had more intrinsic value than real artistic merit. A collection represented a simple form of banking, a sound and good investment taking the place of what the French call " personal property."

With such views, goldsmiths' work, studded and ornamented with precious stones, or rich embroideries in gold, naturally had the preference. Articles of virtu then had a solid value, and while suitable for princely display, could be turned into money at any moment. The craze for manuscripts, rare penmanship, and early illuminated parchments may represent an exception, but only, apparently, as such objects—apart from their rarity, skill and supreme patience in miniature work—were of such an established value as to be regarded like precious gems.

The medieval collections of art and precious things give a true expression of those unsafe and uncertain times and were in harmony with the erratic career of the monarchs and potentates whose peculiar mode of life often necessitated the

packing of the whole museum into a coffer and dragging it with them in their pilgrimages, wars, etc. This not only in some way explains the preference given to goldsmiths' work but the fact that the dimensions of sculpture had to be reduced, and painting, when not for church decoration, was mostly restricted to miniatures, illumination, and designs for tapestries and embroideries.

Clovis, the "Most Christian King," as Pope Anastasius called him, is supposed to have been an eager collector of rare and precious objects. Tradition claims that a saint one day broke one of his rarest cups of jasper all studded with precious stones, and seeing Clovis' sorrow at such a loss, picked up the fragments and praying over them, performed a miracle, handing to the monarch the cup restored to one piece as before. Clotaire, the son of Clovis, had in his mansion at Braine a secret room with chests full of jewellery and precious vases.

Chilperic had a real ambition to collect rare objects of virtu. For this purpose he sent everywhere for all that might be worthy of his collection. Gregory of Tours tells us that he had a Jew as adviser, a man called Priseus.

It is said that when Chilperic exhibited at Nogent-sur-Marne the presents offered him by the Emperor Tiberius II, to show that they did not surpass in splendour the best pieces of his own treasure, he exhibited close to them one of his precious cups, a golden vase studded with rare stones and weighing fifty pounds. Twenty years later, between 560 and 580, Saint Radegond, the daughter of the king of Thuringia, received the poet and canon Fortunatus in her convent of Poitiers and gave him a dinner with the table covered in roses and the richest ornamented silver plates and precious jasper cups. Such a treat inspired the poet with one of his fine Latin poems. Dagobert was not only an enlightened collector of precious things but so extremely fond of artistic "vaisselle" that when Sisinande, a Gothic king, wished to induce the Frankish monarch to join him in his political schemes he promised Dagobert a fine gold plate weighing

five pounds " and more precious still for the beauty of the workmanship."

After a long lapse of time, in which the only museums of the art of the time seem to have been the churches, under Charlemagne and his successors private collections of treasures, art and fine pieces of work again seem to acquire importance. The Bibliothèque Nationale of Paris owns an *Évangéliaire* of rare artistic value, illuminated by a monk named Godescal of the year 781.

The Bible and Psalter of Charles the Bald are said to have been the work of the monks of Saint-Martin de Tours, and are considered a marvel of illumination. Together with these books, now kept in the Librairie Nationale of Paris, Charles presented to the Church of Saint Denis a famous cup known in his time as Ptolemy's cup, a fine work carved from a piece of precious sardonyx. In the will of this monarch's brother, the Marquis of Friuli, a document dated 870, there is, among other legacies, the enumeration of arms studded with precious stones, clothes in silk and gold embroideries, silver vases and ivory cups, finely chiselled, and a library in which among other notable works are the writings of Saint Basil, Saint Isidore and Saint Cyprian. From this time forward a collection of rare things and precious jewels is quite a necessary apanage of kings and princes, but as we have said, it mostly consisted of small objects in which art almost invariably seems to have played a secondary rôle, and in considering the art it is often hard to know whether to admire more the miniaturist's patience or his workmanship.

Later on the cult of pagan art seems to have been revived by the Emperor Frederick II, the son of Barbarossa, but even at this time the case is somewhat of an exception.

Under patrons of art who were as a rule absolute monarchs or iron rulers and all-powerful princes, fakery would have played a dangerous and most sorrowful part, nor was there any inducement to indulge in any of the trickery that had characterized the world of lovers of art during the Roman decadence. A risky game at any time, it might have entailed

and Consequent Changes 67

one of those exemplary punishments which characterized the ferocious Middle Ages.

Coin counterfeiting was naturally the least artistic form of deceit, and being a less hazardous venture seems to have tempted ability in all ages. It represents a link between more proficient periods of art swindling.

Some of these early fakers certainly planted the seed from which sprang the arch-deceivers and clever medallists of the Renaissance.

> There lies Romena, where I falsified
> The alloy that is with the Baptist stamped
> For which on earth I left my body burned.

These words Dante puts into the mouth of Mastro Adamo da Brescia, a skilful counterfeiter of coins whom he met in hell. Adamo was burned at the stake near the castle of Romena in the Casentino, for having cast, by order of the Count of Romena, the golden florin of the Florentine Republic.

About this time counterfeit coining tempted the most diverse classes of people. It had a long list of devotees, including even a king of France who honoured the Republic of Florence with not a few of his swindling specimens of the golden florin. Marostica, a village in the Venetian domains, challenged and defeated the powerful Republic of the lagoon by flooding the Venetian market with the most deceptive samples of false coinage.

CHAPTER VII

THE RENAISSANCE PERIOD

Initiation of the Renaissance period—Newly born passion for the antique—
The Mæcenas and the collector—Plagiarians, imitators and fakers—
Cola di Rienzi, archæologist—A collection of the fourteenth century—
Artists, writers and travellers hunting for antiques—Niccoli, the Medicis,
Cardinal Scarampi and others—The Medici collection dispersed by the
Florentine mob.

THE Renaissance fakers of art have a somewhat nobler pedigree when compared with those of other epochs. The early artists from whom they sprang were not actual imitators of the Greeks and Romans, but were inspired by them to reproduce that pagan expression which had deeply affected their artistic temperament. Were these artists doing it purely for art's sake, or had they the hope that their work might pass as antique ? The answer to this is perhaps to be deduced from the character of the age not yet fully ripe for artistic deception. The sentiment for, and cult of, the antique were certainly growing during this early part of the Renaissance ; they did not come in a sudden burst, but had been gradually developing in the previous years.

As a matter of fact, already in the transitional period which prepared the highest artistic accomplishment of the Renaissance, collections and collectors were becoming not only eclectic in taste, but seem to have been guided by a real artistic fondness for the art of the past. It is no more a question of solid silver and jewels, but of statues and paintings. Catalogues no longer read like that of Charles VI of France : " Inventoire des joyaux, vaiselle d'or et d'argent estant au Louvre et en la Bastille à Paris appartenent à feu

The Renaissance Period

le roy Charles," followed by a monotonous enumeration of jewels, *vaiselle*, etc., but are like that of the Medici collection, and include all the most varied expressions of art—sculpture, paintings, medals, carving, cameos, rare jewels, etc.

In the early part of the 14th century we know that Cola di Rienzi, the Roman Tribune, collected inscriptions. One of his biographers tells us that Cola " occupied himself every day with inscriptions cut into marble, which were to be found round Rome. No one could decipher the ancient epitaphs like him. He translated all the ancient writings and gave the right interpretation to these marbles." It was between the years 1844-47 that Cola compiled a work on Roman inscriptions, re-edited a century later by Signorili in his *Descriptio urbis Romæ*.

Oliver Forza, or Forzetta, who flourished about the year 1335, seems to have owned the first complete collection of which we have notice. Forzetta was a wealthy citizen of Treviso. We know that in the above year of 1335 he came to Venice to buy several pieces for his collection, manuscripts of the works of Seneca, Ovid, Sallust, Cicero, Titus, Livius, etc., goldsmiths' work, fifty medals that had been promised him by a certain Simon, crystals, bronzes, four statues in marble, others representing lions, horses, nude figures, etc. The latter seem to have belonged to an earlier collector named Perenzolo.

To point out that even outside Italy taste had changed at the beginning of the 15th century, we may quote the following description handed down to us by Guillebert de Metz. It gives a full account of the collection of Jacques Duchie, a Parisian, and indicates that at this early time Paris must have possessed more than one of these collections of art and curios.

"The house of master Duchie in the rue des Prouvelles," says Guillebert de Metz, " the door of which is carved with marvellous artistry ; in the courtyard there were peacocks and diverse fancy birds. The first hall is adorned with diverse pictures and instructive texts fixed to and hung on the walls.

Another hall filled with all manner of instruments, harps, organs, viols, guitars, psalters, and others, upon all of which the said master Jacques knew how to play. Another hall was furnished with chess tables and other diverse kinds of games, great in number. *Item*, a beautiful chapel where there were stands to place books upon, marvellously wrought, which had been sent from diverse places far and near, to the right and to the left. *Item*, a study the walls of which were covered with precious stones and with spices of sweet odour. *Item*, several other rooms richly furnished with beds and with ingeniously carved tables and adorned with rich hangings and cloth of gold. *Item*, in another lofty room were a great number of cross-bows, some of which were painted with beautiful figures. Here were standards, banners, pennons, bows, pikes, swords, lances, battle-axes, iron and lead armour, *pavais*, shields, bucklers, cannon and other engines, with arms in abundance, and, briefly, there were also all manner of war implements. *Item*, there was a window of wonderful workmanship, through which you put a hollow iron mask through which you could look out and speak to those outside, if occasion arose, without making yourself known. *Item*, above the whole house was a square room with windows on every side from which one could overlook the town. And when it came to eating, food and drink were sent up by a pulley, because it would have been too high up to carry. And above the pinnacles of the house were beautiful gilt figures. This master Jacques Duchie was a handsome man '*de honneste hebit*' and very distinguished; he kept well-mannered and well-trained servants of pleasing countenance, among whom was a master carpenter who was constantly at work at the mansion."

But Italy at the early part of this century was far more advanced. There was no question here of collectors of dubious taste or odd fancy for the simply curious; on the contrary we are confronted by real connoisseurs and genuine lovers of art, intelligent and eager hunters after all sorts of articles of virtu of past art; and also enlightened art patrons

The Renaissance Period 71

who were munificent toward their contemporary painters, sculptors and literary men.

Taste had changed, and some tendencies merely outlined at the time when religion seemed to absorb all the activities of art, were now in full growth. That which in the art of the Cosmati appeared to be a Byzantine aping Roman art, all that seemed plagiarism of this classic art in Nicola Pisano, takes an interestingly different course with Donatello, Brunellesco, and all of those artists whom a wrong convention calls the forerunners of the Renaissance instead of calling them the real creators of that great artistic movement.

The passion for the antique was reviving. It was no longer a question of sporadic cases but rather of a widespreading taste. Roman art was in the air. Besides Rienzi, this cult of antique memories had already claimed his friend Petrarch and the learned Dondi, a physician from Padua, who visited Rome in the year 1375 to crown a long course of study devoted to the antique. In a letter addressed to his friend Guglielmo da Cremona, Giovanni proclaims the superiority of antique art and is certain that modern artists will be the first to recognize the fact and learn from it. Poor and hard-working, Dondi regrets that his profession, his ailing patients, take so much of his time. But for the profession, "I would rise as high as the stars," he naively declares.

Ciriaco d'Ancona, another great eager collector and intelligent hunter after fine things, visits the Orient and Greece in search of manuscripts and relics of art; Francesco Squarcione comes from the East, bringing to his native Padua fine Greek works, and is perhaps the first artist to devote himself to antiques, just as Niccolo Niccoli, a Florentine lover of art, represents at this time the learned amateur of taste.

Niccoli is really one of the finest types of collectors. Born at a time when Florence demanded that each citizen should belong to one or other of the factions that kept civil war alive in the city, he nevertheless managed to keep free from

all civil strife. His house was the temple of art and of neutrality. A friend of the powerful and wealthy Medicis, who by the way trusted to his infallible eye as a connoisseur whenever rare things were offered, Niccoli never took advantage of this unusual position, but kept himself far from all ambition and was possessed by the sole desire to collect art, study old manuscripts, and be an ever-obliging helper to students. The friends and admirers who came in flocks for advice, to borrow his rare manuscripts, or to visit his fine emporium of art, were always well received. Niccolo Niccoli was born in the year 1368. The son of a rich Florentine merchant he was forced in his youth to give all his activities to commerce. Liberated from the tie of a profession for which he had no call, he finally gave himself to his cherished study of art and literature, attending the lessons of Luigi Marsigli and Emanuele Chrysoloras. His studies were thus the stepping-stone to the collecting of antiquities. In the year 1414 his fame had already extended beyond the city walls. The Chancellor of the city of Padua addressed him in a letter as "*clarissimus vetustatis cultor*." Notwithstanding his great wealth, such was his passion that but for the discreet help of the Medici, the powerful Cosimo and his brother Lorenzo, who became Niccoli's benevolent bankers, on more than one occasion this enlightened amateur might have been forced to sell his precious collection, or at least do that which is most hateful to the true lover of art, sell the best that years of patient work had gathered together. What is most surprising is the fact that Niccoli managed to make one of the finest collections of art of his day almost without leaving his native city. We know of him as going once to Padua to secure a rare manuscript of Petrarch, and later on as accompanying his friend and protector, Cosimo Medici, to Verona, a trip the latter undertook in the year 1420. With Cosimo again he visited Rome, to be horrified at the mutilation inflicted upon the Eternal City by barbarians of all ages and denominations. Yet without moving from his native city, keen-eyed Niccoli managed to search the world

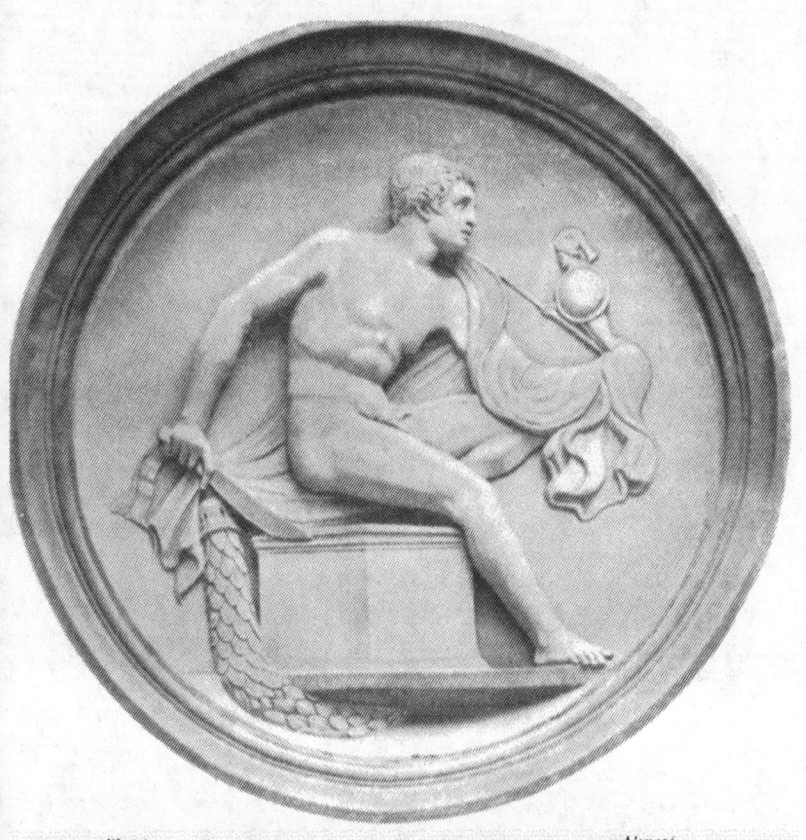

Photo] *Alinari*
DIOMEDES WITH THE PALLADIUM.

An imitation of the antique by Donatello's School (?) and a free copy of Niccoli's cameo, a Greek work. Palazzo Riccordi, Florence.

The Renaissance Period

with the help of agents and friends—some of them, no doubt, the practised servants of the Medicis. There was hardly a rare thing discovered, no matter where, but the fact came to Niccoli's ears, and the "find" generally found its way to this enlightened Florentine's collection. Once he even had the fortune to discover a fine sample of Greek art in Florence, a few steps from the door of his house. It was the well-known cameo which he attributed to Polycletus and which was afterwards so often reproduced by the artists of the Renaissance. Niccoli discovered this rare piece of chalcedony hanging round the neck of a street urchin. He asked him who his father was and found him to be a poor workman. He went to see him, and to the man's surprise offered for the stone the round sum of 5 golden ducats. It is curious to trace the migrations of Niccoli's "calcedonio," as the piece was called later. When Cardinal Scarampi—the Patriarch of Aquileia and the most passionate collector of his time—came to Florence, he went to visit Niccoli and his collection. There he became so enamoured of the "calcedonio" that he proposed to buy it. Niccoli, who could hardly refuse the favour to the powerful and influential Cardinal, consented to part with the rare piece for 200 ducats. Later on the "calcedonio" entered the collection of Pope Paul II, to pass finally to that of Lorenzo il Magnifico. In an inventory belonging to the Medici family the gem is valued at 1500 golden florins.

Not dissimilar from certain modern and older types of collectors, Niccoli was what might be called a strange character. While spending large sums of money on his articles of virtu, he was almost parsimonious in his household, although he liked to drink from rare cups and set his table most richly with all sorts of precious vases. One of his peculiarities was always to be dressed in pink. He had an endless wardrobe of these rosy-hued garments and was as preoccupied with them as he was with the rare objects of his collection. These and other oddities were naturally the subject of gibes and sarcasm from friends and unfriendly humanists, but Niccoli never answered one written line.

content to retaliate with his witty and cutting tongue. He certainly had the best of it in this curious duel, for he forced Aurispa and Filelfe to leave the town, and also, perhaps not through his sarcastic tongue alone but through some Medicean intrigue, compelled his enemies, Emanuel Chrysoloras, his former teacher, and Guarino to make themselves very scarce in the city.

Niccolo Niccoli's name brings us straight to that of his protectors, the Medicis, the family who as collectors of art and fosterers of literature and philosophy surpassed every one of their age.

Cardinal Scarampi's collection, that of Pietro Barbe, afterwards Paul II, and even the most complete of all, that of Niccoli, become rather minor stars when compared with the artistic treasures gathered by the Medicis for generations. This illustrious Florentine family seems to have been for centuries nothing but a succession of patrons of the fine arts.

" No art collection," says Eugene Müntz in his *Les Collections des Médicis*, "has more deeply influenced the art of the Renaissance, no collection has passed through more trials than the one of this family. Ten generations of enthusiastic amateurs have given themselves to its enrichment ; the greatest artists, Donatello, Ghiberti, Verrocchio, the two Lippi, Ghirlandaio, Botticelli, Leonardo da Vinci, Michelangelo and Raphael have sought inspiration and models in the Medici collection. This while, by an unaccountable contradiction, all the revolutions that troubled the city of Florence seem to have continually threatened the existence of such an inestimable gathering."

To be convinced of the extreme importance of the Medici collection one has but to reflect that what now remains of it in the Florentine museums or in well-known private hands is only the smallest part of those past treasures, which has managed to survive the pillage of the collection in the year 1494, when Piero Medici fled and the Medici palace was sacked by the populace and the remaining effects sold and dispersed by order of the Commune. What was later re-

The Renaissance Period

covered by the family was only a small part of the collection. An idea of the magnitude of the Medici museum of art can be gained by perusing the accurate inventories still remaining in the Florentine archives, the list of the objects left by Cosimo the Elder to his son Piero and the catalogue of the collection belonging to Lorenzo il Magnifico, and finally the account of their money.

A brief study of the character of the two most important collectors of the Medici family, Cosimo and Lorenzo il Magnifico, will enable us to judge of the quality and tendencies of the amateur of the Renaissance.

The characteristics of the time in which Cosimo lived and the fact that he had spent a long period in exile, a misfortune brought upon him by jealousy, gave his inclinations as an amateur a different course from what they might otherwise have had. Thus, while on the one hand Cosimo never lost a chance to help artists and to acquire fine works of art, he was shrewd enough to do so without ostentation, to avoid arousing enmity from adversaries. But for this peculiar feeling Cosimo's palace, the present Palazzo Riccardi, one of the most sumptuous monuments of Florence, might have been still more imposing, displaying greater architectural wealth. It is known that Brunelleschi's project was privately preferred by Cosimo, but he did not dare to arouse old jealousies by too sumptuous a display. Michelozzo's design was chosen as the more modest of the two and thus better fitted for the "bourgeois prince" of Florence. Notwithstanding the necessity for caution even in liberality, Cosimo encouraged Poggio Bracciolini and many others in their intelligent search for manuscripts and rare parchments. He had Niccoli as an invaluable adviser and helper, and left to his son Piero one of the finest collections of antiques.

His grandson, Lorenzo il Magnifico, was more free-handed. Times had changed, the Medici family, though without heraldic title, was now master of the city, and the splendours of a man of taste, such as Lorenzo, and his prodigal inclinations, knew no restraint whatever. The difference between

Cosimo and Lorenzo lay perhaps in the fact that the former could not do half what he might have done. Comparing Niccoli and Lorenzo, one might say that the former tallied more with the modern interpretation of the word collector, while the latter, as being far too eclectic a lover of all sorts of artistic expression, was more cut out for the part of an enlightened Mæcenas, a prince-amateur and a generous patron of art and literature. One can hardly even imagine the Magnifico classifying his cameos as did Niccoli, or giving a semi-scientific and rational order to his objects of virtu, but, running on the same lines as Cosimo, Lorenzo invested in the rôle of patron of art and lover of the antique, in which he displayed such magnificence as to fully deserve his appellation. Such was the character of these two Medicis, stated by contemporaries as being more greedy for fame than money. An estimation fully justified, especially in the case of Lorenzo, who in his *Ricordi* notes that his father and grandfather spent 663,755 florins in the space of thirty years and rejoices in the fact. The sum quoted amounts to rather more than a million francs; how many modern heirs would feel like Lorenzo il Magnifico?

Like Niccoli and Cosimo, Lorenzo possessed the excellent quality, most uncommon in a collector, of letting friends and admirers have full benefit of his collection. More than the gratification of an egotistic desire to possess rare and beautiful things, he saw in his artistic pursuits a great means of education and a help to the artists of his time.

According to the taste of his age, Lorenzo was very partial to Greek and Roman art, to all that concerned past civilization. A page of Plato or the beautiful form of a Greek marble aroused in him feelings of emotion more than any modern expression. Not only did he fill his palace with fine pieces of sculpture but his villas also appear to have been replete with them.

"He was bursting with joy," Valori, one of his contemporaries tells us, "when he received the bust of Plato sent him by Girolamo Roscio."

This passion for the antique, however, did not prevent Lorenzo from encouraging the artists of his own time or from taking a deep interest in their art. Eclectic in taste, as a collector he nevertheless had some preferences. In a letter to his son Giulio, the future Leo X, on his promotion to the Cardinalate, he gives advice as to the kind of art which is most in keeping with ecclesiastical taste, but as a matter of fact epitomizes his own penchant as a collector of art. Urging his son to give preference to antique statuary, he discourages him from becoming a collector of jewels, tapestries and embroideries. "Love in preference," he recommends, "fine antique things and books"—*qualche gentilezza di cose antiche*.

Lorenzo the Magnificent seems to stand apart from the lovers of art of his time not only on account of his culture and intelligence, his broad eclectic views and genuine cult of every expression of beauty, but as being a rare type of the grand seigneur, æsthete and humanist. Paul II is a passionate collector of art, but more a scholar than an artist, with him knowledge is supreme; Cardinal Scarampi is, as Ciriaco D'Ancona calls him, an archæologist, and Niccoli, as an eager and intelligent searcher of objects, would make a good type of antiquary of our day, but Lorenzo displays interest in every kind of elevated human expression; his character seems to conform to his noble motto, *Nul ne sait qui n'essaye* (nobody knows who does not try).

His reputation as a connoisseur and expert in art spread afar. Princes and monarchs asked his advice. Lorenzo is not only prodigal in this respect, but also in the artistic things of his collection which he sends as presents. To Mathias Corvinus he sent a bust by Verrocchio, to the Count of Madaloni of Naples a fine horse's head—now in the museum of that city—a rare piece of work which until lately was taken for Greek but is now attributed to Donatello. The Duke of Calabria asks him for an architect, and he sends him one; in the year 1488 he sends to Ferdinand, king of Naples, a fine plan of a palace by Giuliano da Sangallo, and

later he introduces Leonardo da Vinci to Lodovico il Moro, Filippino Lippi to Cardinal Carafa, Sansovino to the king of Portugal. In connection with odd requests that came to Lorenzo from princes and monarchs there is a queer one from Louis XI. The French king asks the Magnificent to lend him for a while the miraculous ring of the Florentine patron saint, San Zanobi, pledging himself to restore the ring to the owners —very likely the Girolami of Florence—and begging Lorenzo to tell him how and in what way it must be worn to perform the miracle, cure his gout and restore him to health.

Through his love of art and his munificence towards artists Lorenzo became practically bankrupt, and certainly had no scruples about using public funds for his private purposes. Not that he was fond of personal display, on the contrary he detested outlays that had no public utility or did not foster some progress.

Rinuccini, another of his contemporaries, tells us of Lorenzo's indifference to personal luxury and of his dislike for society functions. "All the things that in olden days," says Rinuccini, "gave grace and reputation to the citizens; like weddings, dances and fêtes and handsome clothes, he condemned them all and did away with them through his example and his words."

A detailed description of his character as a collector and the quality of his passion is not so eloquent of Lorenzo's particular penchant as his *Ricordi*. Take, for instance, these words concerning his mission to Rome at the elevation to the Holy See of Cardinal Della Rovere. "In the month of September, 1471, I was sent as ambassador to attend the coronation of Pope Sixtus. I was the recipient of many honours in Rome and brought back from the city two antique busts, the portraits of Augustus and Agrippa, given to me by the Pope. I also brought with me the carved cup of chalcedony and many cameos and medals."

It must be said that in forming his collection the Magnifico never lost sight of Rome and its treasures. He had many agents in the Eternal City excavating and looking for antiques

The Renaissance Period 79

to add to his collection. His intercourse with these accomplices, the ruses employed, the adroit management of influential prelates opposed to Lorenzo's schemes, and grieved that rare things should leave Rome, form an interesting chapter of diplomacy.

Glyptography was given preference in Lorenzo's collection. Some of his cameos and engraved precious stones are now the rarest things in our modern museums. Then came a fine collection of coins and medals, 23,000 pieces in all, and another of Etruscan vases. His statues, which Verrocchio and other artists were often charged to repair, filled to overflowing his palazzo in Florence and his villas.

To his assistance came not only special agents, but friends as well. A magnificent vase was obtained by Lorenzo from Venice, and it was through the mediation of his literary friend Politiano that the rare find got into the Magnifico's collection. Politiano writes from Venice to his friend and patron on June 20th, 1491, that Messer Zaccharia has just received from Greece *una terra cotta antiquissima* and that he believes it to be worthy of Lorenzo's collection. Antonio Yvane writing to Donato Acciaioli says that a little statue of Hercules has been found at Luni, and that it and other antiques excavated are to be sent to Lorenzo.

One of his agents sent him a marble statue with an Etruscan inscription; from Siena, Lorenzo receives a bust that sends him into raptures, and he immediately wishes to buy it. To give an idea of his appreciation and willingness to pay whatever it might be worth, we quote part of his letter dated May 15th, 1490, addressed to Andrea da Foiano then at Siena. "Ser Andrea, I received your letter last night, and with it the head which you sent me and which, on account of its being fine and having much of the antique beauty, I would most willingly buy from him who owns it, if he will part with it for what it is worth."

Though there is no document to support the fact, this bust is possibly the one that P. della Valle says was sent from Siena to Lorenzo, representing a head of Jupiter, of such a

character that beheld from one side it had a benign expression, and from the other a terrifying one. Naples also contributed its share to the Medicean collection, from whence arrive the portraits of Faustina and Scipio Africanus, a fine bust of Hadrian and a sleeping Cupid. These last two statues were conveyed to him by Giuliano da Sangallo, who under Lorenzo's directions had asked them of the king of Naples.

As a collector and type of antiquary not disdaining a good bargain, and perhaps influenced by the lineage of shrewd bankers, from which he sprang, Lorenzo made more than one good stroke of business. From Pope Sixtus IV he managed to buy the artistic treasure of the Holy See at such a ridiculous price as to arouse protests from the Pontifical accountants. The deal, which was carried through by Lorenzo's uncle, Giovanni Tornabuoni, caused a scandal that only the Pope's authority managed to silence, and the Medici collection became enriched by many fine pieces. Among them, the so-called "Tazza Farnese," now one of the finest pieces of the Naples Museum, to which the inventory of the collection gives a value of 10,000 ducats, and the rare Greek work known as the "Rape of the Palladium," rated by the same inventory at the sum of 1500 ducats. This celebrated cameo had formerly belonged to Niccoli. Donatello copied it for one of his medallions of the Medici palace. There were other dealings between the Medici and the Holy See, but we fail to know how advantageous they may have been for either side. In the year 1460 the Medici sold a piece of tapestry to Pope Pius II for the not inconsiderable sum of 1200 golden ducats, and later on, through the above-quoted agent, Giovanni Tornabuoni, in the year 1484 several yards of common tapestry were sold to the Pope by the Medicis.

We have spoken at greater length of Lorenzo il Magnifico as he appears to us to symbolize the type of Mæcenas and collector of his epoch, but all Italian princes were more or less art lovers and collectors at that time, as well as being shrewd bargain drivers on occasion. As an example of this, one is led straight to Isabella d'Este and her hard dealings

The Renaissance Period

with Mantegna. Intelligent, keen-eyed and a good connoisseur, Isabella had set her heart on a *Faustina antica* in the possession of the Paduan painter, but did not wish to pay the price demanded by the artist. Negotiations were carried on for quite a time. Knowing Mantegna's straightened circumstances, Isabella coolly and almost cruelly waited the favourable moment to take best advantage of the artist's distressing situation. Pressed by all sorts of needs, the aged artist finally decides to part with his best antique, the portrait of Faustina, a work of art he adored. Conscious of having served the house of Gonzaga most faithfully and knowing Isabella's intelligence and admiration for his bust of " Faustina antica," as he calls it, he determined to offer her the work for a hundred ducats. In his letter dated from Mantua, January 13th, 1506, he tells Isabella all his troubles and how hard it is for him to part with his cherished bust, but also how glad he would be if she will take it, or as he says: "Since I have to deprive myself of it, I would rather you had it than any other Lord or Lady in the world." To this pitiful letter, ending with the touching appeal: "I recommend myself to your Excellency many and many times," Isabella replies later by sending one of her agents, whose letter to her is full of an astute spirit of bargaining and runs as follows:

"In compliance with what your Signoria writes me, I will call to-morrow morning on Messer Andrea Mantegna and will act as shrewdly as possible about the Faustina (*farò l'opera con più destro e acconcio modo saperò*) and will inform your Excellency of the result at once. Giovanni Calandra Mantua, July 14th, 1506."

A second letter from Giovanni Calandra informs Isabella that the artist is obdurate as to the price. That though he is in extreme need he hates to part with his *Faustina di marmo antica* and asks pardon for the refusal, that he hopes to find his price with Monsignor Vescovo di Gonzaga, who has the reputation, Calandra states, to be keen on these things. Dealings through the agent go on, till one day the latter

announces to the Marchesa Isabella Gonzaga that she has become the possessor of the *Faustina antica*, which is already shipped to her (*Mando per burchiello a posta la Faustina a S.V.*), provided she agrees to the price; if not the agent begs that the bust may be sent back, in accordance with his promise given to the painter, should the price not be agreed upon (*acciò possi disobbligar la fede data a M. Andrea Mantegna*). Negotiations between Isabella Gonzaga and the penurious artist who had covered with glory the prince he had served and had decorated with magnificent frescoes the room of Isabella's mansion, lasted from January 13th, 1506, to August 2nd of the same year.

These are but a few incidents of the day. All Italy was collecting. Excitement over antiques had now become a mania, and this is perhaps the best justification for imitators to have turned into fakers.

At this period art collecting ranged from its highest votaries, Lorenzo Medici, the Duke of Urbino, Este, Gonzaga, Sforza, Arragona, down to common citizens who were earnest and intelligent collectors.

One thing to be noted in this epoch is the total absence of the parvenu collector so fully represented in the Roman period. There may be an occasional case of snobbery, like that of Cardinal di San Giorgio, who refused to keep in his house an excellent imitation of Michelangelo, because, though having deceived him and many others, it was not actually genuine, although far better than some of the rubbish of his collection which contained indiscriminatingly anything that had been unearthed in Rome, but a Tongilius, a Euctus, and above all a Trimalcho, do not seem to have existed in the Renaissance period. If they did, they were surely minor characters and quite outside the world of real amateurs.

CHAPTER VIII

IMITATION, PLAGIARISM AND FAKING

The artists' passion for the antique—Brunelleschi, Donatello and their followers—Florence, the School of Padua, Venice—Imitation, plagiarism and faking—The plaquettes and their curious transformations of some Greek and Roman originals—The character of the imitations and that of the intended victims.

THERE is no occasion here to lose oneself in arguments as to whether the artist was the primal cause of the awakening of the taste for the antique, or whether it was a mere synthetic translation of a sentiment already awakened through complex causes, the main one being, perhaps, classic literature. Classicism, lately developed into an entirely pagan æsthetic sentiment, a combination of Philhellenic and Latin tendencies, may as well have influenced art as life in general—a sentiment that at the moment of its maturity aroused anathematic protest from Savonarola and a momentary reaction of pietism. However, the preaching of the friar and his colossal bonfire of art treasures in Piazza della Signoria were mere incidents in the course of Florentine tendencies of art. The *Piagnoni* in Florence may have converted Botticelli and a few other artists, but the pagan sentiment was not dispelled. For the artist of the last part of the XVth century San Giorgio and Perseus were, if not identical, to be treated with the same artistic sentiment.

The real evolution, in our opinion, begins with Brunelleschi and Donatello. In the year 1404 these two artists undertook a journey to Rome. For the progress of art this is a memorable date. The real influence of Greek and Roman art on

84 Imitation, Plagiarism and Faking

the artistic movement immediately preceding the Renaissance begins at that date. It is undeniable that even before this time mythological subjects had become familiar to both painters and sculptors, artists preceding Donatello and Brunelleschi, such as Piero di Giovanni Tedesco, Nicolo di Piero Lamberti (called *il Pela*) and even Nanni and Antonio di Banco, show slight traces of Roman art at times—even to the way of working the marble, as in the ornaments of the north door of the Duomo in Florence, by Giovanni Tedesco —but they are faint and uncertain traits, leaving one undecided whether they be attributable to Roman influence or a mere inheritance from the Romanesque blunt-edged way of working marble.

The years spent in Rome by Donatello and Brunelleschi seem to have moulded the style of these two artists entirely anew, particularly that of the former. The citizens of Rome were more or less surprised at the persistency with which the two artists endeavoured to unearth fragments of old statues, and supposing them to be animated by a mere mercenary hope, that of finding some treasure, they called the two students *quelli del tesoro* (treasure-seekers). It is undeniably true that however profitable their search for old coins and marble relics, their copies and study of ancient art were in their sum total more valuable than the solid gold they brought back with them to Florence. The results are plainly visible in Brunelleschi's architecture and Donatello's sculpture, and the influence that their art exercised over their contemporaries and followers.

As we have said, after his sojourn in Rome, Donatello, particularly, seems to have immersed his art in a bath of past paganism. His art is no fakery, nor is it sheer plagiarism of the antique, but it is all permeated with Greek and Roman reminiscences, and comes at times so close to the Græco-Roman art that it misleads connoisseurs. Speaking of Donatello's art Louis Courajod, a well-known connoisseur, observes: "He entered so deeply into the spirit of antiquity, that some of his restorations of statues are very puzzling,

Imitation, Plagiarism and Faking 85

and it is difficult to distinguish his handiwork from that of the original."

In fact the famous horse's head of the Naples Museum was catalogued as a Greek bronze before it was recently attributed to Donatello or his school. No one can fail to draw a comparison between Donatello's *puttino* and the " Infant with the Goose," a typical example of Græco-Roman art.

One of the first to be affected by the new sentiment in art was Lorenzo Ghiberti. As a matter of fact Ghiberti not only became enamoured of the antique, but was seized by the passion of collecting the best antiques in marble and bronze. You may be sure that collectors of this calibre, unlike the Roman samples, talked very little of patina and a great deal of form, that their enthusiasm was of a higher alloy even than that of present-day collectors, who are rarely artists or even real lovers of art. Polycletus and Lysippus were Ghiberti's idols, and Greek art his worship ; for the era of Imperial Rome he had no enthusiasm. His cult for the Greek went so far as to induce him to reckon time by the Olympiads in his chronology. Instead of telling us that a certain artist died when Martin V was pope, or in the year so and so, Ghiberti states amazingly that the event took place in the 488th Olympiad ! It is not surprising that an artist like Ghiberti, and such a lover of Greek art as he was, should be able to classify Greek art at sight, to discriminate it from dubious Roman products and all the art that so closely resembles certain Greek periods.

That the worship of pagan art was practised by artists with no risk to themselves may be explained by the circumstance that the time of religious intolerance had passed. Intolerance, comprehensible perhaps in the early times of Constantine, when it was a crime for an artist to go to the forms of the past, had gradually sunk into tradition by the dawn of the new era which paved the way to the Renaissance in art and to humanistic tendencies, the most tolerant and unprejudiced period of past civilization.

86 Imitation, Plagiarism and Faking

Lovers of art in this period appear to possess a certain refinement of feeling that the Romans did not have, they stand more as friends to the artist, esteem him more, and thus their pursuit has a wider scope. Even Ghiberti, with all the restrictions placed on his taste by his infatuation for the antique, was, according to Vasari who describes his collection, no narrow specialist in the so much praised modern meaning of the word, namely, a collector who may be useful to the history of art and to knowledge at large, but who does not as a rule possess a spark of love for art or artistic feeling.

As is often the case to-day, the heirs of these old collectors were at times more greedy for money than a reputation for art. Many fine collections were scattered to the four winds, which was also the fate meted out to Ghiberti's collection by his relatives and heirs. Fortunately a few pieces of this stupendous collection have been saved: a fine torso of a Satyr can now be seen in the Uffizi. There are other pieces too that have come down to us, but the finest works, those attributed to Polycletus, among them a rare ornamented vase, are now lost.

The new artistic feeling perpetuated itself in architecture from Brunelleschi to Alberti. The latter built for Malatesta what purported to be a church, but which is in fact nothing but a temple to Love, which the tyrant of Rimini erected and dedicated to the memory of his lady-love, Isotta Atti. The revolution in sculpture effected by Donatello seems to be felt in Padua and Venice. Imitations of all sorts, and probably faked antiques, date from this time. It is difficult to decide whether Donatello's genuine pagan sentiment, his second artistic nature, was solely due to his passion or to a desire to accommodate the general taste for the antique; Italian artists are far too versatile. However that may be, he was no faker; the art of the faker flourished when imitators had lost all artistic personality, becoming mere craftsmen catering as usual to a momentary mania. Then was the time one saw Filarete indulging in most absurd medals and portraits

Imitation, Plagiarism and Faking 87

of dubious, very dubious, historical correctness; Riccio in Padua fabricating and flooding the market with charming little bronzes in which the imitation is so evident that it brings up the question as to what the art of Andrea Briesco (called *il Riccio*) might have been, had he chanced to be born at another epoch. Vellano also alternates fine pieces of work with little bronzes that must have been in great vogue with collectors of antiques. It is to be noted that the mania is not confined to Italy, it takes that country by storm because of its tremendous artistic activity and the fact that in art it is the foremost country of the time; but others were affected too. France is the first as being the nearest tributary to Italian supremacy in art. There are many examples of what we have said, but perhaps one of the most eloquent is the decoration of the castle of Gaillon, where there are some medallions with portraits of Roman emperors of a most mystifying character. Though the work of Italians of the end of the Quattrocento they were classified as antique (*antiqualles*) only a few years later, at the beginning of the sixteenth century.

An evident proof that Quattrocento imitations were not always directed by artistic fancy, but rather by the love of gain by means of fraud and fakery, is given by the fact that some of the statuettes imitating the antique were cast with broken limbs.

The Ambras collection of Vienna has one of these curious specimens—a charming figure, a female nude. This piece has evidently been cast without arms, the clay model having been mutilated before the form was taken for the cast. In the Prado of Madrid there is also a bronze statue of the Renaissance, possibly a cast from the antique, the peculiarity of which is that the arms have been added afterwards, as though in restoration. The metal of the arms is of a different alloy and the modelling of these parts purports to be of a much later date than the rest of the statue.

The first pieces to show a positive character of fakery are imitations of old coins and medals. Then small bronzes

88 Imitation, Plagiarism and Faking

called *plaquettes*, often *pastiches* of antique models, when not actually reproductions fron old cameos.

The Renaissance has also produced many bronze statuettes that seem to have had no other purpose than to take in the amateur—to gratify his demand for antiques by launching spurious products upon the market. The artists responsible for them represent what might be styled the aristocracy of fakers; there is nothing banal about them, their work is generally good, so much so that these imitations have now acquired a value *per se*.

Antonio Pollaiolo, the Florentine sculptor, is one of the most charming imitators of the antique. The Flute Player of the National Museum of Florence is perhaps one of the most convincing examples of this statement. Hercules and Antæus is also a remarkable work by this artist, though the other is superior on account of its simplicity. Of the Flute Player there are copies of the same period in the Cluny Museum and at Avignon. Curiously enough this statuette tempted even the pencil of Raphael, who reproduced it in a sketch-book now kept in the Academy of Venice.

As soon as he had left the goldsmith's shop, Andrea del Verrocchio started the early period of his activity in his new career as a sculptor, and made his way, according to Vasari, by casting small figures in bronze. We know very little of these small statuettes of Verrocchio's, beyond attribution, but, Vasari says, Verrocchio was tempted to make them while in Rome, because he saw how appreciated were antique statuettes, so much so that even fragments fetched fancy prices. Being an excellent craftsman with the chisel, and skilled in the casting of metals, Verrocchio would seem to have been fully equipped for catering to the demand of the amateurs of his time.

Vellano, in his imitations of the antique, seems at times to have even been tempted to counterfeit Egyptian art. His art in imitating is eclectic and most versatile.

Andrea Briesco seems to possess the brusque touch of some antique sculptors combined with the mania of Roman

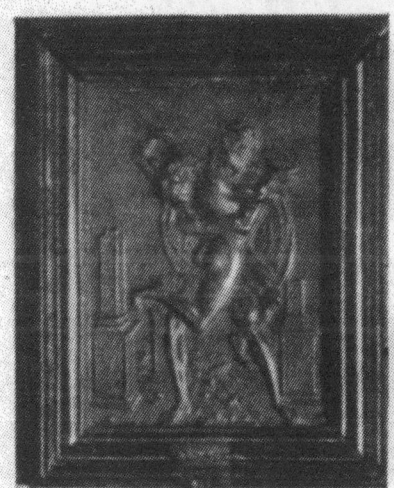
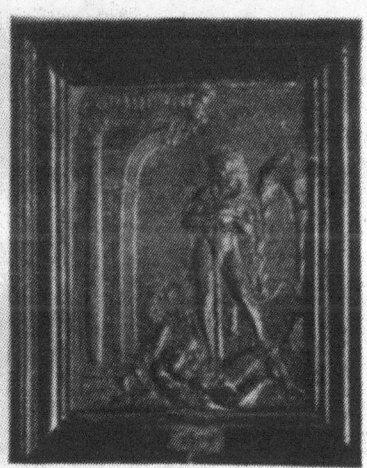

IMITATIONS OF THE ANTIQUE.

By Moderno, XVIth Century.

Imitation, Plagiarism and Faking 89

foppishness in over-draping his statuettes. They are invariably arrayed in gorgeous consular armour, elaborate togas, imperial sandals, and have, as a remarkable contrast, wild, vulgar faces in complete disharmony with the rich decoration of the costumes. However, when this artist models horses or simple nude figures he gets closer to the originals and is evidently an excellent and dangerous imitator. The bronzes of the Paduan school that may, with more or less certainty, be attributed to Riccio, are endless and in some of them the intention of faking is evident.

Jacopo Sansovino, the presumed author of the bronze statuette of Meleager of the Pourtales collection in Berlin, does not seem to take the trouble to disguise the origin of his plagium.

Michelangelo was too great a personality as an artist and too highly gifted to be tempted to hide his genius and waste his fine energies on imitation of the antique. Yet the story of his Sleeping Cupid, sold in Rome as an antique, is very instructive. Though well known it serves admirably to illustrate the character of the amateurs contemporary to the great sculptor. The anecdote casts a certain justified suspicion that the collectors of the Renaissance and early sixteenth century must have been duped on a larger scale than we are led to suppose from the scanty information we possess on the subject.

Vasari informs us that Michelangelo sculptured from a piece of marble a life-sized sleeping Cupid, that in this work he had imitated the antique to a surprising extent; so much so that when the work was shown to Lorenzo di Pierfrancesco de' Medici the latter advised the sculptor to send the work to Rome and sell it as an antique, as "by this means he could obtain a far better price." According to Vasari, the Cupid, marvellously arranged and coloured like an old piece of sculpture, was taken to Rome, buried in a vineyard and then "discovered" and sold as an antique to Cardinal San Giorgio, who paid 200 ducats for the work (a ducat was worth about 9s.). Vasari adds that the person who had acted as go-

90 Imitation, Plagiarism and Faking

between in the affair tried to cheat Michelangelo by saying that the Cardinal had only paid him 30 *scudi* (a scudi was worth about 4s.), and he then comments on the Cardinal's poor taste in not giving the Cupid due consideration after he had discovered that it was modern. He says: "Not recognizing the merit of the work, which consists in perfection, wherein the moderns are as good as the ancients," the Cardinal did not know how lucky he was to own a genuine work by Michelangelo in the place of heaven knows what poor product of some modest master of antiquity.

Condivi repeats the story, which has given ample food for popular fancy and folklore, adding that the irate Cardinal caused the man to be arrested and, giving him back the Cupid, claimed and received the sum paid for it.

The fact that Michelangelo, who went to Rome in the year 1496, wrote in July, 1496, to Lorenzo di Pierfrancesco de' Medici that he had paid a visit to the Cardinal di San Giorgio, shows that the prelate did not bear the artist a grudge for the joke. In this letter Michelangelo tells Lorenzo Medici that he has tried in vain to get the Cupid back from Baldassarre Milanese, the dealer and go-between in the affair of the Cardinal, but seeing that the man is obstinate in his refusal to give back the statue he has been advised to use Cardinal San Giorgio's authority.

Condivi says that in some unknown way this statue passed into the hands of Duke Valentino, and finally became the property of the Marchioness of Mantua, who owned it at the time Condivi, the historian and Michelangelo's pupil, was writing.

After the small statuettes, Roman busts are a source of some excellent imitations. Of these works, both in marble and bronze, many museums possess good examples. The Uffizi Gallery has two or three good ones; besides these the many restored busts and statues of this same Gallery speak of the characteristic pliability and plagiarism in art of the Renaissance. A fine bust in bronze of a hypothetical Roman emperor, formerly in the collection of Baron Davillier, is

Imitation, Plagiarism and Faking 91

now in the Louvre Museum. It is evidently the work of an artist of the versatile and prolific Paduan school.

This very school of Padua, strengthened by the advent of Vittore Camelio, Cavino, de Bassiano, and other capable fakers of art—we feel we need not scruple to use the word in association with these names—is chiefly responsible for those coins, medals and small bronzes that it would be naive to say were made solely for the sake of imitating.

The imitations of bas-reliefs prepared perhaps the popularity of those small bronze bas-reliefs called *plaquettes* which seem to have meant so much to the collector of the time. We even find the angelic Mino, the last Renaissance artist who should have attempted to paganize his sweetly ascetic art, trying his hand at these marble bas-reliefs of Roman emperors, re-edited for the benefit of amateurs. These bas-reliefs already seem to have inveigled artists into palming them off with fantastic tales, giving them what might be called a shampoo of history. In the Brunswick Museum there is a bas-relief in marble, evidently aping antique art, representing an Aristotle in an absurd pointed headgear and with the following inscription:—

ΑΡΙΣΤΟΤΕΛΗΣ
Ο ΑΡΙΣΤΟΣ ΤΟΝ (sic)
ΦΙΛΟΣΟΦΩΝ

A replica of this bronze belonged to Charles Timbal's collection, and is now in the possession of Monsieur Gustave Dreyfus; a third, with an identical inscription, is kept in the Modena Museum; a fourth is in the Correr Museum of Venice; and, finally, a fifth sample of this fantastic Aristotle is in the National Museum, the Bargello of Florence.

It is certain that there was a companion-piece to this Aristotle, the portrait of Plato, which has come down to us in material other than bronze, but which must have once been the pendant of the Aristotle, as there are clay reproductions of both portraits, the Aristotle being identical to

the ones already quoted. Of Plato there are several bas-reliefs in marble, one in the Bavarian Museum of Munich, another in the Museum of Arezzo, and another in the Prado. In the latter museum there is also an Aristotle in marble with its freakish head-covering, long hair and a long beard; of Plato there are two marble bas-reliefs, two medallions. In the larger one there is the inscription:—

ΠΛΑΤΩΝΟΣ ΑΘΗΝΑΙΟΥ

A curious fact to be noticed is that of these two portraits Aristotle's must have caught public fancy more than that of his philosophical companion. Not only because of the numerous reproductions of the one original but because it must have been popular already in the time of Louis XII, being reproduced in clay in a medallion of the castle of Alluye at Blois. In this race for popularity in a foreign country and from a spurious origin, Plato seems to have lost nearly half a century, as we find a reproduction in the castle of Ecouen about the middle of the sixteenth century, which landed finally in the Museum of French Monuments, where Baltard renamed it as the portrait of Jean Bullant. No strange transition when one considers that a cast of the original Plato was, for quite a long time, shown in the Louvre as the portrait of Philibert Delorme.

The Louvre has a queer marble medallion, a work of the beginning of the sixteenth century, of a Roman *Imperator Caldusius*, and a medallion of Cato is now in the Museum of Beauvais.

When Vespasiano da Bisticci tells us that Niccoli " had in his house an infinite number of medals in bronze and silver and gold, and many antique brass figures, and many marble heads, and other valuable things," we can believe that they were genuine, but when it is a question of a later collection of old marble heads, bas-reliefs and medals, we wonder how many an Emperor Caldusius it contained.

This curious trade in and mania for *pastiche* was assisted, it must be added, by the tremendous skill that the artists

Imitation, Plagiarism and Faking 93

of all periods of the Renaissance seem to have possessed in moulding, recasting, and composing one piece from two or three originals.

We know that Verrocchio used to make plaster casts of living people, and the custom of making bust portraits and medallions from death masks was quite common in the Quattrocento and later. Such post-mortem reproductions were often ably disguised by the modelling stick, while at other times they showed only too plainly their ghastly origin.

A regular riot of fakery, combined with the most fantastic metamorphoses of Greek and Roman originals, existed for the benefit of crazy numismatists, greedy collectors of medals and amateurs with a fancy for small bronze bas-reliefs. In the fifteenth and sixteenth centuries the imitation of coins was most varied; some are quite excellent reproductions of the antique ones, others again show the art and style of the artist and his period but faintly disguised. Some of these latter are at any rate charming works of art. The coins, medals and small bronzes seem to emphasize the Renaissance mania for the antique. Now, for instance, after giving the portrait of Adam, Eve, Noah and Ham, Shem and Japhet, the *Promptuarium iconum insigniorum a seculo hominum*, published in Lyons by Guillaume Reville (1553), gives other engravings purporting to be authentic portraits of various personages of antiquity. As a matter of fact many of these portraits are copied from old medals that were circulating at the time, the work of the fifteenth and sixteenth centuries. Mr. Courajod, the former curator of the Louvre Museum, was able to prove this by finding some of the medals from which the portraits of the *Promptuarium iconum* had been copied. These portray Antigone, the lieutenant of Alexander the Great, the king of Phrygia, Lysimachus, king of Thrace. The first, an Italian bronze of the fifteenth century, is characteristic for the effort made by the artist to counterfeit the Oriental style he may have noticed, perhaps, in other coins of the time.

But, as we have said, where the fancy of the faker really

ran riot was in those small bronzes of various origin and still more various purpose, nowadays called *plaquettes*. These bronzes were sometimes cast from the form of an old cameo, at others they imitated or aped a like origin, and whether they may have been used as buttons, pommels of the hilts of swords, or simply been demanded by collectors, they were for the most part imitations of the antique. In these works the metamorphoses of the original are at times so numerous and so absurd as to puzzle the modern collector and cause him to speculate on the acumen of some of the connoisseurs of the past. With some of these small bronzes the metamorphosis is not in the form but in the inscription that sometimes accompanies the *plaquette*, but on other occasions the subject and the figures are considerably altered. As an example of the former we may quote the supposed portrait of Julius Cæsar of the Courajod collection. In this case the *plaquette* bears the inscription " IVLLIVS C. . PP . PM., which has caused the wrong naming of this bas-relief, for an identical *plaquette*, formerly in the collection of Mr. Bardini of Florence, seems to indicate that it must be a question of Cicero. The second inscription runs thus, "M. TVLLIVS .C.P.P.P.M."

As for the second method, the alteration of the form and subject of a *plaquette*, the fancy displayed by the makers borders upon the grotesque.

To begin with a mild form of metamorphosis, let us follow the subject of Apollo and Marsyas in its transformation from the original cameo that was in the collection of Lorenzo il Magnifico and, according to Muntz, is now in the Naples Museum, together with many others from the same collection. In this cameo the god is on the right, playing the lyre held in his left hand, Marsyas to the left has his hands tied behind him, between the two figures kneels Olympus (a pupil of Marsyas) interceding for his doomed master.

The supposed original in the Naples Museum bears but one inscription, "LAVR MED.," evidently standing for Lorenzo Medici, but Ghiberti tells us that on this cornelian " around the said figures were *antique* letters spelling the name of

Imitation, Plagiarism and Faking 95

Nero." There is nothing strange in this, nor in the presupposition that the cameo had been Nero's private seal, as one knows he was fond of playing the lyre, but what casts some doubt on the authenticity of the Naples cornelian stone is the fact that the Berlin Museum possesses a bronze *plaquette*, evidently a reproduction from some antique cameo, with the inscription to which Ghiberti alludes, "NERO–AVGVSTVS–GERMANICVS–P–M–TR–P–IMP–PP–." The cornelian stone kept in the Naples Museum has no inscription and for this reason is supposed by some to be a reproduction from the original ordered by Lorenzo Medici. The *plaquette* of the Berlin collection is thought to be cast from the original Greek cornelian stone, though there are other reproductions in various museums, one for instance in the Louvre very similar to the one of Berlin, another in the collection of Courajod, with the inscription, "PRUDENTIA. PURITAS. TERTIOM. QVOD. IGNORO." Mr. Courajod also owned two more copies of this subject, one similar to the one of the Louvre with the addition of a border, the other of larger dimensions with the figure resting on a ground in the form of a crescent. A bas-relief of this subject, used as an ornament of the pommel of a sword hilt and very similar to the other *plaquettes* was in the Davillier collection. N. Schlifer and Giovanni Boldu (1457) treated the favourite subject with a certain plagiarism of the Greek model. In Boldu's bas-relief Apollo is in the usual attitude, but the other figure has disappeared.

There are many other *plaquettes*, with small variations, in private collections. There is also a *plaquette* of this subject in the Dreyfus collection, in which Apollo has become a woman and Marsyas is playing the flute.

Evidently the subject must not only have been popular among collectors but must have caught the fancy of artists as the composition of Apollo and Marsyas is reproduced in a bas-relief of a fine door formerly in Cremona and now in the Louvre Museum. The one at Naples is repeated almost identically in a cornelian of the *Cabinet des Medailles*, in a portrait of a young girl, attributed to Botticelli, in the

96 Imitation, Plagiarism and Faking

Staedel Museum of Frankfurt; on the frontispiece of a work executed for Mathias Corvinus; on a frontispiece of the Sforziade, that rare work kept in the library of the Riccardi in Florence; on a majolica dish of the fifteenth century, now in the Correr Museum in Venice. There is a plagiarism of this subject in a work by Raphael in the Vatican.

The following examples, however, are perhaps more typical of an intentional transformation, a somewhat reversed case and an exception to the rule in this sort of faking, namely a Christian subject turned into a pagan one for the benefit of the fifteenth-century amateurs. There still exist in San Pietro in Vincoli in Rome, two bas-reliefs representing two incidents in the life of the saint who has given the church its name, one when he is arrested and put to prison, the other when he is chained in his cell and liberated by the angels. The two bas-reliefs, wrongly attributed to Pollaiolo, were ordered from some Roman artist in the year 1477 by Sixtus IV, then a simple cardinal. Of each of these bas-reliefs there is a modified reproduction, one in the Louvre and the other in the Victoria and Albert Museum, and the modifications of both are such as to make people believe them to be pagan subjects and antique work. In the reproduction kept in the Louvre the transformation of the subject without much alteration of the work is so evident that we can see how easily old collectors were taken in by these curious pieces of *truquage*. Of a more naive, but no less efficient character is the transformation inflicted upon the bas-relief of Kensington. Here in order to transform the miraculous liberation of Saint Peter into the freeing of a Roman senator it has sufficed to clip the angel's wings, both inside the prison—the work being divided into two different moments of the action—and where the saints usher the apostle into the street.

There is no reason to disbelieve the supposition that this piece of faking was perpetrated to cater for the mania of the art lover of the time. As a matter of fact the Louvre bas-relief was considered an antique till but recently, and that of the Victoria and Albert Museum, which entered the collec-

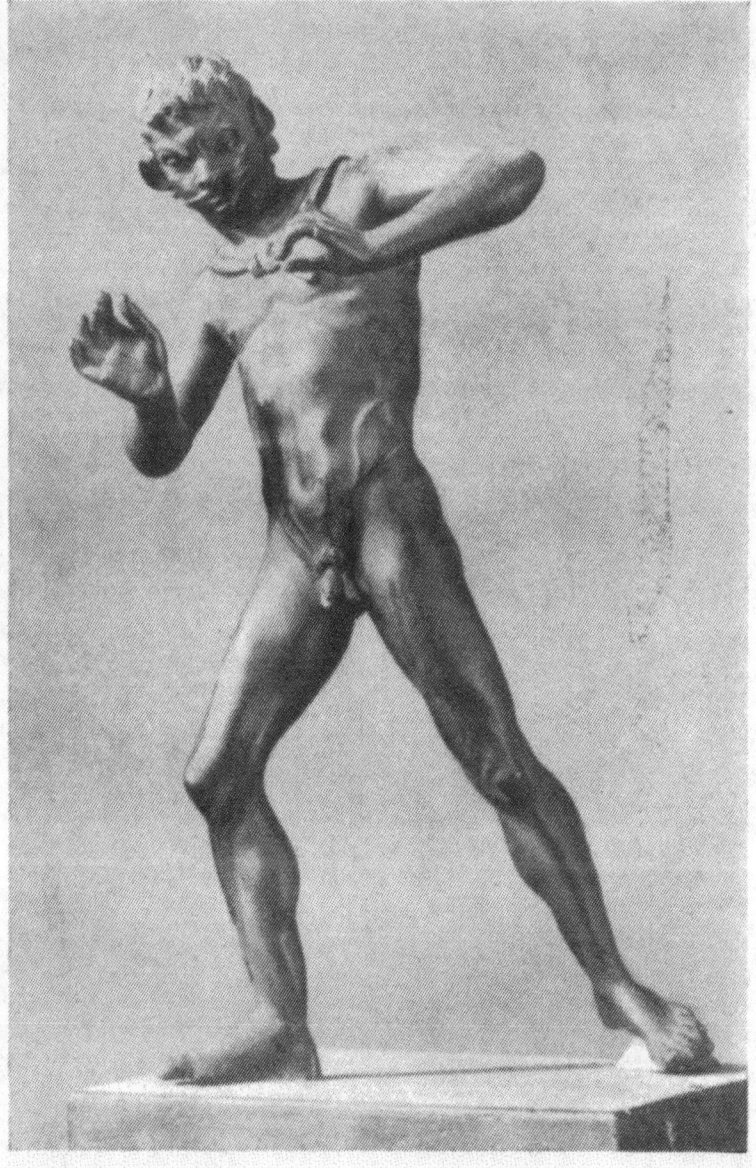

MARSYAS.

An excellent work by Pollaiolo after the antique.

Imitation, Plagiarism and Faking

tion wrongly labelled as the work of Ghiberti, was believed, before 1863, when it was acquired by the Museum, to be a work of the classic Græco-Roman period. As for over three centuries they have passed as genuine work of the Roman Empire, it is not reasonable to suppose that the amateurs of the time were wiser than the succeeding generations of connoisseurs who believed the work to be antique. This fact is eloquently brought out in the case of the work preserved in the Louvre, as this bas-relief was not hidden but has quite a long and well-established pedigree. Among other migrations we can trace it to Malmaison in a sort of select collection of objects coming from Italy. Edme Durand bought it as an antique and in the belief that it was antique kept it in his collection. The Louvre Museum also bought it for an antique and for quite a long time classified it in the catalogue (N. 280) as an Etruscan bronze.

It would take too long to trace all the transformations of small bronzes made for the benefit of the fifteenth and sixteenth-century amateurs, the many reproductions with changes. Of the metamorphoses to which *plaquettes* were subject we can mention another curious example in which a Crucifixion has become a Rape of the Sabines, and as a case in which a popular subject has caused many reproductions, we quote the Palladium of the Niccoli collection which has been reproduced by Donatello, Nicolo Florentino, etc. The statue of Marcus Aurelius also seems to have been a cherished subject for small statuettes from that by Filarete given to Piero Medici in the year 1465 to reproductions of the seventeenth century.

Of all the workmen of that fertile period running between the fifteenth and sixteenth centuries, Moderno was the most active and versatile. There is hardly a mythological subject that has not been treated by him. His imitation of the antique is at times quite convincing, more especially that belonging to the early period of his career. Later on when he enters into what might be styled his matured sixteenth-century temperament, he seems to suffer from the same trouble as

98 Imitation, Plagiarism and Faking

the imitators of the first third of the said century, namely, over-polish and mannerism, which must in fact have been considered an improvement in imitation. Valerio Belli, a sculptor and famous cutter of precious stones and rock crystal, was quite justified in reproducing the subject of his own carving in the small bronze bas-reliefs that now play such an important part in modern collections of *plaquettes*, and which in times gone by must have been the delight also of past collectors. They often bore his signature, which speaks eloquently for the fact that there was no intention to dupe anyone.

There were also other artists who evidently had a hand in faking antiques. They belong more or less to various schools, but chiefly to those of Padua and Venice. The Paduan school is in this respect fortified by the names of Vittore Camelio, Cavino, Bassiano. Almost every bronze founder is associated with an imitator of the antique, either a maker of statuettes, inkstands, perfume vases, or *plaquettes* of various sizes and use. Thus for a second time Italy became a gorgeous market of imitation, very often in itself such good art as to be worthier than the art counterfeited. One of the last of these imitators was Tiziano Aspetti, to whom, rightly or wrongly, small bronzes of private collections are attributed.

From the Anonimo Morelliano one gathers that there was a period in which a gentleman could hardly afford to do without a little collection of antiques. "The bronze figurines are modern by various masters and are derived from the antique," remarks this Anonimo of Morelli, as though explaining that there were some collectors perfectly satisfied with this and perhaps the silent accomplices of a fine piece of faking. The Anonimo tells us that there were many such pieces in the collections of either ignorant or accommodating collectors and art lovers, in the house of Marco Bonavido of Padua, and that of a rich merchant of the same city, the sculptor Alviso; in Venice, in the collections of Odoni and Zuanno Ram. They are often mingled with genuine antiques, which fact causes the Anonimo, who evidently thinks himself either a con-

Imitation, Plagiarism and Faking 99

noisseur or a well-informed chronicler, to say here and there, " the many bronze figurines are modern," or " the many medals are of modern bronze," or " the medals are most of them antique." Precious confessions, as one can see.

We know but vaguely of imitations in painting, but an assembly of such versatile artists can hardly have refrained from imitating the work of some master. Besides, the very teacher at the head of a school did not seem to resent it even if a pupil signed the name of his master. But as regards imitating the antique, there were hardly any samples to imitate. The grotesques of the old Roman ruins may have suggested to more than one artist a new type of decoration; but this plagiarism, if it can be called so, though not without influence on fifteenth and sixteenth-century art, found no practical issue with fakers.

There is, however, an incident in which a piece of faking saved to Florence a masterpiece of Raphael. It is related by Vasari in Andrea del Sarto's life. According to Vasari when Frederick II, Duke of Mantua, came to Florence he greatly admired the portrait of Pope Leo X, the magnificent painting now hanging in the Gallery of the Pitti Palace in Florence. His admiration turned to such greedy desire of possession that when he reached Rome he begged the then all-powerful Clement VII to procure it for him. The Pope agreed to the Duke's request and ordered Ottaviano Medici, then residing in Florence, to have the painting packed and sent to Mantua to Duke Frederick. Ottaviano Medici, a lover of art and a Florentine, hating to deprive his city of such a work, was yet not inclined to resist the wish of the Pope and resorted to a ruse. He informed the Pope that the painting should be sent to the Duke, according to His Holiness' orders, as soon as the frame had been repaired. The Duke of Mantua was also informed that the frame needed regilding and that the painting should be shipped as soon as the repairs were finished. With this excuse Ottaviano Medici gained the necessary time and ordered from Andrea del Sarto an exact copy of Raphael's work, a copy that all experts would

Imitation, Plagiarism and Faking

mistake for the original. The work was done to such perfection that even Ottaviano Medici, who was an art connoisseur, could not tell the original from the copy: the pseudo-Raphael was sent off, the Duke was duped and one of the finest portraits by Raphael was saved to Florence. In Vasari there are comments here and there which lead us to think that many others may have been duped by the versatility of the fifteenth and sixteenth-century painters. We know that Bellini's pupils finished three-quarters of some of the great Venetian master's works, that Calchar imitated Titian so closely as to be taken for the great Vecelli, but we do not know to what extent lovers of art of the time may have been duped.

As for sculpture, we may close this study by quoting what Vasari writes in the life of Vellano. "So great is the power of counterfeiting with love and care any object, that, more often than not, if the style of one of these arts of ours be well imitated by those who delight in the work of whoever it be, the thing that imitates so closely resembles the thing imitated, that no difference can be detected, except by the most experienced eye."

Of Ghiberti, a collector and versatile sculptor, Vasari tells that "he took much pleasure in imitating the dies of ancient coins and medals." Which comment amply justifies the observation that the learned Milanesi adds to the life of Valerio Belli, who at times, according to Vasari, forgot to add his signature, and was extremely clever in counterfeiting antiques, from which ability "he derived very great benefit."

"Antique medals," says Milanesi, "were very much in demand about this time, consequently forgers and imitators abounded; they had in fact multiplied to great numbers and fostered the art of counterfeiting to its highest perfection."

CHAPTER IX

COLLECTORS OF THE SIXTEENTH CENTURY

Collectors of the sixteenth century—Character of the time and the artist's attitude towards the antique—Cellini restores antique statues—New Roman masterpiece discovered in Rome—Decadence of art—A protest of Raphael against daily destructions of Roman relics—First laws prohibiting exportation of Roman finds—Barbaric attitude of a Barberini—First law against the exportation of painting masterpieces.

As we have already observed, centuries in art cannot be separated like horses in stable-boxes. There are periods between one change and another, transitional times that make it impossible to fix any date whatsoever. Thus we may say, without stating a date, that the sixteenth century not only felt the benefit of the Quattrocento for a certain time, but was itself actually Quattrocento for a score of years or more. The men of the past had not vanished; Riccio, for instance, one of the most active imitators of the antique, died in 1533. But when the sixteenth century began to outline its own character, the cult of art, art patronage and the passion for collecting fine things are seen to have taken another turn. The Cinquecento has of course magnificent patrons of art, and almost every prince collects something or other. Life is still imbued with partiality for the antique.

Lorenzino Medici in playing Brutus and actually killing his cousin, Duke Alexander Medici, is reconstructing an old heroic attitude in his learned, pagan mind; Filippo Strozzi —or whoever planned his suicide—makes one think of some hero of Plutarch when he is found dead, apparently by his own hand, with a line of Virgil, *Exoriare aliquis nostris ex*

ossibus ultur (may an avenger arise from my bones), written in his own blood at his side. Painting still deals with subjects from Roman history and so does sculpture, but artists have lost all comprehension of them, a fact still more evident with regard to Biblical subjects. In support of this statement it is sufficient to quote the painting of Paolo Veronese, now in the Academy at Venice, representing Jesus in the house of Levi, one of the artist's masterpieces, in which Christ is in the company of—Venetian gentlemen of the sixteenth century; but if in this painting disregard for the Oriental side of the scene is carried to an extreme, it must be said that Titian and Tintoretto, and a great many other painters of the time, were no better. This trait, which certainly originated in the good period of the Renaissance and which we now find in its full development, indicates that in its more significant and ripest expression the Cinquecento is the logical decline of a past triumph in art, the victim, as it were, of tradition—of tradition and a few artistic personalities, such as Raphael and Michelangelo, who turned a new leaf in art, awakened a new feeling, a new overpowering school. Michelangelo, especially, with his fascinating and inimitable style draws a legion of followers, fostering an art that during the great sculptor's life already is ripe for decadence.

Enlightened collectors abound in this period, their collections increase daily, but are they really lovers of art as their predecessors were, are they worshippers of the antique like the bygone collectors? This is what we ask. In the sixteenth century when art is a tradition of the far past, on the one hand, and on the other, almost a tradition of the recent past, life seems to have taken the selfsame attitude: people are not real lovers of art, but are so merely by tradition. Every well-bred gentleman of the Cinquecento was obliged to have the air of understanding art. Machiavelli might have added an interesting chapter to his *Principe* to demonstrate how important it was for a prince to be interested in art, even though, perchance, utterly indifferent to it in reality. When giving

Collectors of Sixteenth Century 103

instructions in his *Cortegiano*, as to what a gentleman of his time ought to know, Castiglione adds that he must learn to paint. "Even if this art affords you no pleasure," advises Castiglione, "it will give you a better understanding of things, and a clearer appreciation of the excellency of ancient and modern statues, vases, monuments, medals, cameos, carvings, and other such objects."

In a word, ably or otherwise, with natural disposition or not, it was part of good breeding for a gentleman of the sixteenth century to be interested in art and play the connoisseur. It is from this that the Cinquecento suffers. The patent prince-patron of art, the stock gentleman-collector abounds, the genuine lover of art is rare. A prince's house or that of a simple person of good standing was considered incomplete if without a collection of some sort. Yet while the artists of the sixteenth century had certainly derived no small benefit from their predecessors' passion for the antique, they had become far too individual, far too engrossed in their own art to be susceptible to the art of the past. Michelangelo, the artist who lived practically through both centuries, the sculptor whose genius, tremendous and over-individual, was nevertheless responsible for the decadence of sculpture, is a good example of this. He can, like many another Italian artist, show his versatility and skill by imitating an art other than his own, as he did with the Sleeping Cupid that deceived Cardinal San Giorgio, but when the artist is genuine and gives his own artistic temperament full play, craft and virtuosity disappear, reminiscence is impossible. Even when the subject and peculiar quality of the work suggest imitation and turn thought to the antique, Michelangelo remains true to his own grand soul. His Brutus exemplifies the point. It was a Roman subject of classical times, and Michelangelo might easily have been infected by the history of the past and the forms he had admired when interested in the excavation of ancient statues in Rome. Yet his Brutus is more Dantesque in its tragic lines than Roman.

Cellini, to illustrate another aspect, is a different case.

He can repair antiquities for his patron, Cosimo Medici, fairly well, but he, also, is too highly individual to make an excellent imitation of the antique. He tells us that he consented to repair his illustrious patron's Ganymede because it was a fine Greek work, and, prone as he is to self-praise, he tells how stupendously he can do it; but he does not like such work, he calls it *arte da Ciabattini* (cobbler-work). The fact, however, is that he is too much alive to his time, has too strong an expression of his own art to be skilful in imitations. In fact it happened that he had to try his hand at a portrait of Cosimo I, in the guise of a Roman emperor. The portrait of the Grand Duke of Tuscany will never deceive any art simpleton, in spite of its elaborate cuirass fit for Augustus. Cellini is too delightfully cinquecentesque. The same may be said of him as a medallist. Yet in some of Cellini's work, especially his medals, the idea of imitating the Romans must have been in his mind, and no doubt he was convinced of his success. Yet he belonged to the group that by their personality influenced others, and when trying his hand at imitation quite congenial to his own artistic temperament he makes something that is at least three-quarters Cellini.

These artists nevertheless admire the art of the past, though with no danger of infection. Michelangelo is entranced when the *Laocoön* is discovered in a vineyard near the Thermæ of Titus, and goes with his friend Sangallo to see that the precious statue be carefully unearthed. Partly for the sake of gain, and partly, maybe, for the love of art, Cellini often goes to the Roman Campagna to see what "certain Lombard yokels" have uncovered in their daily spading of the soil. Raphael protests, in a famous document addressed to Leo X, against the continual destruction of Roman relics. His words are worth repeating. After declaring that the Goths and Vandals have not done so much damage to Rome as his contemporaries, Raphael concludes by saying that far too many popes have allowed Roman edifices to be ruined simply by permitting the excavation

Collectors of Sixteenth Century 105

of *pozzolana* (clay) from the ground upon which their foundations rest, that statues and marble ornaments are daily burned in ovens and turned into mortar, that Rome, in fact—the Rome of Raphael's time—is built with naught but mortar made from old statues, the sacred marbles of past glories.

Characteristic also is the fact that this country sees the first protective laws against the exportation of antique art. This would seem to indicate the consideration in which relics of past art were held in Rome. Judging by the way it was applied, however, even this act serves to show that there was no more genuine a passion for old and precious antiques in the Cinquecento than in the century before. The Roman laws of the sixteenth century are severe, meting out punishments to all and sundry daring to carry the produce of excavations beyond the Papal domains; but otherwise destruction goes on gaily, there seems to be no discrimination as to what ought to be saved from the doom of destruction and what is not worth keeping. So while edict after edict is promulgated in order to safeguard the excavation of statues in Rome and elsewhere, edicts often full of old-fashioned magniloquence, "Prohibition concerning the exportation of marble or metal statues, figures, antiquities and suchlike," the best buildings in Rome were allowed to fall into utter ruin without a protest. This state of things reached the climax of absurdity in the seventeenth century when Urban VIII, of the Barberini family, declared the Coliseum a public quarry, where the citizens might go for the stones they needed for new constructions—an act still commemorated in the protest of all lovers of art with the proverbial pun, *Quod non fecerunt barbari fecerunt Barberini* (What barbarians did not do, the Barberini did).

From this curious inconsistency in the appreciation of art even Tuscany, the cradle of the Renaissance, is not immune. A Medicean law intended, like the Roman one, to prevent the exportation of masterpieces and rare works of art, makes no mention of precious relics of Roman or Etruscan origin,

106 Collectors of Sixteenth Century

nor even of the fine pieces of sculpture that were often excavated, but considers only the paintings of certain artists of the past school of the Renaissance and those of other contemporary artists, as being worth keeping, so the law declares, for the glory and dignity of Florence. The regulations are given in a second decree, along with a list of the names of the artists concerned, dead and living. Their work must not be taken out of Tuscany. The list is very instructive, for it passes over some of the best artists, such as Botticelli, Credi, the Pollaiolos and others, and prohibits the export of the work of artists that are either unknown to us or are of such mediocrity that it is surprising their work should have been esteemed above the average of their day. The following is one of these lists, the first that was made. 1. Michelangelo Buonarroti. 2. Raffaelo da Urbino. 3. Andrea del Sarto. 4. Mecherino (?). 5. Il Rosso Fiorentino. 6. Leonardo da Vinci. 7. Il Franciabigio. 8. Perino del Vaga. 9. Jacopo da Puntormo. 10. Tiziano. 11. Francesco Salviati. 12. Angelo Bronzino. 13. Daniello da Volterra. 14. Fra Bartolommeo di San Marco (Della Porta). 15. Fra Bast. Del Piombo. 16. Filippo di Fra Filippo. 17. Antonio da Correggio. 18. Il Parmigianino.

Without insisting upon a comment that might appear paradoxical, what kind of collectors of art can be expected from people who place in the same list of merit Leonardo, Michelangelo, Titian, with Cecchin Salviati, Perino del Vaga, to say nothing of the now forgotten Mecherino, a painter whose well-deserved oblivion saves us from judging his poor work. In another list other names are added. They are no less grotesque—Santi di Tito Ligozzi, Jacopo da Empoli, etc, in far too good company.

CHAPTER X

COLLECTING IN FRANCE AND ENGLAND

Passion for collecting art travels to France—The Florentine Republic and the fate of a statuette by Michelangelo—Italy supplies antiques to France and other countries—The fair of Frankfurt—A famous sale—In England the passion for collecting art and curios may have originated in France.

WHILE the passion in Italy for collections of art still goes on enriching museums more through the impetus of the past than from a genuine cult, and produces occasionally, together with many illustrious patrons of contemporary art, some old type of collector fond of the antique with the characteristic greed for all kinds of rarities, France, and later almost every other nation of Europe, awakens to the passion for art and curios. It is no longer a question of monarchs and princes, as was the case in Italy, nobles and the bourgeois as well come to the fore. Even at the beginning of the sixteenth century, France may quote the names of Grolier and Robertet, both financiers employed at Court, both lovers of fine things. The former is a specialist in rare editions and fine bindings, the latter a keen-eyed, eclectic collector, as may be gathered from the inventory of his excellent collection kept in his castle of Bury.

It must be said, however, that Italy still remains a sort of El Dorado of fine art and the inexhaustible mine to which collectors come for their finds. The French had discovered this fact from the time they came to Italy with Charles VIII. Later on Grolier visits Italy and takes back with him some of its treasures. When he has no opportunity to come to Italy himself, his friends and agents continue the search for him; they know his taste and his speciality and are very

alert in the hunt for fine and rare editions. Robertet bargained with the Florentine Republic to exchange his political influence for a statuette by Michelangelo. The Republic had great interest in remaining friends with the French monarch and accepted the bargain, and as the statuette had been left unfinished by Michelangelo, who had moved to Rome by this time, Benedetto da Rovezzano is charged to finish the work and cast it. This statuette of a David was placed by Robertet in the *cour d'honneur* of his castle and afterwards, in the year 1633, removed to the castle of Villeroy, and it is now lost. Only a design of this statue, by the great Michelangelo, is now in the Louvre Museum, and from this we can gather how the statue looked.

What was not bought was carried away from Italy after the fashion of the old Roman conquerors. In the year 1527 a ship arrived at Valencia loaded with artistic and valuable booty from the famous "Sack of Rome." Curiously enough, considering the age, the Spanish municipal authorities of Valencia did not grant the vessel permission to unload her cargo. This fact, quoted by Baron Davillier in his *Histoire des faïences hispano-moresques*, is commented on by Edmond Bonnaffé, a French collector of our times, thus: "I love to think that the captain changed his course and found more hospitable municipalities on the French coast."

The rich artistic booty promised by Italy made it almost obligatory for an orthodox French amateur to undertake a journey to Italy. It is surprising that the *Voyages de Montaigne en Allemande et en Italie*, 1580–81, makes no allusion to this fad and contains very few comments on art. However rich Montaigne's work may be in valuable observations on the life of the time, we should nevertheless have desired him to have a touch of the art lover in him, a leaning to the artistic and beautiful, and we would willingly have exchanged a few words with him on the art and collections of art in the Italy of his day, instead of his long, detailed descriptions of his cures and his eternal search for medicinal springs, etc.

An important annual meeting, one that the true collector was likely to visit, was the fair of Frankfurt. According to H. Estienne this must have been one of the most frequented art markets of Europe. Italy, says Estienne, contributed all kinds of antiques, faiences, old medals, books and brocades; Germany furnished wrought iron and artistic prints, Flanders sent tapestry, Milan its fine arms, Venice goods from the East. Estienne also states that Spain used to send to this fair American products, weapons, costumes, shells and silver-work.

It was not a market exclusively for the genuine, as copies and imitations were to be found there for the economical or the foolish, easily duped amateur. Above all there were those deplorable casts from fine originals that have ever since deceived so many collectors and which so enraged the good Palissy, who laments the fact and stigmatizes it with the saying that it cheapens and offends sculpture, "*mespris en la sculpture à cause de la meulerie.*"

This glimpse of the creation of a market of antique art and bric-à-bracs of high quality would not be complete without some typical sale of a famous collection. Among others that took place towards the end of the sixteenth century, we may quote a notable one, the sale of Claude Gouffier ("Seigneir de Boisy," duc de Reannes and Grand-Écuyer de France), an intelligent gentleman who, with his mother Hélène de Hargest-Genlis, is responsible for one of the finest types of French pottery, the faience d'Oiron. Besides spending considerable sums of money on the factory of this ware, Gouffier was such a liberal patron of art and artists that he ruined himself in the gratification of his noble passion. At his death the creditors seized upon his rare collections and *objets de virtu* and put them up to auction. This sale was not only the artistic event of the day but, perhaps, the most important sale of the second half of the sixteenth century. All Paris of the time seems to have been there. Plates, paintings, works of art, bibelots, *toute la curiosité*, passed mercilessly under the hammer of the

auctioneer—which by the way was not a hammer, a usage originating in England, but as a rule a *barguette*, a small rod, with which the auctioneer struck a metal bowl. Nothing was spared by the creditors, even the wearing apparel and furs of the deceased were offered to the highest bidder. Of these, strange to say, the Duke d'Aumule (Claude de Lorrain, third son of Claude, first Duc de Guise) bought a second-hand *manteau de cerimonie* with the evident intention of wearing it at Court. By a curious coincidence, this sale took place only twenty-five days after the tragic night of St. Bartholomew (September, 18th, 1572), an event that did not prevent Catherine de Médicis from appearing at the sale with her ladies-in-waiting, to dispute with other buyers the spoils of the deceased gentleman.

One of the conspicuous buyers at this auction was a Florentine living in Paris, Luigi Ghiacceti, called by the Frenchmen *le seigneur d'Adjacet* or *d'Adjoute*. Beside "*ung harnois d'homme d'armes complect, gravé et dorré à moresque*" he bought many other things, the portrait of Henry II and also "sixty pictures painted in oils." This Florentine was not only an esteemed collector of his time, but a man of taste who had built one of the finest mansions in Paris, which he showed to visitors, together with his fine museum, "for a sou," so says Sauval, the chronicler quoted above.

While France appears to have been the first country to follow Italy in the artistic movement, about this time, as we have said, all European nations had more or less perfected their taste and acquired the love for art collecting. The English invasion of France is perhaps responsible for the awakening of this passion in England. Warton (*Hist. of Poetry*, II, 254) is of the opinion that after the battle of Cressy (1346) the victorious army brought home such treasures that there was not a family in England, modest though it might be, that did not own some part of the precious booty, furniture, furs, silk stuffs, tapestries, silver and gold works, etc., the pillage of the French cities.

More than two centuries later, part of this artistic booty

Collecting in France and England

may have come back to France. Gilles Corrozet tells us that on the Mégisserie, the quay constructed by Francis I, where artistic sales usually took place, "in the year one thousand five hundred and fifty, in the month of August, there were publicly sold in the Mégisserie several images, altar-pieces, paintings and other church ornaments, which had been brought and saved from the churches of England."

Imitation and faking do not seem to find suitable patrons at this time. Collectors are cold and methodical, and a well-established commerce in antiques, an abundance of objects offered for sale, seem to have precluded a demand for other fakes than those of the past, and a few clumsy imitations. The imitations of this period are hardly convincing. Restorers of the antique were without skill, which fact plainly tells that their patrons were not excessively particular. They were satisfied with a Roman bust, repaired by a sculptor who does not give himself the trouble to disguise his own art.

About the time of which we are speaking, that is to say when the merits and demerits of the sixteenth century had delineated themselves and had reached the summit of the curve that anticipates decline, the work of Michelangelo, Raphael and a few others—if there were any others of that calibre—produced their natural effect. To be a sculptor meant to copy all the defects of Michelangelo, to indulge in over-ripe forms, turgid muscles and exuberance in general; to be a painter did not mean so much servility because Raphael's influence was less extended, but very few escaped imitating or recalling the painting of the fine master of Urbino, more especially as the public was naturally attached to Raphaelite traditions. This was so much the case that not only was Giulio Romano accepted, and a legion of other painters who aimed more or less successfully to imitate Raphael, but later the honour that should have belonged to Raphael was given to Sogliani simply because he had deceived the public by his craft and virtuosity, winning the name of Raphael reincarnated. In our opinion, part of the

energy that was keenly given in olden times to the imitation of the antique was now bestowed on "faking."

It is true that France was coming to the fore about the middle of the sixteenth century with indisputable superiority in art, while Italy turns to inevitable decadence. France had had a "school of Fontainebleau" disposed to exercise the tyranny of genius, but Rosso was not Raphael, and the Italian influence, though of great benefit to the French school, was, after all, a mere passing incident in the course of art in that country. Yet it is surprising that even in France, at a moment when the mania for collecting art was on the increase, the collector does not seem to have been either victimized or annoyed by faking.

It must be said though, with Edmond Bonnaffé, that "the French buyers were regarded somewhat as novices, and everyone did his best to exploit them."

The French art lover, with all his progress and enlightenment, was at this time naive, and easily exploited by trickery. It is easy to imagine that if faking did not become as rampant as before, it must have been because it did not pay as formerly.

Yet H. Estienne remarks on this subject:

"To-day the world is full of buyers of old lumber (*antiquailles*), at whose expense many rogues are prospering. For so little do they know how to distinguish the antique from the modern, that no sooner do they hear the word which so often makes them dip their fingers into their purse, etc."

By this remark, even without other documents, one is entitled to conclude that even at this period, which seems to have been less given than the others to imitation and faking, victims existed and were ready, like the novice or the unwise to-day, to pay fancy prices supported by a name.

Although ranking second in the movement of art—France, England and Germany have risen up and improved their taste, indulging in the true patronage of art—Italy is still the inexhaustible source of antiques, in spite of the fact that

Collecting in France and England 113

the decadence afflicting the country had destroyed the real love of art in the collector. Italian villas and palaces are replete with paintings, the best often in garrets, the bad art of the time in full honour in the important rooms. The Barocco, with its gorgeous errors and few merits, is about to prepare the funeral of Italian art. The seventeenth century is approaching.

CHAPTER XI

MAZARIN AS A COLLECTOR

Collectors of the seventeenth century in France—Louis XIII—Richelieu—Mazarin and his advisers—Louis XIV as an art lover—Vaillant's strange case—Sanson, the hangman, collecting pictures—The second collection of Cardinal Mazarin—Its partial destruction through the Cardinal's nephew—The *medailles insolentes* under Louis XIV—Epigrams on collectors—Duke of Orleans' ill-fated collection.

WE must now give our attention to France as the most prominent country in all that concerns collections of art, because the same conditions appear here that are vanishing from Italy. In the seventeenth century Paris had a well-established market of antiquities, authentic and spurious masterpieces, articles of virtu, etc.; there were also collectors of all types, dealers and the whole assemblage of wise and foolish, honest and dishonest, peculiar to the commerce when it finds its proper market.

Broadly speaking, in the seventeenth century every Parisian seems to have been a collector of something or other. Painting as a rule is given the preference.

It is about this time that Italy, however rich through the daily excavation of antique works of sculpture, no longer seemed to suffice to the greedy demand of France. Peiresse sent his emissaries to Mount Athos, Syria and Africa in search of finds, Tavernier, Thévenet, Lucas, Chardin and Gallant scoured the world in quest of antiquities and rarities both for themselves and for the King of France. Vaillant, one of the most efficient of these hunters, went to the East, sent by Louis XIV, who too has joined the ring of collectors and in a kingly way played the rôle of art amateur. On his return journey Vaillant was caught by pirates, but managing

Mazarin as a Collector 115

to escape embarked for Europe. On the way to France the vessel for the second time met the corsairs. They were seen in the distance and were expected to attack at any moment. The ship was able to escape, but fearing to be caught again and of losing the valuable collection of coins and medals he was bringing to Europe, Vaillant swallowed twenty of the best pieces in order to save them from any possible danger of being taken. This odd story, with its consequences, is related in detail by M. Weiss in his *Biographie Universelle*, with such French frankness as to forbid any attempt at translation.

Besides monarchs, the princes, noblemen and simple middle class of all conditions seemed to be collectors at this period. The passion for collecting numbers names such as Richelieu and Mazarin, among antiquaries, amateurs and dealers were Jabach and others. The number and importance of art collections, as well as of intelligent art lovers in France during the seventeenth century, can be gathered from the many publications on this century. They are many, and most of the contemporary ones are quite documentary and important for the number of collectors they mention. We may quote among them the *Itinerarium Galliæ*, 1612, by Just Zinzerling, a German signing himself Jodocus Sincerus, Abraham Golnitz's *Ulysses Belgico-Gallico*, a work written in 1631 dealing with the collections of medals and painting that the author found in France during his journey. There is also the *Voyage pour l'instruction et la commodité tant des François que des Étrangers*, printed in 1639 and reprinted by Verdier, with interesting additions, in the year 1687. John Evelyn, the English diarist, visited France in the year 1643 and gave an account of many collections of art and their cabinets, which was partially republished in the *Voyage de Lister*, in an edition of the year 1878. We can enumerate further the *Traité des plus belles bibliothèques*, published for the first time in 1644 by Père Louis-Jacob, the librarian of Cardinal de Retz and of President Du Harlay ; the *Liste anonyme des curieux des diverses villes*. etc.

In these works thousands of names of collectors of art, whether specialists or not, are mentioned, not only those residing in Paris but in all towns of the provinces.

Collectomania was becoming epidemic!

The list of seventeenth-century collectors of art has the odd honour of including the name of Charles Sanson, the hangman of Paris, and great-grandfather of the celebrated Sanson, the executioner of the *hautes œuvres* at the time of the French Revolution. According to information given by Grammont, who related to the French king his adventure with Sanson, the man who had been nominated public executioner in Paris by a decision of Parliament dated August 11th, 1688, possibly the first Sanson to enter the undesirable profession, this man was not only a collector of paintings but also a specialist; and logically so. Grammont relates how he was one day hunting for paintings at the fair of Saint Germain, when he came across Sanson with Forest, a painter and art dealer. The hangman was haggling over the price of a few works he wished to add to his collection. One of the canvasses represented a wife mercilessly scourging her husband, another was the portrait of M. Tardieu, the deceased " Lieutenant Criminel," a man Sanson had known very well and to whom he owed a certain gratitude, because, as he remarked to Grammont, when living he had made him hang and torture so many people that his skill and efficiency were gained through the work done in M. Tardieu's time. A third painting he finally decided to buy represented Japanese torturing several missionaries to death. He candidly declared that " spectacles of this kind appeared charming to him " and that he intended to hang the painting in his bedroom.

A characteristic of the latter part of the seventeenth century is not only the many sales of collections of art in France, England and elsewhere, but the appearance for the first time of printed catalogues, prepared either for the sale or as a simple illustrative document of certain collections. The first printed catalogue of France bears the title, *Roole*

Mazarin as a Collector

des medailles et autre antiquitez du cabinet de Monsieur Duperier, gentilhomme d'Aix, and after this many collectors follow the example. Even the learned Marolles is tempted to give to the public his *Catalogue de livres d'estampes et de figures de taille douce.*

To complete the characteristics of the revived market of antiques and articles of virtu in France, now exuberant in its various expressions, we may note the advent of the so-called *amateur marchand.* The "private dealer," a gentleman with a collection who deals secretly in antiques and at the same time plays the grand seigneur scorning commerce, has been perfected since, and the modern one is perhaps more intelligent, shrewder, more the grand seigneur, but less frank and far more dangerous. It may be said, by the way, that the art critic has not yet put in an appearance as a disguised dealer, the wardrobe of the ambiguous trade not having yet supplied the mask. There was no representative at this time of the type of Pietro Aretino—why not call him one of this species—who in the sixteenth century extolled paintings for artists in exchange for paintings and sold his literary eulogies to princes and monarchs.

One of the most characteristic collectors of the epoch is, perhaps, Mazarin, a merchant and intriguer on the one side, and on the other a passionate collector and an epic type of the lover of art.

A brief sketch of his life and of the vicissitudes of his collections of art are worth giving. Mazarin, in a way, so thoroughly impersonates his time, that to portray him as a collector helps to throw light on the *milieu* in which he lived. History handed Mazarin down to us as a politician and capital intriguer, etc., but only few know of him as a lover of art.

As a collector Mazarin recalls the shrewdest kind of the old Roman type. The times are changed and the old ways of Sulla and Mark Antony no longer possible. Violence and proscription lists would not be tolerated, but without the extreme methods of a Roman proconsul, Mazarin possesses

the cunning of a Verres. Like the latter he also finds things by instinct and has the unbounded passion of a true collector. We are uncertain at times whether Mazarin, who was without doubt one of the most appreciative collectors of his day, possessed that rare sixth sense that goes under the name of the collector's touch, but he was nevertheless a man of taste and an art lover of unusual promptitude in the use of the ability of others. Like many a genuine and greedy collector of Roman times, Mazarin was persistent and obdurate in the carrying through of the most complex and discouraging plans in order to secure objects for his collection. In Rome once he saw a painting of Correggio, the *Sposalizio*. It belonged to Cardinal Barberini, who had made up his mind never to part with the masterpiece. To become possessed of it Mazarin made use of a ruse. He asked Anne of Austria to demand the painting from Cardinal Barberini, knowing that stubborn as the Cardinal might be he would not refuse a favour to the Queen of France. In fact, Barberini came to Paris himself to present the painting to Anne of Austria. The epilogue of this *mazarinade* is related by Brienne as follows: "To do proper honour to the gift, the Queen hung the picture in her bedroom in the presence of Cardinal Barberini, but hardly had he left (*il n'eut pas le dos tourné*) than she took the painting and gave it to Mazarin." Brienne ends his account with the observation that Mazarin "had conducted this lengthy intrigue to get possession of a picture." Considering that intriguing was second nature with Mazarin we must say that Correggio's *Sposalizio* was worth the trouble of such a *mazarinade*.

As a collector of art, bric-à-brac and precious things generally, Cardinal Mazarin had an unusually lucky career. Contrary to the rule that exacts a very high price for experience in collecting, Mazarin seems to have been favoured by fortune from the very first; as for scruples, if they are known to a few connoisseurs he knew none.

He was scarcely known. His profession—if his occupation may be so called—was to move between Rome and Paris, to

Mazarin as a Collector 119

play to a certain extent the part of a courier between the two cities, the *navette* (weaver's shuttle) between the Roman State and its intriguers in Paris. During this period of his life Mazarin used to land in the French capital at the house of the Chavignys, where he often arrived " covered all over with dirt " (*tout crotté*).

Passing Monferrato on one of his journeys he bought a rosary, the beads of which were supposed to be glass, but were in fact precious stones, emeralds, sapphires, rubies and diamonds. The rosary Mazarin bought for a mere song was sold in Paris for ten thousand ducats.

His reputation as an excellent bric-à-brac hunter, with a fine eye for works of art, reached Richelieu and this secured to Mazarin the protection of the omnipotent Cardinal; the rest is known.

Mazarin really remained a "private dealer" all his life, a fact that his opponents could not forget. More than one *mazarinade* alludes to the Cardinal's dealings.

Even when writing to potentates or diplomats on the most important political schemes, Mazarin never lost sight of his hobby. In his letter to Cardinal Grimaldi on the importance of watching our " affairs in Italy " he reminds him, by the way, to be on the look out for good books and good paintings, etc.

Through a well-organized network of agents and political friends he received objects for his collection almost daily. Chiefly from Rome, Florence and other cities of Italy, statues, paintings, furniture arrived in a continual stream at the Cardinal's palace. His library numbered twelve thousand volumes in a very short time.

The *Fronde*, however, is no longer satisfied with gibing the Cardinal with *mazarinades* on his buying of books without being able to read them. His opponents, antagonistic to the Cardinal's policy, finally rose up boldly against him. Mazarin was obliged to fly from Paris. By a decree of Parliament his goods were seized and sold. Whatever criticism may be passed on the Cardinal's shady policy, the

destruction of his collection and library is an unpardonable sin and an artistic loss.

Mazarin does not seem to have been discouraged by this unexpected *contretemps*. Learning that Jabach was going to London to be present at the sale of the collection of Charles I, he asked him to buy paintings for him, and through this friend was able to secure for a new gallery the Venus by Titian, the Antiope and the Marsyas by Correggio, the Deluge by Carracci, as well as tapestries of inestimable value.

Two years later Mazarin triumphantly entered Paris again, was reinstated in his former power, and started a new library, while reconstituting his dispersed gallery ; and when he died his collection contained, according to an inventory of the year 1661, 546 pictures, of which 283 were of the Italian school, 77 German or Dutch, 77 French and 109 of various schools. The Italian school included names such as Raphael, Titian, Correggio, Tintoretto, Solario, Guido Reni, the Carracci, Domenichino, Bassano, Albani, etc.

Many of these works are now in the Louvre Museum and nearly all his statues, 350 in number, have also passed to the Louvre and are now kept in the *Galérie des Antiques*.

The inventory also informs us that the Cardinal left twenty-one cabinets, some in ebony, others veneered with tortoise-shell and ivory, and a large quantity of marble tables and Venetian glass, chandeliers in rock crystal, and irons in silver or gilded.

The precious stones were valued at 387,014 francs, the silver of the chapel at 25,995, the plates in silver, gold or gilded (761 pieces) at 347,972, etc. The same inventory also notes 411 fine pieces of tapestry estimated at 632,000, perhaps what a single piece of the best would cost nowadays, but an enormous sum considering the time. There were also 46 Persian rugs of unusual length, 21 complete "ameublements" in velvet, satin, gold embroidered silk, etc.

The library included 50,000 volumes and 400 manuscripts.

Brienne, who was a collector himself on a smaller scale, and who filled at the time the position of secretary to the

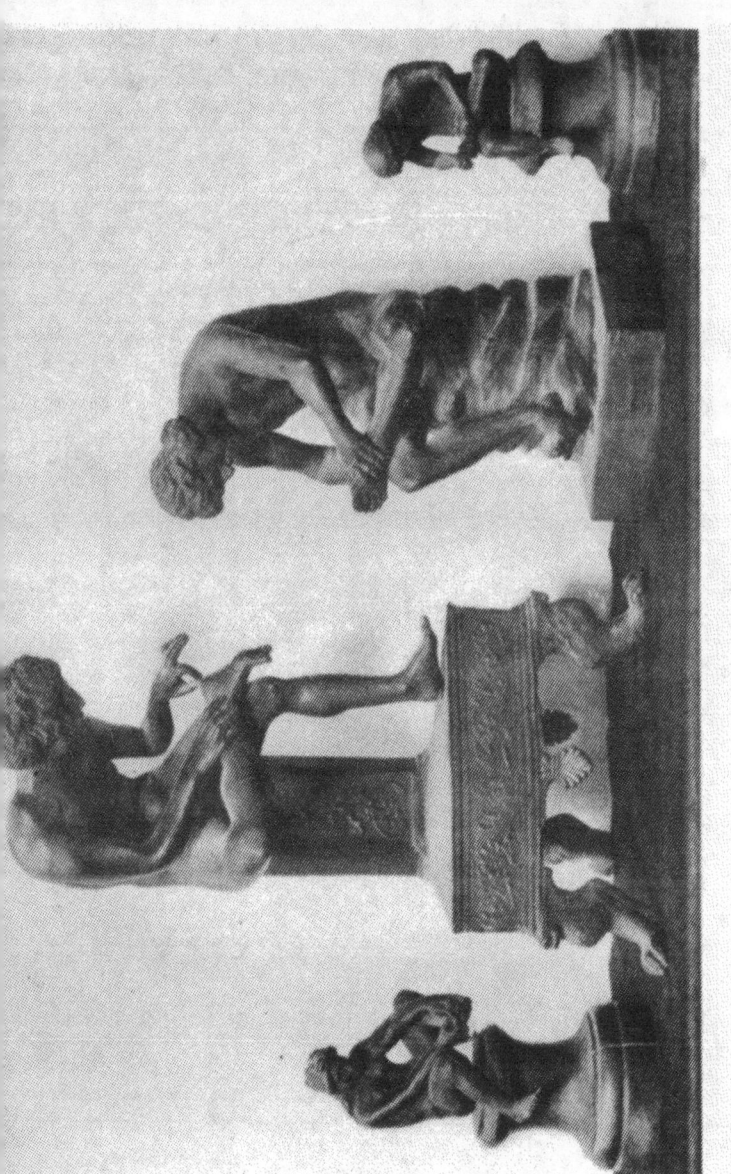

Photo] THE SPINARIO. *[Alinari*

A cherished Roman subject of the imitators of the XVth and XVIth Centuries. Several museums have similar imitations. There is a fine original in Naples Museum.

Cardinal, relates with a certain pathos the last moments of this frantic art collector, and how during his last illness he grieved to leave his cherished masterpieces.

"I was walking," says Brienne, "in the small gallery in which is the woollen tapestry representing Scipio—the Cardinal did not possess a finer one. By the noise of his slippers I heard him coming, shuffling along like a suffering man or a convalescent. I hid myself behind the tapestry and heard him say, 'I must leave all this!' Being very weak he stopped at every step, leaning first to one side and then to the other; gazing at the various objects of his collection, and in a voice that came from his heart, he kept on repeating 'I must leave all this!' Then turning his head to another side—'and also that! What trouble I had to buy all these things. How can I leave them without regret?—I shall not be able to see them where I am going.' I gave a sigh, I could not help it, and he heard me. 'Who is there?' 'It is I, Monseigneur——' 'Come here,' he said to me in a doleful tone. He was nude, only covered with his *robe de chambre de camelot* lined with *petit-gris*. He said, 'Give me your hand, I am so weak; I can hardly bear it——' Then returning to his first idea, 'Do you see, my friend, that fine painting by Correggio, that Venus by Titian and that incomparable Deluge by Carracci—I know that you too love and understand painting. Alas, my dear friend, I must leave all this. Good-bye, dear paintings that I have loved so much, that have cost me so high a price!'" (Brienne, *Memoires*, II, xiv).

These three paintings, Correggio's Sposalizio, Titian's Venus, and Carracci's work, are now in the Louvre Museum.

"*Que j'ai tant aimés et qui m'ont tant coûté!*" The second part of the sad exclamation would indeed seem to belong to this shrewd adventurer, but those not knowing to what lengths the passion for collecting can go, would hardly imagine that a man of Mazarin's temperament could love, really love, anything on earth but power and intrigue.

As a most remarkable contrast to this passionate love for

beautiful things, Destiny ordained that the greater part of the Cardinal's statues and paintings should fall into the hands of his nephew and heir, Armand-Charles de la Porte, Duc de la Meilleraye, the husband of Mazarin's niece, Hortense Mancini. This nephew, who on becoming the Cardinal's heir was allowed to take his uncle's name and titles, was bigoted to the last degree. Idiotically deprived of all artistic sense he thought it his duty to destroy the art collection, to purge the world of the offence offered to morality by nude sculpture, to rid society of the Cardinal's paintings with their shocking mythological subjects. Saint-Evremont relates how this fanatic iconoclast left his mansion at Vincennes one day with the deliberate intention to destroy the fine gallery left to him by the Cardinal, and how on his arrival in Paris he entered the place where it was kept and taking a hammer out of a mason's hand proceeded to smash statue after statue and destroy paintings. But the statues and works of art were altogether too many to be destroyed single-handed, so he armed half a dozen servants with hammers and ordered them to help him in his artistic hecatomb. It was indeed fortunate that upon the Cardinal's death Louis XIV made up his mind to buy some of the best paintings, and that some of the statues had also been taken away from this strange curator of Mazarin's museum, or there would be very little left to-day of one of the most famous collections of Paris. Some of the statues now in the Louvre still show this fanatic nobleman's abuse of the hammer, more especially the one bearing the title " Le Génie du repos eternel."

The monarchs of this time bought paintings, statues and fine things, sharing enthusiasm with private citizens. However, they played their part well and the attitude of the art lover gave them a finishing touch. Yet in less dangerous and despotic an age the pen of a Molière might have tried its caustic ability on some of these types. Louis XIII is, after all, but a mild art lover, at least so he appears by the side of Marie de Médicis who learned the part of Mæcenas at the court of Tuscany. He collects arms and had a *cabinet* of

Mazarin as a Collector

choice weapons, among other curios, his *grosse Vitri*, a carbine of rare merit left him by Vitri. We know of this collection of Louis XIII because it is recorded that when Concini, the Florentine intriguer whom Marie de Médicis had created Maréchal d'Ancre, was killed in the court of the Louvre, "the king, who was in his *cabinet des armes*, heard the noise of the pistols." Anne of Austria, his wife, one of the few women to detest roses and who could not even bear to see this magnificent Queen of Flowers painted in a picture, had a passion for fine book-bindings, and Monsieur Gaston d'Orléans sported medals and also rare books.

As for Louis XIV, the best-staged king of his time, he was apparently ready to buy anything that would add magnificence to his court and be in keeping with his rôle of Roi Soleil.

Notwithstanding his more or less decorative magnificence, however, this monarch was at times a hard bargainer, and like Isabella d'Este, knew how to take advantage of needy or impecunious clients. His transactions with Jabach to buy from him the finest art collection in France are scandalous, nor can these transactions be solely attributed to Colbert, who was for a long time the go-between in this affair. Jabach was a German by birth and Parisian by election, a rich banker, the director of the *Compagnie des Indes Orientales*, intelligent and a most passioned art collector. With great care and expense he had formed the finest collection of his time. Later, through business reverses, his unbounded liberality to artists and the extravagant prices he paid for his masterpieces, Jabach finally found himself forced to part with his collection, and entered into negotiations with Louis XIV who knew its immense value. Dealings dragged on for a long time, and every day Jabach was more pressed by his creditors. Notwithstanding his necessitous condition he rebelled at the absurd price offered and wrote to Colbert to beg the king to treat him "as a Christian, and not as a Moor." Finally Louis XIV, the Roi Soleil, though in this affair a planet certainly that did not shine in generosity, gained his point

and for the absurdly paltry sum of 200,000 livres became the owner of the renowned Jabach collection, composed of no fewer than 101 paintings, a great many of them masterpieces, and 5542 drawings. It is sufficient to say that in this Jabach collection were works by Leonardo da Vinci, the Saint John, the "Concert champêtre" by Giorgione—one of the few authentic works of this master—the Entombment of Christ, the Pilgrims of Emmaus and the Mistress of Titian by Titian, all of which now belong to the Louvre Museum.

With a king who played the connoisseur and collected objects of art and virtu, no gentleman of the French court would acknowledge indifference towards art, or be without a certain hobby of his own, collecting some one thing in particular, being in fact what is generally defined as a specialist.

Speaking of "La Mode" in his *Les Charactères*, La Bruyère lashes the collecting craze of his time without mercy. His Chapter XIII treats of fads and fashions, and in it he tells of the ridiculous freaks of collectors and cleverly points out how utterly deprived of genuine meaning were the artistic pursuits of such amateurs.

Nevertheless, with its good sides and its bad, the epidemic spread, and not only in France, but in other countries as well. We will, however, confine our study of this epoch to France as for the purposes of this brief résumé of the collecting craze France was ahead of the other countries, and thus by the side of the wise and genuine lover of art, possessed all the other degrees of Collectomania.

Though conforming to fashion, every one has his own views on the matter, so that there are dreamers and speculators on all kinds of antiques, but painting is given the preference.

"Pictures are bullion," writes the fat Coulanges to his cold-blooded and well-behaved cousin, Mme. de Sévigné, "you can sell them at twice their price whenever you like." In fact during one of his journeys to Italy, Coulanges, who had caught the collecting fever, made a considerable sum of money in buying and selling pictures, so much money that

it spoilt his taste for, as a chroniclist says, "The treasure, which he saw piled up at the Hotel de Guise awoke in him more expensive tastes." His wife, Marie-Angelique du Gue-Bagnol, collected *raretés curieuses*. Mme. de Sévigné tells us of her delight when she saw in her cousin's house a looking-glass that had been owned by Queen Marguerite.

At this epoch the art and curio market comprised all sorts of odd characters and, as might be expected, the subject gave ample food to writers and chroniclers for skits. La Bruyère is not alone in making sport of the obsessed art collector and crazy curio-hunter. From Molière to the Italian Goldoni the antiquary and his victim are capital subjects. Poetry also contributes its sarcasm. In France some of the minor and justly obscure poets are very useful in the reconstruction of our *milieu*. There are even chronicles written in verse.

For instance, Marie-Thérèse, the wife of Louis XIV, goes to see Caterine Henriette Bellier de Beauvais, the first lady of the bedchamber of the queen dowager Anne of Austria, a lady who is evidently collecting art. The poetical chronicle at once informs the public that:—

> Mercredi, notre auguste Reine
> Fut chez madame de Beauvais
> Pour de son aimable palais
> Voir les merveilles étonnantes
> Et raretés surprenantes . . .

We will spare the reader the description of the collection given in a sort of litany of praise, a sequence of lines like the following:—

> Tant de belles orfevreries
> Tant d'éclatantes pierreries
>
>
>
> Tant de vases si précieux,
> Tant de bustes et tant d'images, etc.

Le Maisel Prieur des Roches is crazy for books, and like a true bibliomaniac he never reads his books, which are gener-

ally bought for the title, etc. This of course is more than enough for his introduction into one of these rhyming chronicles, called *Rymaille* :—

> Les livres Des Roches en belle couverture,
> Mais leur Maistre n'en donne Science ny Lecture.

Paintings being given the preference, they are also the cherished subject for verse. Impassioned specialists who collect the works of a single artist and spend a lifetime in doing it are a capital subject. There is also an Arcadia among art collectors, worthy of the eighteenth century, a regular Arcadia with pseudo-names, etc. One of these rhymed chronicles records the various names assumed by the collectors and amateurs of the Arcadia. As we have said, many of these collectors of paintings are specialists possessed of the hobby of collecting the works of a single master. Poussin is at one time the most fashionable, and while the Poussinists are among the most impassioned in proclaiming the merits of their artist, there are also other " ists." Gamarre, Sieur de Creze, lieutenant des chasses, is apparently at the head of the Poussinists. His Arcadian name is Pantolme.

The widow of Lescot—the jeweller who was one of Mazarin's advisers and was sent by the Cardinal to Spain in search of fine things—collects paintings, but happens to be a Rubenist. However, in due time she is converted by Pantolme (Gamarre) to the Poussinist persuasion and deserts the Flemish art of Rubens and starts a new collection as a Poussinist. She is called Irene in the *Banquet des Curieux*.

It would take long to go over all the pleasantries of the curio-hunters of this time. Bizot, named Lubin in the *Banquet des Curieux*, is a type of collector we have already introduced :—

> Lubin, amateur d'antiquailles,
> De livres anciens et de vielles médailles,
> Philosophe sans jugement,
> Curieux sans raisonnement. . . .

Other odd characters have escaped record in rhyme. A Sieur Basin de Limeville of Blois is a well-known collector of medals. He spent his whole life in buying nothing but medals. Yet no one ever saw his collection; as soon as they were bought the medals were put away in his cabinet, declares an informant of the time. His cabinet is provided with an iron door and a lock with a key of most complex make. At his death the heir tried to open the door but the key refused to open, there being some special handling beside the difficulty of the lock. The man who had made the key was dead and the case was so hopeless that the heir was forced to enter Sieur de Limeville's cabinet through an opening in the wall. Inside the cabinet there was found among a mass of cobwebs a dirty sack filled with the precious medals, the collection to which the deceased had given his whole life.

La Bruyère tells of a man who spent all his years hunting for a bad etching of Callot. He knew the work was the poorest ever done by the artist, that it was not worth the trouble, but he nevertheless gave his whole time and activity to the search for that etching because it was the only work of Callot that he did not possess.

Jacob Spoon, a doctor of medicine and an intelligent but odd individual who died in the year 1685, declares that in his native city of Lyons every one is collecting something or other. Then, and perhaps as a physician he was in a position to know, he says that collecting is a disease, contagious though not fatal.

There is no need of special documents to say that faking must have worked with a certain ease in such a world. Brienne tells us that when Cardinal Mazarin received objects from Italy, Jabach and Magnard were charged to examine them and very often more than one piece of faking was discovered, very successful counterfeits (*Memoires de Brienne*, Chap. IX).

There is no instance to my knowledge of any sentence passed by tribunal upon fakers at this time when everything seems

to have been decided by the almighty power of Louis XIV or the ever-ready Parliament.

Yet the police of Louis XIV seem to have one interest in the collecting of art. They must watch that the books, prints and paintings, etc., offered for sale contain nothing immoral or what we should call nowadays subversive. By this duty the police of Louis XIV become specialists, going in chiefly for medals. In the year 1696 Pontchartrain wrote to M. de la Reynie " to send a man to watch the sale of Abbé Bizot and be on the look out for the *médailles insolentes* of the said *cabinet*." After other injunctions, he then adds: "It is His Majesty's wish that the medals incurring suppression should be put into a sack, this to be sealed and taken to the mint. . . ."

It is clear from this that over and above interest in bad coins and faked medals the police of the *Roi Soleil* were on the look out for a particular historical coin bearing some unfriendly allusion to the King of France, and their earnest efforts to suppress it had naturally made it so rare that it kindled the ambition of numismatists and collectors at large.

The eighteenth century might be called the period of sales of art collections. Everywhere auctions were held of well-known collections; in Holland alone we can register 185 catalogues of art sales from 1700 to 1750. This may be called a sort of record, however, as France in the same period of time counts only thirty catalogues. Following the art sales in Paris we find that from 1751 to 1760 an average of four sale catalogues a year is reached. From 1761 to 1770 the average increases to thirteen; from 1771 to 1775 to twenty-eight, and from 1776 to 1785 to forty-two each year. This is the climax; at this point art sales were social functions and the auction room a place where society met. Collections are dispersed and new ones formed, and the transference of masterpieces from one collection to another through the auction room acquires unusual rapidity. Such a state of affairs inspires Thibaudeau with the following reflection. (Thibaudeau. *Préface du Trésor de la Curiosité*.)

Mazarin as a Collector

"It is like a game of shuttlecock in which the bourgeosie and nobility throw masterpieces to each other and with such swiftness that one really does not know to whom they belong."

The eighteenth century, from the very beginning, numbers collectors such as Crozat, who had a palace in Rue Richelieu and a collection of 19,000 drawings, 400 paintings and 1400 cameos, etc., Comtesse de Verrue and Baudelet. The Duke of Orleans' gallery includes 478 paintings, of which three were by Leonardo da Vinci, 15 by Raphael, 31 by Titian, 19 by Paul Veronese, 10 by Correggio, 12 by Poussin, and many others of the Dutch, Spanish and other schools.

This collection of the Duke of Orleans, one of the finest in France after that of Cardinal Mazarin, seems to have been pursued by the same ill-luck as the latter. The Regent's son, with deplorable prudery, destroyed all the paintings with nude figures; as for the rest of the collection, it was sold later to some English amateurs by Philippe-Egalité.

CHAPTER XII

SOME NOTABLE FRENCH COLLECTORS

Speculation, financial disasters—Many collections change hands—Fakers busy for newly-enriched collectors—Voltaire plays the silent partner to art and curio dealers—Wonderful unearthings of Dr. Uber—Collectors of the time : Mme. Pompadour, Cardinal Soubise, Malesherbes and others—Interspace of the Revolution—Napoleon revives some of the speedy methods of the Romans—Italian museums and galleries plundered by his Imperial agents.

FROM this early period we enter that of the art sales, which, as we have already said, seem characteristic of the eighteenth century. Financial disasters and speculations disperse more than one fortune and usher new-comers into the world of finance. This is the time when masterpieces begin to change hands so rapidly. The spirit of collecting is superceded by that of commerce, and faking appears under new forms, those with no other trickery beyond what commerce with its intrigue and deceit can supply.

" All amateurs," writes a contemporary in the *Chronique Scandaleuse*," are now mixed up with *brocantage* (bric-à-brac). There is not a collector who does not sell or exchange (*troque*), either on account of unstable taste, or for the sake of gain, or to retaliate his own bad bargain upon some one greener than himself."

Even Voltaire, between an epigram and a satire, found himself implicated in *brocantage*, only, more shrewd than Cicero, he saved appearances by an associate, the Abbé Moussinot, he remaining the sleeping partner.

Voltaire's name and his banter over natural history and explanations of geological phenomena—Buffon, the author of

Some Notable French Collectors

a Natural History that Voltaire called "not at all natural," was one of his victims, he having replied to Buffon's learned hypothesis with regard to some sea-shells found on the summit of the Alps that the shells might have been lost by pilgrims on their way to Rome—recalls to our mind an eighteenth-century successful piece of faking and practical joke played on an erudite collector, Dr. Louis Huber of Würtzburg. In the year 1727 two doctors of the town prepared a surprise for Huber, a surprise by which his collection of fossils was to be enriched by some extraordinary specimens. Speculating on the enthusiasm and good faith of the learned doctor and impassioned collector, the two accomplices fabricated fossils of fantastic animals and the most impossible shells. The imitations were generally modelled in clay with the addition of a hardening substance. Incredible as it may sound, some of them represented ants and bees of the most heroic proportions, crabs of new line and shape, etc. These were carefully buried in ground of suitable character where Prof. Huber had been seen to excavate.

The rest is easily divined. What is not easy to understand, however, is the fact that after having made several of these most incredible discoveries Dr. Huber thought fit to publish a work, consisting of a hundred folios, written in Latin and issued under the auspices of Professor Béranger. The book, which was dedicated to the Bishop of Franconia, had twenty-two illustrations reproducing with extreme exactitude Dr. Louis Huber's fantastic antediluvian find.

But this is not all. The learned Faculty of Science of Würtzburg assembled to honour Dr. Huber and the doyen of the Faculty pronounced a speech in praise of his discovery.

What followed can be easily deduced. Only his good faith saved the deceived collector from the sore experiences of a modern sham discoverer of the North Pole.

The curio world, however, still counts some good art lovers and serious collectors, such as Gersaint, Basant, whom the Duc de Choiseul used to call *le marechal de Saxe de la curiosité* on account of his daring and successful inroads on the art

market, where, by the way, though no blood is shed no less strategy is needed than on the battlefield. There are other names worth quoting in this century of decadence, Gloomy and his friend Remy, painter and dealer in pictures and other curios, Julliot, Langlier, Paillet, Regnault-Delalande, Pierre Lebrun and his son, J. B. Lebrun, who married the famous artist Mlle. Vigée, and owned the well-known *Salle Lebrun*, often used for celebrated sales.

Other names might be quoted, La Marquise de Pompadour, Cardinal Soubise, Girardot de Prefond, Fontette, Malesherbes, Marquis de Paulmy, etc.—then, the Revolution comes, the *ancien régime* disappears and with it the dainty furniture, foppish dress, and the supremacy of an art market which with all its oddities were such perhaps as had never been seen since the time of the orgy of curio-hunting of Ancient Rome. This supremacy, deprived of many of its idiosyncrasies, temporarily crossed the Channel and went to England accompanied by many of the treasures that dealers and refugees managed to save from the cataclysm of 1779.

Napoleon may be quoted as an exceptional art collector— if ever such a name can belong to a man utterly deprived of a sense of art but shrewd enough to understand the mighty support given to sovereigns by art—for in the process of time the man formed more than one art collection by methods that in their drastic character greatly resembled those adopted by Roman generals and proconsuls.

This statement is eloquently supported by facts and numbers. Here is a laconic writing of Napoleon in which he informs the Directory of his first artistic "finds" in Italy. Speaking of his agents, he states:

"They have already seized: fifteen paintings from Parma, twenty from Modena, twenty-five from Milan, forty from Bologna, ten from Ferrara."

This is, of course, his first experiment as a novice collector. Other things were to follow, the Medici Venus from Florence, the Roman Horses from Venice, and all the best works of art from the Italian museums, and these but foster more

Some Notable French Collectors

eclectic desires in this strange art lover, who while preoccupied with the problem of transporting heavy statues from Rome and harvesting antiques and Renaissance work, indiscriminately orders to be taken to France with the artistic booty the votive pen that Justus Lipsius left to the sanctuary of Loretto and the votive image left by Montaigne to the same sanctuary. The anecdote of Lucius Mummius of ignorant memory is here repeated in a way, for the officials acting under Napoleon's orders have nothing to say about Montaigne's ex-voto, but when it comes to the pen of Lipsius these worthies gleefully remark: "*La plume de Juste Lipse qui avoit été estimée cinq huitièmes, c'est trouvée peser six huitièmes*" (the pen of Juste Lipse which was supposed to weigh five-eighths, has been found to weigh six-eighths).

From the Revolution to the time of Napoleon's dominion is the period in which the passion for art collecting is least felt. Faking, of course, is an art that does not pay and thus has no *raison d'être*. Yet faking passes from the field of art to that of real life, the new Republic apes Roman customs. David the artist is faked into a Tribune while busy painting Romans that seem to have been brought out of a hot-house and he sketches semi-Roman costumes for the new officials of the Republic, garments that with all the foppishness of the "old regime" had Roman Consular swords, Imperial chlamys (mantle), faked buskins or ornamented cothurnus (boots worn by tragedians). It is this faking of life that feels the need even to alter the calendar, changing the Roman etymology of the names of the months into more resounding Latinesque appellations. At home in this staged drama of life, Napoleon, the friend of Talma and David, continues the grandiose faking with a sort of complex etiquette and a veneer of aristocracy, which makes one sadly think of the truth of the words pronounced by Courier on General Bonaparte's elevation to the throne: He aspires to descend.

Yet even in this peculiar and rather negative world the chronicle of the *curieux* may contain some glorious names, and these no doubt prepared at the beginning of the nine-

134 Some Notable French Collectors

teenth century the return of the cult of art in France, the reappearance of devoted collectors and enlightened amateurs. We may then name successively art lovers and intelligent collectors such as Lenoir, Du Sommerville and Sauvageot, Revoil Willemin. And after them artists, collectors and dealers of the calibre of Mlle. Delaunay, Escudier, Montfort, Roussel, Beurdeley, Henry Grandjean, Mannheim, the first of a dynasty of honest and intelligent dealers; then almost in our own times Baron Davilliers, Bonnaffé, Emile Peyre and others. But art collecting is now no longer an accentuated characteristic of France nor of England, Germany and other European countries which have a tradition and have come to the fore, but other new and powerful States have joined the contest, cast new types of collectors and created a new psychology in the art world which will form the second part of this book.

PART II

THE COLLECTOR AND THE FAKER

CHAPTER XIII

COLLECTORS AND COLLECTIONS

Collectors and collections—Various kinds—Meaning of the word *curieux*—Various types of collectors : the artist, the scholar, the eclectic and the specialist—A large class of collectors as defined by La Bruyère—The ultra-modern collector—The art and curio market—The three stages of the collector's career—The collector's touch—The elasticity of prices and an opinion of C. T. Yerkes—Gersaint's advice and Schlegel's opinion—A Latin saying re-edited by Edmond Bonnaffé.

"*La collection c'est l'homme*," a well-known French lover of art and first-rate connoisseur used to say. Nowadays this transformation of Buffon's threadbare saying is only partially true. It would, perhaps, be more correct to put it in the past tense, as a new type of virtuoso has arisen. A collector of the most recent brand prefers to buy collections "ready-made." Such collections all gathered in good order in the houses of these new collectors speak very eloquently of the owner's financial power, but say nothing of his taste, ability, or love for the artistically fine and beautiful.

However, this being somewhat of a recent change brought about by casual circumstances with hardly any claim as an artistic phenomenon, this study can be confined for the present to that normal period, barely past, when the art and curio collector was really a " collector " and above all a lover of art as well as a passionate hunter after fine things. From the study of this semi-past world of art it will be easy to

proceed to a comparative analysis of the up-to-date one, to the new species of collector who in no way comes under the definition "*La collection c'est l'homme*."

In the foregoing review of collectors and collections, it has mostly been a question of art collectors, with only incidental reference to other kinds of art lovers. Curios, however, imply many other things. The French word *curieux*, which has often been used for lack of a better expression, has a wider meaning. The word *curieux*, which might be translated by the English word "curious," without losing much of its meaning, may have originated in the Latin *curiosis*, though it is doubtful whether the Romans ever applied this word to connoisseurs of art or other collectors. The fact that the artistic world was then divided into lovers of the beautiful and faddists or fools, that erudites had not yet appeared, may have rendered new words of definitions useless. When speaking of his friend Statius as a connoisseur and virtuoso, Pliny uses the Greek word φιλόαλος (friend of the beautiful), a word that might really be used to define the true and genuine collector.

The French word *curieux* appears for the first time in a dictionary by Robert Estienne (1531) and is defined *ung homme curieux d'avoir ou sçavoir choses antiques* but later on, presumably from its probable Italian origin, the word acquires a wider sense, a sense that even finds an echo in Shakespeare, and so also the old meaning of *gentilezza* as used by Lorenzo Medici has a resonance, according to Lacroix du Maine, in the French *gentillesses ou gentilles curiositez*.

Notwithstanding this limitation, for many the word *curieux* has the widest meaning and includes all kinds of collectors. Trevoux' definition "*res singulares, eximiæ raræ*" with Millin's broadening comment "*tout ce qui peut piquer la curiosité par la singularité des formes ou des usages*" (all that may excite curiosity in strangeness of form or use), is the proper one, regardless of Mme. de Genlis, who as late as 1818 goes back to the old meaning and includes under *curiosité* the entirely scientific Natural History collections.

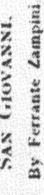

A CHILD.
By Ferrante Zampini

SAN GIOVANNI.
By Ferrante Zampini

Collectors and Collections 137

It must be said that the distinction between scientific and artistic pursuits is not always clearly defined. Science mingles with art with undisputed right, and scientific pursuits at times have artistic interest. The two seem either to alternate their rights or share them in the fields that lie between.

In the artistic field, or rather in that which tallies with Millin's definition of *la curiosité*, there are two quite typical classes even though they cannot be separated by a sharp line of delimitation on account of linking subdivisions. The one includes the art collector alone and the searcher for the beautiful, the other those gathering the rest, things which for " strangeness of form or use " present a certain interest to the collector.

There is no doubt that those of the first class possess the impulsiveness that generally characterizes intuitive and non-learned experience in art, and those of the second combine artistic and scientific interests. The one has a tendency to consider and value objects in a different manner from the other: the artistic temperament has a penchant for synthesis, the scientific is inclined towards analytic methods.

While the collector of the first class has a direct purpose— the search for what is artistically fine, the other is less absolute, and for him objects have what may be called a relative value, the value of the series. In collecting coins or medals, the latter more especially, art plays an undisputed part, but science claims the right of classification, thus placing a relative value of no secondary importance. As a consequence, for instance, a medallist is likely to speak of the rare in place of the fine, or at times use one word for the other. It may be that in the eyes of a numismatist a sample of inferior art acquires great value through its rarity and through the place that it may occupy in the series of his collection.

There are some collections consequently in which the best artistic samples are forced to play a secondary part, the object of the collection being classification, just as shells,

minerals and other purely scientific gatherings would be arranged.

This peculiar tyranny of science may even find scope for action in expressions of art, where science and erudition should have no claim. In museums of painting and sculpture the history of art demands that the objects should be classified according to epochs, schools, etc. The man intent upon such classification often becomes so engrossed in this one scientific side as to grow indifferent to those artistic considerations which give the painter and the real lover of art the joy art is intended to give. Even connoisseurship is often too tainted by erudition, and the curators of museums are very rarely æsthetes. At the sight of a fine work of art, a connoisseur is very often so intent upon discovering the name of its author, the probable school and the epoch—all forms of classification—that he forgets he is before a work of art, that is to say, an expression of human sentiment, which whether good or bad was created solely to arouse artistic emotion in the beholder. The artist, while creating it, had certainly not in mind the history of art and all its erudite paraphernalia.

There are two other distinctions in art collecting, distinctions so closely allied to the above classes that they share the respective characteristics in a very similar manner. They are represented by the eclectic collector and the specialist, two distinct orders both useful in a way, both belonging to the artistic sphere. The eclectic is well defined by Gersaint as "an amateur whose passion presupposes taste and sentiment"; the other, the specialist—generally regarded as having perfected his taste by dropping his initial eclecticism—is a collector who has restricted the field of his activity by grafting, so to speak, the purity of his artistic penchant on something that tends to diminish the broad outlook of an eclectic lover of art, and this in order to enlarge the possibilities of research and information. Thus although the specialist has very often passed through an initial period of eclectic wandering, when he becomes a specialist he is

Collectors and Collections 139

very apt to forget his past enthusiasm for anything but his chosen speciality. Show a fine Limoges enamel to a collector of medals or a medal to a collector of enamels and you will realize the truth of the statement. Of course he will understand the beauty of the work—though not invariably—but he will take no interest in it. While having perfected his taste in some single branch of art, the specialist has unquestionably atrophied all artistic qualities in other directions. This theory naturally becomes more or less elastic according to the genre and the character of the art lover. A man who is a specialist on certain epochs is hardly a specialist in the true sense, but rather an eclectic who has restricted his pursuits so as to reconstruct in his mind the whole artistic expression of a certain age: the medallist and such like collectors have not such a wide scope and their pursuits generally come to be characterized by method, order and a whole Indian file of historic and erudite considerations. The *tout ensemble* of an eclectic's house presents a very decorative appearance, that of the specialist does not always, being mostly encumbered with glass cabinets or pieces of furniture with shelves adapted to his speciality. The eclectic collector will often speak of the beauty of a certain find from a purely artistic point of view, the specialist will grow poetic over the perfect cast, patina, etc. The specialist in medals will often show you two or three specimens of the same medal only distinguished by the colour of the patina or differences of no artistic value, and chronological considerations weigh with numismatists. The specialist must therefore frequently recur to scientific methods.

In Paris there is a loose belief that an art lover who is an eclectic reveals a somewhat provincial sentiment, and that to be characterized as a true Parisian one must be a specialist in some one thing. This belief naturally implies that the specialist has refined his taste and acquired distinction from the grossness and obtuseness with which eclecticism is libelled. Yet this is hardly true, the best French collectors,

such as Davilliers, Piot and others, were always enlightened eclectics in their various pursuits though having a bent towards specialization.

Nevertheless, we repeat that distinctions cannot be made with mathematical precision. The difference between artist and erudite, eclectic and specialist would seem to have been well defined only by Bonnaffé in his characteristic saying: "The first throws himself upon his knees before Beauty; the other asks her for her passports."

Neither of the two methods ensures infallibility. The artistic collector, a lover at first sight, may be deceived by an imitation possessing character and general effect sufficient to pass in his eyes for an original; the erudite with his brain in the place of his heart, who demands "passports" before making up his mind, may be duped by a forged "passport," by an imitation, that is to say, in which the details are respected even to the sacrifice of the totality which so greatly appeals to artists.

There is one more kind of art and curio collector, perhaps the most numerous of all. They have been well defined by La Bruyère more than two hundred years ago. This particular type of art lover is on the look out not for what he really loves but for that which affords him gratifications other than those art is intended to give.

"It is not an amusement," says the author of *Les Caractères* in his chapter on Fashion, "but a passion often so violent that it lags behind love and ambition only as regards the paltriness of its object."

Passing then from the description of the effect to the cause, La Bruyère proceeds:

"*La curiosité* is a taste for what one possesses and what others do not possess, an attachment to whatever is the vogue or the fashion; it is not a passion felt generally for rare and fashionable things, but only for some special thing that is rare and above all in fashion."

To this last category, with a few slight modifications, belongs the type of collector who might be called ultra-

Collectors and Collections

modern to distinguish him from his modern confrères of yesterday, a type that can lay no claim whatever to the definition "*La collection c'est l'homme*," because he never troubles himself to hunt for works of art or curios, never experiences the joys of discovery, experiences nothing perhaps, but being cheated by dealers, friends and experts. The ultra-modern collector is, of course, amply supplied with money, and relies chiefly on his cheque-book. He is always far from the spot where he might learn wisdom, yet not so far as to be beyond the pale of the deceit and trickery of the market of *la curiosité*.

This latest variation carries one direct to the modern American type of collector. Not because the type does not exist in other countries, but because America has furnished the champion specimens who through the magnitude of their speculations in art- and curio-hunting have stamped the type. Yet even in America, where art lovers like the late Quincy Shaw, Stanford White, H. Walters, etc., have been known, the ultra-modern type represents a very recent and astonishing novelty.

One conversation on art with this modern collector is generally sufficient to reveal all absence of real passion. These greedy buyers of works of art and curios have often hardly the time to give even a glance at their clamorous purchases. They have certainly not the enjoyment that other collectors have. When they show their collections, a common way of soliciting admiration is to recount the unreasonable and extravagant prices paid.

What are they after ? What is their main object in ransacking old Europe for artistic masterpieces to be carried off by the sheer force of money ?

Lovesque says one is a connoisseur by study, an art lover by taste, and a *curieux* by vanity, to which Imbert wisely adds : " or speculation."

Making every possible exception, vanity and speculation still appear to rule alternately the ultra-modern collector.

We do not deny that many of them may be animated by

the noble desire to leave their collections to their countries, but yet on closer study the attraction for the greater number of them seems to be either a modification of their financial interests, namely, sport and speculation combined, or an inclination to spend money lavishly, everything being too easily possible by reason of their great money power. In a humorous toast at an American dinner, Stanley, the explorer, said that a citizen of the United States is never at rest till he has found something that he actually cannot afford to buy. The definition fits the millionaire art collector with more correctness and exactitude. In this field he shows himself a regular blasé of buying possibilities—and his passion for art and curios may to some extent bring him out of his torpidity by the extra magnitude of the investment.

As Bernard Shaw says, a millionaire can buy fifty motor-cars but can only drive one at a time. He can buy food for a whole city but has only one stomach to digest it, secure all the seats in the theatre but can only occupy one, etc. But to own a work by Michelangelo or Raphael is a different tale; it affords one the sensation of owning and driving a hundred or more motor-cars all at the same time in a sort of modern —ultra-modern—triumphal march of glory to the up-to-date Olympus of the privileged, where fame is highly seasoned with self-advertisement, and superlatives the daily ingredient of reputation.

For others the modern whim of collecting works of art may represent a diversion from business, or a way in which "to astonish the natives." From this type we come to the old forms of foolishness, the Trimalchos, Euctuses and Paulluses, etc., who have changed the ancient palanquin carried by slaves for a brightly coloured motor of sixty or ninety horse-power.

One reason why this modern type of collector is so commonly deceived is because he generally lives in a sort of fool's paradise of art trumpery separated from the real art market by a little understood feeling of aristocratic pride.

Collectors and Collections 143

The art collector of olden times used to mingle with dealers, learn from them where and what to buy, tramping from place to place, the former El Dorado of the "find." The modern species would consider it beneath him to have anything to do with common dealers or to attend a public sale even for the sake of interest in art. How can they gain experience? They may engage an expert. No doubt a good expert can assist them, but the real collector carries his experience in his pocket, for the expert, like the gendarmes of the well-known French operetta, arrives always too late.

Sometimes a legion of experts are not able to save one from deception. A well-known American collector on a visit to Italy with his small court of experts was once offered in Florence a crystal cup supposed to have been cut by Valerio Vicentino. With the full approval of the experts the cup was bought for the not inconsiderable sum of four thousand dollars. The handsome find turned out to be the work of a faker practising in the North of Italy and the whole scheme planned by a non-Florentine dealer.

The fancy prices paid for antiques to-day and the peculiar idiosyncrasies of this new species of collector have quite logically somewhat changed the character of the commerce, have given another tonality to the *milieu* in which the art lover moves. It must be admitted that the trade in antiques and curios is now far less interesting than formerly. The antiquary and dealer of yore were most interesting and characteristic. Their business could be defined by the Horatian adage, *Omne tulit punctum qui miscuit utile dulci* (he wins the praise of all who mingles the useful with the pleasant), for while they had a keen eye to business, they also possessed the passion and intelligent understanding of art. The real antiquary hardly exists to-day, at best he is represented by some old champion, the solitary survivor of a past generation. The modern variety, even the most enlightened, is nothing but an ordinary dealer. It is no exaggeration to say that traders and antiquaries like old

Manheim and the rest whose intelligent criticism and learning
was of such assistance to the collector are no more. The
vulgar jobbery of the dealer of to-day may eventually find
its justification in the commonplace, unintelligent and gross
clientele upon which it practises. With few exceptions, the
ability of this pseudo-antiquary of to-day is more the ability
of a common jobber than of an intelligent man. The trade
has lost to a great extent the old artistic savour, bluff has
succeeded capability. The new strategy is based upon
knowing before others when some new Crœsus has become
a votary of art, upon getting in touch with him before
he has lost his money or his illusions; it relies also upon
what the French call " puffing what he has to sell," and a
keen insight into the client's weak side, the ability to fan
his pride and ambition.

Of course, as stated above, there are happy exceptions,
merchants still honouring the trade who deal with absolute
rectitude, and would be ashamed to resort to the aforesaid
indirect methods to conclude a sale, but nevertheless " the
gods are departing " and the erstwhile dealer plus antiquary,
this interesting figure once afforded by the art and curio
market, has vanished.

To whatever order a collector may belong—exception
being made for the ultra-modern type who, generally speaking,
has in our opinion hardly any claim to the title of art collector
or even simple curio-hunter—there generally exists a pre-
paratory stage in his career. No matter how the mania or
passion has been caught, there are three stages in its course
that can very rarely be suppressed.

The genesis of the passion is seldom spontaneous, there is
generally an infective cause that helps the development of
the fever for antiques and curios.

"I believe," says Major H. Bing Hall in his book *The
Adventures of a Bric-à-brac Hunter*, " my friend Mrs. Haggle-
ton's taste for collecting the plate of Queen Anne's era
originated in the fact of her aunt having left her a teapot of
that admirable period of the goldsmith's art in England.

ATHLETE.

Imitation of Roman work by an unknown artist of the 15th Century.
It is attributed to Pollajolo.

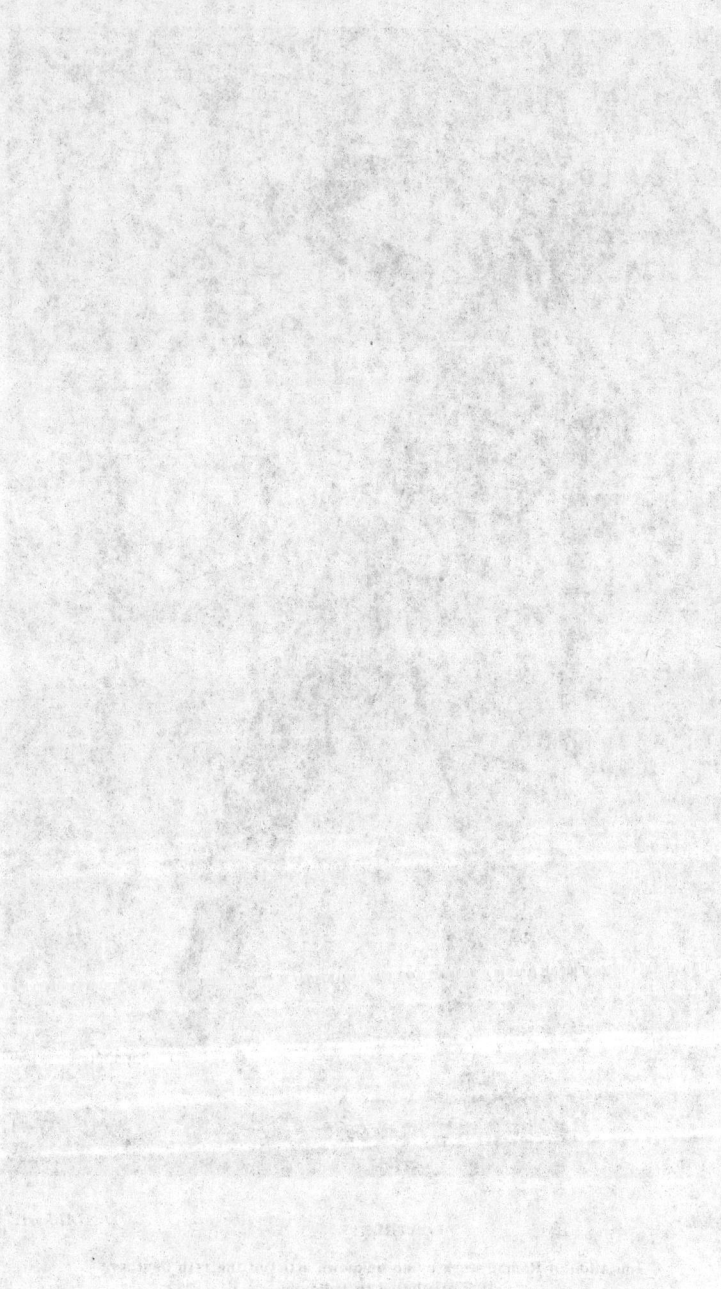

Collectors and Collections

The teapot inspired an ardent desire to possess other articles of the same style. The lady mildly commenced with salt-spoons, and became in due course the proud owner of mustard-pots, salt-cellars, and one large piece of sideboard plate, which from the day she purchased it to that of her death every night faithfully accompanied her to her bedroom. My old bachelor friend Croker, again, began collecting Wedgwood because some one had told him he possessed a very fine specimen; while to my certain knowledge he was as ignorant of its value and exquisite design as his own footman could have been."

There are naturally worthier causes, far higher and more pleasing motives to lead a man of refined taste to become a real practical collector—or dreamer according to circumstances—but the genesis above quoted, to which might be added the having of a collector among friends or relations, is the most common.

One thing is certain, when the passion is genuine and consequently gives proof of being of a character that promises success and satisfaction, there is no cure for it, it becomes chronic almost invariably.

The first stage upon which the collector or simple bric-à-brac hunter is likely to enter might be called the rosy period of his career. He is generally inclined to optimism, he dreams of nothing but masterpieces and astonishing finds, to such an extent that he sees *chefs-d'œuvre* everywhere. If he owns capital, this is of course his most perilous period; if he has no capital, everything depends upon his wisdom, his credit, or the possibility of borrowing money. Naturally we are only referring to the most acute cases, temperaments vary, and the infection may be more or less dangerous according to the disposition of the individual.

Curiously enough, in this Collectomania fever, the first time what might be called a chill is taken, improvement sets in, convalescence perhaps. Chills in the purchasing of curios and antiques often mean an awakening of suspicion of being cheated.

A very bad chill, ague in fact, is usually experienced with the first bad bargain, when, ignorant of possible dangers, one considers oneself a full-fledged connoisseur and adds to one's private collection a pseudo-masterpiece, realizing too late that the purse has been considerably lightened by a round sum paid for—rubbish. There is hardly a more sudden and effectual method of learning wisdom. Some learn at once, others are obdurate and need a whole sequence of misadventures before realizing that they have been cheated, or becoming aware that they themselves are chiefly responsible for being cheated.

These latter over-cheated ones, more especially, either abandon the amusement in a moment of despondency or, if they persist, enter upon the second stage of preparatory training, a stage mostly characterized by scepticism and distrust. At this moment you might offer the neophyte a genuine Titian for a mere song and, blinded by fear, he is likely to believe it a copy; offer him the most authentic medal by Pisanello, the very one he desired, and he will hesitate. Hesitation and colour-blindness are metaphorically the main characteristics at this time.

There is, however, a good-natured type who oscillates, pendulum-like, between one stage and another, from enthusiasm to depression.

Emerging from this second stage of semi-despondency, the neophyte is in all probability regaining a certain equilibrium and realizes above all that the buying of antiquities and curios is no easy matter to be handled by the first newcomer, even though well-stocked with money. This is a salient point in real progress, and from this time each year will add experience and connoisseurship. If the art lover possesses the so-called collector's touch, it is at this particular stage he will discover that such a gift without study and practice does not lead to infallibility.

Speaking of this quality which every beginner believes himself to possess, it cannot be denied that there are people who do have a certain happy intuition of things, an almost

Collectors and Collections 147

miraculous sixth sense, fully testifying to the existence of what the English call the collector's touch and the French name *le flair*, but, alas! it is so very rare. Think of it, rhabdomancy in art!

An amateur's education is in most cases slow and by no means an easy conquest. There are no books that can teach him the practical side, the safe and important side. Book-learning is certainly of great assistance as secondary matter and completely subordinated to the education of the eye. Some of the best art connoisseurs, those of the surest touch, come from an ignorant class of workers, such as the celebrated Couvreur of Paris or the Milanese Basilini, a former carter who was often consulted by Morelli, the Italian art critic and inventor of the analytical method, a connoisseur of undisputed merit.

An antiquary of repute and art dealer of the old school claims that the perfecting of the eye resembles the focussing of a photographic apparatus, with the difference that in photography one can learn how to focus with almost mathematical precision, whereas in connoisseurship it is a continual focussing for when what looks like a supreme conquest is reached, the eye becomes still more perfect and exacting.

Similar progress characterizes the proper valuation of prices, the most elastic side of the trade.

It must be remembered that as soon as an object leaves the shop to enter the collection of a collector of repute, it increases in value, because it is presumed to be genuine and choice, having been selected by an art lover of cultivated taste. Then, too, away from the chaos of the shop and in a good light a work of art shows at its best.

In every branch of commerce there are shops and shops, Piccadilly and Cheapside mean the same also in the world of curio and bric-à-brac.

In conclusion, apart from the pleasure afforded by the pursuit of fine objects, there is hardly a better way for a collector to invest his money, provided he knows how to do it; and there is no worse business, none so unreliable

and hastily ruinous as curio hunting if one is not a true and real hunter.

What to buy as safe investments is told by Gersaint, a dealer and connoisseur of the eighteenth century. He says that " by sticking to what is beautiful and fine one has the satisfaction of becoming the possessor of things that are always valuable and pleasing. I dare say that going in for the *beautiful* diminishes the probabilities of being duped, as often happens to those who are content with the mediocre or are tempted by low prices. It is very rare that a first-rate work of art does not realize at least the price paid for it. The mediocre is likely to lead to a loss."

This advice, however, tacitly presupposes the collector to be able to tell the fine from the mediocre, to be, in a word, either an artist or a connoisseur.

With this part of connoisseurship we propose to deal in another chapter at the end of this work. At present we would state that the safest thing for an art and curio collector to do, whatever his ambition, is to become acquainted with the various ways of the peculiar *milieu* into which he is about to enter, to train his eye as much as possible, to be diffident at first and to have a passionate love for his interesting pursuit.

It will then be for the collector a source of no common enjoyment and a most pleasing occupation, an occupation somewhat justifying the following lyricism of Schlegel :

" There is no more potent antidote to low sensuality than the adoration of the beautiful.

" All the higher arts of design are essentially chaste without respect to the object.

" They purify the thoughts as tragedy purifies the passions. Their accidental effects are not worth consideration ; there are souls to whom even a vestal body is not holy."

As the reverse to the ideal side let us warn the neophyte that the supreme joy of art-hunting is often embittered by the jealousy of colleagues, and that benevolence in the environment in which the collector moves is as rare as the ceramics

Collectors and Collections 149

of Henry II and the painting of Michelangelo; so much so that Edmond Bonnaffé was fully justified in re-editing an old Latin saying into:—

"*Homo homini lupus, fœmina fœminæ lupior, curiosus curioso lupissimus*" (A man against man is like a wolf, woman against woman still more so, but most of all is curio-hunter against curio-hunter.)

CHAPTER XIV

THE COLLECTOR'S FRIENDS AND ENEMIES

Curio-trading—The collector's friends, semi-friends and enemies—The antiquary, the so-called private dealer, the dealer, bric-à-brac vendor and others of the species—Art critics and experts—*Courtiers* and other go-betweens.

MADAME ROLLAND writes in her famous *Memoirs* that one of her greatest objections to a certain suitor was the fact that he was a trader. " In commerce," said this brilliant victim of the French Revolution, " one is supposed to buy at a low figure and sell at an exaggerated price, a scheme usually demanding the aid of lies."

Leaving with Mme Rolland the responsibility of such an assertion, it is quite safe to say that the trade in antiques, the flourishing commerce in curios, is a trade, if ever there was one, in which objects are bought cheap and sold at a high price, with a stock of lies as a necessary asset.

Naturally the statement does not imply that every dealer is a confirmed liar, ready to take advantage of the incautious and unskilled novice through misrepresentation. Yet even at its best the character of the trade in our day is such that it is difficult to score success without—what shall we say ? —flavouring opportunity with fantastic tales, without firing the client's enthusiasm with some form of mirage, namely, tricking his good faith to entice him within the orbit of—faith.

Point out to a buyer, for instance, the different parts of an object that have been skilfully restored, and nine times out of ten the customer will drop the whole business.

Collector's Friends and Enemies 151

It is incredible the amount of stuff even a good art lover will swallow, if properly offered by a person he trusts, just as it is incredible to see how the enhancing of merits with —grey lies, will help the conclusion of a good round piece of business. One must have had a glimpse at the make-up, have taken a peep behind the scenes to become aware that the more imposing the transaction, the more diverting and genial is the comedy played before the customer, who, at first a spectator, in due time will be called in most cases to take his part in the play, the part of the duped.

There are methods to work up public enthusiasm greatly resembling those adopted by the scheming capitalist in the Stock Exchange.

An English curio dealer of unquestionably high repute realized large profits on Dresden china by the artful way he put before the public an article apparently out of fashion with collectors of ceramics. For two or three years he bought all the Meissen ware within reach until he had accumulated a large quantity at extremely low figures. Then he began sending pieces to noted auction sales, where he invariably sent agents to buy them in after running the objects up to an extravagant price. This trick gradually built up a reputation for Meissen china, some noted collector began to take an interest in it, others followed in his wake. When Meissen ware became the rage and prices were accordingly high, the shrewd dealer got rid of his stock at an astonishing profit.

Nothing absolutely dishonest, one may observe. Yet without stopping to ask whether the action comes within Mme. Rolland's hyperbolic conception of honesty, it cannot be denied that in the fine art and curio trade what might be defined as the staging part is the most important, even if it finds its greatest justification in clients who follow one another in taste like so many sheep.

The trade in curios may be more specifically outlined by the study of the dramatis personæ taking part in it. It will then be seen that the artifice practised by the London

antiquary of good repute is rather an anodyne form of misrepresentation. Such trade tricks differ from the commonplace ones characterizing unclean dealing in other branches of commerce; there is a smack of genius about them which might at times plead for the pardon that Draconian laws accorded to well-thought-out and talented forms of theft. A picture of the clever plots and amusing intrigues planned to the detriment of the modern collector would demand the pen of a Molière. Only the illustrator of Monsieur Tartuffe could give the proper colouring to such inconceivable plays.

These plays are hardly new, however. They have been constantly acted and re-acted with creditable success and enlivening innovations. Formerly fools alone were the victims, rarely real collectors. To-day it is different, with the advent of the new type old distinctions have disappeared.

Some among the many art collectors are intelligent in their work, and far from being beginners. They are outsiders, however. Let them look within the penetralia, into the mysteries, the hidden secrets of the trade so carefully concealed from them, and they will learn how little exaggeration there is in the saying that a large portion of the business in antiques and curios is tainted with fraud, charlatanism, etc., and that even some of the best collectors of our time have been deceived to such an extent that they live surrounded by their objects of virtu as in a sham El Dorado.

One of the late Rothschilds, a man known traditionally and *de facto* as a connoisseur, a type of genuine collector, used to say that all the objects of his collection were, like Cæsar's wife, above suspicion. Yet by the side of the finest masterpieces there were some in that collection which were, metaphorically speaking, wives that Cæsar would certainly have repudiated.

"I would no more admit forgeries to my collection than I would allow my wife to wear paste diamonds," was the boast of a well-known collector of bronzes in Paris to a party of connoisseurs lunching with him. "But excuse me," retorted

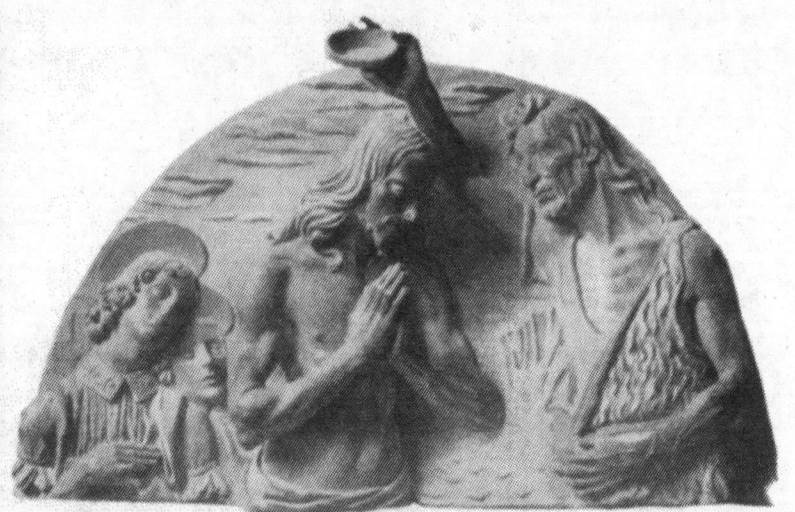

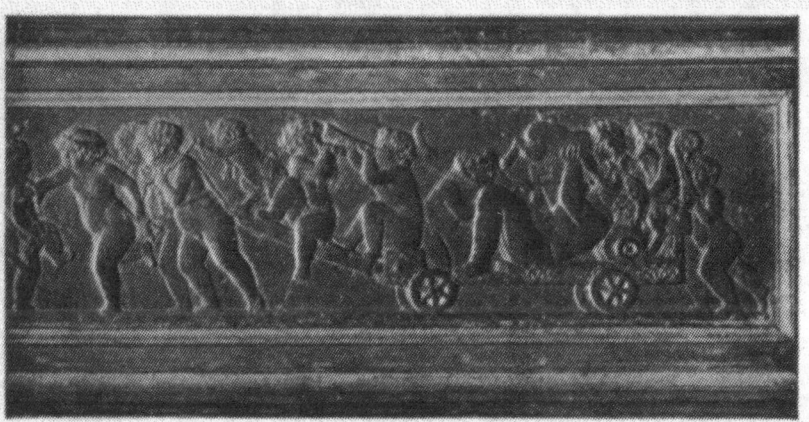

THE BATTESIMO.

A Bas-relief by Sig. Natali, of Florence, bought by the Louvre as work of Verrocchio. Sig. Natali, a fine imitator of the Quattrocento, like Sig. Zampini, sells his products as genuine modern work even if the connoisseurs decide to believe them antique.

BACCHUS.
By DONATELLO.

Collector's Friends and Enemies 153

a moralizing friend who was dying to reveal the truth to the " great specialist," " no one is safe nowadays. There," pointing to a bronze figure, " that is, what shall I say ? a paste diamond ! That object is a fake. I can tell you where it was cast. It was offered me very likely by the same fellow that must have palmed if off on you. . . ." There was no trial, however, because the great bronze specialist recovered his money from the dealer—but, alas ! not his unblemished reputation.

Such stories are not strange when it is considered that museums are regularly infested by forgeries and spurious objects and that these have been admitted to public collections with the full approbation of learned curators and clever specialists. It is easy to estimate how rampant and keen faking must be now that incredible prices are paid for articles of virtu.

How the antiquary, the dealer, the go-between and other characters in this world of deception may prove to be, according to circumstances, the friend or the enemy of the curio collectors, is readily understood. Discrimination, sometimes too late, will teach who is a helper and who not.

The antiquary is generally a dealer who has no shop, but keeps objects of art in his tastefully furnished house, allowing his private show to be visited only by whom he chooses. He is as it were the aristocrat of the trade, the one who is presumed to ask and get the highest prices. This select dealer's success is according to his ability, integrity or the reputation for trustworthiness he enjoys among collectors. We would repeat that the "private dealer" belongs to this high branch of the trade without any definite division. Very often he is a disguised trader with the grand air of a gentleman—an air that has to be paid for by the client, who is less likely in such a sphere to attempt to drive the hard bargain that is peculiar to the humble bric-à-brac shops.

The best and most reliable antiquaries and private dealers must logically be reckoned among the friends of the art lover. The latter is likely to pay them astonishing prices, but he also

pays for security. He knows that the dealer's experience is absolutely at his service, and that if by mischance an object is not what it has been represented to be, the honest dealer will make it good.

To end with a brief classification, it may be noted that there are dealers whose shops have private rooms in the rear where trade can be carried on in the same way as with a dealer who has no shop. From this double-faced form we pass to the real shopkeeper, the vaster class ranging from the vendor who can afford to fill his window with the choicest samples down to the modest curio shop, the benevolent harbour of the humbler modes of expressing art.

With the exception of the unassuming curio shop, which is still unchanged though less replete with interesting things and quite denuded of tempting "finds," the disappearance in the dealer of his former artistic sentiment has fomented in the trade the spirit of association. Trusts and alliances have been formed by big firms, though the advantage to the amateur is to be doubted. At one time such a thing was very uncommon, if not impossible, being apparently prevented by the dealer's originality and artistic temperament.

"*Monsieur, je ne suis pas le gendarme de la curiosité,*" old Manheim used to say to the novice showing him objects not purchased from his gallery. This was the old attitude of the trade. We do not mean that all behaved like Manheim in refusing to play the part of "policeman of curio-dealing," others may have taken the opportunity to run down an article sold by a neighbour, but there was no probability of an object passing from one firm to another in search of better success, or going from Paris to London and vice versa to find the proper atmosphere or the suitable kind of knavery. Psychologically speaking this is speculating on a faddism similar to that which induces the Parisian dandy to send his shirts to London to be ironed, and at the same time suggests an inverted game to the London snob who may believe that Parisian starch is without an equal for shirt fronts.

Collector's Friends and Enemies

The spirit of association and a perfected knowledge of the idiosyncrasies of the modern buyer have led to the discovery that some objects show to better advantage in Paris and that others gain in the sombre grey atmosphere of London, that each background has its peculiar value and may be turned to account respectively in the realization of higher figures. There are even special cases when to fetch the best price an object must be sent to its birthplace where the freakish or immature client's fancy may be tickled to advantage. The whole of this complex game in modern curio dealing may be summed up in the single maxim: "Find the vulnerable spot, the Achilles' heel of your client, and you are safe." It must be added that the Achilles' heel of the modern collector may be of a more complex anatomy but is of more extended proportions than that of the Greek hero. As soon as a star of first magnitude bursts forth upon the financial sky to rise upon the artistic one, all the forces of the latter quickly learn dynamic precision, the extent of possibilities. Whether erratic or not, the orbit of the new star will be studied throughout its course with astronomical exactitude. To continue the metaphorical image it may be added that should the new star prove to be of solar magnitude a whole planetary system of cupidity and greedy desire will soon be formed within its golden rays.

From now forward it is of this shady brilliancy of the planetary system of the curio world that we intend to speak. The honest dealer needs neither our praise nor defence, he can take care of himself, and the esteem he enjoys plainly divides him from the sphere upon which we are entering, the precinct of an art and curio inferno which might bear Dante's superscription: "Through me is the way to the city dolent."

As the main principle of curio-dealing is to buy at a low figure and sell at the highest price possible, it is evident that when this apophthegm falls into the hands of the unscrupulous, the art of buying and selling takes on most Machiavellian hues.

The infrequency of good bargains, which are becoming

Collector's Friends and Enemies

rarer every day, has lately fostered the activity of competition, making the art of buying a shrewd, unscrupulous game, in which the dealer, with his numerous emissaries, is prepared, Proteus-like, to invest himself with every imaginable part.

If an object cannot be secured in a direct manner, the dealer will indulge in side-play, called in the Italian argot of the trade, *di mattonella*. When dealers are not admitted and it is important that the object should be inspected before the conclusion of a business transaction, the antiquary or shopkeeper, namely the buyer, is generally careful to hide his professional quality. He is often introduced as a foreign casual visitor interested in art.

If the pretended foreigner does not succeed in obtaining the object because the owner, perhaps a gentleman, has demanded a big price, then other characters, the decoys in the play, may be put upon the stage to say that the object is not worth the price, that it has been injured in restoration, etc. Sometimes the pseudo-foreigner assumes the part of a novice naively confessing that he is not versed in antiques, but should Professor So-and-so give a favourable opinion he would willingly remit the price. The rest is left to the sham professor.

Of the self-disguising tendency of a noted Italian antiquary when in search for the ever-rarer good bargains, the following amusing story is told.

A noble family of Pisa were induced, by financial circumstances, to part with some of their valuable works of art and made the condition that no antiquary or dealer was to be mixed up in the transaction. A certain Florentine antiquary noted for craft and trickery, in particular, was to be excluded.

The said antiquary got wind of the unusual opportunity and managed to visit the palace in the guise of a stranger. He saw a certain work of art and a bargain was struck with Count Z., the head of the family, to the satisfaction of them both. As the antiquary was about to leave the nobleman said, confidentially, "Don't let anyone know about this

affair, nor that I am selling things. I have a particular objection to dealers, above all to a certain intriguer and thief——" Here he named the very man he was addressing.

When bargains are made on the plan of exchanging one object for another, they are no less disastrous for the unwary and ignorant owner. There are Madonnas by good Renaissance artists that countrymen and villagers have gladly bartered for cheap modern chromo-like paintings worth only a few francs, old artistic stuccos and bas-reliefs secured for some cheap piece of plaster-cast, pieces of old damask exchanged by ignorant priests for a few yards of brand-new shining satinette.

Even such exchanges necessitate at times certain wiles, such as stories by "go-betweens," garbed as monks or priests, posing as benevolent friends of the church or some other meek character.

A philodramatic society, owning a small theatre, once used a piece of fine Flemish tapestry as a drop curtain. Dark and unattractive to the untrained eye, the curtain was hung for lack of a better. It was objectionably heavy to raise or lower. To make things easier and lighter, a Mæcenas of the dramatic art offered to exchange the old clumsy curtain for a new one painted in the most approved style. The proposal was accepted with enthusiasm, and after some time it was casually found out by one of the actors that their former curtain had been sold in Paris to a French collector for a sum that would have built the needy society a palatial theatre.

If a dealer does not succeed in securing a work of art he is apt to spoil all chances for others by what is known as *mettere il bavaglino*, that is, metaphorically, to tie a bib round the neck of the object. The game is played by enthusiastically praising the article that it has not been possible to acquire.

When a certain kind of dealer finds that his offer has not been accepted he becomes artful, admitting that he has tendered all he is able to give, but that he honestly recognizes the article to be worth more. Proceedings now evolve much

as follows : " How much do you think it is really worth ? " asks the owner with legitimate curiosity. " A dealer richer than myself might pay so and so, but then an outsider, of course. . . ." Here the trickster is not likely to estimate the work but will vaguely convey an idea of its immense value by telling of recent sales where millions have been paid for works of art. The result is that the owner loses all balance as regards the value of his object, and in all probability will never sell it for the simple reason that he raises the price every time the sum demanded is reached. A doctor in Lucca who possessed a passable Maestro Giorgio, a ceramic piece that may have been worth ten thousand francs, was unacquainted with its value and would have been willing to sell it for five francs. He received an offer of fifty francs for it, and thinking it generous for a cracked bit of earthenware, became suspicious. Very soon the dealer bid a thousand francs, then gradually worked up to three thousand, the price he had made up his mind not to pass. Then when the " bib " was properly bound round the article he boldly offered fifty thousand—naturally intending to turn it all into a joke should the offer be accepted in good faith. The castle-builder died dreaming of millions, of course before having parted with his dish. The heir sold it for a moderate sum, so moderate a one that it might have raised a posthumous protest from the dead doctor.

In like manner, but this time by way of a joke, an antiquary persuaded a countryman that a brass dish he owned, for which he had refused the few francs that it was worth, was priceless, that there was gold in the alloy and that the chiselling was a lost process in the art of working brass. The specimen was *rarissimo*, he said. As a finishing touch and to give it a flavour of Boccaccio-like humour, he occasionally sent friends to play the part of anxious buyers, offering higher and higher sums. Gradually dealers entered into the spirit of the joke and on passing the village never failed to offer a few hundred francs more for the now celebrated dish.

This trick is also called *inchiodare un oggetto* (to nail down

Collector's Friends and Enemies 159

an object), and is variously denominated in the different provinces of Italy, the curio-dealers' argot varying according to district. The slang peculiar to the trade has not a wide vocabulary, but comprises a few phrases and words by which the initiated can express an opinion upon some special thing or the artistic value of a certain object without being understood by the outsider. For instance, the word *musica* is indicative of faked objects, not as a single word but set in a colloquial phrase. A dealer who wants his aide-de-camp or go-between to know that the object in question is modern and not worth wasting time over, yet would convey this opinion in the presence of the proprietor without letting him understand, is likely to warn his colleague in some such a way as this, "Before I forget it, remind me to buy that piece of music," or any other phrase in which music comes in naturally. To state that a price is too high, that there is no margin for business, or maybe even risk, the dealer will use the word *bagnarsi* (to get wet). It may also be merely hinted as, for instance, "Have you your umbrella?" if it should be raining, or in good weather, "No need for umbrellas." Rather than containing a wealth of words the jargon is fanciful and pliable, forming a sort of summary esperanto which with a few words furnish the freemasonry of the trade with multiform expressions.

The complementary characters to which we have alluded in our bird's-eye view of the curio market are liable to exchange their functions according to the moral principles directing their actions, and in this peculiar chameleon-like attitude change colour and hide, from friendship to enmity, assisting the collector in his pursuit, namely, of helping the dealer to dupe him. In broad terms they include art critics, experts, go-betweens and many metamorphoses of the most variegated agents. To these forces must be added the silent help that is generally operative in favour of the dealer. These are drawn from the multiform and numerous guilds of the restorer, and from the questionable side of the trade, namely, fakers, assumed owners, noblemen or pseudo-noble-

men willing to lend paternity and pedigree to works of art, smugglers and other degenerate forms of criminal and semi-criminal activity.

Speaking of the friends and enemies of the collector whose co-operation is more or less openly apparent and of a less mysterious character, it may be said that the art critic and expert once represented two entirely distinct forms of interest in art. A certain recent evolution of the art critic tends to intermingle the two groups.

The art critic of years ago was, as a rule, either a literary man who had a notion that he knew all about art by simple instinct, or a scholar who, having studied the historical part of art, imagined that this knowledge was more than sufficient to label him a connoisseur.

The victims of this misunderstanding were not only the art critics themselves but museums and public institutions trusting to their knowledge of art and giving them posts as curators or advisers, thus throwing their gates wide open to faking—as erudition without eye or experience seems to possess that deceitful form of suggestion which so rarely affects the cold, keen intuition of the real connoisseur.

That scientists fall an easy prey to suggestion and are prone to daring or misleading hypotheses in art or archæology is beyond question. It is perhaps in the nature of their analytical work to tend to remain purely and simply analytical.

Numerous and interesting anecdotes could be repeated.

A case of archæological suggestive fancy is told by Paul Eudel. A piece of pottery was brought to a member of the *Académie des Inscriptions* as it bore a rather cryptic sequence of letters that had proved puzzling to other authorities. The pot with the letters in question, M. J. D. D., had been excavated near Dijon. As soon as the *Academicien* saw the letters he had no hesitation in pronouncing it to be a Roman vase, a small amphora used as an ex-voto. The letters, he said, represented the initials of the Latin invocation :—

MAGNO JOVE DEORUM DEO.

Collector's Friends and Enemies 161

Being a question of a votive offering, nothing would be more consistent than the words, "To the great Jupiter, the god of gods." Unfortunately such a splendid piece of inductive learning was shattered when an ordinary art dealer examined the jar and declared it to be anything but ancient, a mustard-pot in fact, the initials meaning

MOUTARDE JAUNE DE DIJON.

For a considerable time an inscription found on a worm-eaten piece of a sign-board puzzled the world of erudites. The inscription, evidently the work of a jester, ran thus :—

```
I . C . I . . . . . . . . . . . . . E . . . . . . . . . S .
T . L . . . . . . . . . E . C H . . . . . . . . . . E .
M . . . . . . . . . . . . . . . . I N . . . . . D . . E .
S . A . . . . . . . . . . . . . N . . E . . . . . . . . . S .
```

Needless to say many explanations of the obliterated letters were prompted by the learned suggestive fancy of professors, and many interesting reconstructions of the ancient inscription were given. The riddle, however, was not solved till some one perfectly unacquainted with the art of reading old inscriptions happened to read the letters straight off without regard to spacing, furnishing the following true explanation :—

ICI EST LE CHEMIN DES ANES.

This is the way for asses! has since become a byword in lampooning blind erudition.

Though art was not in question here, the anecdote nevertheless illustrates a tendency of inductive science, a mania, namely, for hypothesis and explanations which in the case of art often encourages the blunders of auto-suggestion. A great distinction between practical and learned opinion is that the former rarely gives at first sight the name of the author of a painting or statuary, whereas the latter almost

invariably baptizes works of art. Hardly has a learned art critic cast his eye upon a work and out pops the name of the artist, the school, etc. Let him talk and you will soon discover that his conclusions are not based chiefly on the perfected comparative work of his eye, but upon notions that book-reading has massed in his head. He will refer to the now almost prohibited and threadbare authority of Vasari—what would an art critic do without Vasari either to abuse or quote—saying that such and such an artist painted so and so, and speak of the influences of masters and schools, go through a list of quotations from Crowe and Cavalcaselle down to more modern writers, display any amount of borrowed wisdom but no originality; finally, through lack of a trained eye, he will grow poetic and enthusiastic impartially before a genuine work or a faked masterpiece.

Were not curio dealers a rather close-mouthed guild, they might divulge some interesting incidents with regard to this subject, and prove that though the case is uncommon there are in this trade not only fakers of great masters but master fakers of public opinion as well.

Of the expert, Henry Rochefort says:

"At first this name *expert* appears to awake in us the majestic idea of science and authority. A dangerous opinion to entertain."

As a matter of fact there is no control, for, as Rochefort goes on to remark: "Who can prevent a citizen from calling himself, for instance, an expert in pictures?"

The dangerous vagueness of the profession, the facility with which the title is acquired, together with the multitudinous offices it fills, make of the expert a perilous companion at times.

There is no doubt that when the magniloquence of the title is justified, through unquestionable ability, supported by a reputation of untainted honesty, the expert may be of the greatest and most valuable assistance a collector can desire. His ability must then be paid for at what it is worth. But even when highly paid it is cheap compared with the

Collector's Friends and Enemies 163

blunders the expert is likely to save the collector—those costly blunders that are so often an integral part of the commencement of the career.

On the other hand, what an ignorant expert, in his supreme disdain for learning, is capable of saying when tendering information, is incredible.

Rochefort has made an amusing collection of blunders by experts when called upon to pronounce an opinion on matters in which practice counts for nothing. The anecdotes were gathered by the French writer in the public auction rooms of Paris where the expert has an official function. Here he is prepared to furnish details and useful hints regarding the objects put up for sale, to enhance their importance.

A collector confided to the care of an expert, Monsieur F——, a painting of a religious subject representing a scene from the Apocalypse. Giving this information, the owner asked the expert to put the painting up to auction at the first important sale.

According to arrangement, Monsieur F—— included the work among other canvasses at a public sale and printed in the catalogue as a description of the subject: *Tableau de sainteté d'après l'Apocalypse* (Sacred picture after Apocalypse).

"*D'après l'Apocalypse?!*" questioned some one when the work was offered for sale. To which the unabashed expert promptly replied:

"Yes, sir, Apocalypse; a German painter not very well known in Paris but highly esteemed abroad."

Another such catalogue, the product of a no less imaginative expert, announced a canvas on sale to be the portrait of Louis XV by Velasquez! A figure of a woman washing dishes, attributed by the expert to Rubens on account of the exuberant rotundity of the model, needed perhaps a further justification for this daring attribution, for it was decorated with the following astonishing comment: "Portrait of Rubens' wife." (It is generally known that Rubens married his cook.)

164 Collector's Friends and Enemies

The recent mania of the collector to possess masterpieces has turned the expert to a most versatile form of activity in order to please this exacting fancy of the buyer. A painting becomes " of the school " of this or that artist when it is really too bad to bear even the uncompromising qualification, " attributed to so-and-so."

It is difficult to tell when a man ceases to be an expert and becomes invested with the part of *courtier*, because in keeping with the general character of the various functions of the curio world, there is no definite and plain delineation between the one capacity and the other. The *courtier* is naturally supposed to know all about the trade, to possess the necessary elements for appreciation of artistic value and to make others appreciate it. His chief mission, however, is to smooth over business difficulties that might arise between the seller and the buyer. As may be logically expected, the metamorphoses of this personage are infinite and may be useful or not to the collector according to circumstances. In conclusion, the go-between is not only often a necessary complement but may at times be used to great advantage. The difficulty lies in knowing how to choose the right sort.

CHAPTER XV

IMITATORS AND FAKERS

The dealer's silent partners—The important and interesting guild of restorers —The imitator an unwilling accomplice—On the shady side of silent activity—Again the faker—The patrician who supplies the pedigrees— The smuggler and his ways—The "black band"—Wise tactics.

WE now enter the department of the curio dealer's silent helpers, the manifold activities assembled under the broad if not indefinite name of restorer. A brief glimpse into this part of the trade will lead us to another artistic division, that of the imitator, and these two last classes of an unquestionable character will serve admirably to herald and usher into that deeper, darker stratum of the commerce in which the faker represents the principal character.

That the restorer should be called the curio dealer's silent partner is quite correct as a true definition. The day one of these mute confidants should feel inclined to boast, he would find no mercy from the dealer and no gratitude from the duped or disappointed collector whose eyes he had opened by revealing the truth.

This was fully exemplified by a clever restorer of paintings, employed by an Italian antiquary at forty francs a day—no mean pay—on account of his unusual ability in the imitation and restoration of works by Botticelli more especially, as well as for other *pastiches*. Thinking to start a profitable business of his own as an art restorer and that his merits would be valued *per se*, he disclosed the secret of the made-up Botticellis to a rich collector and let out that he himself to all practical purposes had painted the gem of the gallery. He was promptly discharged by his employer and

the collector to whom he had told the truth became his worst enemy.

The activity of the restorer is naturally multifarious, many-sided as is the trade in curios. His methods will be better explained when art faking is described. The procedure in imitating, restoring and faking is more or less identical, though in faking it is more synthetically perfect than when limited to restoring various articles of virtu. There are people who consider restoration a blessing, others the reverse, a regular curse; particularly in the case of works of art of no mean merit.

Without doubt the restoring of works of art has at times greatly contributed to their preservation, and more than one masterpiece has come down to us, thanks solely to some clever restorer who at the right time prevented its complete ruin. This is the good side of the profession, but as for its reverse, the art of restoring has, through the ignorance of workers, greatly damaged well-known works of art by the repainting or obliterating of different parts, often helping deception by embellishing bad art into deceitful good art. In this way the art of restoring has proved a bridge to fakery.

Restoration at its best and in the true artistic spirit never consents to falsify any part of the work. Lies, even in art, no matter how well they may be told, remain lies.

Artistically and ethically speaking the operations of the restorer should be confined to work intended to save a work of art from the ravages of time. These operations are many, most varied and not at all easy. They demand long practice, a deft hand, patience and skill as well. The process of restoration may mean, for instance, the transference of the layer of paint from a rotted panel to a new one or to canvas, the consolidation of a ceiling painting or other deteriorating forms, revarnishing and, to a certain extent, cleaning.

In sculpture orthodox restorations appear to be of a more limited character, being chiefly confined to collecting broken pieces and surface cleaning. Of course the repairing of limbs

Imitators and Fakers

and missing parts has its importance if done with great artistic discrimination.

According to responsible art critics the restoration of paintings may consist of repainting the missing and obliterated parts and that of sculpture in the replacing of lost fragments only when decorative parts are concerned, important for the better comprehension of the whole but not expressing any marked characteristic of the artist.

When in the service of the antiquary, the art of restoring has no such scruples or limitations. As a matter of fact its limits then rest with such restrictions as the dealer's conscience may impose, and it must be confessed that this is rather a narrow and at the same time very elastic boundary. The different views as to restoration are epitomized by the curious distinction made by connoisseurs and dealers, when judging between the two cleverest restorers of Italy. The upshot is: If you have a painting that needs repairing and you wish to restore it to its former state go to Cavenaghi, but if perchance you are interested to sell it go to—the other one.

Disproportion and overdoing in restoration turns this very legitimate art at times into sheer faking. A bust of a Roman emperor, for example, that may have been found headless and which the restorer completes into a Julius Cæsar by copying the head of the great Roman dictator from another statue, represents a form of faking. Yet, were our programme one of disclosing the names of saints and sinners instead of that of pointing out sins, we could designate more than one dealer of good repute who sincerely thinks, we may assume, that his form of daring and attractive restoration cannot be called faking.

Another rather questionable form of restoration is that of composing, say furniture or any other ornamental goods, from old bits or fragments taken from various rotten objects. There is no doubt that a tasteful artificer can do effective work by composing a table out of two or three broken ones, but nowadays such is the abuse of the method that we are only surprised that the trick is not more easily discovered.

Imitators and Fakers

Some of these gross and hastily put together compositions of uneducated dealers must count upon clients not only ignorant, but utterly deprived of good taste. The faking qualities of this method are proved, for as soon as the buyer knows of the admixture he refuses to buy the object. Yet such trickery is generally admitted in the trade.

There is, perhaps, a justification for this method of restoring antiques when the character of the article is decorative, as in certain pieces of furniture, marble or stone work, such as chimney-pieces, ornamented doors and so forth. Yet even in such cases honesty would seem to claim that the buyer be warned as to the extent of the restoration.

Nevertheless the temptation to keep the secret must be great, considering how rarely such patchwork is discovered even by experts, and how easily it calls forth the praise and enthusiasm of art critics.

Another form of restoration of a most questionable character, as the decorative nature of the object cannot be claimed as an excuse, is that, by which a painting is transformed or embellished by repainting large missing portions more or less fantastically, or by supplying the artistic quality that is wanting. Such work is either done by totally repainting the missing parts, or by veiling and repainting here and there, so as to give the work the attractiveness of a masterpiece.

Naturally in the vast field covered by the questionable genius of this deceptive art, limits are set by the greater or lesser capacity of the restorer, just as the quality of the restoration determines whether he is to be called a professional repairer of paintings or a faker.

It is incredible what an amount of work is executed nowadays intended to give a coquettish character to a daub, or to enhance the value of a fairly good painting. Even many masterpieces sold in recent times have been to our knowledge decorated with fantastic backgrounds of castles and quaint landscapes, and mottoes and coats-of-arms have been added to portraits. A barrel of alcohol—spirit, it is known, dis-

Imitators and Fakers 169

solves fresh varnish and modern retouching—would accomplish wonders with famous masterpieces of recent acquisition and cause many a disillusionment to the curators of museums.

As regards the juggling of poor or deficient works of what is generally called a school, into a *trompe-l'œil*, making one believe it to be a painting by the master of the said school, should Italian export officials be inclined to make public what is intended to remain private, many an astonishing *coup de théâtre* would reveal the true nature of supposed masterpieces bought by unwary collectors as genuine *chefs-d'œuvre*.

A member of the board of exportation explained to the author, how it happens, that the officials are frequently led into the penetralia of the make-up of a pseudo-masterpiece. Sometimes the work is done so well that it would deceive the very officials and experts of the export bureau. In this case the antiquary, who has sold the painting and is desirous that it should reach its destination without hindrance from the export office, pays a visit to the inspector and shows him a photograph of the supposed masterpiece, as it appeared before its coquettish restoration. After this graphic proof the office has nothing more to say and permission to export is granted. The members of the Commission do not consider themselves to be responsible to collectors. But they do demand documents as guarantees, and two photos, one taken before restoration and one after, are generally exacted and kept in the office. One of the Commission showed us some of these photographs, two in number for each object, before and after the restoration. One could hardly believe the miracles accomplished in this line. Botticini easily becomes a Botticelli after a few caresses by a clever hand, and we know cases in which a mediocre work by Ridolfo Ghirlandaio has been turned into a Raphael. These photographs are exacted by the inspectors as a protection from any possible accusation from the central department located in Rome. When the Press gives an elaborate account of some

Imitators and Fakers

American having captured a masterpiece, giving facts and details and the reproduction of the *chef-d'œuvre*, adding that it comes from Italy, when London art magazines go into ecstasies over some newly-acquired find, and wonder how the Italian Government came to allow such a magnificent "find" to slip through its fingers and cross the frontier, the Central Office in Rome naturally becomes alarmed and demands an explanation from the local office responsible for the exportation permit. As a convincing answer the two photographs are then sent to Rome, with the consequence that the case is dismissed. The various export offices, whose chief duty it is to impede the exodus of fine works of art, do not consider themselves under any obligation to prevent sham masterpieces from leaving Italy.

The imitator, a type to figure later as a help to the better understanding of the faker, occasionally becomes an involuntary or accidental accomplice in deception. His complete equipment, his excellent work, which but for his rectitude and scruples might turn him into a formidable faker, are frequently exploited by others, who, on coming into possession of some of his good imitations launch them upon the collector world, just as they might any species of faked works of art. Many of the noted bastard masterpieces in museums are the work of imitators that have been palmed off by tricky dealers without the consent or knowledge of the artist, and it has often been the latter who has helped in the discovery of the fraud.

There are also cases when simple plagiarism or chance similarity has been turned to advantage by shrewd people. The fact that Trouillebert's painting greatly resembled Corot, was sufficient to give corrupt dealers the chance to pass off Trouillebert's landscapes as works by the famous French master. This was done, of course, in spite of Trouillebert's protests, who never thought of imitating Corot.

It is curious when some work of a clever imitator or genial faker falls in the course of time into the hands of the restorer to be repaired—there are circumstances in which modern

Imitators and Fakers

paintings may need repair. Something still more extraordinary happened to a clever restorer and imitator living in Siena who received from England one of his own paintings —one of his first imitations of Lorenzetti—obviously damaged and entrusted to him for restoration.

There are other characters which will form the subject of a more particular study. These individuals belong to the shady side of the commerce and have no redeeming points whatever. They comprise fakers, forgers, smugglers, deceivers at large, and the whole clan included in the vague and broad term " the black band," as some collectors call them.

The faker is the *Deus ex machina* in the most varied kinds of deception. Fakers are not only those who furnish spurious works of art and well-imitated articles of virtu, but also those who help in any form or manner to dispose of sham objects. Thus the parts played by masquerading aristocrats, lending their names and swearing to heirlooms, the debased patricians helping to build the reputation of an artistic product, are forms of faking, as well as others which aim at cheating or deflecting public opinion or a genuine appreciation—forms of faking that will be more clearly outlined when degenerate varieties of art sales are described.

One of the most clandestine helpers of art and curio-dealing and one who is in close contact with the dark side of the commerce is the smuggler, a genuine specialist not resembling other smugglers but with characteristics of his own worth notice.

Needless to say smuggling has no *raison d'être* in such countries as have no custom laws to regulate the export of artistic goods nor put duty upon their entrance within the precinct of the State. It is also obvious that the dual form of such legislation, laws to prevent exportation, and importation dues, has produced two corresponding kinds of smuggling, the one aiming to baffle prohibitive laws on exportation, and the other trying to undervalue artistic goods generally taxed *ad valorem*.

Imitators and Fakers

Italy being the classical country of art treasures which have been exploited for centuries, and the first to issue laws and penalties on the subject, it is naturally ahead in the cryptic art of smuggling. The high tariff of the United States, but recently abolished, and the incredible prices paid by the citizens for antiques and works of art in general, make it the country best adapted to illustrate the branch of smuggling which aims at avoiding Custom House dues.

When reading old and modern laws promulgated against illicit exportation of works of art, one cannot help wondering how such daring still exists, and how there should still be people willing to brave the severity of these laws. The Medicis, it is known, prescribed punishments in the second half of the sixteenth century; the Papal laws that followed were if anything even more Draconian, to say nothing of the iron laws of the former kingdom of the Two Sicilies, the severest of them all. Modern governments may not impose prison and galley so freely upon the culprit, but they are no less hard on the transgressor. Money fines are certainly exceedingly heavy, they amount at times to large fortunes.

The present laws on the export of art from Italy have a preventive character which the old regulations had not. Every owner of a work of art is himself eventually responsible, and is bound to bring it before the inspectors of the Export Office, who after close examination give or withhold permission to pass the frontier. When permission is granted there is a tax to be paid averaging between 5 per cent and 20 per cent *ad valorem*, according to the inspector's estimate, and should the object leave the country after permission has been refused, the owner is held responsible and may be called before the tribunal to answer for his action and to pay damages.

An Italian adage runs: *Fatta la legge trovato l'inganno*, which in a free translation may be rendered: Make a law and the means of evasion are found.

This is somewhat the fate of the protective laws regarding art in Italy, the more stringent and circumspect they are

Imitators and Fakers

the law-breaker apparently becomes correspondingly bolder and more astute.

The way in which Italian authorities have been hoodwinked at times, points to the magnitude attained by the shrewd activity of the law-breakers, and to how their art has almost been turned into a science, even calling in the aid of psychology—in this case a deep study of the faulty idiosyncrasies of the officials.

A few skirmishes between the two parties concerned will serve to demonstrate the variety of the *modus operandi* adopted by the law-breakers and their final success over an easily conquered opponent.

In the case of a painting of unusual artistic value, a work that has not been put upon the prohibited list of the official catalogue, and the reproduction of which is unknown to the authorities, but which might, nevertheless, by its good qualities catch even the generally inexperienced eye of the inspectors—mostly art critics of the literary species—the work is transformed into a daub without damage to the painting or change to any essential part. The process is exactly the reverse of that helping a poor painting by clever restoration and additions. Here it is a question of reducing a good work to an apparently bad one, obtainable chiefly by veiling the good qualities of the work, altering good drawing by cleverly introducing offensive disproportion of limbs, etc. There is a difference, however, between the work intended to embellish a painting and that aiming to do the reverse. The former, with the idea of facilitating the sale, is permanent, the latter is only temporary, just to get permission to export. This latter work must be executed in such a way that it can be washed out without damage to the work after the painting has safely crossed the frontier. For this operation a coat of glue is generally given as a preparation, then the modifications are painted in with tempera on the layer of glue, which is easily dissolved in water, together with the retouching when the work is to be restored to its original state.

Imitators and Fakers

Similar treatment is also given to statues, busts and bas-reliefs, more especially when of material that allows the addition of parts that can be removed afterwards without damage to the original. How well the work is done and how successful it proves is hardly credible. Security lies in the fact that should a question be raised afterwards when the work has been sold to some noted collector outside the country, nothing can be said or done, as permission has been granted and there is no pictorial proof that the work had been done for the occasion.

Naturally this method is not of daily or common occurrence, nor, as we have stated, can it be applied to well-known works the photographs of which could be obtained to contradict evidence.

Sometimes more is undertaken than retouching or apparently maiming the artistic qualities of a work. One antiquary who intended to send off a painting that might be detained at the Export Office, pasted paper over the picture, and then after the usual coat of glue painted in tempera a very mediocre landscape. With this he obtained the export permit and packed his work as prescribed by law before the eyes of the authorities, after which the case was sealed by them and safely sent on its way to the frontier.

Leaving the endless tricks which might be grouped more or less with the above we will take up other curious ways of eliciting permission, methods showing the deceiver to be as good an observer of human nature as he is a true psychologist.

A noted bric-à-brac dealer entered the Export Office bringing a Della Robbia with him. According to custom when official inspection is sought, the bas-relief was packed ready for the permit and seal of the office. Taking off the lid of the case, the dealer handed the documents to the inspector to be signed.

"You must take us for fools," said the latter, struck by the beauty of the work. "Do you really think we allow such works to leave the country?"

Imitators and Fakers

"Well, don't say anything and I'll explain things — look here."

The bas-relief was taken from the case and with a pocket-knife the dealer scraped a piece of plaster from the apparently aged back, showing not only freshly baked clay but the mark of a well-known modern factory of ceramics.

"Modern! I confess I should never have thought it."

"Keep our secret," pleaded the bric-à-brac dealer. "You see they go to America."

Satisfied that his professional honour was safe with the dealer, who would naturally not expose the blunder, and not considering it within the sphere of his activity to see that Americans were not fooled as he himself had been, the inspector granted permission, provided the documents should be honestly endorsed by the declaration "modern."

Later on the dealer presented himself with a similar work. The case was hardly opened when the same inspector exclaimed, "Oh these Americans! Another cuckoo."

"Well, as you stop the genuine we have to content ourselves with sending off imitations," observed the dealer with intentional flattery.

"They seem to prosper," laughed the inspector, signing the papers and sealing the case for expedition.

Needless to explain, this time it was a genuine Della Robbia, sent off with all the requisite legal papers, and labelled by the man of law as a modern work.

Some years ago an antiquary of Rome, the owner of a statue of fine Greek workmanship, knew that if the work should be presented to the Export Office, permission would be refused. The statue had been excavated in three separate parts and subsequently recomposed, and it was thought wise to take it apart again and send it off in that state. The head, the finest piece, was taken across the frontier as luggage by a tourist, the torso was sent out of Rome to get the permission from the office of another city, and the legs were the only part to leave the capital with free and unsuspecting permission from the Central Office.

A marble statue, now in the Museum of Art in Berlin, a work of heroic proportions, passed the frontier in two parts, each piece packed in separate trunks such as are used by ladies. The statue had been sawn in two along the line of the drapery in such a way that when the two parts were united the join could hardly attract attention. That the great weight should not arouse suspicion the two marble blocks were hollowed out and thus considerably lightened. The two parts of the statue were first conveyed to Paris, that haven of smuggled goods, where they were reunited and the reconstructed statue was finally sent to its destination. Though cleverly put together the joint is noticeable to an experienced eye upon close inspection. One wonders whether the authorities of the Museum ever discovered that their fine specimen of Roman Renaissance, which had been bought in a single piece in Italy, with the assurance that it was the dealer's affair to get it to Berlin, had been delivered in two patched pieces almost as hollow as a plaster-cast.

Another curious form of smuggling, which must be classed among the suggestive methods, consists of perturbing and influencing the opinion of the Export Office employé or, if necessary, that of his immediate superior, very often the curator of a museum or the highest authority on artistic matters in the province.

This sort of innuendo is accomplished in several ways. Sometimes a confrère will drop into the office as if by accident when the case is there ready for examination, and on seeing the object will exclaim, "That awful thing, sold at last!"

He will naturally be asked to explain what he knows about it. He may say that it was offered to him, but that he had refused it because repainted and restored by so-and-so. He is likely to conclude by saying, "Ask the man who restored——" of course, another confederate.

Though it may appear naïve and clumsy to the outsider, this latter method has been known to work extremely well. It is only to be expected, too, when the depth and calibre of Italian official wisdom on art matters is taken into considera-

Imitators and Fakers

tion, the post of inspector being filled chiefly by scribblers or art critics, seeking Government employment; or perhaps they may be students fresh from a recently instituted university course on art, their main equipment being historical studies. There is no question but that they are excellently informed, so far as art erudition is concerned, but they lack experience, and the trouble is that the chief requisite in an office such as the Export Office is a long experienced and sure eye, with a thorough knowledge of the trade in curios, and its peculiar resources in deceit. One word of doubt let fall at the right moment works wonders when dealing with people whose lack of practical knowledge is so appalling.

We recall the case of an inspector who felt uncertain as to the artistic value of a painting and finally resorted to the experience of his immediate superior, the curator of a museum and a well-known art writer. On examining the work the latter pronounced it to be a good specimen of the Ferrara school, and declared that permission could not be granted. The owner and would-be exporter, an antiquary in great favour, called on the curator, who had had the painting transferred to his own private room with a view to making a careful examination. He directed the curator's attention to the repainted and repaired condition of the work. Persuaded finally that the painting was nothing but a shocking piece of modern restoration the curator granted permission. A friend who was present and noticed the dealer's satisfied smile, asked him afterwards whether the work was really so bad as he had represented to the curator.

"Not a single retouch," was the answer, "most genuine."

"But you convinced him. You pointed out the restored parts."

"Yes, suggestion is one of our most formidable weapons," assented the antiquary, doubling his crafty smile. "Yes. Suggestion is one of our best accomplices."

Although recognizing that many of the employés of the Export Office are quite unfitted for their difficult task, through their particular form of education, we are ready to admit

that to decide almost at sight, what may safely leave the country and what must be retained, is no easy affair. Imitations at times are so perfect that even the most experienced eye, without mature and well-pondered examination of the object, is apt to be duped.

Some years ago one of the sons of Professor Costantini, a well-informed antiquary of Florence, made a copy of an Antonello de Messina that was in his father's collection. The copy was undertaken to oblige an English friend, and being painted on an old worm-eaten panel of wood, so cleverly imitated the original as to be mistaken for it. When the work was to be exported the official refused his permission on the ground that it was by a great master and must consequently remain in Italy. However, as the young artist insisted in his declaration that it was a copy made by himself, appeal was made to the curator of the Uffizi Gallery of Florence, Professor Ridolfi. The latter confirmed the inspector's verdict, reiterating the prohibiting injunction, and a sort of consultation was held, with the aid of Professor Supino, curator of the National Museum, Professor Elia Volpi, a highly esteemed antiquary of Florence, and a German artist, acting restorer of paintings at the Uffizi Gallery. They unanimously declared the work to be old. Some attributed it to Antonello himself, others to his school, there was no suspicion of modernism. The whole affair was afterwards settled as it should have been from the first. Professor Costantini invited Professor Ridolfi and the others to see the original painting at his house.

When the high tariff on imported works of art and curios was still in force in the United States, smugglers relied chiefly on undervaluation, as orthodox smuggling, namely introduction into the country without any payment of duty, was hardly possible under the vigilance of Argus-eyed Custom House officials. Thus the grand art of smuggling works of art and antiques of repute, always pliable to circumstances, relied mainly upon the ignorance of the so-called appraisers. At first a legal estimate enclosed with

the documents accompanying the goods from their place of departure was sufficient and very rarely discussed. Gradually the United States Custom House agents grew suspicious, and to support the low valuation it became necessary to adjust the objects, in very much the same way as was done to obtain export permission, from the Italian office.

One of the tricks practised in the case of furniture is to take off all ornamental and carved parts by disjointing or sawing and then polishing or in some way adjusting the place left bare. The ornaments are sent separately to be replaced when the piece of furniture is safely beyond the reach of the Custom House laws.

Custom House officials all the world over are generally reckoned by trained smugglers to be very poor judges of art. They consider them capable of making a great fuss over the wrong article and letting the dutiable ones slip through their fingers. Something of this kind happened at the Custom House of Bercy, Paris, where, with no intention of smuggling or deceiving the officials, Dazzi, an Italian dealer, came to pay duty in a sort of topsy-turvy way. Together with other things, Dazzi was importing into France a box of modern bronzes, imitating objects of Pompeiian excavation and coated with an indecent patina, green as a lizard's skin, and a piece of seventeenth-century silk damask, which according to French law should have been duty free as only antique goods of the eighteenth century and onwards pay. After a long confabulation the appraiser of the Custom House decided that being, as he thought, of modern fabric, the damask must pay duty and that the bronzes, supposed by him to be two thousand years old, might enter free of duty. Dazzi saw that this queer exchange was to his advantage and submitted to the strange verdict without further observation.

In Italy, the law on exportation, intended to prevent the exodus of fine works of art, is often turned to advantage by sharp dealers who manage to have their mediocre goods detained at the Export Office, and when exportation has been

finally permitted make use of the momentary detention to enhance the merits of the object exported.

This trick has been practised to such an extent that, particularly in America, it is not unusual to hear an amateur extol some bit of rubbish with the remark, " It was stopped by the Italian inspectors, but my man managed to get it through by greasing the paw——"

An imitation of the work of Bellano, a bas-relief in clay, was in custody at the Export Office and afterwards allowed to pass, being recognized as modern. This was quite enough to advertise the work as excellent, so excellent that it was held up at the Italian Export Office. The bas-relief is now shown in the collection of a New York amateur, and the romantic tale of the refused permit adds flavour and draws particular attention to the masterpiece, and yet—— !

This is more or less the dark side of the traffic in curios and the various questionable forces that many collectors call " the black band." As will be shown later, the " black band" is a Parisian expression, denoting a more restricted field of activity.

How is the beginner to cope with such odds ? To become acquainted with the peculiar *milieu* to be avoided in the commerce of antiques requires time, to learn to detect restorations and repairs, we mean undue repairs, is an art in itself that demands considerable experience.

To sum up, while striving daily to become more efficient, relying as little as possible on the help of others, or knowing how to choose the right sort of aid, it is most important to be circumspect, to assume in principle that the beginner is likely to be duped at the start, and to believe that there is more wisdom than people are ready to think in the advice of Paul Eudel, *Soyez athées en objets d'art* (Be sceptical in art objects !).

CHAPTER XVI

THE ARTISTIC QUALITIES OF IMITATORS

Sculptors—A few notable examples—Bastianini's art and the adventures of his Girolamo Benivieni—A modern imitation of Renaissance art entered at a Munich museum as a genuine antique—The sculptor's art and method—The Verrocchio, Robbia and Co., Ltd.—Signor Natali's art and Signor Bonafedi's patina—Various methods of would-be makers of old masters—Painting—The Sienese imitative school—Mr. Salting's experience—Professor Ezio Marzi's imitation of the Flemish school—Stone and ornamental work—Professor Orlandini's art—Iron work—Weapons, etc.

From the point of view of art, the creator of "finds," the imitator of masterpieces, and faker of sham "*chefs-d'œuvre*" are not attractive personalities. The value of their art—if it deserves so noble a title—is likely to vanish as soon as the scheme is detected and to leave us with something of the disillusionment experienced when viewing a set of stage scenery by broad daylight.

The simple imitator, the man who honestly declares his work to be modern, though of a higher moral standard than his comrade the forger, is no more likely to win our admiration. The difference between the two, artistically speaking, is that the one is apt to irritate us from the first, the other only after we have been "taken in," the first cheats himself alone when he believes his patchwork to be good art, the second is ready to deceive any and everyone who credits his artistic lies. High above these two classes, however, stand a few gifted beings who seem to have actually imbibed the artistic qualities of Renaissance art to such an extent as to have attained a new and genuine personality—modern in date but old and faithful to the past in creative conception.

Artistic Qualities of Imitators

In this case, imitation becoming creative, as we have said, it rises to the rank of real art.

Up to the present, since Bastianini's excellent work was first launched, many of the imitators who followed and who have successfully duped museums and art lovers, belong to the commonplace order. Their success is chiefly due to the deficiency and lack of practice among curators, collectors and connoisseurs at large.

The more recent imitations that have deceived some of the most experienced eyes in Florence, Munich and Paris have revealed the names of two sculptors, Zampini and Natali, who apart from their imitative ability may, like Bastianini, be studied and admired *per se*.

Both these artists have some points in common with the sculptor who puzzled all the French connoisseurs of the Second Empire. Both, like Bastianini and other good and honest imitators, have made the fortunes of others, not their own; like him, too, have sold their products as modern, only to realize that as soon as believed antique they reached fabulous figures.

The portrait bust of Girolamo Benivieni—for which Bastianini received 350 francs—was finally sold to the Louvre for 14,000 francs. Before landing in the Paris Museum it had passed through the hands of Freppa—a Florentine antiquary—Nolives, a connoisseur who travelled in Italy in search of "finds," and Nieuwerkerque, Princess Mathilde Bonaparte's all-powerful protégé, who was responsible for its acquisition by the Museum.

This classic piece of fakery is worth recalling in all its details, together with the stir succeeding Bastianini's declaration of himself as the author of the Benivieni bust and the humiliating figure cut by the officially recognized connoisseurs and art critics after the *dénouement*.

Contrary to the general mode adopted by imitators and fakers of copying the various parts here and there from Renaissance work, welding them into a would-be *tout ensemble* of originality, Bastianini had so imbibed the character of

Artistic Qualities of Imitators 183

the fifteenth century that he was able to work without immediate suggestions other than the influence of the recollections and skill he had acquired by copying from good old models in his preparatory period. Thus the work was done straight from nature, the model chosen being an old man nick-named the *Priore*, employed in a cigar factory. When the clay was still fresh, struck by the unusual Renaissance style of the bust, someone suggested the name by which it was finally christened, and Bastianini inscribed the words: HIERMUS BENIVIENI.

The name of Girolamo Benivieni, Savonarola's poet friend, was in keeping with the austere features of the portrait, and the modest employé of the Florentine cigar factory well represented one of the most illustrious types of Republican Florence.

When Nolives exhibited Bastianini's work in 1867 as a specimen of Renaissance sculpture at the Retrospective Art Show of the Palais des Champs Élysées, an influential art critic wrote:

"We have not known Benivieni, but are prepared to swear that this portrait must be extremely like him. Who is the artist that modelled it? We are almost tempted to label the work with a string of names from the glorious period of Florentine art."

Noting, incidentally, that the art critic's temptation to go through a long litany of names by way of attribution is simply delightful, we may state that the illustrious writer was not the only one to be caught and duped by Bastianini's capital work. The supposititious Girolamo Benivieni had turned the heads of all the art intellectuals of Paris.

Later on, when Nolive's collection was put up to auction the bust was acquired, as we have already stated, by Nieuwerkerque for the sum of 13,600 francs and was finally placed in the Louvre Museum.

It is said that, believing the bust to be antique, Nolives wrote to Bastianini bantering him upon his gross error in letting such a stupendous "find" slip from his hands.

Finally the name of Bastianini as the author of the bust leaked out. Admiration began to cool, opinions as to the genuineness of the work were divided and a long polemic over the case ensued.

When Bastianini, up to then an obscure Florentine artist, finally declared in a letter sent to the *Diritto*, an Italian newspaper, that he himself was the author of the Benivieni, he was supposed to be an imposter.

Among others to contest Bastianini's assertion was the talented sculptor Lequesne, who went so far as to call the Florentine artist a liar, maintaining that the men who could mould clay into such forms as that of the bust were no more of this world, having long since disappeared. At the end of his invective against the Florentine sculptor, M. Lequesne swore that should Bastianini be able to prove himself to be the sculptor of the Benivieni, he himself would be willing to serve such a sculptor, if only to mix his clay.

It would be tedious to follow the long and spicy polemic from which Bastianini was perforce to issue triumphantly. Pamphlets and articles were written on both sides, Bastianini himself taking part in the controversy and showing himself to be a wit worthy of those old Florentines whom Dante designates as having a " *spirito bizzarro.*"

Irrefutable proofs—the first plaster-cast of the head which had been kept by the sculptor, witnesses who had seen Bastianini at work, the assurance of the model and his true resemblance to the pseudo-Benivieni—cut short all possibility of further discussion. The actual author of the Renaissance bust that had puzzled the learned public of the French capital, was beyond all doubt Bastianini.

Naturally this was not Bastianini's first essay. In the year 1864 a bust by him, an effigy of Savonarola, had been exhibited at the Palazzo Riccardi in Florence. This work, too, was taken for antique. Vincenzo Capponi, a Florentine dealer, secured it for 640 francs and sold it for ten thousand. Another work, a charming type of Florentine youth, a girl singing, was sold to M. Édouard André of Paris.

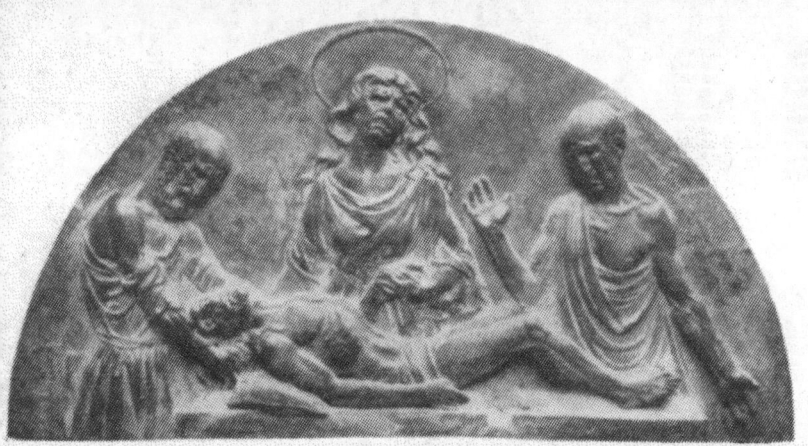

Resurrection.

By Signor Ferrante Zampini, bought at Munich as work of the XVth Century. Zampini was a clever Italian artist, who possessed the rare gift of imitating Renaissance work. He never deceived anyone with his imitations, but his work passing through several hands eventually deceived the connoisseurs of the **Munich Gallery**.

Pieta.
By Sig. Ferrante Zampini.

Artistic Qualities of Imitators

Bastianini's imitations are of such excellency that they are now held in high esteem by collectors and are bought by museums at extremely handsome prices. The Victoria and Albert Museum has one of the most complete collections of Bastianini's art, where the whole range of this genial imitator of the Renaissance can be seen almost *au complet*.

Signor Ferrante Zampini, whose imitations deceived the museum of Munich and many good connoisseurs and specialists, worked with different methods.

The Pietà—the large lunette which together with other works deceived the art authorities of Munich so completely—had passed in Florence from the studio of Ferrante Zampini to the well-known atelier of Signor Bonafedi, a painter of uncommon talent whose ability in colouring and in giving a proper patina to clay is unrivalled. This work was afterwards sold (for the sum of 1200 francs), as modern, to Professor Paolini, a violinist, who also sold it for modern to a German, and finally, through a string of collectors, the Pietà landed in the Munich Museum for 14,000 francs.

It is said that the discovery of its modern authorship was due to a successful antiquary of Florence, a collector who has sharpened his natural alertness after a sad experience when he bought a bronze by a living German artist as Quattrocento work, and who is in a position to know more than one *histoire* through a regular network of informants. On this occasion his informant, it seems, was close to hand in the person of his packer.

As for other antiquaries who had had no forewarning from kind informants, they have been more or less taken in by Signor Zampini's works which have appeared now and then on the market since the year 1904. Less exception seems to have been taken to the work of the other modern imitator, Signor Natali. His imitations, made previously to his best one, bought by the Louvre Museum, appear to have travelled very far; some of them are still in undisturbed enjoyment of honour as Renaissance work in private collections.

Ferrante Zampini's first work was a portrait of a lady, a finely executed head evidently made under the direct impression of those busts attributed to Laurana, those that Courajod insisted upon calling death masks. This piece, however, had no fortune in the world of antiques, it travelled from place to place, and finally, as faithful as a carrier-pigeon, returned to the man who had bought it from the sculptor.

A strikingly fine clay head followed. It closely resembled the portrait of Colleoni, though giving the general of the Venetian Republic a more aged appearance than that of the equestrian statue in Venice: it was readily bought as a Verrocchio.

Since then Zampini has produced several works of his peculiar art. Although they have realized large sums of money his own gains were but small.

A curious proof of Zampini's excellence in imitating the Quattrocento is given by the following incident. A French collector bought from a Florentine dealer a genuine piece of Renaissance, and a work by Zampini. After taking the two purchases to Paris the collector sent back the *real* article as a fake, keeping the Zampini bust as a recognized authentic object of art. A Munich princess possesses one of the finest works of our sculptor which still defies all evidence—even now after the Munich disclosures have enlightened the Bavarian connoisseurs.

Professor X. of Florence, a connoisseur whose ability is beyond question and whose experience is highly esteemed among art lovers, bought a clay bust by Zampini, believing it to be work of the fourteenth century. Some time after he had transferred the object to his collection the clay began to peel off and show signs of the progressive scaling usually called *sbullettare*.[1]

[1] "Sbullettare" signifies the scaling of terra-cotta by which it becomes full of little holes, as though pitted by small-pox. The word is derived from *bulletta* (a nail or tack), the poor victim looking as though nails had been roughly drawn out.

Artistic Qualities of Imitators

Zampini, it must be said, often uses Impruneta clay (that used by della Robbia), and he was not aware that to prevent scaling—a phenomenon that may set in months after the work is baked—this peculiar earth must be moistened as soon as it leaves the oven. Had this been done the work would have been saved that curious scaling which in the end told the truth about the bust. But for this unforeseen circumstance the work might still be playing its part in the world of antiques.

Professor X., however, knew that antique busts are not liable to suffer from this peculiar kind of small-pox and called the go-between who had helped in the conclusion of the business and a friend who had shared his admiration and to them he confided his suspicions. The bust then disappeared for some time. Later, however, the same friend of Professor X. who had admired the bust before it began to scale, was called in to admire it again in the collection of Professor Y., another noted connoisseur, who had bought it as antique. For reasons of his own, possibly so as not to spoil the new owner's pleasure, the friend did not reveal the secret of the make-up. But Impruneta clay seemed determined the truth should become manifest to all, in spite of circumstances. Within a few days the work that had already been attributed to Verrocchio by the new owner, began to peel once more, and the secret of its modern date was revealed a second time. Professor Y., who is an honest dealer and a connoisseur of such ability as to be able to afford a blunder without loss of a well-deserved reputation, laughed at the clever joke played upon him and buried the Verrocchio in his cellar—the Erebus to which all honest antiquaries relegate their bad bargains.

The bas-relief which has been bought by the Louvre at a larger figure than any other recent acquisition of this nature, is the work of a young sculptor, Natali, a Florentine who has lately emerged as a clever imitator of the Renaissance. The newspapers have already spoken of the last part played by the supposed Verrocchio in the Museum, and the magnificent sum paid for it. What is not generally known is that the

curator's eyes were opened—wisdom and knowledge are often wakened in this way !—by an anonymous letter written from an aggrieved would-be partner in the affair who had been, as it were, " cut off with a shilling " in the handsome transaction.

Though Bastianini, Zampini and Natali seem to exploit a common field and to work with identical aims, they so essentially differ in the quality and character of their work as to deserve a brief comparison.

Bastianini, who flourished when connoisseurship was yet without the powerful aid of photography, appears in some way at a disadvantage when compared with the others, and this although his qualities as a modern sculptor, even though academic, were perhaps of a more solid character than theirs.

Apart from his Benivieni, his Savonarola bust and a few heads of aged people in which the sculptor reveals his best and strongest qualities as an imitator of the Quattrocento, his work is of a perplexed and, consequently, weaker nature. We very much doubt whether some of his female heads now in the Victoria and Albert Museum could deceive in these days even a mediocre connoisseur.

In Bastianini's minor works one is likely to find the explanation of this curious artistic temperament—he was a lover of modern life and prided himself upon cooking macaroni fit to make a Neapolitan blush, he claimed to be the best ball player (*giocatore di pallone*) of his day and could pass from modern art to antique imitations with a facility that astonishes us. In his less important works an oscillating mind is evident, swinging like a pendulum between modern and antique art. It is clear that the two artistic personalities worked alternately in Bastianini's mind, leaving no deep or permanent impression. This artist's imitations, consequently, bear every symptom of immediate suggestion—fugitive impressions cleverly caught and blended into a surprisingly harmonious whole, thanks to his uncommon skill in modelling.

Artistic Qualities of Imitators

It is this happy *tout ensemble* (summing up of qualities and circumstances) that raised the artist above the level of the obvious imitator, more especially when modelling certain heads the character of which would seem to tally with the original impression—some early souvenir or first work in copying maybe—he had received from the masters of the Renaissance.

With Ferrante Zampini the artistic evolution is somewhat reversed. A man of taciturn disposition, inclined to dream and of mystic tendencies, he must have cogitated, loved and longingly caressed his idea before giving it form. Rebelling against any academic yoke it was not long before he began an intercourse of sentiment with the work of the past, questioning those old masters as to the reason why their sentiment should clash with scholastic tuition. He must have actually saturated his mind with old forms before taking up the modelling stick. To see him working without a model, without a suggestion even to aid his creation, made one almost believe that through some mesmeric power the soul of an old master had passed into his own, and that he was enjoying at the moment all the glorious freedom of irresponsibility.

Thus while Bastianini worked in a well-lighted studio, filled with plaster-casts of the creations of Verrocchio, Pollajuolo and other great masters, Zampini models in a small room, working in the faintest of lights, surrounded by bare grey walls. With blinds almost drawn, this sculptor holds that he can dominate the masses with security and be in closer touch with his vision. Perhaps the great unity of his work really is due in part to this unusual method of modelling, a method which, while it permits him to detect errors of mass, and to correct the general lines of composition, at the same time harmonizes into a happy ensemble the characteristics of the older style he imitates.

It may be said also that while Bastianini rarely attempted compositions in bas-relief, confining his main work of imitation to heads, Zampini boldy attacks the difficulties of large

bas-reliefs and grouped figures. Though Zampini's works vaguely suggest reminiscences—either in composition or in form—this sculptor must be credited with an unusual power of synthesis, and we are not surprised that the Munich authorities were deceived by his art.

Natali's workmanship is of a different nature. This young artist—the author of the Baptism, the lunette bought by the Louvre as a work of Verrocchio—shows great versatility even when not imitating the old masters, and he is, above all, a virtuoso—a true product of Latin facility.

But it must be added that while the lunette of the Louvre shows happy composition, with charming details here and there in its interpretation, it does not possess the intimate qualities, the essential unity, of Zampini's work. The latter may be taken for Verrocchio or not, according to the ability or appreciation of the critic; but Natali's lunette might be modernized as "Verrocchio and Co.," or (since in the angels the manner of Andrea Robbia alternates with Verrocchio) we might even go a step further and describe the composite result as "Verrocchio, Robbia and Co., Ltd."

Not only because Natali occupies a room in Bonafedi's studio, and appears to work under this artist's supervision—at least it was so when we had occasion to study the work of this excellent imitator—but direct from the work in the lunette of the Baptism one feels inclined to look on this young artist as endowed with the defects and good qualities of a painter indulging in plastic work. The composition, for instance, harmonious and rich, with a happy suggestion of light and shade, lacks the directness of form peculiar to sculptors, and the modelling shows here and there—and this even considering the task the artist has imposed upon himself of imitating Quattrocento work—the flatness and dryness of a painter who models without plastic insight or preoccupation. These characteristics, these pictorial qualities which are not to be seen in Signor Natali's modern work, are perhaps the disguise with which he sometimes veils his touch—the touch of a modern sculptor. Though admiring this excellent

Artistic Qualities of Imitators

imitation, we must say we are surprised at the fact that it was not sooner detected as modern work.

From Bonafedi, a painter possessing great facility in execution and uncommon versatility as an imitator, the mere association of ideas easily leads one to the Siena imitators who have for years held the privilege of being the strongest imitators of early Quattrocento work. Joni and others have, unwittingly, deceived more than one connoisseur. One of these Sienese products was bought by Mr. Salting for twenty thousand lire.

There is no doubt that the imitation bought by Mr. Salting as work of the old Sienese school is one of the best that modern Siena has ever produced. Yet anyone already acquainted with that kind of work, and who had seen at least one specimen out of the many that have met with good success among unguarded collectors, would not have found it difficult to detect the first-rate imitation that so triumphantly entered the Salting collection. It is said that Mr. Salting got his money back, and the painting was returned to the dealer; a remarkable occurrence and a proof of good faith, as usually when the collector finds he has been duped and is not disposed to keep it quiet, the vendor is either not to be found or he has taken prudent measures and good care to be on the safe side legally.

In our opinion the drawing of the Sienese imitator is too caligraphic, it reproduces too closely, namely, the forms of well-known originals, and this while the composition is not always free from plagiarisms that are too easily recognizable. Some of the later artists of Florence, and elsewhere, have broadened the technique, appearing less servile because better versed in the qualities of the old masters, and through this deeper insight their work is more convincing and synthetic.

One of these characteristic workers is Professor Ezio Marzi of Florence, an imitator of the Dutch school, who has never sold his panels as antique, but whose work, it is said, through others, has penetrated into more than one collection, where

it is held to be genuine and above suspicion. His Teniers, now honoured as such, are many, and if Marzi instead of being stationary in Florence like most of his compatriots who, generally speaking, never travel, should indulge in one of those erratic trips of which Americans are so fond, visiting collections here and there, he would have good cause to laugh in his sleeve.

Like many of his Italian brothers of the brush, Ezio Marzi has eclectic tendencies and a most versatile workmanship. But what places him apart from his confrères who also imitate the art of the past, is the fact that when he chooses to be Ezio Marzi in his painting, that is to say to paint something of his own, giving a true expression of his own personality, he can do so without infection from reminiscences of his workmanship as an imitator. In a word, Marzi is a painter of mark, extremely original and fully temperamental—a rare thing among imitators of other people's art. As regards his plagiaristic indulgences, he has tried the most varied and dissimilar schools of the past, successfully too. His preference, however, for Dutch or Flemish art has finally prevailed. Possibly at his first essays Marzi was the obvious sort of imitator, servile to direct suggestion of form, disguising artistic thefts from old masters by the usual well-matched mosaic, but now this inevitable preparatory period is dismissed and surpassed. When imitating Teniers this artist is really composing Dutch scenes without a scrap of suggestion in his studio.

While Marzi affords us a good type of the imitator in painting and Bastianini and Zampini show us the best possibilities of assumed characters in sculpture, Professor Orlandini of Florence imitates Quattrocento ornamental sculpture with capital results. We can repeat here the same comment passed on Marzi's art: his works, too, are sold as modern, but, alas, how many ornamental chimneypieces and would-be aged *lavabos* now decorating rooms, are Orlandini's work, although ostentatiously shown as pure productions of the Renaissance. Not so pure, though, always, for Professor Orlandini is at

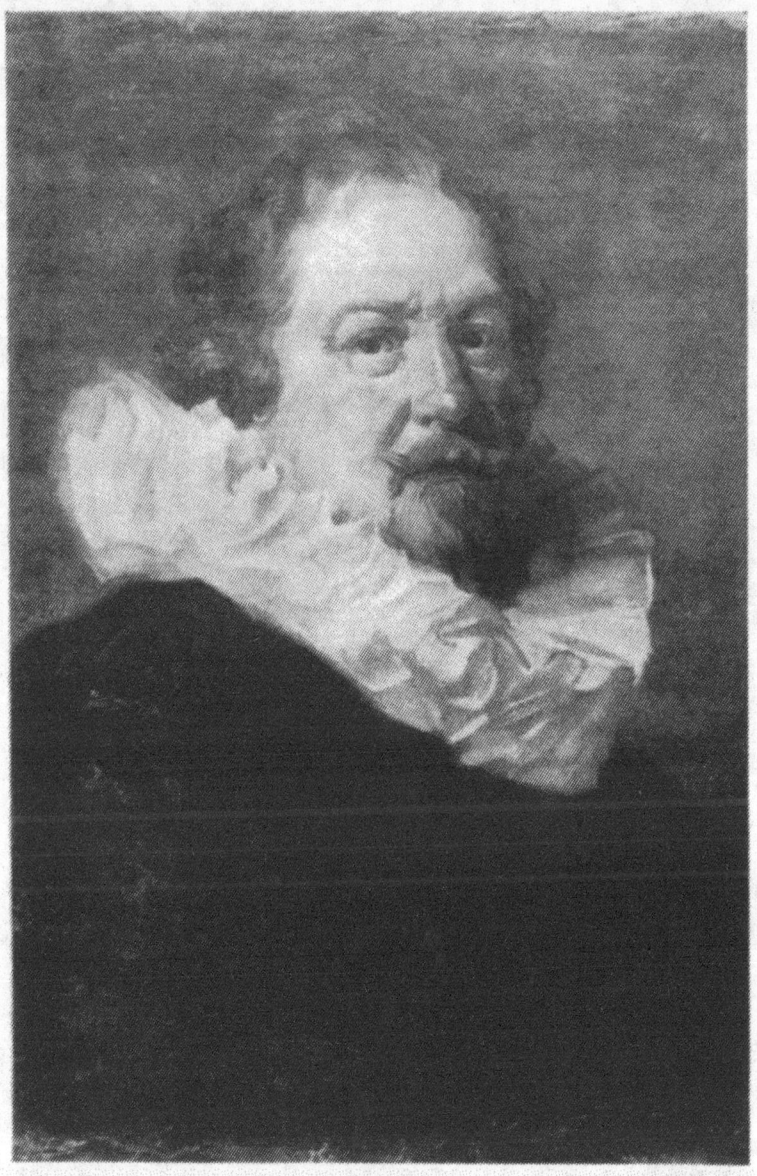

PORTRAIT.

An imitation of Dutch School by Prof. Ezio Marzi, an Italian artist, who does his work with no apparent sense of plagiarism, but who is so versatile in Dutch School that but for his honest dealing he might prove a danger to amateurs.

Artistic Qualities of Imitators

times forced to fall in with the customer's ambition and thus allows himself to give full play to over-ornamentation, producing a sort of Quattrocento *usus Americanus*.

Still, when left to his own artistic bent we know of no one who can turn out of the Fiesole stone an aristocratic-looking chimneypiece more closely resembling the work of Desiderio da Settignano.

As a brief observation it may be added that Professor Orlandini is a sculptor of the old school who deals chiefly with hard materials. This fact greatly contributes to give his art that stern sobriety of line that is a characteristic mark of the Renaissance artist.

In the present flood of imitations it has been urged that honest artists should put their signatures to their modern antiques, thus preventing the danger represented by imitations when launched on the market by able imposters. There are a few who do sign their productions, but we must say such an act does not win the deserved success. The buyer seems to demand a certain amount of illusion which would inevitably be destroyed by a signature in full sight. Besides, supposing that to prevent any possible fakery all imitators should decide to sign their work, what guarantee would such a movement represent? Nothing is easier to erase than a signature on a painting, and so far as a sculptor is concerned it is a baby trick to cover the artist's mark.

Commerce has its risks, risks placing an elective stigma on any enterprise, rendering it more difficult and eliminating the incapable. In our artistic *milieu* such risks are doubled, thus while "imitation," and its black sister "faking," represent a formidable danger, they also, through the said magnified risk, confer upon the elect ones, the true connoisseurs, the exclusiveness of an aristocratic caste.

And yet, unlike the beginner, these superior beings who have in a way learned through experience how to cope with dangerous odds repeat with Bonnaffé:

"Do not trust the collector who never makes a mistake. The strongest is he who makes the fewest mistakes."

CHAPTER XVII

FAKERS, FORGERS AND THE LAW

Faking and fakers—Views of art forgers—Too great a productiveness aids the exposure of fakers—The chink in the armour of silence and mystery—Collector's view of the dangerous trade in counterfeited objects—Laws and tribunals—Grotesque cases in court—M. Chasles' autographs—A collector who lacks a Rameses—The faker for gain and the one for fun—Some moral considerations on fabricators of modern antiques.

MORAL considerations apart, the faker of objects for collections is far more interesting a personage than some of his duped victims. His artistic personality separates him from the commoner class, the peculiarity of his trade, while not redeeming the disreputableness of his conduct, confers upon him the poetical nimbus of art and mystery, just as an undefined feeling of heroism or chivalry may, to an imaginative mind, turn an old-fashioned brigand into a classical type of buccaneer.

These mute workers, who actually earn their money by false pretences, deluding and deceiving with callous energy in what a commercial mind might call " their line of business," are not infrequently people of scruples and probity in all other respects, men to whom credit might be given with safety.

As we have stated before, the collector is partially responsible if excellent imitators sometimes turn into fakers. Ask the forger how it was that he became such, and nine times out of ten you will either hear that he was tired of seeing others make indecent profits out of his work, or that he was prompted by the consideration that there were fools ready to pay ten times the value of his work, provided he did not claim author-

Fakers, Forgers and the Law

ship, and would pretend his work was antique. Curiously enough, when questioned about the beginning of their fraudulent profession, some will speak of their transition from honesty to dishonesty with the reticence of a woman gone astray; others, perhaps the larger number, are boastful and inclined to glory in the success accorded to their fakes.

La Rochefoucauld has written in his *Maximes* that it is easier to deceive oneself than others. The vaunting class of fakers have somewhat reversed the terms of this saying, their common tenet being that it is easier to cheat others than to cheat oneself. This maxim, however, gives the faker undue confidence and a too prolific activity in creating sham masterpieces, and eventually contributes to the exposure of his fraud and the final ruin of what he considers, and what has proved to be, a most remunerative business. Many discoveries of falsified *chefs-d'œuvre* are due to over-productiveness of the faker. His self-confidence augmenting his activity to alarming proportions, it naturally increases the probability of discovery.

However, the faker is perforce a close-mouthed fellow, always on his guard and very rarely taken, as one might say, by surprise. Nevertheless he too possesses what might be called in fanciful metaphor the Achilles' vulnerable spot where his silence may be attacked: it is his pride that must be tickled.

It was an aim of mine in the past to trace forgery in art to its origin. Not exactly as a hobby but in the belief that in these days it is important to know how works of art are imitated and faked, that it is part of modern connoisseurship in fact. To-day one must learn how to detect forgeries just as one must learn how to admire genuine art.

Forgery museums, intelligently organized, would be far more interesting—and more original—to-day than the various galleries of fine arts.

On more than one occasion after having traced the forger, the above system of flattering his vanity has extorted an unexpected confidence. To give an instance: some time ago

the Italian market began to be infested by good imitations of bronze figures of the type of the Paduan school. An antiquary, from whom I have the story, traced the forger to Modena and called upon the fellow whom he held in suspicion. At first he had no clue, but finally, becoming friendly, he happened to surprise a confession from him under the following circumstances. It must be noted that a faker will talk freely on the subject of forgery, never presuming to be discovered and always as an outsider. Speaking of imitations, the antiquary expressed his surprise at the sure modelling and most convincing patina of some recent imitations he had seen. He explained that the imitation was really so good that he himself had been deceived by a small group representing a nymph and satyr. Circumstances alone had saved him at the last moment from being taken in and giving his opinion by attributing the bronze to Andrea Briosco. The piece to be sure was convincing enough to pass for one of the best works Briosco ever conceived. It was really worth the extravagant sums collectors are willing to pay for Briosco's piece, called *il Riccio*, even though it was modern.

"Perhaps it was worth it," remarked the artist with the characteristic rebellious accent peculiar to successful fakers.

This first burst of self-pride, properly nourished by the other with eulogies of the great artist who had modelled the group, drew forth the desired disclosure. When the antiquary remarked:

"That group ought to bring a big price. If collectors were not, generally speaking, so utterly deprived of true artistic sense, if they were not——"

"Such a pack of fools and snobs," interrupted the artist.

The chink in the armour of silence was now discovered. Though without giving a hint as to his craft or the recipe of his wonderful patina, upon promise of silence with regard to his name, he proudly acknowledged authorship of the bronze group supposed to be of the school of Padua, and finally offered to show other pieces ready to enter the world

of fakes, finished and ready to go and play the part of masterpieces of the Renaissance.

When the artist was asked how he managed to dispose of his faked goods, he averred that that part of the business belonged to the dealer. A specialist like himself, he said, had nothing to do with that side. The only compact he had made was with his own conscience, being perfectly aware that he was handsomely paid and that his agent realized three times as much.

According to him, even museums were buying spurious works of art, and labelling them with pompous attributions, knowing all the while that they were not authentic.

We quote this as a mere incident to show the view and supercilious attitude taken by the faker with regard to his art.

Incidentally and from the same source came the information that some well-imitated octagonal tables that had fetched high prices in the antique furniture market as real Quattrocento work were made in Bologna, and that the old patina and blunt corners were acquired by real use, the tables being lent for a time to cheap restaurants and the shops of sausage-dealers. The bronze faker of Modena possessed one of these tables which showed a casual knife cut and the abuse of age. To make the piece more handsomely suggestive, upon the top of the table there had been roughly scratched with a nail a square of the geometrical lines of the old game of " Filetto." One could easily work up one's fancy before that perpetrated abuse and imagine crowds of lansquesnets or inveterate dice-throwers.

When asked why he did not put his signature to such excellent work as his, that it would certainly be valued on its own merits, he shook his head and repeated the refrain so often heard from successful fakers that the time of the old-fashioned intelligent and art-loving collectors had passed, that collecting was nowadays nothing but a fad, that the modern collector is only a pretender. In proof of his assertion he referred to the then recent incident.

"See what happened to Donatello's *puttino* in London."

For those who may have forgotten the incident, we will recall how a little bronze statue by Donatello was vainly offered for sale to the London dealers. This statue was missing from the baptistery of San Francesco of Siena. The statuette represented a *puttino* (boy) and, hardly a foot high, had been stolen from the church at Siena in the beginning of the nineteenth century. It mysteriously found its way to London, where it was in all probability buried and forgotten in some private collection for three-score years or more. When the forgotten statue suddenly emerged from its nook of oblivion it was offered for sale simply as an old bronze, but being taken for a modern imitation it fetched no decent price. A Bond Street specialist refused it at two thousand francs. The Donatello was finally bought for 12,000 francs by the Berlin Museum, this being about the fiftieth part of its present value.

It is curious to hear the various opinions entertained by collectors and art lovers concerning faking and its alarming and increasing success. An old collector who had, no doubt like so many of his colleagues, learned his lesson through being duped, unhesitatingly declared that faking is a grand art with a reason for existence as it seems to meet a real need of society, the need of being, as it were, deluded and cheated by elegance. Queer ethics answering to the Latin saying: *Vulgus vult decipi, ergo decipiatur* (The crowd likes to be deceived, let it be deceived!).

A former curator of the Victoria and Albert Museum used to pay due tribute to the art of good imitators and fakers, who had succeeded in deceiving the vigilant eye of the guardians of museums, by stating that imitations are really too good to be mistaken for antiques, much better, indeed, than some of the examples of the art they would falsify.

The really experienced collector is inclined to look upon faking as a huge joke to be played on greenhorns and the inexperienced, even although some of the silent torpedoes of faking do triumphantly succeed in hitting people who are iron-clad with knowledge.

Fakers, Forgers and the Law 199

Novices take two opposite views of the matter. One class is positively ashamed of having been "taken in," and hides the fact by concealing the proof of his ignorance in a dark corner of the house; the other, viewing the deception in a more business-like way, has recourse to the courts with more or less happy results. The latter class is naturally inclined to favour the greatest possible severity of the law.

In some of the cases in which the tribunals are called upon to pass judgment, one is inclined to wonder whether in pronouncing a severe sentence on the culprit, the magistrates do not feel like laughing up their sleeve at the supine foolishness of the plaintiff.

The case of M. Chasles, a celebrated and highly esteemed mathematician and member of the Paris *Institut*, furnishes us with proof of how a man can be great in his own speciality, yet likely to be taken in under peculiar and rather astonishing circumstances.

Monsieur Chasles had apparently taken to autograph-hunting, one of the most dangerous pursuits a mere *dilettante* can dream of. His career at the beginning was perhaps that of any other neophyte, and except for the astonishing sequence, might belong to the trite record of daily happenings on the unsafe side of curio-hunting.

The celebrated mathematician had hardly gathered his first autographs when to his misfortune he met with a certain Vrain-Lucas, an imposter whose talent fitted to perfection the over-trusting mathematician.

But for the documentary evidence of the trial (quoted by Paul Eudel in his book, *Le Truquage*), it would be utterly incredible that anyone, particularly a learned man, could be gulled to such an extent. Yet on the 16th of February, 1869, Monsieur Chasles appeared before the Paris Court of Justice as a plaintiff, and the public discussion of the case—which ended in the condemnation of the defendant, Vrain-Lucas, to two years' imprisonment and a fine of 500 francs with costs—clearly divulged how the eminent professor had been the victim of *le sieur* Vrain-Lucas, a semi-learned man

of unquestionable talent and a stupendous and fertile power of invention. For the total sum of 140,000 francs he had sold to his client would-be authentic autographs and pretended indisputable original manuscripts—really the most extraordinary pieces a collector ever dreamt of!

Among other things there was included: a private letter of Alexander the Great addressed to Aristotle; a letter of Cleopatra to Julius Cæsar, informing the Roman Dictator that their son "Cesarion" was getting on very well; a missive of Lazarus to St. Peter; also a lengthy epistle addressed to Lazarus by Mary Magdalen. It should be added that the letters were written in French and in what might be styled an eighteenth-century jargon, that Alexander addressed Aristotle as *Mon Ami* and Cleopatra scribbled to Cæsar: *Notre fils Cesarion va bien*. Lazarus, no less a scholar in the Gallic idiom, and to whom, maybe, a miraculous resurrection had prompted a new personality, writes to St. Peter in the spirit of a rhetorician and a prig, speaking of Cicero's oratory and Cæsar's writings, getting excited and anathematic on Druidic rites and their cruel habit *de sacrifier des hommes saulxvaiges*.

Mary Magdalen, who begins her letter with a *mon très aimé frère Lazarus, ce que me mandez de Petrus l'apostre de notre doux Jesus*, is supposed to be writing from Marseilles and thus would appear to be the only one out of the many who can logically indulge in French, the *jargon-bouillabaisse* that Vrain-Lucas lent to the gallant array of his personages.

After such a practical joke played on the excellent good faith of M. Chasles, some of the other autographs seem tame. The package, however, also contained scraps jotted down by Alcibiades and Pericles, a full confession of Judas Iscariot's crime written by himself to Mary Magdalen before passing the rope round his neck; a letter of Pontius Pilate addressed to Tiberius expressing his sorrow for the death of Christ. Other astounding pieces of this now famous collection were: a passport signed by Vercingetorix, a poem of Abelard and some love-letters addressed by Laura to Petrarch, as

CHILD.

By Donatello whose taste in statuary was chiefly formed in Rome.

well as many other historical documents down to a manuscript of Pascal and an exchange of letters between the French scientist and Newton on the laws of gravitation, the Frenchman claiming the discovery as his own.

The latter manuscript caused a memorable polemic between the savants of London and Paris, a regular tournament of clever arguing among the scholars of the two countries, which finally led to the discovery of the huge fraud of which M. Chasles was the assigned but unresigned victim.

The chance way the imposture was exposed makes one wonder how it was possible for the case to have the honour of serious discussion among scientists. Among other historical blunders is the supposition that Newton could have exchanged letters with Pascal on the laws of gravitation. The former being but nine years old when Pascal died, he had certainly not yet given his mind to the observations bringing about his marvellous discovery. Further, as an example of gravitation, Pascal relates that he has noticed how in a cup of coffee the bubbles are attracted toward the edge of the receptacle. It is known that coffee was imported into France some nine years after the death of the great French philosopher and mathematician.

Leaving the man who does really artistic work we are now introduced to the majority of the class, mere fabricators of artistic *pastiches*, which notwithstanding complete absence of meritorious qualities are nevertheless effective decoys for unwary art lovers.

To this legion belong, of course, the most mediocre painters and sculptors, those whose chief cunning lies in the transference of age to their modern fabrications. They are guided in their work mostly by a considerable amount of practice in restoring old paintings, marbles, stuccoes, and so forth.

There is also a peculiar type of impostor who plays his tricks solely for the fun of it, a curious type who for the joy of having cheated some one, will deny himself the pleasure of revealing his name and glory in his success.

To this stamp must have belonged M. A. Maillet, a dis-

tinguished chemist who in 1864 took the trouble to publish a book on antediluvian excavations, for no other purpose evidently than to fool scholars given to that particular study. Needless to say the volume met with astonishing success. Among reproductions of genuine antediluvian relics, the eminent chemist interspersed his writing with spurious and fantastic illustrations of pretended finds of his own invention. They consisted of carved bones with figures, symbols and mysterious writings.

To say that no polemic or learned appreciation of the volume followed its publication would be to slander the too easily kindled enthusiasm of learned specialists. As usual the polemic revealed the true character of the volume, but before reaching its conclusion there was more than one reputation sullied and more than one scientist who lost caste. The perplexity and chaotic confusion caused by the publication was felt by M. A. Maillet to be ample recompense for his labour and expense.

The jovial faker, who is out solely for the fun of making game of some one, is no modern invention. Notably in Italy it is not uncommon to find a Greek or Latin inscription, traced centuries ago, with no apparent purpose than that of puzzling posterity, or putting historians off the scent. This would seem to be a still more remarkable form of faking, as the author not only derives no profit whatever from his trouble, but is not at all likely to be present to enjoy the result of his dupery.

Even among these mysterious helpers of the trade in curios—those who work for their living—they are rarely deprived of that facetious spirit that gives them a relish for some brilliant case of deception. Their joy is not wholly permeated by venal considerations.

There is no question but that some fakers go to work like true sportsmen. Hearing them boast, or describe some of their successful comedies in which they have been author, actor and manager all in one, it is not difficult to deduce that the only genuine thing to spur their imagination and activity

Fakers, Forgers and the Law 203

is the desire to cheat any and everybody willing to be convinced by them or their work.

The chief characteristics of some of these comedies, which often necessitate the help of the faker's bosom friend, the dealer or go-between, are pluck and an uncommon knowledge of the psychology of collectors. In more than one instance psychology would appear to have actually made the impossible become possible.

The story of the forged Rameses is still floating as a tradition in the gossipy world of antiquities in Paris. In his work, *Le Truquage*, Paul Eudel relates the anecdote in all its amusing detail.

A Parisian collector was, it seems, the happy owner of the most complete collection of Egyptian fine art objects. Not a specimen was missing apparently. But, as Eudel observes, " Is a collector ever ready to call his collection complete ? " A collection is like a literary work which never seems to go beyond the " preface," and there is no limit to it.

The collector in question had, however, set his limit, deciding that his collection might be considered complete as soon as he had secured one of those serene-looking, colossal Egyptian statues with which to ornament and complete the courtyard of the mansion housing his collection.

To be rich, to have a fixed desire and to blazen forth one's particular hobby is a dangerous combination of ingredients in the world of curio-dealing, especially with the ever-ready and active faker close to hand.

To gratify this collector's hobby an informant turned up one day to report that near Thebes a splendid statue of heroic proportions had been discovered. It was said to be the effigy of a Rameses in all its impassive beauty. Having knowledge of the collector's penchant the informant's agent in Egypt had kept back the secret of the discovery. In this way the collector was given the first refusal, the statue was all ready to be shipped, the whole at the reasonable price of a hundred thousand francs.

As usual the proposal was accompanied with convincing

documents, stamped letters, descriptive memoranda and so forth. Within view of a long-desired ornament, the collector was easily induced to take part in the transaction to be carried on with the usual secrecy, upon the condition that the statue should be taken straight to his house on its arrival, and in such a way as to preclude all knowledge on the part of others.

Anyone unacquainted with the psychology of collectors—something that never happens to fakers—might be inclined to imagine that the schemer would try to hasten the conclusion of the business so elaborately planned, for fear the buyer might change his mind or have his eyes opened in some way. But our man knew that the collector would speak to no one, lest he might lose the rare chance offered him, and also that the longer the delay, the more obstacles met with or surmounted, the keener would he become to possess the exceptional " find."

Finally, when the arrival of the statue was announced and it reached the Paris railway station in due time, the collector, suspicious and afraid like all true art lovers, insisted that it should be conveyed to his house by night.

After so much picturesque mystery the *dénouement* came, as usual, too late and in the most banal manner. The fraud was exposed on the very day of the exhibition, and the enraged collector started an energetic search for the culprits, but the birds had flown—he only found the empty cage, namely the atelier in a neighbouring street where his Rameses had been given birth. The debris of the would-be Oriental granite still strewed the floor.

" *Sic transit*—— "

The faker and the forger are not prone to repentance. Vrain-Lucas, who had made himself notorious by cheating M. Chasles, had hardly regained his liberty after serving his term before he was again called to answer for another fraud. For a poor provincial priest he had falsified a whole genealogical tree.

Paul Eudel relates of one Oriental faker who proved himself as impenitent as resourceful. Clever and gifted with the

Fakers, Forgers and the Law 205

peculiar shrewdness of the Oriental, he made his first *coup* by selling to the German Emperor some Moabite pottery which had certainly never been on the shores of the Jordan nor on the coast of the Dead Sea. This clever piece of trickery was recently discovered by the eminent Orientalist M. Clermont-Ganneau.

Back in Jerusalem and silent for a time, he next appeared in Europe offering the savants a most astonishing relic. Quite unabashed by the exposure of the Moabite pottery, he went straight to Berlin to offer some old passages of the Bible of most authentic character. They were written on narrow strips of leather supposed to have been found on a mummy.

Scholars examined the precious relics with care and silently concluded to decline to enter into the bargain. The precious document, though evidently forged, had been falsified on a piece of very old leather, the only part unquestionably aged.

The surprising part was that the culprit was not at all discouraged by the first collapse of his scheme but went to London, where he offered his Biblical find to the British Museum for the trifling sum of a million pounds sterling.

The plan very nearly succeeded. Daily papers became excited over the discovery of the rare Moabite manuscript, a document dating from at least the eighth or ninth century before Christ.

The learned Dr. Ginsburg, who set himself to the task of deciphering the obscure and indistinct characters of the worn-out leather strips, recognized in them a fragment of the fifth book of the Pentateuch. When M. Clermont-Ganneau came to examine the document he declared it for many reasons to be a daring forgery.

Apart from the fact that the strips could not have enwrapped a mummy, as neither Hebrews nor Phœnicians had the custom of embalming their dead, the leather said to have been found in Palestine could hardly have withstood for so long the action of a damp climate. Such preservation would

only be possible in the dry climate of the desert or some one of the favoured parts of Egypt.

It was discovered at the same time that the strips of the famous manuscript had been cut from a piece of leather some two centuries old—the erased original characters still being traceable—upon which the Biblical fragments had been copied in the Moabite alphabet.

The artist with a vaster range and wider scope for duping is, without doubt, the one working on artistic frauds, as the proportion stands at one collector of manuscripts to a thousand art collectors. It is immaterial to him whether he meets specialists or eclectics in this large field—they are all good game. The facility with which he is thus able to dispose of his wares makes him still more refractory to reform. Silent, often obscure, always mysterious, he claims for his activity what must appear to him a noble justification: he paradoxically believes himself to be a real factor of his client's happiness. But for him some of the collectors would find it tremendously difficult to possess masterpieces, and if they die happy without realizing that they have been fooled, where is the difference?

After all, in this fool's paradise they are happy and undisturbed—so very few realize either that they have been totally duped by a fake or partially cheated by over-restoration. Most of the modern collectors too often resemble that type of art lover:

> . . . Qui croit tenir les pommes d'Hesperides
> Et presse tendrement un navet sur son coeur.[1]

[1] . . : Who thinks he holds the apples of the Hesperides
 Whilst pressing tenderly a turnip to his heart.

CHAPTER XVIII

THE FAKED ATMOSPHERE AND PUBLIC SALES

The art of producing a faked atmosphere—Private sales of faked objects of art—Real and spurious noblemen as elements in creating the desired atmosphere for an antique—The various and endless possibilities in private dealing—Public sales—Auction sales—Various characters among frequenters of public sales—*La Bande Noire*—The trick of the sale catalogue as a proof of authenticity, etc.—The part played in public sales by Peter Funk and the transformations of this helpful personage.

In most cases the art forger is provided with an indispensable accessory in the person of a co-worker who helps to dispose of the artist's questionable product advantageously. This may be done by one agent or by many, according to circumstances, but the spirit of the mission is always the same, to steep faking, namely, in another kind of fakery, no less illusive and delusive, the deception that serves to misguide judgment through false information about some particular object of art, or to create a misleading suggestion around the work of art offered for sale. The trick might be termed "producing a faked atmosphere," in plain words the creation of a false atmosphere of genuineness is an additional fakery to the success of a faked object of art or curio, and it is a most multiform species of imposture and a very dangerous adjunct to the already deceptive trade. So multifarious is the deception practised that an attempt to classify it in its diversity would probably fail to illustrate in full the metamorphoses of this supplement to the art of faking.

As this support to faking is chiefly concerned with the sale of objects of art, our investigation can be broadly divided

according to the kind of sale, private or public, the latter generally taking the form of an auction.

In private sales the limit is not so much set by the seller's conscience as his inventive powers, and his more or less fertile imagination. His method relies mainly on the power of suggestion brought about by false information or, as we have said, by the silent misleading glamour of a pseudo-environment. The former works principally with the decoy of invented documents calculated to lend certain objects an appearance of historical worth, or wrongly to magnify their artistic importance. It is not always the documents that are fitted to the faked art, sometimes the case is reversed and the artist creates work to fit a genuine document. The same is done with signatures, more especially in painting and sculpture.

There are all kinds of specialists in the world of faking who can imitate artists' signatures, marks and so forth, but, alas, it is not said that to a genuine signature our versatile and imaginative artist cannot supply a genial piece of fraud the only genuine part of which is represented by the signature. This is often performed by painting over works that have been defaced, either partially or completely, and yet by some chance still bear the artist's signature in one corner— generally the least abused spot of a painting whether on canvas or panel. The same trick is carried out with equal facility in sculpture. To illustrate what at first sight would seem more complex than fitting a painting to a signature, it is sufficient to recall the false Clodion group, sold in perfectly good faith by M. Maillet du Boullay to Mme. Boiss, also a dealer, whose experience, like that of many others, had a noisy sequel in Court.

M. Maillet du Boullay had bought the clay group some years previously. The subject, a satyr with a nymph, was of the kind that the French call *un peu leste*. For five years Mme. Boiss found no buyer. It was after this long period of actual possession that she discovered the clay statuette to be not by Clodion but in all probability the work of a noted

faker of Clodions, Lebroc, and that a small bit bearing the signature and date, both by the hand of Clodion, had been cleverly inserted at the side of the group. The line of the join had been concealed by colour and patina.

The purchase money, however, was not refunded as the Court accepted the theory advanced by M. Senard, acting for M. Boullay, that Mme. Boiss had after all enjoyed the possession of the group for five years and had perhaps put forward her claim because she had not been able to sell it on account of its objectionable character.

In the cases when the documents are the original ones and the work of art is not, the artist naturally creates his work in accordance with the indications given in the documents. The occurrence is not common, but it has nevertheless taken place. We have heard of a man ordering a portrait to be painted to fit a detailed description of one of his ancestors given in an old letter. The Florentine " Prioristi " and old diaries can well be used for the purposes of such suggestion. An old family chronicle recorded a marriage with some detail, sufficient at any rate to inspire an art counterfeiter to model a small bas-relief representing the scene. When the work was suitably coated with old patina, put into a sixteenth-century frame and an old worm-eaten board fastened to the back, the authentic document was carefully pasted on as proof of genuineness.

Possible combinations of this sort of scheme are endless and can be applied to almost every expression of curio-dealing.

What we have styled "faking the *milieu*," in order to enhance the value of a genuine article or to give additional effect to a falsified one, trades upon the fact that a collector prefers to buy from a private house rather than a shop. This often appeals to him as convincing proof that the article is genuine, and it also appears to confer a higher value by comparison with the surroundings in a shop.

To humour this peculiar trait in the collector, environments have been faked as well as objects of art, and in the evil grand art we are illustrating they furnish to-day more

often than not the proper dignity which aids highly profitable sales effected through private transaction.

When a work leaves the faker's hands there are many ways in which to give birth to the false and illusive dignity designed to lend importance and an air of genuineness. One of the simplest methods is to provide the work with a respectable passport in the person of a patrician, real or faked, according to opportunities. This decoy is prepared, of course, to swear that the object has been in his family for centuries. When the mansion is really old and the family of ancient lineage, success is practically assured. How a man of noble birth can lend his name to such deception can only be explained by a form of degeneracy which, unfortunately, is not extremely rare in our times. It is known to be practised with both genuine works and with forgeries. In the former case it helps the command of an extravagant price, that would never be reached in a shop or through the hands of a dealer; in the latter, working through suggestion, it serves to dispel any lingering doubt from the buyer's mind. When it appears difficult to bring off the deal, in the case of forgery, the object is taken to the country by preference and placed in some old villa or mansion with the connivance of a genuine nobleman, who will receive a secret visit from the purchaser —all acts in the antiquarian world, it must be remembered, savour of mystery and secrecy—and play the dignified part of a member of a time-honoured family who collected works of art in years past. A sham nobleman may also give himself out as Count So-and-so and safely act the part for a day or even a few hours. It must be borne in mind that this course of working by suggestion is very dangerous to the purchaser; by its silent and convincing method art antiquaries of skill and veteran connoisseurs have been deceived.

Another application of this deceptive scheme, that relies on a favourable environment to help fraud, is the sending of counterfeit objects to remote country places supposed to be unexplored. This also is based upon a psychological peculiarity of some collectors, who still hope and believe that there

are yet unsearched regions in the world of antiques, oases that have escaped the ever-vigilant eye of the trader. As a matter of fact if anything like neglected corners exist where one may hope for a "find," they are in large cities, such as Paris or London, particularly the latter, where even Italian antiquaries go at times to hunt for what it would be hopeless to seek in their own country.

Be it understood, the above two ways of disposing in private of pretended genuine antiquities are likely to be combined. The nobleman who charitably houses the masterpiece that the amateur is after, completes the stage-like effect of the hatched environment, with sham documents, etc.

Among public sales it is, as we have said, the auction sale that offers the greatest possibilities to those who falsify an "atmosphere" to put the client on the wrong track so profitable to the faker. As may readily be seen, a false environment and any tampering with the elements that go to the formation of a right opinion as regards an *objet d'art*, invariably lead not only to the acquisition of the wrong thing but to the payment of an exorbitant price for its worthlessness.

Much that is amusing and that would bring home this point could be written on public sales. Enough to fill a bulky volume could be culled from what has taken place at the *atrium auctionarium* to the modern Hotel Drouot or the historical sale-room still extant and busy in London.

Cicero tells us that one of the first auctions to be held in Rome was the sale of property that Sulla had seized from proscribed Romans. He also tells us with his usual rhetorical emphasis that all Pompey's property was put up to auction and disposed of to the highest bidder by "the *præco's* lacerating voice." This great sale included a large portion of Mithradates' treasure, the catalogue of which cost thirty days' work to the Roman officials who took the objects in charge. "At this sale," adds Cicero with redoubled emphasis, "Rome forgot her state of slavery and freely broke into tears." It may be, but Mark Antony, to be sure, took

advantage of this supposed public emotion and had all the valuable lots knocked down to himself at ridiculously low figures. Some of them, it is said, were never paid for at all by this audacious triumvir.

Another famous auction sale in Rome was that of Juba, king of Numidia, who left his treasure to Rome in the time of Tiberius. Caligula was his own auctioneer, and in this way disposed of furniture in his imperial palace that he considered out of fashion. His example was followed by Marcus Aurelius who sold in the public square dedicated to Trajan the jewels and other precious objects forming part of Hadrian's private effects. In order to pay his troops, Pertinax put up to public auction all Commodus' property, a most confused medley of imperial effects, an *omnium gatherum* ranging from the deceased emperor's gorgeous robes to the gladitorial array he used in the circus, and from his court jester to his slaves. Perhaps the most remarkable part of the sale was Commodus' original and interesting collection of coaches, an odd assemblage that should have been capable of stirring even Julius Cæsar's blasé mind, who, it is said used to attend sales in quest of emotion. They afforded him a certain stimulation, for Suetonius speaks of him as rather a rash and unwise bidder. Caligula's coaches were of all kinds and shapes, there were some for summer with complex contrivances to shelter from the sun and cool the air by means of ventilators, and some for winter devised in such a way as to give protection from cold winds. Others were fitted with a device that would now be called a speedometer, a contrivance for measuring the distance covered by the vehicle.

The mania for sales went so far with the Romans that at the death of Pertinax, the empire itself was put up to auction and knocked down to the highest bidder, Didius Julianus.

Although not so complex as the modern houses of public sale, the Roman *atrium auctionarium* was not simplicity itself. The original auction sales of the Romans consisted of the disposal of war spoils to the highest bidder, in the open air on the battlefield or in a square of some conquered city.

and Public Sales

In order to indicate the spot where the sale was to take place a lance was driven into the ground. The name of *sub hasta* was therefore given to these rudimentary auction sales, which is the etymology of the Italian word *asta*, still used for auctions. The *tabulæ auctionariæ*, giving daily notice of the number and description of objects offered for sale, were in some way the forerunners of the modern catalogue, just as the *præco* must be considered as the ancestor of the auctioneer or, maybe, the *crieur*. There were also amanuenses who wrote down prices and purchaser's name as each lot was sold.

Martial tells of a curious incident at an auction in which a girl slave was offered for sale. When the bidding failed to elicit a higher offer, Gellianus, the celebrated auctioneer, ended his eulogy of the beauty of the human merchandize by giving the young slave a couple of kisses. " What happened ? " says Martial in conclusion. " A buyer who had just made a bid of 600 sesterces on the girl, immediately withdrew his offer." Times are changed. It is no longer a question of selling slaves in our modern *atrium auctionarium*, but the auction room itself has nevertheless remained about the same, a great place of interest, an assemblage of types such as old Tongilius, Licinius and Paullus who, revived and modernized, gather in our sale-rooms, elbowing the crowds of bidders, among whom are shrewd, clever buyers, true, impassioned collectors, cool and self-possessed customers.

The auction room is no less freakish than in olden times. There may be, in fact, reason in the refusal to bid for young slaves that the buyer considers defiled by the kisses of the auctioneer, even if he were a Gellianus, the man *à la mode ;* but we can find none, for instance, in what happened some years ago at the celebrated Ćastellani sale in Rome. On account of Castellani's high reputation among collectors and the fine things offered, this sale gathered to Rome a cosmopolitan crowd of connoisseurs. While a fine Cafaggiolo vase was under the hammer, the employé who was exhibiting it to the public dropped it and it broke to pieces. At the moment

of the accident the object had just been sold to the last bidder, who naturally enough, immediately declared his offer cancelled, as he had made a bid on a sound vase and not a heap of debris. The auctioneer then proposed to put the fragments of the vase up to auction and a fresh start was made. Strange to say the second bidding reached a higher figure than the vase had fetched when offered to the public intact and in all its faultless beauty. But for the consideration that the second sale may have tempted some who regretted that they had let slip the chance to bid on the fine Cafaggiolo, one would be inclined to deduce that in the world of curios an object acquires more worth the more it is damaged.

It is true that while a broken china vase is practically worthless, a piece of faience does not lose value by being broken and put together again, if it does not actually rise in value, as in the case of the Castellani Cafaggiolo.

Though to an outsider, the auction room may doubtlessly appear very simple in mechanism, it is rather a complex affair; its atmosphere has engendered any amount of side speculation. This is the more marked in such sale-rooms as have, by reason of the importance of the sales held in them, in a way fertilized, as it were, every kind of speculation. Rochefort, whose passion for bric-à-brac took him to the Hotel Drouot almost daily, has a good deal to say on this subject. In his amusing book on auction sales in the celebrated Parisian sale-room—a book, by the way, which is now almost out of print—the witty Frenchman deals at length with the odd characters and silent speculations that have, all unnoticed and unmolested, grafted themselves upon the popular institution of the Rue Drouot and other auction sale rooms.

As for the types of frequenters, they are of all kinds and the most nondescript character. First comes the collector in all his most interesting and amusing personifications. Rochefort divides the amateurs hanging about auction rooms into three distinct classes, which he subdivides into *genres* and *sous-genres*, to use the writer's own terms.

According to Rochefort's classification, the first class consists, broadly speaking, of persons who pay more for an object than it is worth; the second is composed of collectors who generally buy a thing for what it is worth; the third and last comprises those who pay less for a thing than it is worth. Rochefort aptly observes that the three divisions resemble the classes of a school, the students passing from the lowest to each of the more advanced classes.

The collectors of the first group, all freshmen without exception, are separated by Rochefort into sincere art lovers and mere *poseurs*. Speaking of the sincerity of collectors and premising that sincerity does not always imply an intelligent knowledge of art, Rochefort wittily remarks: "There are people who with the greatest self-confidence buy a daub for a Titian."

"Suffice it to say," adds the writer, " that at the sale of M. Patureau's collection, a Virgin of the Flemish school, possibly a Eckhout or Govært Flinck, was sold for a Murillo at the price of 45,500 francs." In this foolish acquisition insincerity is out of the question, *poseurs*, snobs and the like rarely carry their foppishly garbed insincerity to the length of paying such high prices for mere parade.

In reference to real connoisseurs, to quote Rochefort again, who was certainly most well informed on the subject, he says that they are so rare that it is scarcely worth while to speak of them.

The most genuine living exponent of the species is already a fake among faking: becoming, namely, the owner of expensive curios not for art's sake but chiefly in order to be able to ask his friends: " By the way, have you seen my collection ? " or " the last masterpiece I have bought," etc.

The *poseur*, however, in his flippant and manifold attitudes, may be certain that schemes of deception are multiform and always a match for any incarnation of this type. He is the prey, and there are all kinds of snares waiting for him, just as there are many ways of catching birds.

A collector who does not belong to the general class of

collectors is the private dealer, who all too often joins forces with the "black band" of the sale-rooms.

Among the buyers at the Hotel Drouot, there are to be found, says Rochefort, all manner of originals. Take for instance the *maquilleur*, who is a regular godsend to restorers of paintings. The *maquilleur* is a purchaser of paintings who can never bring himself to leave a canvas in the state he bought it. If it is the portrait of an old woman, he is sure to take the work to a restorer to see if the wrinkles can possibly be smoothed out, if it is a landscape he invariably has changes to suggest. When the canvas has been duly *maquillé* he often takes it back to the auction room to try his chances with some novice. By the side of this character is the "cleaner," the man who insists upon cleaning every painting that falls into his hands. On coming into his possession the work may be as bright and fresh as the varnish of a newly painted motor-car, it makes no difference, he will clean it all the same.

"Cleaning spells death to pictures, just as spinach spells death to butter," wisely says the French writer in conclusion, laying down a humorous aphorism implying that to clean paintings practically means to ruin them.

The very antithesis of the cleaner is the defiler of pictures. Diametrically opposed to the former, who worships soap, dye and other cleansing materials, he no sooner becomes the owner of a painting than he proceeds, as he says, to confer the proper age upon the work, by a coat of dirt, the would-be patina of age, which he ennobles and honours with various names : harmonizing, toning, etc.

Curious as it may sound, from among all the queer legion of auction room questionables, this member is less dangerous to art than many others, especially his pendant, the cleaner. This is readily understood when one considers that a skilled hand may remove any artificial patina, which is frequently separated from the pigment of the painting by a hard layer of old varnish, without any serious damage to the work of art, while the cleaning of an old painting proves more or less

ruinous to its artistic qualities. In fact, the use of strong chemical means either to remove aged dirt or centennial varnish brings away some of the colour as well. The damage done by cleaning with spirits, or other strong methods, is exceedingly great to some of the Dutch paintings, finished to a great extent by veiling with delicate layers of transparent pigment diluted in varnish. Venetian works, the colours of which do not always withstand the dissolvent properties of reagents, suffer irreparably from cleaning.

According to the author of *Les Petits Mystères de l'Hôtel des Ventes* it is by no means impossible that the manipulations of these two art fiends may bring it about that a work be bought and cleaned by the cleaner, then put on sale again and bought by a defiler, to reappear at the auction room covered with fresh but soiled and old-looking patina.

These two characters, like the *maquilleur*, are chiefly hobbyists and rarely associate. There are other oddities, such as restorers, providers of documents, simple intriguers and unscrupulous business men who club together. One of their common schemes is to create pseudo-collections, supposed to have belonged to some noted person. Such collections are often composed only a few days before the auction sale and labelled as the property of Conte X. or Baron D., or styled anonymously, as having belonged to a "well-known collector," or more often uncompromising initials designate the pseudo-owner of the works of art put up to auction.

The profits to be gained by commending one's own goods and running down those in competition with them is accountable for other strange professions that flourish in the stuffy atmosphere of auction rooms. The competition between genuine collections belonging to genuine collectors and these faked ones impels the schemer to extol the importance of the latter, which has doubled and disciplined the activities of many strange helpers and queer professions.

One of the most important personages of this unnumbered company of frauds is the *ereinteur*. He is, as the French

The Faked Atmosphere

word indicates, a man whose part in the business is to hang about auction rooms, and run down works from which he has nothing to gain, or, impersonating the character of a disinterested outsider, to praise works the sale of which will bring him profit, whether directly or indirectly. This defamer or praiser of works of art according to orders, puts himself in the way of possible clients, makes their acquaintance, and cleverly manages to influence their opinion as though incidentally. He may pass himself off as a simple art lover, a dealer, or any other suitable character. It must be added that the *ereinteur* is not always so venal as to sell his praises or defamation, he is not always what might be called professional. There exist a number of people who slander merely for its own sake, urged either by jealousy, evil disposition or a tendency to gossip.

At important auction sales this over-courteous personage is far more dangerous than the man who does his work systematically and as a profession, likely to be spotted by the public.

One of these art slanderers came very near inflicting a deadly blow to the successful sale of a Donatello bronze put up to auction in London at a well-known art sale-room. On the day the objects were on view, the work—which by the way belonged to an Italian antiquary who enjoys the reputation of being one of the best of connoisseurs—was much admired by English art lovers and possible buyers. A French art writer and connoisseur posed before the bronze and remarked that it was a clever fake, possibly an imitation of the eighteenth century. The comment passed from mouth to mouth, and as the French critic was known to understand the Italian Renaissance, those present expressed doubts as to its authenticity. To counteract this unexpected check the antiquary hurriedly threw himself into a cab and visited the most serious frequenters of the auction room during the few hours preceding the sale and thus had time to convince them. A new atmosphere soon prevailed and the Donatello reached the record price of £6000. It was afterwards dis-

covered that the French critic had had a quarrel with the Italian antiquary, hence the spiteful comment.

Some of these misrepresenters are not content with going about the sale-room in search of opportunities to injure by running down a work or praising rubbish to the disadvantage of good things. They pass judgment, favourable or the reverse, at the very moment a certain object is offered for sale, an act which, strictly speaking, is against the law—but the hidden practices of auction room intriguers are more or less baffling to protective laws, like all the worthy members of the "black band," whose chief purpose in attending auction sales is to promote what is called the "knock-out." This is a scheme of combined forces to hamper the natural course of bidding and to oblige the unwary to renounce competition or to pay an exaggerated price.

In its simplest and most schematic form the knock-out works as follows. A certain number of dealers, go-betweens or other promiscuous plotters, band together in a secret society for the purpose of discouraging buyers not belonging to their set. Though secret because of the law, the society is in fact notorious among many of the regular frequenters of auction rooms as being both imperious and obnoxious.

This is not only carried on in Paris but in other cities too, where auction sale parasites manage to evade regulations and escape the vigilant eye of the law.

By this system the way is opened to any member of the society to "cure" an outsider of ambition or hope to buy advantageously at a sale. If X., a new-comer, offers for some object its value, or even a trifle more, he will nevertheless lose the object or be forced to bid to a foolish figure, as one of the conspirators will bid against him and if he happens to be obstinate he will pay dearly, but if by mischance the object is left to his opponent after the fever of bidding has inflated the price, the society makes good the loss sustained by its member.

Dividing the money losses among the members of the society, considerably lessens the loss of the bidder who has

run the price up to an extravagant figure, in order to "punish" some one they consider an invader.

The division of "damages" is generally effected as follows: After the sale all the objects bought by the partners are put up to auction a second time among the members of the society. At this second sale the goods are likely to be disposed of at their real commercial value. If, as is sometimes the case, the total returns of this second sale are inferior to those of the auction room, the difference, paid to keep in force the rule of "punishing," is jointly borne by the co-operators, and thus the cost of this "chastisement" game amounts to a small tax that each partner of the "black band" very willingly pays. The "black band," as it is called in Paris, is so powerful that many not belonging to the society often consent to deal with the members. Sometimes they ask one of them to buy on their behalf. There may, of course, be a trifling commission to pay, a certain percentage, but in the end it comes considerably cheaper. Such transactions are naturally against the disposition of the laws on auction sales, and are invariably made without the consent or knowledge of the directors of the sale-room, and it must be understood that if discovered there may be repression and an unexpected and brusque recall to the strict observance of the law. Hence the fluctuating success of such societies, which, however, notwithstanding the trammels of regulations, appear to prosper.

One way of faking reputations, as it might be called, by which an object is sold at a higher price than it would reach under ordinary conditions, is to list it in the catalogue of a forthcoming sale of some noted collection. The "faked reputation" here consists in the fact that the name and reputation of the collector who had formed the collection bestows lustre upon the object inserted in the sale. This illegal proceeding, which well-known and reputable sale-rooms will not countenance, has occasioned endless lawsuits with the usual uncertain results, as the illegitimacy of the object is not always easy to prove.

and Public Sales

Another method of faking the reputation of a certain work of art is the following. Suppose a dealer possesses a very mediocre picture of little value and wishes to have documentary proof that the work has cost him a good price, instead of a low sum, he has only to send the painting to the auction room and ask his comrades to run the bidding up to a certain figure, then by buying in his own property and paying the percentage due to the auctioneer he withdraws the picture with the receipt, the document he desired. By this trick, when an opportunity presents itself to sell the work, he is able to produce what looks like a convincing proof of his honesty and square dealing. "You see, sir, I am going to be very candid and sincere with you. Here, let me show you what I myself paid for this painting," he will say, and show the receipt of the public auction sale.

Not infrequently the responsibility of the attribution is left to the owner of the work of art, by which means *objets d'art* are often christened with names of a most fantastic paternity. This is easily done; take for instance a canvas that might or might not be righteously baptized "School of Leonardo." The work is presented by the owner to be sold by auction and declared as a Leonardo da Vinci, and in the catalogue it will naturally be put down to Leonardo. When the owner goes to buy in his own canvas, he has, of course, no interest to run the price up to a fancy figure, his sole aim is to be able to show to some future buyer a catalogue with the attribution printed—and, curiously enough, printed attributions would appear to carry undisputed weight! It is nevertheless a bait only for greenhorns, with whom its effect rarely fails.

To prevent objects put up to auction from being knocked down at an unreasonably low figure it is an accepted system to place a reserve price upon them, to write down when consigning the goods, namely, a certain sum representing the lowest figure at which the object may be sold. The auctioneer keeps this price *in pectore*, on his private list, that is to say. When the article is put up for sale it is either

The Faked Atmosphere

offered straight away for the price quoted or the latter is led up to by by-bidding. If this proves to be impossible, the object is bought in and the owner has merely a slight percentage to pay on the last bid and can withdraw his property. Thus while an auction sale always presents hazards, the reserve price is a guarantee against the risks of flagging moments. The room may chance to be deserted of its best public through unforeseen circumstances, enthusiasm may suddenly cool unaccountably, and for these and other reasons a reserve price is therefore a legitimate defence.

Strange to say, even this honest and recognized safeguard has been turned to cunning abuse. The principle of the reserve price, at least, has brought into being that questionable personage nicknamed in English auction rooms Peter Funk, a most undesirable " faker of situations."

The fact that the reserve price given to the auctioneer is often disclosed to interested collectors, and that it may be divulged by auction-room clerks and so become known, induced collectors with *objets de virtu* on sale to send friends or agents secretly, in order to run up the bidding to a certain figure. The name long since given to this complacent, secret partner shamming the art buyer is Peter Funk.

"Funkism," if one may be allowed to coin a neologism, certainly has its right to existence and originated in the legitimate desire to protect objects from falling at ridiculous prices in depressed moments of the sale, but it has now become a regular curse, especially at first-class auctions, where by reason of the great interests at stake, the system can be worked to its full magnitude and no expense spared. As an example—and one that to our knowledge worked greatly to the advantage of the seller and not at all to that of the buyer, from whom " funkism " robs all chance of the " fair play " which should be the dominant note in auctions— we may quote the sale of an Italian collection at Christie's at which, certainly without the knowledge or even suspicion of the auctioneers, Peter Funk played havoc under every

form and guise. To make sure that the keen-eyed collectors should not discover the pseudo-collectors, the latter were all imported from the Continent and given strict injunctions to buy at the stated price, to bid without comment and to indulge in none but commonplaces in conversation with the public, the dealer employing them knowing how impossible it is for a non-collector or a feigned art lover to say three words about a work of art, without giving himself away. A good appearance, natural bidding without emphasis or theatrical pose, an occasional " yes " or " may-be " or " hem " when questioned, and a whole string of uncompromising banalities, these are the stock-in-trade of an improvised Peter Funk, who may not be so capable as the professional one but has the advantage of being less easily detected.

A clever Peter Funk knows the right moment to run up a price, judging from his competitor's enthusiasm up to what sum he can safely bid before abandoning the game, and by counting on his opponent's rashness and impulsiveness runs him up to bids which he afterwards regrets. Risky as it is, rarely does an object remain in the hands of Peter Funk, and if it does, the owner will supply him with the money and withdraw the article, paying the auctioneer's dues, a comparatively modest percentage.

These combined forces in the auction room secretly working as a sequence of traps caused a well-known French collector to propose as an inscription to be put over the door of one of these dangerous dens: "*Ici il y a des pièges à loups.*"

It is not meant by this that all auction rooms are infested by brigands, who leave no chance for fair-play, and that all who ever enter them come out regretting the attempt to buy by a system that appeals to the public for its square dealing. Not at all, the best artistic investments are often made at public sales, but rarely, alas, by the inexperienced novice who has but a limited knowledge of art, and is besides wholly unfamiliar with the ways of auction rooms.

224 The Faked Atmosphere

This double form of ignorance needs the warning that there are traps, so that coolness and wisdom may enter the brain of the enthusiastic beginner, two necessary items in gaining experience at a reasonable price.

PART III

THE FAKED ARTICLE

CHAPTER XIX

THE MAKE-UP OF FAKED ANTIQUES

Paintings, drawings, etchings, etc.—How the art of faking necessarily borrows technique and experience from the restorer—Old and modern ways of imitating the technique of painting—New pictures on old canvases and old paintings repainted and doctored—Suggestions for imitating the preparation of panel or canvas—Imitating characteristic paintings in impasto—Veiling and varnishing—Imitating the cracking of varnish—Old drawings—Technique of the proper abuse to give an appearance of age to drawings—Etchings—Fresh margins to old prints, etc.

OPINIONS as to the restoration of objects of art are of a most varied character; more especially in the case of painting, an art of rather complex technique. The various opinions about the restoration of paintings may, however, be classified into three distinct categories. One might be said to be entirely in favour of the process, one entirely discountenancing it, and between them one which is permissible as it has to do only with mechanical methods calculated to reinforce pigment, or the canvas or panel, and is not concerned with what might be called the artistic side of the art, such as retouching or filling in the missing parts of a painting.

Speaking of certain restorations of his time, even Vasari remarks in the Life of Luca Signorelli, that "it would be far better for a masterpiece to remain ruined by time than to have it ruined by retouching by an inferior hand."

Baldinucci tells us how Guido Reni objected to the retouching of old paintings, more especially the work of good masters,

The Make-up of Faked Antiques

and that he invariably refused to do it himself, no matter how much a client was disposed to offer for the work.

Milizia, the architect and writer, says that to retouch an old painting, particularly a fine work of art, is to pave the way for future and wider destruction, as in the course of time the retouching will show itself and then another act of barbarity will have to be perpetrated.

According to the opinion of a well-known Florentine antiquary and famous restorer of paintings for the American market, a picture has nothing to gain from the hand of the restorer. On the contrary, his opinion is that: " As soon as a restorer lays hands on a painting he ruins it."

The class we have placed between the two extremes, the one using a certain discrimination, accepting such methods as are intended merely to preserve the work without encroaching upon its artistic merits, such as furnishing a fresh panel or canvas to a painting, removing old and deteriorated varnish, etc., being the wise one is, of course, represented by the minority.

Needless to say, the main forces of the class supporting restoration in its extreme form are drawn from the ranks of restorers or authors of works teaching the grand art of resuscitating masterpieces, such men as Merimée, Vergnaud, Prange, Deon, Forni and Secco Suardo. The latter, in fact, does not hesitate to call restoration a magic art and depicts the restorer as a regular miracle-worker.

We do not propose in this chapter to follow the various methods of restoring paintings according to the character of the work, fresco, tempera or oil, but simply to indicate some of the restoration processes that are useful to fakers in deceiving inexperienced collectors.

In the case of faking up an old painting of weak or defective character, into the delusive suggestion of a work of good quality, the process consists principally of bringing the form into proper shape by veiling and toning the crude parts of the colouring. This work, the success of which chiefly depends upon the skill and versatility of the forger, is generally effected

The Make-up of Faked Antiques

by first removing the old varnish with a solvent. There are many kinds of solvents which can be used, according to the quality of the varnish, the most common, however, is alcohol. It must be very pure, containing the minimum of water. Ordinary alcohol is likely to produce opaque, white patches, a phenomenon called by the French restorer *chanci*, and very difficult to obliterate once it has appeared. Being one of the strongest solvents and of dangerous and too rapid action at times, the alcohol is generally mixed with turpentine to the proportion of half-and-half to start with. Then, according to the greater or lesser solubility of the varnish, the proportion of alcohol is gradually increased. This mixture, called *la mista* by Italian antiquaries, may be substituted, as we have said, by various solvents—potash, soda, ammonia, etc.—according to the nature or hardness of the varnish to be dissolved. Some restorers also resort to mechanical methods to remove old varnish. These methods, too, are various. If the varnish is hard it can be cracked by pressure from the thumb, a long operation requiring no small amount of patience and skill. If it possesses sufficient elasticity to withstand this process, it is generally removed with a steel blade in the form of an eraser. The latter operation is not only very difficult but very slow, particularly when the painting possesses artistic qualities that must not be impaired by the removal of the varnish.

This first operation successfully accomplished, the artist steps in and proceeds to help the work, say of such and such a school, to resemble the painting of the master of this school as much as possible. The process is naturally executed by the aid of a more or less complete collection of photographs of the work of the master the faker intends to imitate. The retouching may follow the most varied methods. To take the most common case, that of oil painting, the new work can be carried out with oil colours previously kept on blotting-paper to drain off the oil which is then substituted with turpentine to give the colours their lost fluidity; it may also be effected with tempera colours or with colours the fluid

element of which consists only of varnish. The use of tempera is preferred by restorers because, although it presents the extreme difficulty of changing hue when varnished and consequently demands no little experience to judge the requisite hue or tone, still once laid down it is not likely to change with time as oil retouching on old paintings generally does. The mixing of colour with varnish alone has the advantage of keeping the proper tone from beginning to end. This method is extremely useful not only in the painting of missing parts but also to veil and tone what has been painted in tempera if this is not entirely harmonious with the rest after varnishing. Needless to add, those colours the fluid part of which is supplied by varnish are unalterable as they do not contain any oil whatever. One of the difficulties in handling these pigments is the lack of fluidity, hence turpentine may be added with advantage.

However, as the above methods of retouching are not proof against chemical tests, alcohol being the proper solvent with which to do away with added touches to old paintings which have been done with either oil or varnish colours, the shrewder fakers either mix amber varnish with the colours or give the fresh touches a solid coating of this varnish, which when well prepared is supposed to be insoluble and not easily acted upon by solvents. Although more than one special work on the art of restoring gives recipes for the preparation of this varnish, in practice very few know how to prepare it in the proper way.

We have here presupposed that the picture was in good order, that there were no missing parts of importance, or rather that, with panel or canvas unimpaired, the work only required to be retouched by the artist, a rare case, as when the paint has vanished the preparation of the panel or canvas has generally vanished with it, on account of its adhesiveness.

We do not propose to give the various recipes for the plaster dressing forming the preparation of the panel or canvas. They are different according to time and country and can be

The Make-up of Faked Antiques 229

found in special works on painting. Under ordinary conditions it is very easy to substitute the missing preparation, just as it is easy to give it the proper surface either by pumice or skilled coating with the brush, but in the case of a painting on canvas it is very seldom that there are not big holes right through it. The first operation in such cases is to recanvas the work, to line it, namely, with another canvas which is pasted to the old one and flattened with an iron till perfectly dry. The missing part must then be filled in, imitating the weave of the canvas on which the work is painted. No easy matter this, as the different weaves of canvases are as characteristic as signatures: no two are ever alike. The new canvas showing through the hole is therefore either covered with a patch of canvas taken from some corner of the painting to be restored, or it is given the same appearance by pressing a piece of the old canvas upon the fresh preparation of the part missing, thus moulding the texture of the threads. This must be done skilfully in such a way that the parallel lines of the threads match. There are some clever fakers who imitate the old canvas by strokes of a hard brush upon the fresh preparation of the new pieces, reproducing the characteristics of the canvas by actually copying from the original part.

When a painting is finished there are various methods by which an appearance of age may be given or restored to it. From asphalt to liquorice hundreds of things are used, either dissolved in turpentine or water, glue, albumen, etc. Veiling with varnish, coloured with the proper pigment, generally gives the finishing touch.

The imitation of old and cracked varnish is simple enough. First one must give the canvas a coat of diluted glue, then varnish before the glue is quite dry. As the underlayer of glue dries quickly and has a shrinking capacity disproportionate to that of the varnish, it is easy to understand that the result will be a cracking of the varnish. A close or a coarse network of cracks is obtained by increasing or decreasing the inequality of shrinkage between the two layers,

or by hastening or retarding the drying of the upper layer by artificial means. Although comparatively easy, these operations nevertheless demand no little experience to be crowned with due success.

If a painting has been repainted only in the parts that were missing, and the old varnish has not been removed from the rest of the picture, it is a question of not only giving the varnish of the new spots cracks like the old varnish, but these must imitate as closely as possible those of the original part of the painting. In such cases a needle is used to make the cracks on the newly varnished parts. When the grooves have been made in the varnish they are filled in with water and colour or soot to give them the desired appearance of age.

Such, roughly, is the method mostly in use for oil paintings. With the necessary variations, and the use of the proper medium, the same method also answers for tempera. It is rare that frescoes are imitated or retouched, but in such cases fresh cheese is used as the vehicle for the colour, and when dry it not only acquires the quality of insolubility but also the opaque hue of the fresco.

As far as technique is concerned, the imitator does not find it easy to imitate the work of those artists who paint in impasto, that is to say with a thick layer of pigment, the consequent characteristic strokes of the brush requiring no little experience for reproduction in all their force, character and characteristics. Through long study and practice some finally succeed in imitating the work of such painters as Rembrandt or Frans Hals, but such cases are extremely rare. Forni, who has written a work on the restoration of paintings, suggests a method of imitating impasto painting with its characteristic brush strokes which, in our view, can only be applied in the case of repairing a part missing in some old painting. Forni's method consists of first reproducing the peculiarities of the brush strokes in a plaster composition closely resembling that of the preparation of the canvas, and then giving the proper colouring. According to Forni this method has the advantage of giving the impression of a frank and vigorous style of

The Make-up of Faked Antiques

painting such as is usual with the impasto technique, and yet it has been achieved slowly and patiently.

One of the side-businesses of picture faking is the providing of suitable signatures. When one considers that paintings generally bear the artist's signature, more especially in recent times, it would be strange if this branch of the shady trade did not number specialists who can imitate signatures to perfection, as well as reproduce artists' special monograms.

It is easy to understand how old drawings and sketches may be imitated. Just as in the case of faking a painting, the artist tries first to become familiar with the work he wishes to imitate. It is then usually executed on old paper and when finished soaked in dirty water, dried and scoured with pumice to give it the apparent abuse of age. Some imitators, however, do not give themselves the trouble to find the proper paper, and it is not unusual to see imitations on modern paper, or would-be sixteenth-century work on paper bearing the mill-mark of two or three centuries later. But these of course are the gross imitations only intended to dupe the most naïve of beginners.

Prints are also imitated, and nowadays to perfection with the help of mechanical aids, when they have to reproduce an excellent original. The ageing process is the same as that used for drawings. There is one difference between them to be noted, it is that in the case of old prints or etchings the presence or absence of the margin counts for much. An etching with its original paper margin is far more valuable than one that has been cut to fit a frame or for any other purpose. Hence one particular branch of faking of the prints is to refurnish paper margins to those specimens that have lost them. The work is more or less successful according to the skill of the faker, but is usually effected in the following manner: The etching is cut all round the edge reasonably near the printed part, then a large piece of old paper is cut to fit the etching as a frame and the two edges are brought and held together for some time by a paper lining at the back. The crack of the join between the old etching and the new margin

is filled in with paste of the same composition as the paper and smoothed even by a mechanical process. It is of course needless to add that such a method is not likely to take in a true collector, but the faker knows that foolish clients are sometimes numerous and his best supporters.

Miniature work is easy to imitate, not only on account of its technique, in which originality has a comparatively small rôle to play, but because it needs hardly any patina or ageing.

Pastels and water colours, more especially the latter, appear to be a little out of the forger's line. Yet pastel, with its peculiar technique, affords possibilities for faking.

Copies of noted originals have not escaped the speculative spirit of the counterfeiter. They are generally sold as contemporary copies or antique copies, and they seem to command higher prices, even if an old copy is at times far inferior to a modern one.

In the faking of modern, or semi-modern art, the technique intended to confer age and venerability to the work finds no place. In such cases, it is easy to understand, the main craft lies in imitating the style of the master counterfeited.

Speaking of such imitations, we may note that fakers contemporary with the artist are perhaps the most dangerous to the neophyte, and as imitations have always existed more or less, and are by no means only the product of the greed of modern fakers and dealers, a collector is often taken in by a false Corot or a false Rousseau, in which the only legitimate thing is perhaps the date, the forgery having been perpetrated during the master's lifetime.

Naturally, the imitation is not always made for the purpose of cheating, but almost always with the hope of becoming as popular as a certain master by imitating his style. It is very often the work of pupils, as in the case of the Watteau imitations by Lancret and Pater.

It is known that the work of Paul Potter has been imitated by Klomp, that Jacob van Huysum has counterfeited the work of Breughel and of Wouwermans, that Constantin

The Make-up of Faked Antiques 233

Netscher made plenty of money copying Vandyke Charles I portraits, and that Teniers the Younger sold false Titians.

To go back to prints and etchings before closing this chapter one must make a distinction between old imitations and modern ones. A good connoisseur is never at a loss to detect signs of counterfeit, but there is an essential difference of criterion needed in judging old imitations of etchings and modern imitations. In old prints involuntary discrepancies are sure to occur as they have been reproduced by hand, and the connoisseur must therefore be acquainted with them. These variations are more or less known to experts, whereas in the case of a modern purely mechanical reproduction, a magnifying glass and technical experience are the chief requirements. Marco Dente's reproduction of Marcantonio's work and the copies of Callot's etchings by some of his pupils are examples of the imperfections of old imitations, details having been omitted.

CHAPTER XX

FAKED SCULPTURE, BAS-RELIEFS AND BRONZES

Faked sculpture—Clay work—The false Tanagras—Imitation of Renaissance work—Bas-reliefs and busts—Baked clay and *stucco-duro*—The Clodions—Bronzes—The importance of patina—The patina of Pompeiian bronzes and excavated bronzes—Renaissance patina and that of later times—Gilded bronzes—Marble work and its general colouring—Sculpture in wood and ivory—The Ceroplastica.

WE must repeat that in sculpture also, faking borrows largely from the art of restoring. Indeed it is no exaggeration to say that nearly all branches of the faker's art turn for help to the restorer's methods. And here again, as in painting, we are also immediately confronted by two forms of trickery; one is the creation of a modern object in imitation of the antique so as to deceive the collector, and the other the reconstruction of some fantastic piece of forgery from an inferior object, or one greatly damaged by over-restoration. To speak of over-restoration is in such cases to use a euphemism. We can offer an example showing how this over-restoration of objects is nothing but a form of faking highly flavoured with different varieties of deception. A rich American bought a marble statue some years ago representing a famous Roman empress. It was bought not only because the Roman art appealed to him but as the portrait of that particular Roman empress. As a matter of fact, the whole statue had been faked by the addition of new portions to a headless, limbless torso, which was the only genuinely antique part. We must say, however, that the new head given to the half-faked statue was extremely well done. It

Faked Sculpture, Bas-reliefs, Bronzes

had been copied from a well-known model and except that the patina of the marble was not so perfect as might have been expected from a great master in trickery, the most experienced collector might have been deceived.

Clay work is perhaps the most popular form of plastic art among the fakers of antiques. As it has the special advantage of being made from casts of originals, it does not present any real technical difficulty, and it demands no expensive additions and may be given colour and patina with comparative ease. Of course many of these advantages are also shared by bronzes, stucco, and all productions worked from an original model in clay or any other plastic substance, such as wax, pastiline, etc.

Tanagra figurines undoubtedly hold the first place in the large class of faked clay work. There has been an uninterrupted succession of forgers in this line from the time Tanagra work first came into fashion with collectors, to the stock imitations now sold in Paris and still bought for genuine Tanagras by over-naïve collectors. The old Baron Rothschild, who had a fine collection of Tanagra figurines and no small experience as a connoisseur, used to say that when it is a question of a Tanagra one must see it excavated, and even that nowadays is hardly a guarantee of genuineness.

The imitations are generally cast from good originals, and as the clay shrinks considerably in drying and baking, the imitation is usually smaller than the original and can therefore easily be detected when confronted with a genuine piece.

Some of the more advanced imitators have somewhat obviated this difference of dimension by mechanical methods of expanding moulds, but the work in such cases is not so perfect as otherwise and what is gained on the one hand, namely, a dimension identical to that of the original, is lost on the other, as methods of taking over-sized moulds from originals are generally imperfect.

A flourishing product of the Italian market are bas-reliefs and clay busts in imitation of Renaissance work.

Faked Sculpture, Bas-reliefs, Bronzes

When not the work of clever artists who model direct from the clay, having studied and mastered the old style, it is the product of miserable mechanical deception aided by ability to disguise its patchwork nature, the trickery and general sleight-of-hand of the wily art of faking.

In the case of bas-reliefs they are often composed of different parts belonging to different originals, sometimes originals unknown to connoisseurs and art critics. This method has been applied to the imitation of Renaissance terra-cotta busts. A bust bought at a high figure from a Venetian antiquary many years ago and believed to be genuine Quattrocento work was afterwards discovered to have been made from the cast taken from the face of a recumbent figure on a tomb in the church of San Pietro e Paolo, to which had been added the back part of another bust, the whole finally set upon a pair of shoulders cast from another original of the period. The monument from which the face had been moulded was so high up on the wall of the church of San Pietro e Paolo that no one knew of the existence of this original and the other parts of the faked object had also been taken from little known originals. The fraud was discovered in Paris some time after the bust had entered a noted collection, a lawsuit ensued and the collector eventually recovered the money he had paid.

Italian art of the fifteenth century has produced many clay bas-reliefs, apparently from one and the same original and yet presenting slight differences, additions and modifications evidently made after the clay had left the mould but when it was still fresh. This fact has greatly incited the fancy of Italian forgers and largely contributed to the confusion of art critics and the duping of more than one collector. These bas-reliefs represent sacred subjects for the most part, and sometimes it is not merely a question of putting a rose in the Madonna's hand or a little bird into those of the Infant Jesus, in order to lay claim to due originality, but the modifications are so radical that the whole appearance of the work is changed. It is generally done as follows. A good plaster-

Faked Sculpture, Bas-reliefs, Bronzes

mould is made from a good original, and a clay reproduction formed from this mould, which is then modified and changed while still fresh. Should the work to be divested of its original character represent, say, a Madonna and Child, the artist may proceed to alter its size by modifying the border; then, to transform the subject, he may make an addition on one side, of the heads of the ox and ass, taken of course from another original. To change the pose of the Madonna the clay is generally cut behind the head and neck with a fine wire and then the position of the head can be altered at pleasure; from being erect, for instance, it can be inclined, or vice versa. By the same method, and no small amount of skill, arms and hands can be given new attitudes, etc. The final result is a work which passes as an original among foolish art lovers who collect series.

Stucco duro imitations are produced by almost identical methods. These compositions are generally made of plaster, which hardens as it dries after being poured into a mould. When the original is to be modified a first model of clay or some other soft modelling material is indispensable, of course, and from this a mould is then taken for the casting of the *stucco duro*.

To colour and give a patina either to baked clay or stucco is comparatively easy. The colouring is given with tempera colours, the patina with tinted water, for which tobacco, soot, etc., may be used, applied with smoky and greasy hands. A coat of benzine in which a small quantity of wax has been dissolved is finally laid on with a brush and the whole polished with a brush or wool.

As we have said, however, fakers are especially partial to clay work. It requires little outlay, the finished work can be fired at small expense, the colouring and patina can be given "at home," not needing the special light of a studio, etc. Not only in the case of Renaissance work has this method been the favoured one but in other types of art forgery, the eighteenth-century terra-cottas, for instance, the lovely work of Clodion, Falconnet, Marin, etc. Paris is glutted

238 Faked Sculpture, Bas-reliefs, Bronzes

with imitations of Clodion's clay groups. Some of them are sufficiently good to puzzle the best connoisseurs. As we have seen, a pseudo-Clodion sold years ago in perfect good faith by M. Du Boullay to Mme. Boiss caused a complicated lawsuit and many inconclusive discussions among art critics and connoisseurs of the calibre of Eugène Guillaume, Chapu, Millet, Carrier Belleuse, and specialists on Clodion's work such as Thiacourt. It was finally established that the bit bearing Clodion's name was authentic and had been inset in a group of much later date, a spurious original, but even this was not absolutely proved and simply offered as the most acceptable hypothesis. As Paul Eudel remarks, to decide the matter, " Clodion would have to raise the stone of his sepulchre and to rise from his tomb in order to supply an irrefutable solution."

The initial process for faking antique bronzes is very similar to that used in clay and stucco forgeries. By initial process we mean, of course, the way the mould is made for casting the bronze. When the pseudo original has been modelled in clay, the form of it is naturally taken to obtain a matrix of some harder material, and from this matrix is taken the mould that is used for the cast. There is also another system of casting bronzes greatly in vogue among fakers, more especially for small objects, which is called *cire perdu*. It is a simplified method, consisting of modelling the object in wax, then taking its mould, which is emptied by melting the wax. The details of these two methods of casting bronze, the ordinary casting and the *cire perdu* process, can be found in any technical work on bronze casting and need not be repeated here.

The patina of bronzes presents a difficulty in addition to the artistic difficulties of creating a convincing pseudo-original, difficulties common to clay, stucco, and, in fact, all faked sculpture. Patina, the *nobilis ærugo* of Horace, is the peculiar oxidization acquired by bronze with age. For the connoisseur, the patina is not only a part of the artistic *tout ensemble* of a bronze object—so much so that

Faked Sculpture, Bas-reliefs, Bronzes 239

there are collectors more impressed by the beauty of the patina than by the artistic value of the piece—but it is the chief indication of the authenticity of the work.

According to Pliny, great importance was attached to the *nobilis ærugo* by the Roman connoisseurs also, especially in the case of the famous Corinthian bronze. This metal was classified into five qualities by the Roman amateur according to five different hues or patinas depending upon the proportion of gold and silver in the alloy. Roman art lovers made a regular study of bronze patina and of the composition of the bronze of art objects. The components of this knowledge were not only gathered from the appearance of a certain bronze, but by its relative weight and the odour of the metal. That the odour of an alloy should have been made a test to judge of its component parts is very possible as the smell of bronze and brass is essentially different, and there is no reason why a practised Roman nose should not have distinguished slight differences according to the proportion of the various metals in the alloy.

One reason, apart from artistic motives, why the collector gives the patina so much consideration is, as we have said, because the patina nowadays is one of the safest guides in buying antique bronzes. Whilst the artistic qualities of certain objects may be reproduced with skill or trickery, patina of a really genuine and entirely convincing appearance is supposed to be beyond the faker's art. Our own and other people's experience leads us to doubt this, but such, as a matter of fact, is the common belief among collectors. Faked patina, it is true, is less transparent and duller than the genuine, and it can easily be detected by shininess at the points and sharp edges of a bronze where it is difficult to fix the imitation patina, but, we would repeat, there are bronzes in Naples and some of the cities of Northern Italy that have deceived the best connoisseurs, and samples may be seen in nearly all the important museums of Europe and America. Almost all works treating specially of metal casting give various methods for obtaining a proper patina

according to the different hues one may wish to give the bronze. Yet modern methods of colouring and oxidizing bronze do not seem to satisfy the antiquary and, in consequence, the faker of antique bronzes. All modern mechanical methods produce fine colouring without brilliancy, colouring that does not seem to possess the vibrant quality of old patina, oxidation that appears to be too superficial to show the depth of colouring peculiar to patina obtained by the slow process of age. To obtain such an effect the faker resorts to the most varied and out-of-the-way methods, and when possible tries to hasten the slow oxidation of age by greasing and smoking the object, putting it in damp places and treating it with acids. Often the most varied methods are used in conjunction or alternately with a patience and persistence worthy of a more honourable cause, but practised with ever-greater keenness, alas, with the promise of much gain. Some of the most successful patinas are obtained not only by duly working at the colouring and oxidation of the metal, but by composing the alloy in such a way as to favour the production of a convincing patina later on.

Naturally, the differences of the patina of old bronzes depend not only upon the various conditions to which the work may have been exposed through age, but also upon the colouring or kind of artificial oxidation that may have been given it upon leaving the foundry.

Thus whilst an antique bronze brought up from the bottom of the sea may have the peculiar patina of age acquired under these special conditions and another statue exposed only to atmospheric oxidation may show the different hue belonging to the effect of air, there are bronzes which have been coloured upon leaving the foundry, and even when age has given brilliance to the patina they bear the characteristics differentiating the school or artist. The most difficult to imitate are the excavated Greek, Roman or Etruscan bronzes, especially when the humidity of the soil or some peculiar condition has produced a kind of patina possessing

Photo. *Alinari.*

AN IMITATION OF ROMAN WORK. AN IMITATION OF 16TH CENTURY WORK.
Latest part of XIVth Century.

Faked Sculpture, Bas-reliefs, Bronzes 241

the appearance of enamel. Among the artificial hues of Renaissance bronze, the brownish tint of the Paduan school is characteristic, and worthy of note are some of the blackish specimens of Venetian bronze, as well as the whole emporium of samples of the versatile Florentine school. Some of these patinæ are reproduced fairly well, and now that Gianbologna and his school are beginning to be appreciated, we would state that faking is successfully studied to produce the reddish patina of some of the not always exquisite but yet invariably interesting little bronzes of Tacca Susini Francavilla and others.

It was once believed by some collectors that gilded bronze could not be imitated, that the galvanoplastic method was as recognizable as any false and badly made coin. We doubt this, for we fail to see why the old system of gilding with mercury could not be applied to imitations. It is somewhat slower and more expensive, but the profit, as usual, makes it worth while in the eyes of the faker. Gilding is certainly imitated to perfection on modern pieces purporting to be the work of French artists of the eighteenth century and some of the counterfeits of Gutierrez' and Caffieri's work have even the varnish that was at one time considered inimitable.

The great progress made in imitating patina, has rendered the collecting of bronzes one of the most dangerous branches the collector can choose.

In the case of marble, stone or other hard material that has to be chiselled, the faker generally starts his work along the lines of the sculptor, that is to say, he models the original in clay, casts it in plaster and transfers it to the marble by the usual methods. Then when this artistic part has been accomplished successfully, the marble or stone must be given the appearance of antiquity and the patina belonging to age. This is generally effected by two distinct operations, one relating to the form, the other to the colour and the whole peculiar harmonization of tone and polish called patina. As regards the form, modern sculpture being somewhat too

Faked Sculpture, Bas-reliefs, Bronzes

precise and sharp-edged, the chief aim of the operation is to destroy these qualities, as well as to confer upon the object the abuse that is supposed to be traced upon an antique during its long pilgrimage through the ages. The marble is therefore skilfully chipped here and there with mallet and chisel, sand and acid are applied to dull the over-sharp tooling, and sometimes to cause corrosion, etc. The principle accepted, it is easy to understand that ways of ageing sculpture are multiplied, and vary according to the illusion the faker intends to convey. The fact that old Greek and Roman work is not identical with Renaissance productions in appearance, as the former are generally excavated while the latter come down to us through a long succession of owners, is sufficient to show that there are slight differences which must be taken into consideration.

For colouring marble and stone, a general tone is usually given at first which is intended to destroy the crudeness of the new material, especially in the case of marble. One of the most common ways is to wash the object with water containing a certain quantity of green vitriol. When applied before the stone has lost its permeability, this solution penetrates deeply, particularly in marble, and the colouring is not easily destroyed or washed out by long exposure to atmospheric action. Some use nitrate of silver also when a different hue is to be given, but the solution mentioned first, which confers the proper ivory tone to the marble, is the most common. Naturally, a tone given by these means is too uniform and monotonous to be taken for the colouring of old age, so the artist calls his talent and experience into play to produce the desired variation; there is, in fact, no other teaching but experience and taste. It is to be noted that in the colouring of stone, and particularly marble, the artist has an almost complete palette at his disposal, for in this branch chemistry supplies nearly every hue possible.

We may remark by the way that the art of colouring marble was already well understood in the days of ancient Greece, and it is a fact that more than one statue of that

Faked Sculpture, Bas-reliefs, Bronzes 243

period shows signs of colouring wonderfully preserved through the ages. In Italy, where marble dyeing is still a flourishing art, it is done with very few colours: verdigris, gamboge, dragon's-blood, cochineal, redwood and logwood.

Nearly all vegetable dyes are suitable, and many coal-tar colours, if properly used, give a very fast and beautiful colour to marble. It is essential for the solution of all dyes to be made with alcohol or ether, and only such anilines may be employed as are soluble in fat. Some solutions may be applied direct to the marble, whatever its temperature; others require the heating of the marble, to increase its permeability and consequent faculty of imbibing the colouring solution. The quality and condition of the marble must also be taken into consideration. If the marble has not been polished properly, or has been touched with greasy hands, a patchy effect or stains will result.

Rubbing with flannel and the moderate use of encaustic, give the finishing touches, when the character of the patina requires the shiny effect so often seen in old marbles.

Objects sculptured in wood represent no change of technique for the forger of antiques as far as the carving is concerned. The forger's ability to imitate the work of an old master is purely artistic, and cannot, of course, be achieved by any special method; but the art of giving the object a convincing appearance of age is fairly mechanical, depending upon the use of alkali, permanganate of potash and other substances. The process being somewhat complex and common, as a matter of fact, to all kinds of wood carving, it will be given in detail when imitation antique furniture and the methods of producing it are described; faked furniture being, perhaps, one of the most productive branches of the obscure trade of counterfeit antiques. Sometimes artistic figures or bas-reliefs in wood are either coloured or gilded. In the case of polychromatic work, the wood is generally coated with a plaster preparation to receive the colour, and the technique for ageing or giving a patina is that already described for stucco or clay work; in the

Faked Sculpture, Bas-reliefs, Bronzes

case of gilding, the appearance of age is given to the new gold by colour veiling, also liquorice juice and burnt paper are used with advantage applied to the gold with a soft brush.

Ivory work too, which represents one of the most dangerous fields to neophytic enterprise, requires no special technique in counterfeiting as far as the artistic creation is concerned. It must also be tempting to the carver as a material, for certain naïve effects of primitive art seem aided by the essential qualities of the ivory, its fibrous constitution in particular. One may safely say that there is nowadays hardly a single genuine Byzantine Christ; there are, however, plenty on the market of course.

The old cracks of antique ivory are very easily imitated. There is more than one method for producing them, the most common is to plunge the piece into boiling water and then dry quickly before a fire. The operation can of course be repeated until the desired effect is attained. Here also smoke and tobacco-juice can perform miracles. Sometimes ivory pieces are placed in a fermenting heap of fertilizer or wet hay. The methods are, in fact, most varied, and an inventive spirit seems of great assistance to the faker in devising new schemes every day.

We now come to the last class of this chapter, ceroplastics, which includes all forms of modelled wax, small bas-reliefs supposed to have been the originals of *plaquettes*, little family portraits in coloured wax, etc. In this branch, patina and complicated methods to attain an appearance of age hardly come into consideration, a mere touch of the hand is at times sufficient to stain the wax, and work of this kind takes the colouring so readily after it is modelled that no craft is needed in imitating old wax work, provided the artist is able to imitate the antique handiwork. Besides, wax portraits have been for the most part kept under glass and have come down to us as fresh as though made yesterday, not only those of a century or two ago but also those that have reached a most respectable centennial age. Wax work is one of the

Faked Sculpture, Bas-reliefs, Bronzes 245

easiest to imitate and one of the most difficult to detect when imitated. We are therefore inclined to advise the freshman collector to abstain from buying this kind of work, unless irrefutable documentary evidence is offered in the shape of a well-authenticated pedigree of the work.

CHAPTER XXI

FAKED POTTERY

Faked pottery—Old unglazed types—Artistic and scientific interest in pottery—Oriental glazed pottery—Greek and Etruscan half-glazed vases—Faience and its various types—Italian factories, Cafaggiolo, Urbino, etc.—Iridescent glazes, Hispano-Moresque, Deruta and Gubbio—French pottery—Faked Palissy and imitations of Henri II—Other types of French faience—China, the old and modern composition of china—Various ways of faking china of good marks—Half-faked pieces—Blunders in marks—Glasses and enamels.

POTTERY presents one of the richest and most varied fields for imitation and faking. The endless types and specialities of this class seem to have spurred the versatile genius of the imitator.

Broadly speaking, and age apart, pottery may be divided into two classes: one in which glazing does not appear, and one in which this important element of ceramics lends an entirely different character to the product.

The first class more especially, if not exclusively, may be grouped into two types according to character: those that interest the scientist in particular, and those that come more into the domain of the artist and art lover. It is of course understood that there is no definite line of demarcation between the two.

Faking, however, with a great spirit of impartiality, makes no distinctions and is ready to meet its clients on the scientific or artistic field, and fully prepared to accommodate the scientist with an artistic bent or the artist possessing the learned propensities of the historian.

Thus Mexican idols and Peruvian pottery, as well as the productions of savage tribes, are imitated and copied with the

Faked Pottery

same interest as the unglazed vases of Samos, Greek clay urns and Roman lamps. What regulates the increase of the forger's activities and spurs his genius is, as we have said, the demand for an article and its price.

There is nothing surprising then in the fact that some rather indifferent types of pottery of savage tribes, or incomplete aboriginal specimens, should have been faked as though they presented the interest of a *chef-d'œuvre*. Not altogether of this class, but certainly of limited interest so far as art is concerned, are the Mexican articles which have been among the most exploited by those who know that these kinds of relics are in great demand by scientists as well as collectors who have a passion for specialities.

In the Exhibition of 1878, a group of scientists put the incautious upon their guard by exhibiting a whole series of faked Mexican idols, pottery and so forth. But as the articles, especially at that time, were in great vogue, the warning was not sufficient for specialists and collectors, and the show of faked Mexican art proved such a success that it stirred the honesty or cynicism, we hardly know which, of a Parisian dealer who conceived the notion to advertise his wares: " Forgeries of Mexican idols, 5–25 francs."

Unglazed Oriental and Græco-Roman pottery, with its fine forms and decorative character, has not only proved an attraction to the collector but very tempting to the faker who finds no great difficulty in imitating it. The way to render such pottery antique-looking is easy. Acids may play their part here too, but they are hardly necessary as the porous nature of the clay makes it able to absorb any kind of hue, tone and dirt if buried in specially prepared ground or in a bed of fertilizer.

Curiously enough from one point of view, the imitation of this early art generally flourishes on the very spot where the originals are excavated, and still more odd is it that on more than one occasion those duped were the very ones supposed to be good connoisseurs and who took direct interest in the excavations. Thus it is that there is an

Faked Pottery

abundance of faked Samos, Rhodes and other specimens, in collections now housed in museums. A superficial inspection of the Cesnola collection in the Metropolitan Museum of New York, ought to be sufficient to prove that even connoisseurs as good as Cesnola, are not quite safe in this speciality against the trickery of modern imitators.

With Greek, Campanian or Etruscan pottery that bears a peculiar polish or glazing the nature of which is still a mystery to ceramists the case is somewhat different; good imitations are rare. Naturally there cannot be included among convincing imitations those upon which a lead glaze has been used, as such imitations are covered with a thick layer of shining glaze and are only intended for veriest neophytes who have presumably never seen an original. Successful imitations are either finished with a very thin and non-shining glaze or an encaustic polish. To ascertain whether encaustic has been used, one has only to rub the piece with a cloth soaked in benzine, which will soon turn it opaque.

In the pottery museum of Sèvres there is an interesting series of faked Greek and Etruscan vases, urns, etc. It comprises some good specimens of the work of Touchard, an imitator flourishing about the year 1835, other pieces by the Giustiniani of Naples, and some of the most successful fakes of this particular kind of pottery, the pieces by Krieg from the Rheinzabern factory. These pieces were sold to the Sèvres Museum as genuine, by a Bavarian, in the year 1837.

We are told that a good method in imitating Etruscan pottery is to work with *engobe*, adding a well-ground *frit* to the *barbotine* that contains the elements of a glaze. To our knowledge all imitations of this kind are wanting in appearance and it is safe to assert that they could hardly receive serious consideration from a true connoisseur.

As regards glazed Oriental ceramics, there are to be noted some good imitations of Persian work and, above all, imitations of the characteristic pottery of Rhodes. Factories for these ceramics are almost everywhere. Perhaps the best imitations come from a factory in Paris. Imitations from this

Faked Pottery

factory have succeeded in deceiving more than one connoisseur. A well-known curator of a Berlin museum bought one of these samples as genuine, paying eighty pounds for it, and an antiquary of Florence, quite a specialist in ceramics, very nearly committed the same mistake, but by good luck he was warned by a friend who had been taught by hard experience that this Oriental pottery is a product of very Western origin. Curiously enough the manufacturers do not sell their produce for anything but imitations; however, through the usual frauds in which the market in antiques abounds, these pieces are evidently palmed off on unwary collectors outside France. Oriental pottery is usually so well preserved, thanks to its hard glaze, that the faker is spared all complicated processes to give the piece an appearance of age.

The glazed work of Hispano-Moresque pottery presents a more or less successful field to imitators. The lustrous glaze of various hues does not seem to offer difficulties to the modern ceramist, who has learned how to use the mysterious co-operation of smoke in the so-called muffle glaze. Yet when confronted with originals, which are becoming rarer and rarer in the market every day, the best of imitations leaves room for meditation as the genuine is usually a very uncomfortable neighbour to the counterfeit.

The Italian Renaissance with its various and interesting types has yielded a fine crop of imitations. In fact plagiarism was already rampant when the old factories, now extinct, were in full activity. Thus on more than one occasion Faenza has copied Cafaggiolo, and the models of Urbino, Pesaro and Casteldurante are often interchanged, while the factory of Savona seems to have blended its unmistakable individuality with the models of all the most successful factories. Cafaggiolo, Gubbio and Derutha are perhaps the types of old Italian pottery to which the faker has given preference. There are some modern imitations of Cafaggiolo made by a ceramist of Florence so well done that thay have deceived the best connoisseurs of Paris and Berlin. But for the fact

Faked Pottery

that we have pledged ourselves to point out the sins and not the sinners or their victims, we could enumerate a rather interesting list of illustrious victims to this clever imitator of Cafaggiolo, who is still at work in Florence and more dangerous every day by reason of the perfecting of his deceitful art.

There are also old imitations of Cafaggiolo, made by the Sicilian factory of Caltagirone, and if one thing surprises us more than another it is that good collectors should buy this type freely as genuine. They are apparently blind to the grossness of the imitation and above all to its dark, dirty blue which has nothing in common with the beautiful colour of a genuine Cafaggiolo.

Another cherished type offering great enticement to the Italian faker, even though not imitated successfully enough to take in the real expert, is the work of Della Robbia. Imitations of this work, copies from good originals and honestly sold as such, are to be seen at one of the most important potteries of Florence, Cantagalli, a firm of almost historical reputation. Being intended to be sold as reproductions, copies or imitations, no patina is given to these.

It is not only in Italy that Italian faience has been freely imitated but also in other countries, particularly France. Among the successful imitators we may quote Joseph Devers, who made such good imitations of Italian faience that he had the honour to sell some of his specimens to the Sèvres Museum in 1851. Looking now at these imitations of Della Robbia, made so successfully by Devers in 1851, one wonders how they could have been taken for genuine by experienced connoisseurs.

The lustre work of Maestro Giorgio Andreoli and Derutha has been imitated by many factories, but, notwithstanding the efforts put forth and the progress made in discovering the secret of lustrous glazing, the imitations, especially of Maestro Giorgio, are deficient. In the Gubbio work of the best epoch a special firing must have been used, especially for the red hue, which is so original and characteristic that it seems to

Faked Pottery

defy imitation. That the Maestro Giorgios must have been glazed at a low temperature, at any rate for the production of the iridescent effect of the colours, may be concluded from an incident that occurred in Gubbio years ago. On the spot where Maestro Giorgio is supposed to have had his furnace for firing his masterpieces, some debris of fine Gubbio work was found. By chance a woman put one of these pieces that had apparently not received the last firing for the iridescent hue into the warming pan with which she was warming her hands, and the moderate heat of the ashes was sufficient to produce the iridescent effect. Imitators of this kind of work use various methods, but one of the most common is muffled glaze, specially prepared and aided by smoke which envelopes the piece when incandescent and the glaze about to melt.

In France the hard-glazed work of Palissy was naturally an incentive to the imitator's versatile aptitude, and later on to the faker's. Being as esteemed for his work, as ill-treated for his religious convictions, Palissy had many imitators in his own time, mostly among his pupils or enthusiastic followers. However, Palissy died in the Bastille without revealing the secret of his glaze or the composition of his clay, so even his followers could only grope in the dark, to use the expression by which Palissy defined his long and arduous research, before he discovered the secret of his marvellous pottery. Perhaps because plagiarists are, after all, always plagiarists, the fact remains that none of the sixteenth and seventeenth-century imitators reached the level of the master.

However, false Palissys are legion now. They are of all kinds and the originals being now practically off the market, museums, as usual, abounding in pseudo-Palissys, so a comparison with an original is not always possible.

Apart from his immediate followers, Palissy was copied and imitated at Avon near Fontainebleau in the seventeenth century during Louis XIII reign. Demmin, a real authority on Palissy ceramics, mentions many false Palissys now in

museums, some of them regular *pastiches*, suggested from well-known prints of a later date than Palissy. According to Demmin, some of these pieces are in the Victoria and Albert Museum, the motives of the composition, old-fashioned gardens, being taken from engravings in the style of Lenotre, possibly dating between 1603 and 1638.

In modern times there are to be noted imitations by Alfred Corplet, a restorer of pottery who filled the market after the year 1852 with passable imitations, sold as such, of Palissy work. For a long time he had been a restorer of broken and damaged Palissy work and thus he had had opportunity to study the work of the master closely, and at one time his imitations fetched high prices. A. M. Pull also imitated Palissy work about the year 1878, as well as Barbizet Brothers, of whom a *plat à reptiles* is kept in the Sèvres Museum. Some firms even reproduce sea-fish which are never found on genuine Palissys, as the master only moulded such animals and fish as he found in the environs of Paris.

There are many fakers who still love to imitate the work of Palissy, and if we may give advice to the inexperienced collector we would say: "Don't go after Palissys nowadays, as a find in this line is almost an impossibility; good originals are either kept in well-known collections or jealously guarded in museums."

Henry II faience, the technique of which is as much a mystery as Bernard Palissy's glaze, has also been imitated, but, with the exception of a few specimens, the imitations are so coarse that they could hardly be dangerous even to the neophyte who had perchance some slight acquaintance with originals. As in the case of Palissy, however, Henry II ceramics do not abound on the market and such a thing as a find is not to be hoped for.

More common are the imitations of Rouen, Moustiers, down to the ceramics of the Revolution. The latter were at one time in such demand that a very commercial type was produced which can be imitated, of course, with ease. In this field also, therefore, do not get excited too quickly over

Faked Pottery 253

some truculent subject with the conspicuous date of the Terror. Naturally among these subjects, the *assiettes au confesseur* and *à la guillotine*, depicting the execution of Louis XVI, are too tempting to forgers not to be given a certain preference among the faked pottery of the Revolution.

We would point out, further, that the pottery of all parts of the world has invariably been faked or imitated, as soon as a promise of success was presented to the imitator and of gain to the faker, but it is not the purpose of this work to make a long exposition of the countless types of faking, which would considerably increase its bulk and risk monotony by an endless list of names and almost identical facts with the usual dramatis personæ—the cheater and the cheated.

To give an appearance of age to pottery, especially glazed pottery, there are various methods, as we have already said.

Sometimes it is not only a question of determining whether an object is genuine or not, but as pottery is apt to be one of the most restored articles of antiquity offered to the collector, the art lover must be acquainted with the means of detecting which parts of a piece of pottery have been restored, often over-restored. There are two ways of restoring pottery where parts are missing. One is to make the missing part in clay, bake it, and glaze and colour it to imitate the genuine part of the object. When this is done the new part is cemented to the old, and the piece is supposed to have been only broken and mended, a fact which does not lessen the value of the object in the eyes of the collector so much as incompleteness would. As this operation is an extremely difficult one which only a few specialists can perform—there is a Florentine ceramist who does it to perfection—and very expensive as well, only really fine pieces of pottery are restored in this way as a rule. Ordinary pieces are repaired as follows. The fragments of the object are carefully cemented together and the missing parts are then supplied with plaster. Some use plaster mixed with glue, others some similar

Faked Pottery

composition, in fact any soft substance will do if it will harden after it has been modelled and properly shaped. When the missing parts have been filled in and carefully polished with sand-paper, they are prepared for oil paint with a light coating of a weak solution of glue. After this the artist paints in the missing pattern with oil colours and a brush, copying from the original parts of the object. This finished, the glaze is imitated by a coat of varnish.

Incredible as it may sound, in the hands of a clever artist this rather clumsy method produces an almost complete illusion. It is, however, easy to ascertain what parts have been repaired. The new parts are warmer to the touch than the glazed pottery, and they will also smell of turpentine or oil paint. Should an old mending have lost all smell, the heat of the hand is sufficient to revive it. Place your finger for a time on the part you suspect, and then smell it and you will be able to detect whether the part has been repainted with oil colours. A piece repaired by the other method is naturally more difficult to detect; an experienced eye, however, will notice some slight differences in colour and form between the old and the new parts, and sometimes the join is not quite perfect, a defect that is often remedied by filling in the crack with a mastic imitating the glazed ground of the piece. This rarely occurs, however, as a good repairer can generally calculate to a nicety the shrinkage of the part to be added and makes such a neat and perfect fit that only an experienced eye can detect it.

In the case of a purely modern imitation, the faker's art consists, as usual, in giving the piece a convincing appearance of age, once the actual making has been performed. This is generally effected by exposure to apparent ill-usage, by greasing and smoking the object, then cleaning it and repeating the operation over and over again till the dirt has penetrated into all the cracks, or by burying it in a manure-heap and letting it remain till it has lost all freshness. There are also chemical ways by which the glaze is eaten and its composition altered. It is a fact that fluoric acid readily

Faked Pottery

eats the glaze just as it dissolves glass, and under certain circumstances the lead in the glaze under the form of silicate changes under the action of hydrosulphuric acid.

Cracks or a regular network of *craquelage* are generally produced on new ceramics by the same principle as they are obtained on oil paintings, namely, by producing artificially a difference in the shrinkage capacity of two superimposed layers. In oil painting it is the layer of pigment and of varnish, in the case of pottery the two layers are represented by the baked clay and the glaze. If the clay has a smaller shrinkage than the glaze, in the second firing of the piece to melt the glaze, the latter will dry in a network of cracks like those on Chinese or Japanese vases, which are reproduced by this method. Reversing the game, the glaze peels off here and there in drying and produces the imperfections sometimes desired on imitations of old and damaged pottery.

An artificial disproportion between the shrinkage of the clay and the glaze is usually obtained by modifying the quality of either the one or the other. Does the clay shrink more in the firing than is desired, the ceramist generally mixes it with non-shrinking elements such as powdered brick, or even another kind of clay which he knows must shrink less on account of its composition, although it may not be suitable in colour and quality. By this same modification of the composition the shrinkage of the glaze is increased or diminished. Glazes are generally composed of a combination of silex, furnished by sand, and oxide of lead with the addition of some flux such as borax. With an increased quantity of silex in the composition of the glaze the shrinkage capacity is diminished. Consequently a predominance of the other elements, lead, flux, etc., produces the opposite effect, namely, giving the glaze a greater shrinkage capacity. Some workmen prefer to modify the quality of the clay to obtain the desired *craquelage*, others find it more practical to modify the glaze.

A full account of faked china would probably fill a bulky volume. It may be taken for granted that every kind of

artistic china worth imitating has tempted the faker, with disastrous results to the unwary collector. We have mentioned some of the most noted forgeries of faience, merely to show what a happy hunting-ground ceramics have been to the faker of all times, and with china this is doubly the case. From the early attempts of Bottger, those rare specimens of rare china, down to almost modern samples of Sèvres there has been a long succession of types that have kept generations of fakers and imitators incessantly busy.

Curiously enough and with no intention of cheating, as far as china is concerned, noted factories have themselves greatly added to the confusion between originals and copies by becoming their own plagiarists, as it were, by imitating old kinds. Thus the Meissen factory now puts upon the market types of old Dresden very satisfactory to people not intimately familiar with the fine old models of the factory. The same has been done at Sèvres, Doccia and other factories. Then, too, in some cases the plagiarism is furnished with distinguishing marks that have increased the confusion—for the neophyte collector, be it understood.

It is well known, for instance, that before closing its doors towards the end of the eighteenth century, the Capodimonte factory sold all the models of the factory to Ginori's noted china works at Doccia, and together with the models the right to use the N surmounted by a crown which was the Capodimonte factory mark. Ginori's factory has ever since reproduced imitation Capodimonte with the mark of the Royal Neapolitan factory. Of course the pieces may be sold by the firm as Ginori ware and not as Capodimonte, but once on the market they are sure to come into the possession of some unscrupulous dealer who will palm them off as Capodimonte.

A good connoisseur, however, can tell, almost at sight, the real Capodimonte from the ones Ginori's factory has been turning out for more than a century. The latter are not so

Faked Pottery

fine in form or colour, and although made from the same mould are not so well finished and retouched as the real Capodimonte.

Apart from this, a large contribution to imitations of highly reputed china is made by smaller factories that find it convenient and profitable to copy pieces of celebrated marks. Some of these factories even go so far as to imitate the mark, rendering the deception perfect.

There is another form of deceit in the market for artistic china, peculiar to this particular branch. Many factories are in the habit of disposing of such artistic pieces as are not considered altogether up to the reputation of the factory. These pieces are often bought by clever workmen who embellish them with skill and patience, and then sell them profitably. If the mark is missing it is added with muffled colours. To obviate this irregularity some of the best factories either erase the mark on the wheel, or cut certain lines in the glaze which indicate that the piece is genuine but not recognized by the factory as up to its standard of artistic value. Of course even a moderately expert collector knows the indelible sign made over the genuine mark, but there, nevertheless, seem to be people who buy such pieces under the impression that they are genuine first-rate Dresden, whereas no other claim can be made than that the white background and the mark are authentic, both baked *a gran fuoco* as the decoration is generally muffled work and can be executed by any skilled workman who has built a muffle in his own house. Nowadays defective pieces are destroyed by reputable firms; but years ago they were not only sold off, but even given to the very factory men, who took them home, decorated them and put them on the market as genuine pieces. Some of these curious fakes are naturally almost as good as the genuine article, being at times the work of the same artist and the defect of the first firing is not always visible as a slight curve in a dish, or a tiny speck in the glaze of a vase, is a sufficient blemish for the piece to be thrown aside by the factory.

Faked Pottery

Where the faker does not always display his usual sharpness is in the falsification of marks of noted factories. He is apt to make gross mistakes by copying a mark from an original without knowing the historical characteristics of the marks of certain factories, their peculiarities and eventual changes. Take, for instance, the Sèvres mark. It is known that instead of dating the pieces in figures, the Sèvres factory began in the year 1753 to mark the pieces with an A between the entwined initials of the King's name, and that each successive year was marked by the French alphabet till the letter Z was reached in 1776, after which the alphabet was repeated again, doubling each letter, thus :—

1753	A
1776	Z
1777	AA
1793	ZZ

It is, however, not unusual to see a faked piece of Sèvres imitating the work of the end of the eighteenth century wrongly marked as to date, the faker having evidently copied the mark from an original, unaware that it represented a date as well. This incredible ignorance can only be explained by the fact that many of these clever imitators, are artists altogether unacquainted with any information outside their imitative art. There are also other difficulties in the imitation of Sèvres and its marks, more especially the pieces of the above series, of which the faker appears to be unaware. Beside the factory mark, in the alphabet series particularly, there is always the special mark of the artist who did the decoration. These marks are generally not very conspicuous, initials, dots, lines, etc., and belong to specialists, miniature portrait painters, landscapists or simple decorators. By copying the old marks mechanically without knowing the information carried by the artist's initials or marks, the faker is liable to attribute a piece of faked landscape painting to a portraitist and vice versa. Errors of this kind are more common than is generally supposed.

Faked Pottery

In faked china there is no question of patina or devices by which to confer an appearance of age to the piece, nor of artificial breakages for, by a freak of connoisseurship and contrary to faience, repaired china has lost in a great many cases all artistic and monetary value.

We now turn to glassware and enamels as bearing a certain affinity in the domain of faked art and antiquities with the glazed pottery already illustrated.

The museum of Saint-Germain contains specimens of faked Roman glass with iridescent effect produced by the queer scheme of sticking fish scales to one side, which as every one knows are iridescent. A most naïve form of faking to which later progress in the grand and artistic profession of duping unwise collectors hardly renders it necessary for imitators to have recourse.

Phœnician glass, the little scent bottles, the so-called lachrymatories or tear-bottles, furnish a large source of profit to the faker. They do not command high prices, and appeal to the less fastidious class of collectors, tourists, and are sure of finding purchasers. Interment in earth or manure gives the desired iridescent quality to the glass in time.

From these antique types we will proceed to others of more recent times which demand more care and skill to imitate, not so much on account of the art as the peculiar defects of certain kinds. While Cologne distinguishes herself with imitations of specimens of old glass, the so-called product of excavation, and other cities of Germany reproduce old national types, Italy has revived old Murano with a certain amount of success, as well as various kinds of Quattrocento and later samples.

These imitations are not always made with the intention to deceive and their success depends upon the class of collector. He who has perfected his taste finds that although they may approximate to the old originals materially, artistically they are wanting. The excess of precision that belongs to modern reproductions somewhat lessens the

artistic effect and forms one of the salient differences between old and new.

But these after all are not dangerous, they represent the cabotage on the sea of deceit; there are also fine pieces of real artistic value that are imitated by artists of every nation such as old Bohemian *chefs-d'œuvre*, Murano chandeliers, the latter sometimes composed of old and modern parts.

Cut glass is another branch in which the skilful imitator has triumphed. The work of Valerio Belli and others is so well imitated that even the best connoisseurs are deceived.

With regard to enamels we would repeat the usual refrain, do not buy them until you know whence they come, and until you have traced at least two or three centuries of well-authenticated pedigree.

There are ordinary imitations in the antique market which are quite easily distinguished, but there are others, regular *chefs-d'œuvre* of art and craft, that defy and have, in fact, defied experience and knowledge.

Not all imitations are by Laudin or Noailher, whose work may be of interest to the accommodating taste of lovers of imitations, but there are products of a higher grade, unfortunately for collectors and museums, and these are not sold as imitations, but good round sums have been paid for them and they have, in a way, ruined the reputation of more than one collector and expert.

The technique of the work is identical with that of the past, and the process for giving an appearance of age very much resembles that already described in this chapter, though there are some fakers who claim to have found a patina that cannot be dissolved, being incorporated with the enamel as a glaze obtained in the second firing. The many lawsuits and summonses at the Courts with respect to the buying and selling of counterfeit enamels, are ample proof that faking is rampant also, in this interesting branch of art-collecting.

It suffices to say that among the illustrious victims of faked enamels there is to be included the elder Baron Roths-

child, or *le Baron Alphonse* as he was briefly called among antiquaries.

The first of his bad experiences in faked enamel was revealed to the wealthy Baron by Mr. Mannheim, one of the finest and most honest connoisseurs of Paris, then taking his first steps in the traffic with antiques. From the first, Mannheim had an excellent eye and he discovered that a place of honour was being given to a false piece in Baron Alphonse's rare series of choicest enamels. At first he did not dare to reveal the secret, but after having gained the certitude that not only the one piece, but others also, of the collection were more or less clever fakes, he took the opportunity to speak that was offered one day by the Baron's praise of this fine piece of enamel.

At first the Baron was of course obstinate in his unbelief, but upon a final test and the opinion of other experts, Mannheim's good eye finally triumphed. The *chef-d'œuvre* and other spurious pieces for which the multi-millionaire had paid a fortune disappeared from the collection.

Long after the above experience with which Mannheim's name was connected, Rothschild bought an altar-piece of immense value and great artistic merit. This fine enamel had been sold to the Baron by a London dealer, who had evidently bought the piece as an antique and did not scruple to sell the rarity to his best client for one million lire.

Having been told by his dealer that the enamel had originally come from Vienna, Baron Rothschild one day pointed it out to an Austrian attaché, his guest, commenting upon its beauty and his own good fortune in having it in his possession. He concluded by expressing his surprise that Austria should let such a fine work of art cross the frontier. The attaché said nothing in the presence of the other guests, and only whispered to his host "I will come to-morrow to tell you what I think of your find!" The next day, in fact, he returned and revealed to the Baron how he had been deceived in what he thought to be a precious original, as it was nothing but a copy of a well-known altar-piece preserved in Vienna. He was

Faked Pottery

even able to name the man who had made the copy of the precious enamel, a certain Werninger who had secretly made a reproduction while restoring the original.

The Baron claimed and obtained his million from the London dealer, whose good faith in this affair was beyond question, and a warrant was issued against Mr. Werninger. The dealer did not recover the price he had paid but Mr. Werninger was sentenced to five years' imprisonment, ample time in which to meditate upon the reprehensible side of his alluring art.

As usual we must conclude the illustration of this particular branch of the trade with a warning, for if Baron Rothschild had to regret the acquisition of expensive enamels, and he is not the only conspicuous connoisseur to do so, what is the fate likely to overtake the first exploits of a neophyte in the field! If not assisted by a first-rate expert, the freshman had better not meddle with enamels for a long time, but assuage his passion by going and admiring well-known and authentic pieces in famous museums.

CHAPTER XXII

METAL FAKES

Metal work—The bronze family: brass, copper, and their various colours and patinæ—Beaten iron work—Arms and armour—Artificial rust and chemical oxidation—When the imitators of arms and armour used steel and when iron—Cast iron pieces—Chemical tests—Difficulties in the connoisseurship of arms and the story of three shields—Old and modern imitations—Silver work—Its colour and oxidization—Why artistic pieces in precious metal are in danger of being destroyed—Fashion one of the dangers of silver plate—How far reliance may be placed in marks—Gold work—The tiara of Saitafernes—Jewels and their extreme rarity—Imitations and forgeries of all ages—Advice to the non-initiated in the art of buying jewels.

WHEN speaking in another part of this work about the methods of conferring an appearance of age to newly cast bronze, we remarked that the faker's best accomplice in the ageing process was chemistry. The colouring and bronzing of metals in fact is usually accomplished by one of two methods, by the action of chemicals or by the application of bronze powders rendered impalpable and used as a pigment.

The latter method is mostly used in modern industrial art, but has, nevertheless, been applied in imitating antiques and in disguising mended parts, etc. It is often used with success in the case of imitations of excavated objects which generally have a bluish-green patina. This may be imitated to deceive the eye of the beginner only, by the application of green-bronze lacquer of a dull lustre, or of green varnish. The green of the bronze colour is best prepared by mixing Frankfort black with chrome yellow.

These are, however, but cheap and not always convincing expedients, the real way to give tone and colour to bronze and other metals is by resort to chemistry.

Metal Fakes

A brown colour on bronze, for instance, may be obtained by preparing a sand bath large enough to contain the article to be bronzed. When the object has been cleansed from all grease by dipping in boiling potash lye, it is treated with white vinegar. After this preliminary operation the object is wiped thoroughly dry and then rubbed with a linen rag moistened with hydrochloric acid. When this coating is perfectly dry—a quarter of an hour is sufficient—the article must be heated in the sand bath until it has acquired a bluish tint, and a final rubbing with a linen rag soaked in olive oil will change the blue colour to brown.

Recipes and processes are endless and so rich in hues that almost any tone may be obtained. To any interested in this branch of imitating old metals we can but suggest the excellent book, *The Metal Worker's Handy Book*, edited by William T. Brannt.

As we have said, there are many methods by which to give the proper patina to metals, and a good deal of mystery, some fakers and imitators claiming to be in possession of unrevealed secrets.

When exposed to the air for a long time, copper and bronze acquire a fine brown or green patina which, as every collector knows, greatly enhances the merits of an artistic piece in these two metals. A perfect imitation of the result of a long process of time is not an easy matter, in fact an almost impossible task.

Formerly the patina of a bronze was in a way the final test of authenticity, but nowadays there are modern imitations of so deceptive a character that the best connoisseurs are taken in.

One of the best known methods by which old patina is imitated on copper and bronze, is to follow as closely as possible the process by which the genuine patina is produced. Thus the action of rain, interment, immersion in some permeating substance that will generate hydrosulphuric acid are called into service by those willing to wait a comparatively long time for the desired effects. Others accelerate

Metal Fakes

the above process by increasing the proportion of the natural conducive elements. The objects are also treated with water containing ammonia, carbonic acid, etc., exposed to the intense and direct action of vapour or vaporized acid in order to produce those basic salts that form a certain patina.

To obtain the malachite kind of patina that generally characterizes objects found in the ground, the imitator generally brushes the metal over with a very weak solution of cupric nitrate to which a small quantity of common salt in solution may be added. When completely dry it is again brushed over with a liquid consisting of one hundred parts of weak vinegar, five of sal-ammoniac and one of oxalic acid, and the application is repeated after the first has dried. In about a week's time the metal will have acquired a green-brown colour that may be polished with encaustic if the patina is to have a shiny appearance.

Such is the leitmotiv, more or less, of the processes for obtaining the green or brown-green patinæ. Some dip the object in cupric acid and then place it in a room in which an excess of carbonic acid is produced, by others preference is given to one or the other element according to the tone and colour desired.

Brass articles are coated with green patina by a solution containing 150 parts of vinegar to which has been added ten parts of copper dissolved in twenty of nitric acid. An application of this liquid is generally made on the object.

The brown patina usually characterizing old medals is obtained in many ways. One is by heating the medal at the flame of a spirit lamp and then brushing it with graphite. To colour a number of medals at the same time, some imitators dissolve thirty parts of verdigris and thirty parts of sal-ammoniac in ten of water, adding water to the solution till a precipitate is no longer formed. Then the medals are placed in a shallow dish without touching one another and the boiling solution is poured over them. The medals are allowed to remain in the solution till they have acquired the desired tint which should be a fine brown.

Green or bluish patinæ may also be given to bronze or copper by triturated copper carbonate used as a paint with a pale spirit varnish, shellac or sandarac, and applied with a brush.

Verdigris generally gives a bluish tint and crystallized verdigris a pale green tint. The two tones can be mingled to obtain some special hue.

Iron work is perhaps one of the easiest to imitate and give an appearance of antiquity. As far as the actual work is concerned, it rests entirely upon the skill and artistic taste of the worker. Patina on iron is either caused simply by rust or by a slow process of oxidation which confers a rich, dark tone to iron. There is also a special patina seen on iron that has been under water for a long time, but this is rare in imitations and very difficult to obtain.

The rusty coating on iron can be produced by almost any preparation capable of oxidizing the surface or transforming it into basic salt provided a red colour results, as with nitric or hydrochloric acid, for instance.

The brown patina is often obtained by oiling the piece and exposing it to the direct action of flame. The two methods may be alternated and the corrosion of the acid here and there adds character to the piece. Methods are so various, however, that the way to obtain a convincing patina is perhaps contained in the dictum of an Italian antiquary: "To inflict upon the object that is to be turned into an antique every possible indignity and abuse."

The patina in imitations of old iron work is so well reproduced nowadays that even experts are unable to distinguish the real from the unreal with certainty, so much so that more than one has had recourse to an analysis of the composition of the iron in order to decide whether the object were modern or antique.

This justifies the verdict of Moreau, an expert and celebrated artist in iron, who when called upon to decide whether a certain artistic key exhibited at the Paris World Exhibition of 1878 were really of ancient workmanship, replied that he

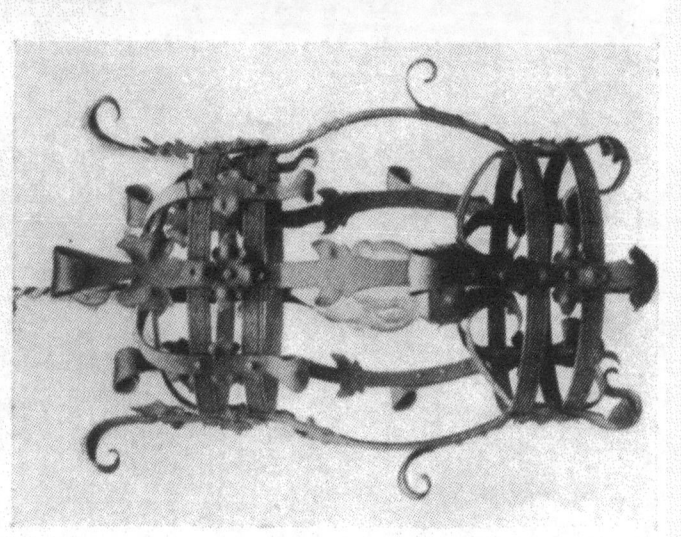

Mantel-Piece.

By Prof. Orlandini, an honest imitator of the Renaissance, who is responsible for many fine pieces of ornamental work and many good restorations of antique works.

Lamp Designed by Professor Orlandini, Jun.

Metal Fakes

could not tell unless he were allowed to break the key and examine the grain of iron.

Italy is one of the countries where the imitation of old iron is traditional. In olden times it was the work of Caparra and other artists of the Renaissance that were imitated, nowadays old models are reproduced for the benefit of the tourist, and some are conceived in the old style with extreme perfection for those collectors who go in for originals and who buy this modern work as genuine *chefs-d'œuvre* of the Quattrocento and Cinquecento.

Florence, Venice, and the town of Urbino furnish the Italian market with the best imitations of old candelabra, andirons, gates, lamps, and keys; in fact everything that is likely to attract the tourist or please the collector.

Nearly every country possesses good imitators of artistic old iron, which is perhaps due to the fact that such imitations do not require any great artistic ability, nor is the coat of rust on modern iron a matter incurring expense or complicated methods. The most difficult in this field are the imitations of arms of all kinds, which require a skilful workman and often a finished artist in iron work.

In this particular branch of faking it is not only a question of reproducing old weapons of a national character, but the forger frequently turns his attention to imitating arms of exotic type. We all know that Constantinople is the place *par excellence* for imitations of old Oriental arms and armour, but very few are aware that when they buy an Oriental poignard or Turkish gun ornamented with passages from the Koran in Africa, for instance, they are buying goods made in Germany. As a matter of fact, however, German factories supply Oriental maritime markets with all their fine arms. We still recollect the amazement of an American tourist who on returning from a fair near Tangiers showed the hotel-keeper his find, a fine Morocco knife with a carved scabbard in brass, and was told that it was German. As he persisted in his incredulity, the hotel-keeper showed him the mate of his bargain, which had been presented to him

by the German commercial traveller who had lodged in his hotel.

As usual, collectors of the genre being diverse as to taste and calibre as connoisseurs, the accommodating faker has goods to suit the varied scale of his clients, or rather there are fakers of arms and armour like the Venetian rubbish which is for easily pleased greenhorns, and others producing fine goods for the man of exquisite taste such as the product of Vienna, Belgium, France, and sundry Italian artists of forged steel. We have purposely made a distinction by saying sundry Italian artists, because while the imitation of arms in other countries assumes the character of factory work of extremely good quality, in Italy the artist who forges steel, chisels it and imitates old weapons, is usually a solitary worker in his own home, a fact that makes him far more dangerous to the collector. These artists are often simply imitators of the old style whose work is sold by others as antique. One of them used to live in Lucca whose imitations of old daggers *cinquedee* or *lingue di bove* have become famous. Another in a town of Northern Italy, imitates Negroli and Milanese work with uncommon success.

Many of these artists, who imitated and copied old damascened work to perfection, with no thought of cheating, have executed fine work that can stand upon its own merits so to say. Such, for instance, is the work of Zuloaga, the father of the painter of that name, and of another Spaniard of repute in the artistic world, Mariano Fortuny. This excellent painter was also a first-rate chiseller and good artist in damascened work. He imitated the Moresque style to perfection. At the sale that took place after his death, one of his productions, a damascened sword, fetched the price of 15,000 francs, and was sold with no other recommendation than that of being a modern imitation of the antique by Mariano Fortuny.

In a letter written to the well-known amateur Baron Davillier, Fortuny speaks of a flourishing factory near his studio in which excellent imitations of armour were made.

chiefly repoussé shields. It may be taken for granted that if such a judge as Fortuny called the imitation of this Roman work excellent, some of them are at present enriching well-known collections.

There is a scarcity of genuine pieces on the market, in fact hardly a single fine Cinquecento sword or halberd is to be seen in shops now or is for sale. The few still obtainable are poor specimens as a rule, and this fact ought to put the neophyte on his guard when he is offered some gorgeously ornamented sword, pike, ranseur or partisan lavishly chased and gilded.

Some years ago an elegant lady was asked why the fair sex preferred to dress elaborately rather than in the stylish simplicity of tailor-made gowns, to which she replied, "Perhaps because it is less expensive." In a way the fine plain swords and unornamented pieces of armour are more difficult to fake; they would seem to demand the same eye for form as a perfectly cut, well-fitting, simple tailor-made gown. This combined with the collector's cheap taste in arms may be the reason why the faker gives preference to imitations loaded with chased or damascened ornamentation, and enriched with gilding and elaborate arabesques.

The rarity of imitations of fine weapons characterized by elegant lines, simplicity and sobriety of ornament, suggested to the author some years ago the solution to a difficult problem propounded by Baron Nathaniel Rothschild.

When called to Baron Rothschild's magnificent mansion in Vienna, I found this rich and sagacious collector had received two fine swords that were being offered for sale. One was simplicity itself, the other over-ornamented and lavishly gilded on blade and hilt.

"Which do you advise me to buy? I must decide between the two."

To be frank, they both looked genuine to me, but the Baron's question roused a suspicion in my mind that one of the two swords was a forgery.

"I should buy this one," I answered, pointing to the sword almost deprived of ornament.

"You have a good eye," complimented the Baron. "The other sword is an imitation, one of the most admirable I have ever seen."

My discernment, however, was merely based on the accepted aphorism that the combination in art of simplicity and extreme elegance is difficult to imitate, otherwise who knows but what I might not have selected the faked sword.

It must be added here, that an imitation can very rarely bear close comparison with a genuine piece. The proximity of the genuine article is always rather disastrous to the fake, and never more so than in the case of arms and armour. This may be accounted for by the difference in the modern methods of working and ornamenting steel. These methods not only produce a difference in the raw and worked steel that connoisseurs claim to distinguish, but the ornamentation itself is wrought by other means. Engraved ornaments, especially on pieces that do not aim to deceive first-rate connoisseurs, are rarely done by the old method but preferably by acids.

Damascening, such as is rarely done now even in the East, was a skilful and complicated operation by which steel blades and armour were inlaid with gold or silver ornamentations. The designs were first cut deep into the steel with a burin, then the gold or silver was beaten in with a hammer, not only until the surface was smooth, but until the inset was securely worked into and held by all the irregularities of the groove. Such work is now imitated by gilding over a rather shallow groove obtained by the action of nitric acid. The sombre shine of old steel is generally reproduced by a thin coat of *encaustic*. The sum total of these differences, together with a certain loss of artistic sense in the art, are the causes perhaps of the disastrous effect upon fakery of a close proximity with genuineness, as above noted.

This, of course, is in common cases, for, as we have said, there are sporadic workers in steel who produce pieces

Metal Fakes

that baffle the best connoisseurs—as an artistic object cannot always be tested by breaking it and examining the texture of the metal, which would be the safest method at present.

Here again we are forced to advise the new-comer in the field of connoisseurship during his search for arms in his first enthusiastic stage, to use more than one grain of salt with what he hears, and several pounds of scepticism when he comes across what would seem to be a real find. For over thirty years arms, we mean fine specimens, have practically disappeared from the market. Pistols, guns and weapons of a late epoch may still be seen, but not swords of the Quattrocento and early Cinquecento.

Also in this field the semi-faked article has the usual luck of fetching a good price with the majority of collectors. Plain old pistols are often embellished with all kinds of most seductive additions. Mottoes are engraved or inlaid in silver on blades originally simple but deprived of the elegant simplicity to which we have already alluded.

These, however, are the cheap articles of the trade; but the story of three shields, a well-known incident still recounted among Paris collectors, offers ample proof that there are also in this field imitations that defy the best connoisseurs, as we have already said, and gladly repeat, in order to render our warning to the novice all the more emphatic.

One of these skilled imitators flourished several years ago in Italy's chief rival in antiquities and faking. We refer, of course, to Spain.

The first of the three identical shields, all of which came to Paris, was palmed off on Mr. Didier-Petit, an excellent connoisseur, who paid the good round sum of £400 for this fine piece of imitation. It was repoussé work with a mythological subject in the centre, " Jove fulminating the Titans." The person to be struck down really, however, was poor Mr. Didier-Petit, rather than the Titans, for on realizing that he had been fooled he died of grief or apoplexy, brought on by his disillusion and wounded pride as a connoisseur.

Under the auctioneer's hammer at a subsequent sale, the famous shield fetched £20.

The second, of identical make, was very nearly passed off on Baron Davillier, perhaps the most esteemed connoisseur of his time. Baron Davillier was offered the rare piece in Spain. He was struck at first by its beauty and appearance of authenticity as well as the plausible story by which the owner explained his possession of such a valuable object. The bargain was struck at £320 and, happy over his piece of good luck, Baron Davillier, like a true collector, hastened to convey his find safely to his home in Paris. Noticing at the Custom House that the official treated his precious find with indifference, he became suspicious, and his suspicion of having been cheated grew to certainty before the end of the journey. It would take long to recount the circumstances by which Baron Davillier recovered his £320, suffice it to say that he did recover them and the Spaniard replaced the faked shield in the panoply from whence the Baron had taken it down, swearing all the time that it was genuine even though the Baron had seen another like it, that there might be twins among articles of virtu, etc.

But there was still the third of the shield triplet fated to come to Paris, bought by the well-known expert called, or rather nicknamed, Couvreur. Curiously enough, this third expert from one and the same city was also a specialist in arms, as Baron Davillier might have been considered, had his immense knowledge not conferred upon him the character of a specialist in almost every branch of connoisseurship.

Where did Couvreur buy this third shield? From the very man who tried to cheat Baron Davillier. It appears it was not the same shield as the Baron's, though of identical workmanship, for there were trifling differences between it and the fake No. 2 to reach Paris. Couvreur had paid a fine price for his find, £800. He never recovered his money and created a scandal by presenting the piece for exhibition at the World's Show of 1878, insulting the judges upon their refusal to place it among the genuine pieces. Thus he

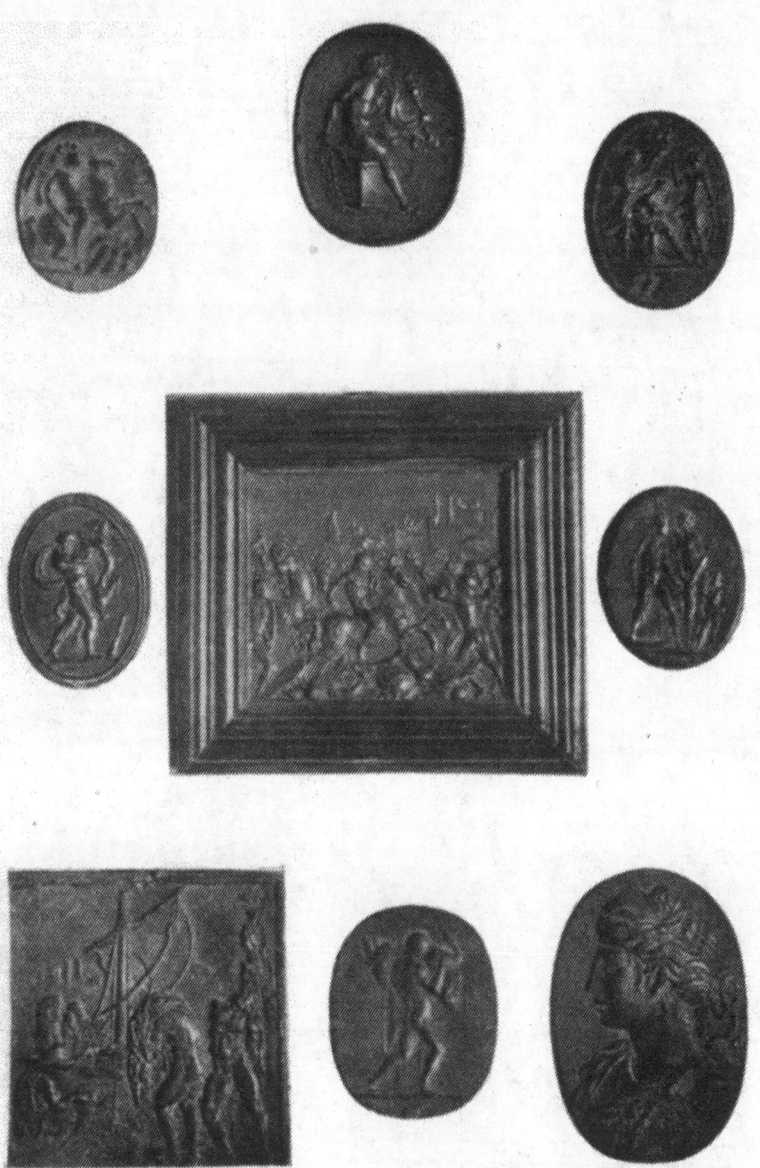

PLAQUETTES OF VARIOUS ARTISTS.
Imitations of Roman work.

Metal Fakes

lived and died maintaining that all who believed the piece to be a fake were fools.

This story only goes to prove that in every branch of imitation or faking there exist some artists of unusual talent able almost to attain perfection. Those who remember the story of the famous Gladius Rogieri quoted by Paul Eudel in his amusing book, *Le Truquage*, and all the discussion held in Court over this supposed sword of the valiant King Robert of Sicily, are aware how a good connoisseur such as M. Basilewski and a well-informed dealer like M. Nolivos can be taken in by a fine piece of faking, and how a legion of experts may give contrary evidence as to the authenticity of an object. And if this could happen in Paris, one of the most enlightened cities as to connoisseurship, and among a coterie of specialists, it may be imagined what possibilities for deception are offered by America, that El Dorado of fakers.

While speaking of first-rate imitations by fakers conscientious enough to use steel, we may add that there are successful imitations in which iron and cast iron have been substituted for the orthodox metal for weapons.

The learned Demmin declares that " the casting which forgery has made it very difficult to recognize " is a source of no little embarrassment to collectors. He suggests that when there is a suspicion that a piece is cast, an unimportant part of it should be filed and, as usual, the texture of the material be examined. If under the magnifying glass the grain appears coarser and very shiny, the piece has been cast. To tell iron from steel Demmin suggests that a drop of sulphuric acid diluted with water should be applied. If the action of this liquid turns the metal black it is steel, if a greenish mark is made that can be easily washed away with water, then it is iron. The black stain is produced on steel because the acid eats into the iron and not the carbon contained in the composition of steel.

Before closing the topic of arms and armour, we may observe that marks on these pieces, whether engraved or

impressed, are hardly a guarantee, as marks can be as easily imitated on these articles as on any other kind of artistic imitation. In the case of weapons they have even been imitated by workers contemporary with the artist they fraudently copy, in order to take advantage of the high reputation of certain marks. The work of a Missaglia, Domenico or Filippo Negroli, however, is not only attested by the stamped name or *sigla* but by the inimitable sum total of their art. Many imitators have made a great study of copying impressed marks, but have neglected or failed to copy the individual characteristics that bear witness to an artist as much as his signature.

In the imitation and faking of ancient art in its various branches, the methods and the results all differ so little that we fear to grow monotonous in this brief sketch of the questionable trade when now entering another class of metal work, that of silver and gold.

The precious metals require no recipe for patinæ, as patinæ play no part. This is especially so in the case of gold, but as naïve collectors of all branches of art present the same idiosyncrasies, it is evident that the general trend of trickery in the human comedy is more or less identical, when allowance is made for the different materials peculiar to each particular art. Indeed the whole matter might be reduced to a simple equation with no unknown quantity, namely a fool on one side and on the other a fraud which works out to a positive and disastrous result for the former.

In the case of silver, although there is not exactly a question of patina properly so-called, there is certainly a question of colouring or oxidizing, for old silver, as everyone knows, never keeps the brightly shining appearance of a new piece. It rather improves with time by the acquisition of a low, pleasing tonality which has a most favourable effect, a sort of pleasing light and shade, which the flat negative shininess of a new piece rarely possesses.

In England the conservatism of the upper classes has preserved some really genuine silver articles with duly authenti-

Metal Fakes

cated pedigree. In France the spirit of the Revolution may be responsible to a certain extent for the scarcity of rich pieces of artistic silver, only long before the *ruit hora* of the Revolution various circumstances had rendered the life of artistic silver precarious, risks to which all artistic objects in precious metals are liable. Many fine pieces of silver, in fact, were coined into money during Louis XIV's time, when the State became a financial wreck under the glorious reign of the *Roi Soleil*. Changing fashion and taste also, combined with the fact that the silver was for use and not collections, contributed to the destruction of old types of silver-plate to make way for new ones more in keeping with the new forms dictated by fashion or altered taste. To the combined effect of financial distress and changing taste Italy also owes the destruction of old silver that would otherwise have come down to us intact, just as nowadays plated silver is likely to pass undisturbed from one generation to another.

It is not uncommon in Italy, to hear that some aristocratic family had ancient silver melted down a few years ago, to make new and commonplace table spoons and forks. A lady from Siena who did this for a whim, kept one piece of the old silver service and was much astonished to learn later that this one piece alone would have fetched a sum sufficient to buy the coveted new set of table silver. In Italy, and more especially in Tuscany, the heavy taxes levied by Napoleon during the occupation forced many Florentine families to get rid of their silver-plate. As a matter of fact in Italy and elsewhere fine pieces are very rare nowadays. Yet a few years ago fickle fashion helped several people of good taste to form excellent collections, gatherings of artistic pieces that the art lover would seek in vain to-day. That was the happy time, when old-fashioned and yet artistic silver was hardly reckoned above the intrinsic value of the metal it contained. Fifty or so years ago it was not uncommon for one of the few collectors of artistic silver to come across some artistic beauty offered at so much a gramme, generally a very

moderate figure slightly above the current price of the metal or at times at the actual value of the silver. To quote one instance out of many. In 1855, at the sale held after the death of Mlle. Mazencourt, some particularly fine flambeaux and other pieces of silver were sold at the price of 20 centimes a gramme. Such conditions explain how Baron Pichon, a collector of taste, was able to buy for the moderate sum of 300 francs an artistic bowl which was sold at his death for 14,000 francs, a price that could easily be surpassed nowadays.

Unfortunately for the true collector, not only has old silver become fashionable, but it has become fashionable to be a collector of artistic silver, and thus real connoisseurship and ignorant greedy wealth have started the usual competition that inevitably creates an artificial standard of values, all too apt to generate faking. Faked silver, in fact, came at once triumphantly to the front in forms of all kinds, entirely new pieces successfully parading as old, were launched upon the market as well as plain old pieces decked out with the heavy ornamentation likely to suit the taste of the parvenu. There was also the usual piecemeal of different authentic parts, joined together more or less harmoniously by modern work, in fact all that the faker's genius and versatility is able to produce.

Silver marks, which on genuine pieces guarantee the quality of the metal and the authenticity of the piece as the work of a certain artist, factory or mint, can, unfortunately, be imitated with success. In fact the faker who is a good psychologist and knows that the neophyte amateur relies largely upon his knowledge of marks, generally expends great care upon the imitation of the various hall-marks.

Though, as we have already said, silver has no patina properly so-called, there is the tone and colour which has to be imitated. To dull silver—to give it, we mean, the leaden-brownish colour acquired by age—a mixture with sulphur or chlorine is used. A solution of pentasulphide of potassium—the liver of sulphur of the shops—is generally used. Liver of sulphur is prepared by thoroughly mixing and heating

Metal Fakes

together two parts of well-dried potash and one of sulphur powder. This mixture also takes effect on cupriferous silver, but the result is not so fine. A velvety black is obtained by dipping the article into a solution of mercurous nitrate previous to oxidization. This method is used when a half polish is to be given to the silver, leaving the dark tones in the grooves. Another method consists of dipping the article into chlorine water, a solution of chloride of lime, or into *eau de Javelle*. Special works on metals also give many other methods and it is for the imitator to chose the best adapted for the particular case and to use his artistic criterion to obtain a convincing effect.

Passing on to gold, more especially in jewellery, we may say that imitators and fakers have wrought havoc by filling the market with spurious products. Imitation in this branch ranges from copying the old art of working gold, of which the famous tiara of Saitaphernes, bought by the Louvre, is one of the most striking examples, to the small piece of jewellery with imitated enamels or more or less genuine stones. In this line there is something to suit all tastes, from the eager connoisseur, difficult to please, still on the look out for the marvellous jewellery of the Rennaissance and early sixteenth century, to the less exclusive, satisfied with later epochs down to the eighteenth century.

There is no way of helping the neophyte to collect jewellery, not only because fine old pieces are extremely rare, but because no advice or theoretical hints can help the discernment of the genuine article, only sound and well-tested experience, gained often at great cost, is of any real avail.

In this branch also there are imitations that are entirely new and others, like the above-said tiara, that have become such by the preponderance of restored parts, or because the latter are the most important artistically speaking. In the tiara of Saitaphernes the genuine part, if genuine, is the upper portion of the domed tiara, which is said to have been an ancient drinking cup reversed and placed at the top of the tiara.

Metal Fakes

Many well-imitated rings are really old worn-out rings used for the circle, to show that they have been used, on which the artistic setting of the jewel or other ornamental part has been soldered.

In conclusion, when you would buy old jewellery buy as if it were modern and pay the price of imitations, then if by some rare chance you are mistaken you will experience the unique pleasure of possessing a "find," but never reverse the process, for if you buy an ancient piece of jewellery you will certainly realize in due time that it is really modern.

CHAPTER XXIII

MUSICAL INSTRUMENTS

Carved wood—Artistic furniture—Wood staining and patina—The merits of elbow-grease—Painted and lacquered furniture—Veneer and inlaid work—Musical instruments—Imitations and fakers of musical instruments—Connoisseurship of musical instruments twofold—Attribution and labels—Some good imitators—The violin as example—The restoration and odd adventures of well-known musical instruments—Legends and anecdotes that help—Analysis of form and of sound—Rossini's saying.

THE finest pieces of faked furniture are very rarely entirely new, sometimes they are old pieces to which rich ornaments have been added; at other times, and this is the most common occurrence, they are put together from fragments belonging to two, three, or even four different pieces, the parts and debris, in fact, of old broken furniture. There is also the entirely new fake imitating old furniture, but this is rarely as convincing as the other which is the really dangerous type even for an experienced collector.

Impressed by the great amount of faked furniture glutting the Paris market, Paul Eudel says, "in principle there is no more such a thing as antique furniture. All that is sold is false or terribly repaired."

In Italy, that inexhaustible mine of past art, it is still possible to find genuine pieces, provided, of course, that the collector does not insist upon having those first-rate pieces now belonging to museums or collections formed several years ago. There are, however, in Italy, as in every other country, modern productions of antique furniture for the novices in the collector's career. This furniture may be

carved out of old pieces of wood or ordinary wood. In both cases it is generally necessary to give an old colouring to the wood, for which there are a variety of methods according to the desired effect, tone, colour, etc. Many use walnut-juice, others permanganate of potash, and still others the more drastic system of burning the surface of the wood with acid. The old way of imitating worm-holes was to use buckshot, a ridiculous method which nevertheless had its vogue and apparently satisfied the gross eye of some collectors. Nowadays worm-holes are made with an instrument that imitates them to perfection, although they do not go so deep as the genuine ones, and this difference, by the way, is one of the tests to tell real worm-holes from spurious ones. As new furniture that imitates old is generally too sharp-edged and neatly finished, it is usually subjected to a regular course of ill-treatment. French dealers call this process "*aviler un meuble*," and it consists of pounding with heavy sticks, rubbing with sand-paper, pumice, etc.

The finishing touch, that peculiar polished surface characterizing ancient furniture, is usually given by friction with wool after a slight coating of benzine in which a little wax has been dissolved. The less wax used and the more elbow-grease, the more will the polish resemble that of real old furniture and the more difficult does it become to detect the deceit. If much wax has been used the scratch of a needle is sufficient to reveal even the thinnest layer, but if it is so imperceptible as to stand this test it is very difficult to tell the real from the imitation. The polished parts of an old piece of furniture are not casual but the result of long use. Prominent parts are naturally, therefore, the ones to get so polished rather than other parts.

I remember witnessing a curious sight one day when admitted to the sanctum of a well-known antiquary. Half a dozen stools had been repaired, most generously repaired, a new patina had been given and now they were to receive the last touches, the polished parts that add such charm to old furniture. The workman who had half finished the job

kept passing and repassing close to the stools which he had arranged in a row, rubbing his legs against each one. I asked him the meaning of the performance and he answered that as there were no sharp edges on the lower part of those sixteenth-century walnut stools, he wanted to find out where and to what extent they would be most polished by use. Not having a genuine stool from which to copy, he had resorted to this means so as to make no mistake. I very nearly asked him if he thought everyone was the same height and had the same length of leg. But as the work proceeded I gathered from the practical application of his method, better than I could have done from any explanation, that he was endeavouring to get a mere hint, where to begin to rub with his pad, in order to produce that vague patch of hollows one notices sometimes in church benches.

The same patience is necessary in making imitation worm-holes, which are so cunningly distributed, so convincingly worked in their erratic manner of piercing wood as to suggest to Edmond Bonnaffé the fine bit of sarcasm : "*Des vers savants chargés de fouiller le bois neuf à la demande.*"

That piecemeal kind of furniture, the parts of which are unquestionably antique but of various origins, being the remains of more than one piece of furniture—*l'assemblage*, as the French call it—may prove a danger to the best connoisseurs if done well and with taste. In certain respects the piece is genuinely antique, but not exactly as the collector understands the word, hence its fraudulency entitles it to be classified among fakes. It is incredible what an industrious antiquary is able to do in the way of piecing furniture together. This consists not merely of finding a top for table-legs, or legs for a table-top, but there is no limit to the invention of this piecemeal furniture. A wooden door may furnish the back of a throne when well matched with a rich old coffer; the gilded ornamentation of an altar may be transformed into the head of a Louis XV bed, and so on. In the same way a simple piece of furniture may be enriched by attaching ornaments, coats of arms, etc. The whole is in-

variably toned and harmonized by means of one of the above-mentioned methods.

Naturally, ignorance of style sometimes leads some fakers to extremely amusing blunders, but it must be confessed the cases are rare, and this piecemeal furniture has been palmed off on too many connoisseurs, and graces too many well-reputed collections to be dismissed with a smile of incredulity. Were antiquaries more disposed to talk or less indulgent towards the conceit of collectors, it might be learnt that all the rich furniture sold during the last twenty years to museums and collectors belongs to this composite order.

A special branch of the imitation of antique furniture is inlaid work, the French *marqueterie* and Italian *tarsia*, by which designs are traced upon the surface by inlaying wood, ivory or metal. There are various epochs and styles of inlaid furniture. One may begin with the geometrical patterns of the Trecento or the *cappuccino* of about the same time and later, and gradually pass through the many styles and methods to the complex ornamentation of Buhl's work.

The early work, including the *cappuccino*, a peculiar inlaid ivory work with geometric patterns, is very well imitated in Italy where restorers of this kind of furniture generally turn into good imitators, and become at times impenitent fakers of the most fantastic would-be old style. Skill in inlaying wood and ivory according to different epochs and the ordinary collector's love of ornamented furniture have suggested to some imitators the most absurd combinations of styles, a riot of incongruity and incompatibility. It is not rare to see fine chairs that would otherwise be tasteful but for the heavy ornamentation of inlaid wood or ivory arabesques, grotesques, etc. The outrage of having a fifteenth-century, inlaid after the style and designs of at least a century later, is not uncommonly excused by the explanation that it appeals to the tawdry taste of customers and that the article commands a higher price by the addition of the heavy incongruous ornamentation.

This peculiar form of degeneration in taste, the passion for

excessive ornamentation, is also what often mars the imitations of seventeenth- and eighteenth-century painted furniture, imitations of the Venetian style especially being generally very carelessly finished but overcharged with gilding and cheap bits of painted ornamentation.

French imitations in this line are not so debased as some Italian, but like them they are not very convincing, as it is almost impossible to imitate the French eighteenth-century gilding, and the carving of this epoch shows such neatness and is so clean cut that the gilded parts assume an appearance of metal, a quality that the modern industry of antiques does not find convenient or is unable to imitate. The French Buhl also is often imitated with celluloid instead of tortoiseshell and can only succeed in attracting the very easily satisfied collector. This is the case with some other cheap imitations overcharged with ordinary gilded bronze. By the side of these specimens, however, French art also counts some excellent imitations done by real artists, which if not successful in deceiving experienced collectors are nevertheless regular *chefs-d'œuvre* in the art of imitating the finest and richest pieces of the Louis XV and Louis XVI styles.

The simplicity and purity of line that characterized English styles from the end of the seventeenth century to the best period of the next, helped to keep the imitators of this country within bounds. Their fancy in any case was less inventive and less disastrously enterprising than that of the cheap imitators of Italian furniture.

Before leaving the subject, we may say that many of the walnut panels in furniture, which appear to be so elaborately carved, are not carved at all but burnt into the desired patterns. The process consists of making a good cast iron matrix from a fine bas-relief, then heating it and pressing it upon the wood by a special procedure by which all the superfluous wood is burnt away and the rest takes the shape of the mould. This method not only gives the wood the desired form in perfect imitation of carving, but the burning stains it to a fine brown tone very much resembling old

wood, after which an application of oil or encaustic is sufficient to give it a semblance of patina.

In another part of this book we have noted that in Bologna more especially imitations of old tables are placed for a time in cheap restaurants where, through grease, dirt and rough wear and tear, they acquire that fine patina so highly esteemed in ancient wood. Such pieces are not only found in towns but are housed here and there about the country, sometimes in old palaces and villas, or else in out of the way nooks. The former system gives the alluring sensation of buying something really worth while, and at first hand, from its historical owner; the latter that a real find has been discovered, that find which is the eternal *fata Morgana* of freshman collectors.

Imitations of musical instruments vary according to the style of the instrument and its musical quality. In some fakes the musical quality is of minor importance to a certain extent, the artistic properties and ornamentation being the chief consideration with the collector. In other instruments the quality of the tone is of importance, so that though the form may not be neglected, the faker must bear in mind that his imitation will have to stand a double test: it must satisfy the ear and stand the examination of an experienced eye.

The first class includes collectively such instruments as are no longer in use and are highly ornamented with carving, inlaid work or gilding such as lutes, archilutes, harps, virginals, spinets, etc.; the second comprises instruments still in use such as violins, 'cellos, etc. The ornamental, strange and obsolete instruments are the ones that fakers chiefly furnish to the ordinary trade.

Naturally the trade in imitating instruments for the mere curio hunter and non-musical collector, is not so remunerative as other branches of the shady art of faking. The number of collectors in this branch is comparatively restricted, many of them talented and not easily duped as is the case in all branches not enjoying popularity. The tourist would rather go home with a painting or faked bronze of Naples or elsewhere, than carry an instrument he cannot play, which will

probably be an encumbrance and dust-catcher in the small rooms of big cities. On the other hand, however, there is nothing complicated about this branch of faking. It is usually an easy matter for a guitar or mandoline maker to invest in the small amount of material needed, and to turn his hand to the work. It must also be taken into account that these workers are very often repairers of ancient instruments whereby they learn to make their imitations technically correct, though this is by no means always the case. We have, indeed, seen appalling exceptions, pianos of an early period transformed into spinets, lutes with grotesque and impossible finger-boards, etc. Some careless and certainly unmusical imitators go so far as to make instruments that could never be played, and even put common wire instead of gut strings, which makes one wonder what kind of collector it can be who delights in such delusions.

Our intention is to deal only with the artistic side of musical instruments, so we lay no claim to real connoisseurship of musical instruments, more especially as regards the family of stringed instruments which finds its best and most complete expression in the violin. Yet the fact that the great discoveries have generally been made by ignorant men like Tarisio, not necessarily fine musicians, goes to show that connoisseurship of form has its importance, greatly resembling after all, the connoisseurship of other branches in its summing up of various analyses into a final synthesis of form and character. True, in a good violin there is rarely any ornamentation, or if there is, it still more rarely furnishes a clue; but although all is entrusted to simplicity of line and form in its most aristocratic and elemental expression, there still seems to be enough to tell of the " touch of a vanished hand."

" How interesting," justly remarks Olga Racster, " it is to observe an expert spelling out the name of an old fiddle by the aid of this ' touch of a vanished hand.' How eagerly he seeks it and finds it with the help of that alphabet which lies concealed in the colour, shape, height and curves of an old violin."

Musical Instruments

Together with the difficulty of faking instruments the synthesis of connoisseurship in this line could not be better expressed. As for the quality of the tone, the expert relies purely and simply upon his ear, no book or hints of a practical character can assist the expert to perfect his ear. All depends upon natural disposition and the experience of a well-trained organ in this most important part of connoisseurship of musical instruments.

When Rossini was asked what is required to make a good singer, he said: " Three things, voice, voice, voice." The quotation fits here for the chief requirement of a good connoisseur of musical instruments as regards their musical quality consists of a triply good ear.

CHAPTER XXIV

VELVETS, TAPESTRIES AND BOOKS

Olla Podrida: Genuine and faked antique stuffs—The peculiar knowledge necessary to an expert on stuffs—The difficulty in imitating Renaissance velvet—Collectors of costumes—Collections of dolls—Tapestries—Repairs and faked parts or qualities—Book collecting—Two kinds of book collectors—The faking of editions and rare bindings—The extended and ambitious activity of the art of faking—Faked aerolites!

ASSEMBLING in this chapter a variety of objects under the title of minor branches of art collecting, we do not use the term artistically, but merely because these branches apparently attract fewer art lovers than the others, and the activity of the faker is more restricted in their case. In many of these branches, too, the art of collecting and connoisseurship is reduced to technical knowledge and artistic sentiment plays a very secondary part.

If there is any one branch of collecting in which it is necessary to be a specialist to ensure success, that branch is unquestionably antique stuffs. Artistic sentiment and good taste are of comparatively slight assistance compared with technical knowledge, and they may even at times produce two dangerous psychological elements only too often responsible for collectors' blunders: enthusiasm and suggestion. The technician with knowledge of the different qualities of materials, with an eye for the various peculiarities of the weave and colour, and sound information as to the character of the various patterns, etc., is doubtlessly the best equipped as a connoisseur of stuffs. This may sound absurd to the outsider, especially to artists, whom we have ourselves found to be over-confident as to their qualities, their pictorial

eye, their full acquaintance with form. Yet too many of these artists, not being collectors or experts, have bought modern goods as antique, old furniture re-covered with modern brocade that no expert would for a moment have taken as being of the same date as the furniture. We refer, of course, to those modern imitations generally the easiest to detect, however artfully they have been coloured and aged to give them the appearance of genuine antiquity.

The detection of modern products offers no difficulty to the expert. They may look extremely convincing to the uninitiated or beginner, as they possess what may be termed a general impression of antiquity, but to the trained eye of the expert there are too many essential differences; and they lack, above all, a character that in the case of a large quantity of stuff and not a mere sample, is inimitable. For the Jaquard machine is not the old weaving loom, the material used is produced with greater care and precision which gives the fabric a different look even when the coarseness of ancient textiles has been imitated, the colours are different and so is the chemical process for dyeing the thread, etc. The sum total of these elementary differences with which the art of imitation cannot cope, is what reveals to the expert almost at sight the antiquity or modernity of the product. In conclusion, with the exception of some rare samples of small pieces, the modern imitation of ancient stuffs is but a successful optical illusion.

Imitations that count at least a century of age, on the contrary, prove dangerous puzzles to experts and connoisseurs of this speciality, these imitations having been made in almost exactly the same way as the originals, before weaving machines were invented, and when the thread was spun and dyed in the simple old way before aniline dyes had furnished beautiful but most unstable colours.

In France, under Louis XIII, Renaissance patterns were admirably copied, as well as those of the sixteenth century. The reproduction of old designs is not confined to Italy and France alone. In nearly every country there have been

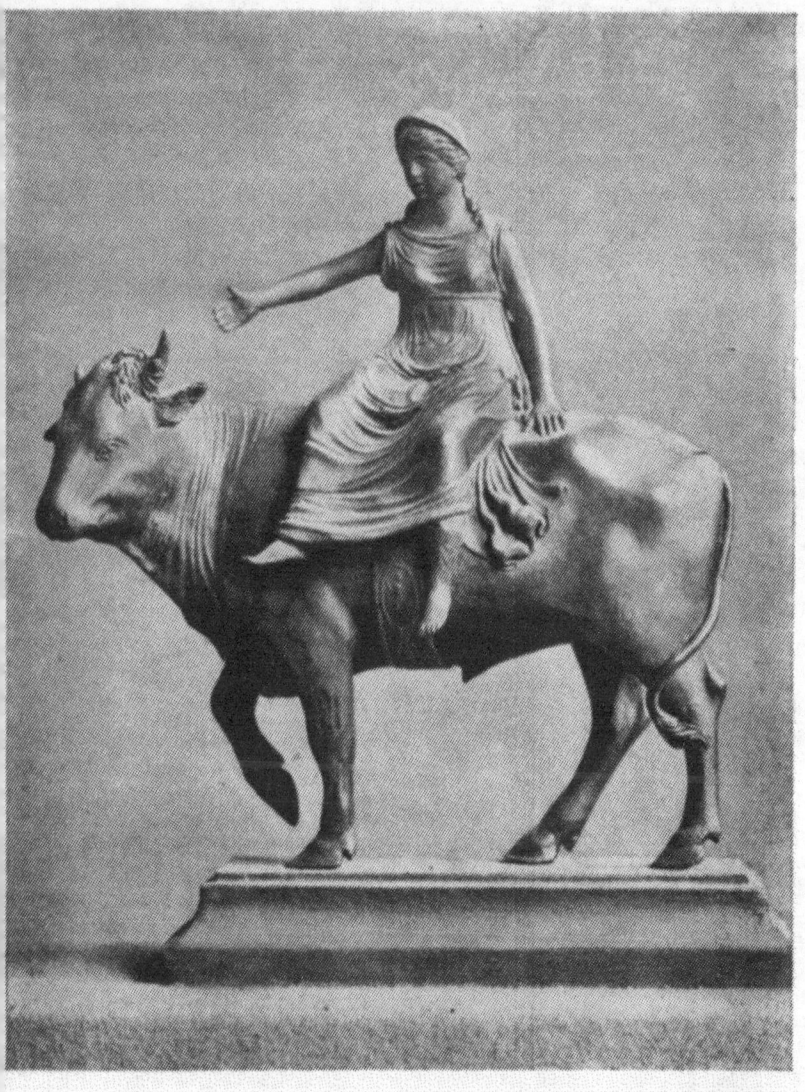

EUROPA ON THE BULL.

By Andrea Brioschi called "Il Riccio." Imitation of the Antique, Padua School.

Velvets, Tapestries and Books

imitators of the best samples of ancient stuffs, damasks, brocades and velvets.

As regards imitation, the more complex the pattern in design and colouring, the easier it can be reproduced with success. In fact plain velvet is the most difficult to imitate. No one, not even in the past, has ever reproduced the fine velvets of the Quattrocento and early Cinquecento with complete success.

Methods of ageing modern stuffs which have not the advantage of the genuine hues of age of old imitations, greatly resemble in general lines those adopted to give an appearance of age to other objects. If the colouring is crude and too new looking, the stuff is exposed to atmospheric action, rain, dew and sunshine. Needless to add, this treatment must be followed with care and discrimination otherwise the fabric may be reduced to a rag as well as to an appearance of age. To harmonize the colours and give them a more faded look, some put the goods into a bath of slightly tinted liquid, thus obtaining on the fabric what in painting is termed velatura. Others put the liquid into an atomizer and steam it on to the stuff. This process has the advantage of giving alternate hues without any sharp delimitation between them.

These methods, however, by which the artist can display variation, are not convenient or possible in the case of large quantities of fabric, nor is the result convincing in the proximity of the original. One does not need to be an expert, in fact, to see the difference between the old and the new on a piece of furniture or in a room where imitations have been used to supply what was lacking.

To make imitations more convincing, more especially in the case of small pieces, some antiquaries stitch on bands before discolouring the stuff, which are afterwards taken off leaving parts with fresher colours, as often happens in really antique pieces that have belonged to ecclesiastical copes, etc.

Strict order having been dispensed with in this chapter,

and as, after all, fabrics are involved, we may here touch upon the subject of dress and past costumes. The rarity of such collections depends not only upon the fact that the roomy space of a museum is indispensable for their display but largely upon the scarcity of past century costumes. This branch of collecting is very useful to the history of fashion and national costumes, but it must be considered that to be of interest to the collector a dress must be at least forty years old, and very few garments attain that age nowadays. Either they are altered to conform to fashion, or unpicked or given away until they have run through the scale of society and end in rags. The rarity of the genuine article appears to correspond with the rarity of collectors of this line, and there is therefore no question of fakes, unless one should take seriously certain comic incidents and consider as a collector the simpleton who buys the cast-off costumes of an elegant fancy dress ball as genuine articles, those poor imitations, with no pretence at being anything else, of Henry IV, Marie Antoinette, and other historical garments.

Having mentioned the subject of costumes, we may speak of another kind of collection that is also very useful to the history of past usages and fashions, that of dolls and toys of past centuries. Dolls and children's toys are not an invention of to-day. It is safe to say that their existence can be traced almost as far as the history of civilization. The Romans used to bury dolls and toys with the bodies of their little ones or place them in the funercal urn, a usage that has preserved for us specimens of these tiny objects that have drawn smiles from young lips closed and sealed centuries ago. Together with these relics are other images that illustrate the history of costumes like the dolls, the statuettes offered to temples and churches as ex-votos and those used in the construction of the old *presepio* (birth of Christ scene), the Christmas Eve representations of the Bethlehem scene. These wooden dolls and statuettes are not only artistic in themselves, but are dressed in stuffs of their epoch very often cut in the fashion of the time.

Velvets, Tapestries and Books

Some of these collections have really been excellent commentaries on the history of fashion and domestic customs of past ages. Among the few important collections we may quote as an example that of Mme. Agar, exhibited by this celebrated French artist several years ago in the Palais de l'Industrie now demolished. Mme. Agar's collection was very complete and illustrative of fashion and life in Holland centuries ago. The collection had originally belonged to the infant princess, the daughter of William of Orange and Nassau. Not only was it extremely artistic, containing several interiors of Dutch houses with inmates and accurate details suggesting a painting by Terburg or Teniers, but it represented all kinds of expression of seventeenth-century Dutch life. Mme. Agar came into possession of this fine collection under the following circumstances. Returning from one of her artistic tours in Belgium she visited the city of Ghent and found the collection in the hands of a gentleman to whom she had been introduced upon her arrival. She offered to buy it, but the owner refused all offers declaring that he did not wish to part with the precious collection. However, after having heard Mme. Agar at the theatre one evening, he was so taken by her art that he wrote to the actress the very same night, "Come to fetch my toys. I offer them to you, they are yours."

There is no question of fakes in this branch either. The difficulty in finding old stuffs and linen with which to garb the figures is sufficient to discourage the trade, especially when one remembers how few customers the imitator could hope to attract.

The art of tapestry weaving is the most complete of the class. Although technique may play its part in constituting expert knowledge, it is certainly subordinate to the artistic qualities necessary to perfect connoisseurship.

Faking plays no part in this field, at least not the conspicuous part that it plays in painting and other artistic products likely to attract rich amateurs. This is easily understood when one takes into consideration the time.

patience and money needful to the making of tapestry; it costs something like eighty pounds a square yard. The imitator also knows that it would be a waste of time and money to fake old tapestries as any expert can tell modern work from old. The apparatus has hardly undergone any essential change it is true, but the materials are so different from formerly that fairly tolerable imitations can only be given in the case of repairs to old pieces. On account of the great cost of modern tapestry the few existing factories either belong to the State or potentates, or they are supported by the lavish encouragement of some modern Mæcenas. As we have said, the difference between the work of modern and ancient tapestry does not lie in a difference of process, unchanged in essentials since the Egyptian dynasties, but rather in the impossibility of obtaining materials like the old ones.

Although some unscrupulous dealers do palm off over-repaired pieces of tapestry on foolish novices, the repair of tapestry is no faking after all, for the decorative character of the fabric fully justifies the mending and restoration of missing parts and, unlike painting, the work does not bear an individual imprint. It is our duty, however, to warn the neophyte that repairs are very seldom pointed out by dealers and that it is absolutely necessary for the collector to train his eye in order to be able to detect the modern parts from the old and to know how much must be bought as antique and how much as modern. This is not so difficult as it may appear. The modern parts are worked in with the needle and although the threads have generally been specially dyed, as the usual colours now on sale are very rarely suitable, there is a slight difference in the final effect. Nothing to offend the eye, even when closely examined, but enough to warn the expert of the size of the repaired piece. Sometimes the repairer of tapestries uses a method which in our opinion comes under the head of faking. This consists of re-colouring faded parts with water-colours or tempera. Some of this touching up is really cleverly done, at other times it is so

Velvets, Tapestries and Books 293

clumsy that one wonders how even a novice can be taken in. If there is any suspicion that the tapestry has been coloured, a practical test is the displacement of the threads with a needle as the fresh colours are generally laid on with a brush and never penetrate between the threads where the old faded colour is visible. Incredible as it may seem, some tapestries are touched up with pastel. This was sometimes done even in the eighteenth century to disguise defects and crudeness of tone and now it is practised to deceive the eye by making a better match between the old and the new parts. Of course pastel work is easily detected if one is allowed to rub the part, but this is not always feasible, especially at public sales where the tapestry is hung on the wall, sometimes very high up, on purpose to defy close inspection. There is also a method of fixing the pastel retouch with an atomizer and a certain liquid sold in Paris, but even these means are not so effective as milk and tempera, and hard rubbing with a white cloth will always reveal the deception when pastel has been used.

Rugs, particularly Oriental rugs, belong in a way to the same family as tapestry and may be classified with it. There is this difference, however: being less complicated in character and for the most part adorned only with geometrical patterns and rudimentary arabesques, rugs are imitated with greater facility. Things do not change so quickly in the East as in Western countries, and there the old weaving apparatus is still in use and materials are only just beginning to be imported from Europe. A large field is thus opened up to imitation, and to a certain extent to faking also. It is nevertheless hard to deceive experts and specialists. Keen-eyed and accustomed to distinguish between different kinds, and to judge of age, they are also able to detect modern frauds. But, alas, good experts are rare and conceited collectors abound, and for this reason fraud is rampant and remunerative, even in this field. Those buying rugs for the sake of having a collection and not to furnish their houses with a comfortable and highly artistic luxury are advised to place

themselves in the hands of an expert. It will save time and trouble. An eclectic collector, however gifted, will rarely consent to go deeply into this branch, as the mastery of it implies great sacrifice of time and the boredom of learning a difficult language, things that prove no obstacle to the passionate lover of the speciality, but tedious and irksome to the general art lover.

Following an erratic course in this chapter, we will now pass on to books, manuscripts and autographs, a branch with many devotees and all kinds of collectors, in which trickery and faking find an almost incredibly large sphere of action.

Book collectors are of two kinds, the one who prizes the work for the rarity of the edition, and the other who is attracted by the binding. The former is the true book collector, the latter is really only a collector of rare and artistic bindings. The two preferences do not mutually exclude one another, of course, and when found together offer the most complete kind of book collector.

It might be imagined that imitations in this branch would be confined to such pieces as only require the faker's shrewdness and imitative skill and not the great amount of work and money demanded by the reproduction of a whole edition, but this is not the case. As soon as fashion—sovereign and despotic in this department also, taste and art being secondary—sets a value on what is called a rare edition, false ones find that the work pays and imitations are thrown upon the market at once. About the end of the eighteenth century a speciality was made in Lyons of reproducing all the rare editions of Racine's works, while Rouen acquired a certain notoriety in faking old volumes of Molière with every detail carefully and accurately copied—quality of the paper, the type, decorative initials, tailpieces, etc. That the labour was worth the trouble and expense is amply proved by the high prices that some original editions have fetched. The first edition of Molière's works, dated 1669, was sold in Paris for 15,000 francs. At M. Guy Pellion's sale separate works bearing various dates were sold—*Le Tartufe*, 1669, for 2200 francs,

Velvets, Tapestries and Books

Le Misanthrope for 1220 francs, and few volumes below this price. Fashion having set extravagant prices—the original edition of Molière's works was sold at 70 to 100 francs apiece at Bertin's sale, 1885—old incomplete editions have been completed, and for the late-comers not in time for this half-genuine article, full and first-class imitations are provided.

Missing pages of rare volumes, incunabula or precious, highly prized editions, are often supplied by the most skilful pen and ink work. It is surprising to see how well the clever calligraphic artist can imitate the printed characters, and how carefully and faithfully the missing pages are copied from some complete edition. In a damaged edition it is generally the frontispiece that is missing or the ornamental title on the first page. Some of the latter are true works of art and require most artistic penmanship for their reproduction. The illusion is, nevertheless, often complete. Paul Eudel tells an amusing story of an expert who had not noticed that one of the pages of a certain work was a clever piece of penmanship added later, but to whom the secret was revealed by circumstantial evidence which saved him from being cheated. The work was so admirably done that the expert had not detected it to be pen work, till he happened to notice a worm-hole in the parchment of that page whereas the preceding and following pages bore no hole. As it was impossible for a worm to reach a page in the middle of the book without boring through the others, he surmised that the hole must have been there when the page was done, that the page was a later addition in fact. Once suspicious, it is easy to ascertain the truth. A closer examination showed M. Pourquet, such was the name of the expert, that the page in question was hand work, and not print.

It is true that nowadays, by means of photo-mechanical reproductions old books, characters and illustrations can be imitated to perfection, and there are also mills that can supply all sorts of old-fashioned paper to order, as near as possible to a given sample. Experts claim, however, that

such fakes are only dangerous for the inexperienced collector, that a magnifying glass reveals the action of the acid in a sort of scalloped edge to the ink lines, and that, although well imitated, the paper has a different grain when closely examined, etc. But it is, of course, understood that fakes are not as a rule intended to baffle the skill of the expert but rather to take advantage of the inexperienced.

The expert who gives his attention chiefly to the bindings of the books needs to be more of an artist than the other. We know that editions, too, have their elegancy, forms and tasteful simplicity needing, as it were, an artistically trained eye to enjoy their beauty and appreciate their value, but compared with bookbinding their artistic quality seems to be of a more restricted kind. In bookbinding, art in all its decorative eloquence appears to claim full rights. There are bindings of past centuries—more especially in Paris, where bookbinding has always been a grand art—that are really *chefs-d'œuvre*. As usual it is the unwary who in this branch also pays the highest tribute to fakery.

From the Grolier bindings down to the last specimens of the eighteenth century, imitation has a wide field of action for its versatility, but according to experts the most exploited period is that running from the early years of the seventeenth century to the end of the eighteenth, one of the most difficult to imitate and yet one of the most profitable. There are, of course, various ways of faking old bindings. Many have tried to fake the whole, beginning with the fabrication of the ornaments cut in iron which are used to stamp the gilt ornaments on leather or parchment. In the opinion of the connoisseurs of Paris, where these imitations appear to find their best market, they are far from convincing, being only intended for such as seek a certain decorative quality without pretending to be experts or collectors. Specialists say there are imitations of a far more dangerous character, those composed of various genuinely antique parts, those relying upon some authentic element in the process of making, and original bindings fitted

Velvets, Tapestries and Books

to other books which thus embellished and enriched fetch higher prices. The first of the above operations knows no limits but those set by the material, it may be a question of using old leather or aged parchment, or of using old labels, or of taking advantage of the characteristic coloured lining papers that modern industry reproduces fairly well. Here we have, in fact, the usual composite style with which a fanciful binding is made or a book put together out of various elements that are perfectly genuine, but belong to different sources.

The second manner of faking in decorating the cover of a book is to use some old iron stamps for the impress on the leather of the binding. Some of these old implements that have escaped destruction are now used to advantage, especially to stamp decorative coats of arms on imitation antique bindings, so that the buyer should think the books have come straight from the former library of a nobleman. The faker has used this trick successfully with Americans particularly. In this way the stamps of the *Sacré de Louis XV*, which are, apparently, still in existence, have been used as a decoy on fine bindings, as well as that of the Rohan-Chabot family coat of arms perpetuating the supposition that books belonging to that illustrious family are still on the market. The third method is called in French *rembotage* and consists, as we have said, of transferring covers from one book to another. There are some good editions that have lost their covers and some worthless books with fine bindings—fakery repairs this injustice of fate by transferring the good binding to the more meritorious book, a simple act of justice invariably rewarded in the world of fakery by the large sum that can be asked for the edition thus treated.

There are naturally many ways to discover the bindings that have in one way or other received the paternal and not at all disinterested caress of the faker, but the best and safest way—shall we ever tire of repeating it—is to train one's eye to that helpful synthesis of judgment called experience. Newly coloured and patinated leather does not stand rubbing

with a damp cloth like the old does, modern gilding and modern stamping imitating antique designs are heavier and less clean cut as well as not so rich—qualities best understood by comparing modern work with the old, for although the differences are slight they are, nevertheless, plain to the experienced eye accustomed to comparing old and new. Even *rembotage*, the most difficult to detect, may be found out by examining the way one part is joined to the other, the peculiarities of the work, etc. All that can be said, however, to put the neophyte on his guard who may imagine that hints from books or special works on the subject are sufficient to assist him, is : Go slow, and if you are really anxious to have a good collection and prepared to pay good prices, in the beginning ask the man who knows for his help—*Experto crede*.

It is obvious that no artistic temperament, taste or knowledge of art is necessary in order to become a collector of autographs. This class of collector, who may boast an uninterrupted line from scholars to specialists, has neither the assistance nor complicity of art. Consequently the faker, who inevitably follows suit, must have a knowledge of history in order to avoid historical blunders, he must be acquainted with particulars connected with the personage whose autograph is to be forged, and above all must be an expert imitator of other people's hand-writing, in fact in him the art of forging signatures must be brought to the highest perfection, for here documents are to be forged, a succession of calligraphic characters and idiosyncrasies far more difficult of execution than a mere signature on a false cheque.

The aptitude of a bank clerk gives promise of a good expert in this subject. Studies of various papers according to epoch is not of such assistance here to the expert as in the case of books, for there is still plenty of old-fashioned paper on the market, enough of it at least to bear a few lines from a celebrated man, the chief quality needed is experience gained by comparing originals with forgeries, or better still such familiarity with a given man's hand-writing that its

Velvets, Tapestries and Books

genuineness can be judged at sight, as a bank clerk does with a signature.

There are some artists also in this class, but not only is it rarer, but their work deals less with autographs properly so-called than old documents mostly on parchment with illuminations, etc.

Stamp-collecting hardly comes within our sphere, and represents rather a minor department of connoisseurship. Several books have been written on the subject, many with valuable hints as to prices and with reproductions of the best samples, etc. We would warn our readers who may perchance be interested, that every stamp of value has been faked, that, strange to say, some of these fifty-year-old fakes fetch handsome prices and flourishing factories have been established to supply not only the rare specimens already acknowledged as such, but to produce at a few hours' notice any sample despotic fashion may suddenly raise to the rank of a rarity. Art plays so small a part that the way to become an expert on the subject is to become an—expert. Beyond this, which is only in appearance an *idem per idem*, there is very little to be done. Experience consists of being familiar with the original, the kind of paper used, the colours, peculiarities and also defects, particularly the defects, as when the stamps were printed that are now rare, the art of printing was in its infancy compared with our times.

There is no occasion to speak of minor fancy collections that, as usual, form links between the true collector and the man with a mania. Even in these minor branches there may be more than one interesting collection, such, for instance, as that of General Vandamme who left his relatives no fewer than sixty thousand pipes, and Baron Oscar de Watterville's and others. Art plays no great part in these minor expressions of curio-collecting and science also occupies but a limited field. One axiom may be given, however, which holds good for all classes of collecting, whether artistic, scientific, or anything else, and that is that as soon as the prices of certain articles come under the nomenclature of

300 Velvets, Tapestries and Books

fancy prices, through fashion or merit, the faker is ready to hand.

In the Paris world of fakers, a larger world than the outsider may imagine, an amusing anecdote is told. Learning the high prices paid by astronomers for bolides, an inveterate faker called upon a well-known chemist to propose a partnership for the production of imitations of meteorites. Even if an invention, the anecdote gives the full size of the faker's spirit of enterprise.

CHAPTER XXV

SUMMING UP

WITH some show of reason Swift affirmed that all sublunary happiness consists in being *well deceived*.

We are perfectly aware that this book does not support Swift's ethics of happiness, for while agreeing that the English satirist's theory may hold good on a great many occasions, we claim an exception for collectors as a class. In the world of art, art lovers and collectors, to be well deceived means to be living in a fool's paradise, a most costly dwelling which promises no eternal joy. On the contrary, the happiness derived from being well deceived in this case is generally not only of very short duration but inflicts smarting wounds to pride and pocket.

In the world at large there seems to exist a certain benevolence towards deluded ones, which makes it at times possible for the well deceived to be the only one of his entourage unaware that he has been duped. In the world of collectors such a thing is almost an impossibility for, to quote a well-known French art lover: "After pictures by Michelangelo and specimens of Medici ware, the rarest thing to find with collectors is kindliness."

The same art lover assures us that in this peculiar world not only is kindliness (*bienveillance*) rare, but the opposite sentiment has been developed almost to the point of genius. Collectors, especially first-rate collectors who have finally emerged into fame through the complex resultant of a good eye, shrewdness and extreme skill in fencing with strong competitors, have a regular talent for flavouring bitter pills for deceived friends and comrades with troublesome in-

nuendoes and smarting disclosures, for, as the above-quoted connoisseur declares, they have a way of praising with " praise that exasperates and with homicidal compliments," and there is a type of collector who knows his repertory by heart, a man who is a "*toreador raffiné—il massacre artisiement.*"

What the neophyte can do to avoid being " artistically " massacred, as the French connoisseur puts it semi-euphemistically, is difficult to say. Books and special treatises may explain the nature of the deceit, point out the dangers awaiting him and show how traps are laid and how they work, but to pretend to become a truly safe buyer on the security of knowledge gathered from books and manuals would be like attempting the ascent of some dangerous peak on the strength of wisdom drawn from works on Alpine climbing.

The rudiments of the art do not concern so much the knowledge of how to buy as of how not to buy, how to resist, namely, the first impulse, which in an inexperienced art lover proves to be one of the worst dangers. The slow, prudent method must be learnt of not listening to first impulses till the first impulses are supported by something better than the innate conceit of a beginner. We know, of course, that there may be occasions when even a beginner may have cause to regret not having listened to a first impulse, but such a thing is further from the general rule than the beginner claims, and in any case it pays in the long run to let a good chance slip rather than risk becoming the possessor of some expensive would-be *chef-d'œuvre*.

In addition, during the early stages in particular, a certain amount of scepticism must temper a too ready belief in what the dealer has to say or show, in support of his assertion. There will come a time when experience will help the collector to detect more easily than at first alluring, suggestive information, etc.

Naturally it is not all dealers who are on the watch to take advantage of the beginner. On the contrary, there are

Summing Up

more honest dealers in the antique market than one would think, but the trouble is that the dishonest ones seem to be to the fore, to be ever there ready to confront the inexperienced novice, and their noisy deceits become far more known than good, honest dealing, causing perplexity in some collectors so that it may be they disbelieve the man who is telling the truth and give credence to the liar, who being a perfect master in the art of misrepresentation, seems to be honesty itself.

Here, too, the determination to be rather sceptical as to documents, letters, pedigrees and mercantile evidence may lead the beginner to miss some good opportunity, but the case is rare and such losses are as a rule amply covered in the summing up of the total cost of apprenticeship, through not having paid for experience the extravagant price usually demanded. In due time the art lover's ability to discern between dealing and dealing will be sharpened, and he will be able to defend himself better.

This merely concerns dealing and experience in distinguishing the genuine from the fake. But even supposing perfection has been attained in this part, the fact does not necessarily imply qualification as a connoisseur, collector, expert or even simple lover of art. A collection may be composed of genuine articles and yet be a poor one, utterly devoid of artistic merit or even commercial value of importance. To have paid a high price is no guarantee of merit. There are, as a matter of fact, perfectly genuine paintings for which extravagant fancy prices have been paid, but which in the eyes of a true connoisseur are not worth the nail they hang on.

It is almost impossible to conceive that experience in distinguishing the genuine from the false should be acquired without the attainment of some artistic progress prompting discrimination between poor art and mediocre, and mediocre art and fine art, yet this artistic side is the most difficult to develop to that perfection and semi-intuition of the beautiful, so necessary to the real and first-rate connoisseur.

By what method this artistic side may be perfected in the collector is still more difficult to tell, for in this direction experience only counts to a certain extent. In fact as regards this artistic education of the connoisseur we are inclined to repeat with Taine, in his *Philosophie de l'Art:* " Precepts ? Well, two might be given : first to be born with genius— that is your parents' affair, not mine ; second to work a good deal to bring it out, and that is not my business either."

Here too, then, actual methods are out of the question. They are, perforce, of such a general character as to be no more use than telling a blind man to keep in the middle of the road because there are ditches on either side. It is, further, not uncommon for contrary systems to lead to equally happy results according to the person employing them. One antiquary when undecided as to the genuineness of a painting used to have a photograph of it taken, for, he said, he could easily detect the traits of forgery on seeing the work in black and white with all colours eliminated, or, to put it in his own words : The faked side sweats out. Another connoisseur held exactly the contrary theory, declaring that he could tell nothing from photos but needed the colours to help to detect the genuineness or fraud of the painting. Perhaps the former had an artistic temperament based chiefly upon the charm of form while the latter was what in art is termed a colourist.

In addition, at times another misleading cause may be added which comes under the form of intervening suggestion and may put even a highly gifted artistic temperament off the scent.

Perhaps an example will best illustrate this peculiar interference, which is not only of a circumstantial order, as we have seen in another part of this book, but may be the result of an unconscious *parti pris*.

Some years ago when Mr. Stanford White imported works of art and antiques for his millionaire patrons, a Mr. X., who owned a fine mansion on Fifth Avenue, very much admired an early fifteenth century single andiron that was among

Summing Up

the imported goods. He wished, however, to have a pair. The suggestion that a modern copy should be made from the only remaining original at first disgusted him, for everyone knows how easily American collectors buy imitations for originals and how disgusted they are if the dealer honestly says that a certain work is an imitation. On being assured that the imitation should be perfect, the new piece was finally ordered and the antiquary arranged for an artistically exact copy of the ancient andiron to be made in Italy. However, possibly because not wishing to be suspected of concocting "modern antiques," or for some other reason, the Italian firm sent a perfect copy of the original in a brand new condition, suggesting that a certain Italian artist living in New York should give it the proper patina as he was fully initiated in the cryptic art of making new objects look as old as might be desired. The art critic chosen to come and judge of the final result of the work was, as the artist knew, rather distrustful of Italians and their tricks, as he put it.

The Italian artist did the work as well as it could be done, and knowing that it was going to be judged side by side with the original, the hardest test that can be inflicted upon an imitation, he managed to cheat the art critic by being excessively frank and honest, taking advantage of his prejudice against Italians and a probable momentary mental attitude. The two pieces were shown in the artist's atelier, the imitation being placed by the artist in the full light and the original in the most benevolent corner, far from the window in a half-shade. The first thought that passed through the art critic's brain as he entered the studio was that the "tricky Italian" had put the imitation where the light was less strong and the shade more benevolently helpful.

"Very good," he remarked; "but of course even when not in the full light an imitation is always an imitation."

"But that is the original," replied the artist, for to make his positive assertion the more definite the critic had been pointing to the wrong piece.

A stony silence followed.

The story ends here and we do not know whether the critic ever forgave the artist his honest trick. Knowing that the art critic was a real connoisseur, a good exception to the class, we are quite sure that his judgment was perverted by the preconceived notion that the Italian had placed the imitation in the shade and thus had hardly let his artistic temperament and knowledge of art come into play in forming an opinion, or rather the opinion was already formed, and too quickly expressed, by a semi-subconscious process of reasoning that had nothing in common with art judgment.

So many are the special cases, and so little the assistance generally given to new-comers, that the safest method in conclusion is to have no actual method, to watch and study one's own temperament, value the first results objectively, to be ready to learn as much as possible from experience under whatever form it comes and finally, like in so many cases of human life and possibilities, to work out one's own salvation.

In this way, even if not called to the Olympus of the elect, the art lover will certainly reduce his bad bargains to a minimum—bad bargains in the way of buying the wrong things as far as the genuineness of the article is concerned as well as with regard to its artistic worth. With this he must rest satisfied for, as we gladly repeat once more with the Nestor of French connoisseurs: "Beware of the collector who never makes a mistake; the strongest is he who makes the fewest mistakes."

* * * * *

As we have seen, the genus *curieux* (curio-hunter) comprises a most complex and multiform assembly of types. From the distant ages of Roman dominion down to our times, collectomania has produced characters graduated in originality from the grotesque to the tragic, the false to the genuine, the sordid or wicked like Mark Antony and Verres to noble representatives like Julius Cæsar, Augustus and Agrippa.

Summing Up

Curiously enough the noble type of collector and the usefulness of his mission have generally escaped the observation of writers of all ages. They seem to have been quicker to see the grotesque side of collectomania than its utility. Martial, Juvenal, Pliny, Seneca and others are not dissimilar in their remarks from—say, Molière and La Bruyère.

So strong is the inclination to place the types in a grotesque setting, to make them the target of witty sallies, that they very often mistake oddities for signs of idiocy, idiosyncrasies and peculiarities for craziness, and, carrying their analysis no further, they let loose the vein of their satire on people whose passion for collecting has been of extreme use to the intellectual world, greatly assisting progress and the civilization of humanity.

"Just like a donkey beholding a lyre," gibes an old Greek epigram in allusion to collectors who, while buying eagerly, give so little time, or none at all, to the enjoyment of the artistic merits of their acquisitions. Addressing one of his contemporaries who had a passion for collecting manuscripts and volumes but no inclination to read them, Lucian remarks: "Why so many literary works? Do you collect them in order to lie on the learned thoughts of others, or to paste the parchment of the volumes to your skin? With it all you will not become a jot more learned; a monkey is always a monkey, even though covered with gilded garments."

To follow up the special case of book-collecting to which Lucian's remark casually leads us, the same sentiment as that of the Greek writer was entertained centuries later by Petrarch and Robert Estienne. The former was a poet and bibliophile, the latter a famous printer, author of the *Thesauros linguæ latinæ*. The two did not spare satires on the mere collector of books.

A like attitude is taken towards Mazarin by a mediocre poet of La Fronde, who reproaches the Cardinal with collecting books without reading them; the same reproach that contemporary writers make to Magliabechi, a passionate collector of rare editions who never went further in a book

than the title-page. Yet, to confine ourselves to these alone, to Mazarin is due one of the finest libraries of Paris which still bears his name, and by his careful, patient work, Magliabechi was the founder of the Magliabechiana, now the National Library of Florence, a marvel and model of historical character to other more modern institutions of the kind. These two persistent and passionate book collectors have certainly contributed more to science and its progress than many of those scholars who made fun of their hobby.

It must be taken into consideration that collecting, after all, is a passion, at times a deep and firmly rooted one, and that passion, like love, in its most exalted expression does not represent normality, but while on the one hand presenting qualities of an intuitive character, can be coupled with oddities and idiosyncrasies, frequently the inevitable heritage of originality.

Hannibal who stored his money in the hollow of the bronze statues of his collection, Sulla who put to death citizens to seize their rare pieces of art, and Julius Cæsar who travelled with his cherished objects of virtu, are known to us as collectors mostly through their peculiarities, the amusing anecdotal side of a passion, certain to be exploited by a writer, be he chronicler or historian.

Yet, to go back to the unjustified and indiscriminating spirit of satirists, both of ancient and more recent times, which tends to consider the collector a maniac or fool, many a Greek and Roman *chef-d'œuvre* of art has nevertheless been spared to our admiration by the patient persistence and art-loving care of collectors.

It would, indeed, be interesting to follow the passage of some of the most noted specimens of past art. If one could trace the true history of each one of these objects in all its details, it would perhaps give us the history of the collecting passion together with tangible proof of its merits and utility.

It would, indeed, not only be interesting but also instructive to know the vicissitudes of some of the works of art that

have come down to us. The few hints existing as to the lineage of owners of some of the most famous pieces of Greek and Roman art, certainly promise interest even though marred at times by the fact that much of the information rests upon the vague authority of tradition, or is strongly doubted by modern criticism.

"We owe, it is more than possible, the Venus of the Hermitage to Cæsar; the well-known 'Whetter' has almost certainly been saved to our admiration by Lucullus, just as Cicero may be thanked for the 'Demosthenes' and the collecting passion of Sallust has handed down to us the 'Faun,' the 'Hermaphrodite' and the 'Vase' of the Villa Borghese."

These remarks of a well-known French collector who mainly notes works contained in the Louvre Museum might be extended to many other collections, especially those of Rome, where several of the works of art have old historical records of undisputed character.

From the Renaissance down to our own days the pedigrees of celebrated works of art are not only surer, but present at times a less interrupted line of descent. With such it is not uncommon to find a rare object pass from one collector to another, receiving the same care and consideration as though passing from father to son as a cherished heirloom—and it is, in fact, passing from one to another member of the same family, the family bound by an identical burning passion, that of collecting.

As to the essence of this passion, so often confounded with mania—a mistake calling forth the following comment from a French collector: " . . . *confondre la 'manie' avec la curiosité, c'est prendre l'hysterie pour l'amour, ' la Belle Helenè' pour l'Iliade* "—we should like to quote Gersaint, one of the few men who as art dealer and collector in one, what might be styled private dealer in modern phrase, impersonated the passion, as we have said, in its highest expression among the many collectors of the eighteenth century. It must be understood, of course, that Gersaint,

one of these maniacs in, say, La Bruyère's opinion, was a representative of those passionate collectors who subordinate every other passion of mankind to the one they have made the sole aim of their lives. " . . . A *curieux*," says this unilateral lover but not hobbyist collector, " has the advantage of not falling an easy prey to the many passions so familiar to the human family : the *curiosité* fills all the empty spaces of his leisure moments. Entertained by his cherished possessions, he has time only for working at the advance of his *curiosité*, and his cabinet becomes the centre of all his pleasures, and the seat of all his passions."

The outsider and half-way-insider will agree that this is a trifle too much; but, after all, the great collectors who have left to the museums of their countries fortunes that would have been lost but for their intense passion—treasures of art left by the ignorant to the doom of decay—have all felt, more or less, the burning passion described by Gersaint, in the passage quoted which goes on to assert that a true paradise awaits the perfect collector, who is never bored, and never the prey of spleen.

Without discussing the promises held out by Gersaint, as the perfect collector is, to our knowledge, rare, let us state that our book does not hope to urge any reader on to the perfection that ushers into Gersaint's bliss, but if the brief glimpse we have given of Collectomania with its pleasures and dangers should convince some really passionate lover of art that collecting has a nobler aim than that of mere pleasure, if we should discourage a Tongilius or Paullus, or if this work should scare some modern Clarinus and do away with a noisy, useless up-to-date Trimalchus, we shall feel that the purpose of the book has been justified to some extent.

INDEX

Adamo da Brescia, counterfeiter of coins, 67
Adventures of a Bric-à-brac Hunter, 144
Agar's, Mme., collection of dolls, 291
Agesilas, 21
Aglæphon, 25
Agrippa as an art lover, 31
Alberti, 86
Alcohol as a solvent, 227
Alexander the Great, 37
Alluye, castle of, 92
Altar piece, Rothschild's faked, 262
Amateur marchand, the, 117
Amber varnish, 228
Ambras collection, the, 87
American collector, the, 141
Andirons, story of the, 305
Andrea da Foiano, 79
Andrea del Sarto, 99
Andreoli, Maestro Giorgio, 250
Anne of Austria, 123
Anonimo Morelliano, the, 98
Antiquary, old and modern, the, 143, 153
Antique, passion for the, 71
Antiques, the collection of, in Italy, 82
Apelles, 20
Apollo and Marsyas, 94
Apollo, Sulla's statue of, 36
Apollo, temple of, at Delhi, 23, 61
Apollo, the golden, 18
Aponius Saturninus, prætor, 29
Archæological suggestion, 160
Aretino, Pietro, 117
Aristotle, 18
Aristotle, bas-relief of, 91
Armour, faked, 269
Arms, the imitation of, 267
Art collecting, spread of, in Europe, 110
Art critic, the, 160
Art, influence of Greek and Roman, 83
Art in Rome, 20
Art museums in Rome, 61
Art sales, 128

Artist and erudite, 140
Artistic war booty, 21
Artists as connoisseurs, 288
Artists at Rome, status of, 20
Aspetti, Tiziano, 98
Athens, 18
Atria auctionaria, 28, 212
Atrium, the, 48
Atticus, 40
Auction room, atmosphere of the, 214
Augustus and Vedius Pollio, 52
Autographs, forged, 200, 298

Baldinucci, 225
Barberini, Cardinal, 118
Barbizet Brothers, 252
Barquette, la, 110
Barocco, the, 113
Bas-reliefs, bronze, 91, 235
Basant, 131
Basilini, 147
Bastianini, 182, 188
Belli, Valerio, 98, 100
Bellini, 100
Beniviene, Girolamo, Bastianini's bust of, 183
Biblical subjects, 102
Bibliomaniacs, Roman, 50
Biographie Universelle of M. Weiss, 115
Bisticci, V. da, 92
"Black Band," the, 171, 180, 219
Boethus, 30
Boiss, Mme., 209
Bolides, faking, 300
Bonafedi, Signor, 185
Bonnaffé, Edmond, 108, 112, 149, 193
Bookbindings, 296
Book collectors, Roman, 49
Books, 294
Bracciolini, Poggio, 75
Brass articles, patina for, 265
Bric-à-brac, 130
Bric-à-brac shops in Rome, 29
Brienne, 119
Briesco, Andrea, 87, 88
Bronze and other metals, to give tone and colour to, 264

Index

Bronzes, 30, 89, 238
Brunelleschi, 75, 83
Brunellesco, 71
Brunswick Museum, the, 91
Brutus as a collector, 40
Brutus of Michelangelo, 103
Buffon, 131
Bullant, Jean, 92

Cafaggiolo, 249
Calamis, 46, 59
"Calcedonio," Niccoli's, 73
Calchar, 100
Caligula, 29
Caligula as an auctioneer, 212
Callot's bad etching, 127
Camelio, Vittore, 91
Cameos, counterfeit, 58
Candelabras, 30
Canvas for restoring paintings, 229
Capodimonte factory, the, 256
Cappuccino, 282
Cardinal di San Giorgio, 82, 89
Carneades, 41
Carracci, "The Deluge" by, 120
Castellani sale, the, 213
Castiglione, 103
Catalogues, first printed, 116
Cathegus, 25
Catherine de Medici, 110
Cavenaghi, 167
Cavino, 91
Cellini, 103
Ceroplastics, 244
Cesnola collection, 248
Charles the Bald, Bible and Psalter of, 66
Charles VI, catalogue of, 68
Chasles, M., 199
Cheese as a vehicle for colour, 230
Chemistry's aid to faking, 263
Chilperic, a collector, 65
Christian and pagan subjects, 96
Christianity and art, 63
Chronique Scandaleuse, 130
Chrysogon, 25
Chrysoloras, Emanuele, 72
Claywork fakes, 235
Cicero and Art, 19; imitation and fraud, 24; pubilc auctions, 28; a collector of doubtful taste, 40, 41; Chrysogon, 45; *citrus* tables, 54; public sales, 211
Cinquecento art, 102; velvet, 289
Cinquecento collectors, 102

Ciriaco d'Ancona, 71
Citrus or *thuja*, 54; qualities, 55
Citrus tables, craze for, 25, 54
Clarinus, 32
Classification, 138
"Cleaning," 216
Client and art market, 31
Clodion's clay groups, 208, 238
Clodius, 31
Clotaire, a collector, 65
Clovis, a collector, 65
Craquelage, on pottery, 255
Cressy, influence of the battle of, 110
Crieur, the, 28
Crozat, 129
Coaches, Commodus' collection of, 212
Codrus, the needy collector, 32
Coin counterfeiting, 67, 92
Cola di Rienzi, 69
Collection, a form of banking, 64
Collector, the: the home of the, 18; and satirists, 32; types of, 34; rapacious, 37, 38; ultra-modern, 141
Collectors and collections, 135
Collector's touch, the, 146
Colouring marble, 242
Commerce and art collecting, 130
Commodus' effects, sale of, 212
Concini, 123
Condivi, 90
Connoisseurship and erudition, 138
Conquerors as collectors of art treasures, 22
Constantine, 18, 63
Constantinople and Oriental arms, 267
Copyists in Rome, 59; Greek, 59
Corinthian bronze, 30, 51, 239
Cornelius Nepos' statuette of Hercules, 37
Corplet, Alfred, 252
Correggio, the Marsyas and the Antiope by, 119
Correr Museum, 91
Corvinus, Mathias, 96
Cosimo I, 104
Costantini, Prof., 178
Costumes and dress, 290
Coulanges, 124
Counterfeit coining, 67
Counterfeiting, imitation, and forgery in Rome, 58
Courajod, Louis, 84, 92

Index

Courtier, the, in Rome, 28 ; modern, 164
Couvreur, 147
Curieux, meaning of, 136
Custom House officials, 179
Cut glass, 260

Dagobert, 65
Damascening, 270
Damophilus, 21, 43
David, statuette by Michelangelo, 108
Davillier collection, the, 90, 95, 108, 140
Dazzi, the Italian dealer, 179
d'Aunale, Duc, 110
de Bassiano, 91
d'Este, Isabella, 80
de Genlis, Mme., 136
de la Porte, Armand Charles, 120
de Limeville, Sieux, 127
de Sévigné, Mme., 125
d'Orion, faience, 109
Dealers, traders and shopkeepers, 154
Death masks, 92
Deceptive surroundings, 210
Della Robbia, imitations of, 250
Delorme, Philibert, 92
Delphi, 17
Demasippus, 25
Demmin, 251, 273
Derutha, 249
Devers, Joseph, 250
di Banco, Antonio, 84
di mattonella, 156
Didius Julianus, 212
Dolls and toys, 290
Donatello, 71, 83, 84, 86
Donatello's *puttino*, 197
Dondi, 71
Dreyfus, G., 91
Drouot, Hotel, 214
Duchie, Jacques, collection of, 69
Dyes for marble, 243

Eclectic and specialist, 138, 140
Ecouen, castle of, 92
Electrum, Helen's cup of, 18
Enamels, faked, 259, 260
England, rise of the passion for collecting in, 110
English furniture, 283
Ennius, 22
Epitrapezios, the, 36
Ereinteur, the, 217

Eros, the tearful collector, 33
Estienne, H., 109, 112
Estienne, R., dictionary of, 136
Etchings, margins for, 232
Etruscan pottery, 248
Eudel, Paul, 180, 199, 203, 238, 273, 278, 295
Evander Aulanius, 60
Evangéliaire, a rare, 66
Evelyn, John, 115
Ex-voto objects, 290
Exhedra, 49
Expert, the, 162

Fabius Maximus, 19
"Fabius Pictor," 20
Faked atmosphere, the, 207
Faked reputation, the, 220
Faker, the, 194
Faker, the jovial, 202
Fakers, the aristocracy of, 88
"Faking the *milieu*," 209
Faking in Rome, 27, 57
"Faustina antica," Mantegna's, 81
Filarete, 86
Firminius, 31
Florence, National Museum, 91
Flute player, the, 88
Fontainebleau, school of, 112
Forgeries, 153
Forni, 230
Fortunatus, 65
Fortuny, Mariano, 268
Forzetta, Oliver, 69
France and art collecting, 107
France, art in, 112
France, seventeenth-century art in, 114
Frankfurt, fair of, 109
Frederick II, Duke of Mantua, 66, 99
Freppa, 182
Friuli, Marquis of, 66
Fronde, the, 119
Fulvius Nobilior, 21
Furniture, faking, 167, 279

Gaillon, castle of, 87
Gegania and Clesippus, 29
Gellianus the auctioneer, 213
German-made arms, 267
Gersaint, 131, 148, 309
Ghiacceti, Luigi, 110
Ghiberti, Lorenzo, 85, 94, 100
Gilded bronze, 241
Gilles Corrozet, 111

Index

Ginon's china works, 256
Ginsburg, Dr., 205
Giovanni Tornabuoni, 80
Girardon, 40
Giuliano da Sangallo, 80
Giustiniani, 248
Gladius Rogieri, the, 273
Glass, faked, 259
Glazes for pottery, 255
Glyptography, 79
Go-between, the, 164
Godescal, monk, 66
Gold products, spurious, 277
Gorgas, 21, 43
Gouffier, Claude, 109
Græco-Roman pottery, 247
Græculi delirantes, 20
Gratianus, 31
Greek copyists, 59
Greeks, the, as art collectors, 17
Green-bronze lacquer for metal, 263
Green or brown-green patina, 265
Green patina, 266
Grolier, 107
Gubbio, 249
Guillebert de Metz, 69
Gymnasium of the Areopagus, 17

Hall, Major H. Bing, 144
Hannibal, 37
Hercules and Antæus, 88
Hercules of Lysippus, 19
"Hercules Musagetes," 22
Hercules, statuette of, 36
Heius of Messina, 49
Henry II faience, 252
Hispano-Moresque pottery, 249
Holland, collections in, 128
Horace, 25; the *crieur*, 28, 32; book collecting, 50; patina, 51
Huber, Dr. L., 131

Imbert, 141
Imitation and fraud in Rome, 24
Imitations, contemporaneous, 232
Imitations by noted factories, 256
Imitator, the, 170
Imitators and copyists, 59
Impasto painting, 230
Imperator Caldusius, 92
Impruneta clay, 187
Inlaid work on furniture, 282
Inscriptions, 93
Iron work, 266

Isotta Atti, 86
Italian artists, versatility of, 86
Italy, collections in, in the fifteenth century, 70
Italy, exportation laws, 179
Italian faience, imitations of, 250
Itinerarium Galliæ, by Just Zingerling, 115
Ivory work, 244

Jabach, the dealer, 115, 123
Jests, 160
Jewellery, old, 278
Juba, King of Numidia, 212
Julius Cæsar, 21, 31; a specialist, 42
Julius, Prætor, 60
Jupiter, colossal statue of, in the Louvre, 39
Jupiter, head of, 79
Jupiter Olympicus, temple of, 21
Jupiter, temple of, in Elis, 23
Justinian, digest of, 63
Juvenal, Codrus, 33; Tongilius, 34; Licinius, 34; precious goblets, 52

Krieg, 248

La Bruyère, 124, 140
La Rochefoucauld, 195
Lamberti, Nicolo di Piero, 84
Laocoön, the, 104
Laws against exportation, 172
Lebroc, 209
Lequesne, M., 184
Les Collections des Medicis, 74
Lescot, 126
Libraries at Athens, 18
Licinius the nervous collector, 34
Liste anonyme des curieux, 115
Livy, 61
Lorenzo, il Magnifico, 75, 77, 78
Louis XI and the miraculous ring, 78
Louis XIII as a collector, 122
Louis XIV as a collector, 39, 123
Louvre, the, 40, 41, 92, 96, 120, 122, 187
Lovesque, 141
Lucian, on Roman tourist guides, 62, 307
Lucretius, candelabra, 30
Lucullus, 60
Lustre work, 250
Lyndon, Minerva's temple at, 18
Lysippus, statue of Hercules, by, 36

Index

Machiavelli, 102
Magliabechi, 307
Maillet, M. A., 201
Malachite, kind of patina, 265
Malatesta's temple of love, 86
Manheim, connoisseur, 54, 261
Mantegna and Isabella d'Este, 81
Maquilleur, the, 216
Marcellus, 19
Marcus Agrippa, 43
Marcus Aurelius as an auctioneer, 212
Marcus Aurelius, statuette of, 97
Marguerite of Antioch, 39
Mark Antony as a collector, 22, 31; rapacity, 38, 39; Corinthian bronze, 51
Marks of noted pottery factories, 258
Marks on steel, 274
Marostica, 67
Marsigli, Luigi, 72
Martial, 26; the *septœ*, 31; Milonius, 32; Clarinus and Paullus, 32; Eros and Mamurra, 33; statuette of Hercules, 36, 213
Marzi, Ezio, Prof., 191
Mazarin as a collector, 115, 117, 120
Mecherino, 106
Médailles insolentes, 128
Medals, forgers and imitators of antique, 100
Medals, patina for old, 265
Medici collection, fate of the, 74
Medicis, the, 72; Piero, 75; Cosimo, 75, 104; Giulio, 77; Ottaviano, 99; Alexander, 101; Lorenzino, 101
Mediæval collections, 64
Mégissene, the, 111
Meissen china, booming, 151
Meleager, statuette of, 89
Melpomene, colossal, in the Louvre, 41
Memoires de Brienne, 127
Mettere il bavaglino, 157
Mexican idols, 246
Michelangelo, 89, 102, 103, 111
Michelangelo's David, 108
Michelozzo, 75
Milanesi, 100
Milizia, 226
Millin, 136
Milonius, 32
Miniature work, 232
Miniatures in Rome. 30

Mino, 91
Minor collections, 299
Moabite pottery, forged, 205
Modena Museum, 91
Moderno, 97
Molière's works, 294
Montaigne, 108
Moreau, artist in iron, 266
Morelli, 147
Mosaic, a Roman, 46
Muffled glaze, 251
Mummius, L., 19
Munich Museum, the, 185
Murrhines, 52
Murrhines, prices paid for, 25
Museum of Arezzo, 92
Museum of French monuments, 92
Museum of Munich, 92
Museums and forgeries, 153
Musical instruments, 284
Mustard pot, find of a, 161
Myron, 39
Mys, bronzes of, 30

Napoleon as an art collector, 132
Natali's imitations, 182, 185, 190
National Museum, Florence, 91
Nero, 18, 46
Newton and Pascal, 201
Niccoli, Niccolo, 71, 92
Nicomedes, King, 37
Nieuwerkerque, 182
Nolives, 182
Nonius, 38
Numismatists, 92

Octavianus, a collector of Corinthian bronze, 51
Oeci, 49
Orlandini, Prof., 192
Orleans, Duke of, 129
Oriental pottery, 247, 249
Oriental weapons, 267
Over-restoration, 234

Paduan School, 91, 196
Pagan art, the worship of, 85
Painting, imitations in, 99
Painting, transformed, 168
Paintings, restoring, 225
Palazzo, Riccardi, the, 75
Palissy, 251
Palladium, Niccoli's, 97
Paolo Veronese, 102
Paris, art sales in, 128

Index

Parvenu collector, the, 82
Pascal and Newton, 201
Pasiteles, 21
Pastels and water colours, 232
Patinæ, 51 ; bronze, 238 ; marble, 241
Paul Potter, 232
Paullus, 32
Pausias, 42
Perenzolo, 69
Peristyle, the, 48
Perronet de Granvelle, 39
Pertinax, public auction by, 212
Peruvian pottery, 246, 248
".Peter Funk," 222
Petrarch, 71
Petronius' collection of Murrhines, 54
Petronius and art, 20, 26
Phœdrus, on faking, 59
Phidias, 20
Philippe-Egalité, 129
Photographing pseudo-masterpieces, 169
Pietà, Zampini's, 185
Pinacotheca of the Acropolis, the, 49, 71
Piot, 140
Plaquettes, 88, 91, 93
Plato, portrait of, 91
Plautus ("Menœchme"), 28
Pliny, 18 ; Gegania and Clesippus, 29 ; candelabra, 30 ; Nonius, 38 ; the "Young Philippian," 40 ; Polygnotus and Pausias, 42 ; Scaurus, 46 ; Corinthian bronze, 51 ; patina, 51 ; Murrhines, 52 ; *citrus* tables, 54 ; as a connoisseur in bronze, 57 ; counterfeit Sardonyx, 58 ; Evander Aulanius, 60 ; Pliny, the younger, on faking, 59
Plutarch, "Sulla's private travelling god," 36
Police of Louis XIV, 128
Polish of faked furniture, the, 280
Politiano, 79
Pollaiodo, Antonio, 88
Polycletus, 24 ; bronzes, 30 ; cameo, 73
Polygnotus, 42
Pompey, a generous collector, 41
Pontchartrain, 128
Pope Leo X, portrait of, 99
Pope Sixtus IV and the Medicis, 80
Pottery, faked, 247, 253, 254
Pourquet, M., 295

Poustales collection, the, 89
Præco, the, 28, 213
Prado of Madrid, the, 87, 92
Praxiteles, 46
Precious stones, imitation of, 58
Prices and values, 147
Prints and drawings, faking old, 231
"Prioristi," Florentine, 209
Private collections at Rome, beginning of, 22
Procopius, 62
Promenade of Pompey, 42
Propertius and Cynthia, 42
Protective laws, 105, 172
Psychology of collectors, the, 203
Ptolemy's cup, 66
Public auctions in Rome, 28
Public sales, 211

Quattrocento imitations, 87 ; velvets, 289
Quintilian, 24

Racine's works, 294
Radegond, St., 65
Raester, Olga, 285
Rameses, the forged, 203
Renaissance fakers of art, 68
Restorers and fakers, 59, 165
Restorers' workshops in Rome, 60
Restoring paintings, 226
Retouching, 225
Reville's *Promptuarium*, 92
Revolution, ceramics of the French, 252
Revolution, French, influence of the, 132
Rhodes' pottery, 248
Riccio, bronzes of, 87, 101
Richelieu as a collector, 115
Ricordi of Lorenzo Medici, 78
Ridolfi, Prof., 178
Rienzi, 71
Rinuccini, 78
Rochefort, Henri, 162, 214
Rolland, Mme., 150
Roman busts, imitations of, 90
Roman house, the, 48, 49
Roman, the, not a lover of art, 18
Romano, Giulio, 111
Rome : the home of the collectors, 18 ; development of art, 21 ; beginnings of private collection, 22 ; fictitious art and fraud, 24 ; freakish prices, 25 ; *septæ*, 28 ;

Index

public auctions, 28; an emporium of art, 44; Roman house, 48; faking and copying, 59; artistic life, 60
Rosary, Mazarin's valuable, 119
Rossini, 286
Rothschilds, the, 152, 235, 260, 269
Rovertet, 107
Rugs, Oriental, 293

Sacrarium, the, 49
St. Martin de Tours, monk of, 66
Saitaphernes, tiara of, 277
Sales of art collections, 128
Sales and auctions, 208
Salle Lebrun, the, 132
Salting collection, the, 191
Sanson, Charles, the executioner, a collector, 116
Sansovino, Jacopo, 89
Sardonyx, counterfeited, 58
Satire, on collecting, 125
Satyricon, the, 47
Sauval, 110
Savonarola, 83
Sbullettare, 186n.
Scaling of terra-cotta, 186
Scarampi, Cardinal, 73, 74
Scaurus, 45; his atrium, 49
Scientific and artistic pursuits, 137
Scopas, 46
Seneca and art, 20; collectors, 32; bibliomaniacs, 50; veneered furniture, 55
Septæ, the, 28, 29
Servilia, 47
Servilius, 46
Sèvres, museum at, 248
Shaw, Bernard, 142
Shaw, Quincy, 31, 141
Shields, story of the three, 271
Siena imitators, 191
Sigillaria, the, 31
Signatures and monograms, 193, 208, 231
Signorili, *Descriptio urbis Romæ* of, 69
Silver, artistic, during the French Revolution, 275
Silver, colour and tone of, 276
Silver marks, 276
Silver work, 274
Silver, wrought, rage for, in Rome, 25
Sisinande, 56
Sixteenth-century art, 101

Slang, art dealers', 159
Sleeping Cupid, the, 89
Smuggler, the, 171
Sogliani, 111
Solvents used in restoring pictures, 227
Specialist, the, 138
Spoon, Jacob, 127
Sposalizio, Correggio's, 118
Squarcione, Francesco, 71
Staedel Museum, the, 96
Stamp collecting, 299
Stanley, H. M., 142
Statues, 35, 36, 37
Stemmata, 49
Strongylion, bronze by, 40
Strozzi, Filippo, 101
Stucco duro imitations, 237
Suetonius, 29; Cæsar, 43, 212
Suggestion, influence of, 177
Sulla, 22, 31, 36
Supino, Prof., 178
Symbolic art, 63

Tabulæ auctionariæ, 213
Tanagras, faked, 235
Tane's *Philosophie de l'Art*, 304
Tapestries, 49, 291
Tardieu and Sanson, 116
"Tazza Farnese," the, 80
Tedesco, Piero di Giovanni, 84
Tempera, use of, in restoring, 228
Temples as museums of art treasures, 18
Textile material, antique and modern, 288
Theophrastus, 18
Thibaudau, *Trésor de la Curiosité*, 128
Tiberius, 11, 65
Timonacus, 43
Tintoretto, 102
Titian, 102, 120
Tongilius, the important collector, 34
Tortoise-shell as veneer, 55
Touchard, 248
Tourists in ancient Rome, 61
Trade and art, 150
Traité des plus belles bibliothèques, 115
Transferring bookbindings, 297
Trevoux, 136
Trimalcho, 26
Triclinia, 49
Trouillebert, 170
Tuscany, protective laws in, 106

Index

Uffizi Gallery, the, 90
Ulysses Belgico-Gallico, Golnitz's, 115
Urban VIII and the Coliseum, 105

Vaillant, 114
Valentino, Duke, 90
Valerius Maximus, 20
Varnish, imitating old and cracked, 229
Vasari, 86, 88, 89, 99, 225
Vedius Pollio and Augustus, 52
Vellano, bronzes of, 87, 88
Vellano, Vasari's life of, 100
Velleius Paterculus, 19
Velvets, quattrocento and cinquecento, 289
Veneering in Rome, 55
Venetian works, effect of cleaning on, 217
Venus Anadyomene of Apelles, 60
Verres, the greedy collector, 22, 30, 31, 37
Verrocchio, Andrea del, 88–92
"Verrocchio and Co.," 190
Vicentino, Valerio, 143
Victoria and Albert Museum, 96, 185, 188
Vindex, the real connoisseur, 35, 37

Virgil, 101
Vitruvius, 20; private palaces, 45
Volpi, Elia, Prof., 178
Voltaire, 130
Voyage pour l'Instruction, Verdier's 115
Voyage de Lister, 115
Voyage de Montaigne, 108
Vrain-Lucas, 199
Vulteius Medas, 28

"Wall breakers" at Athens, 18
Walters, H., 141
Warton, 110
Weapons, faked, 267
Wax work, 244
"Way for Asses, The," 161
White, Stanford, 141, 304
Winckelmann, 36, 53, 58
Wood carving, colouring, 243
Worm-holes in furniture, imitation, 281

"Young Philippian," the, 40

Zampini, Ferrante, 182, 185, 198
Zenodonis, a copyist, 59

www.ingramcontent.com/pod-product-compliance
Lightning Source LLC
Chambersburg PA
CBHW011514200526
45163CB00017B/3123